MW00581028

Intimate Interiors

Material Culture of Art and Design

Material Culture of Art and Design is devoted to scholarship that brings art history into dialogue with interdisciplinary material culture studies. The material components of an object—its medium and physicality—are key to understanding its cultural significance. Material culture has stretched the boundaries of art history and emphasized new points of contact with other disciplines, including anthropology, archaeology, consumer and mass culture studies, the literary movement called "Thing Theory," and materialist philosophy. **Material Culture of Art and Design** seeks to publish studies that explore the relationship between art and material culture in all of its complexity. The series is a venue for scholars to explore specific object histories (or object biographies, as the term has developed), studies of medium and the procedures for making works of art, and investigations of art's relationship to the broader material world that comprises society. It seeks to be the premiere venue for publishing scholarship about works of art as exemplifications of material culture.

The series encompasses material culture in its broadest dimensions, including the decorative arts (furniture, ceramics, metalwork, textiles), everyday objects of all kinds (toys, machines, musical instruments), and studies of the familiar high arts of painting and sculpture. The series welcomes proposals for monographs, thematic studies, and edited collections.

Series Editor:
Michael Yonan, University of Missouri, USA

Advisory Board:
Wendy Bellion, University of Delaware, USA
Claire Jones, University of Birmingham, UK
Stephen McDowall, University of Edinburgh, UK
Amanda Phillips, University of Virginia, USA
John Potvin, Concordia University, Canada
Olaya Sanfuentes, Pontificia Universidad Católica de Chile, Chile
Stacey Sloboda, University of Massachusetts Boston, USA
Kristel Smentek, Massachusetts Institute of Technology, USA
Robert Wellington, Australian National University, Australia

Intimate Interiors

Sex, Politics, and Material Culture in the Eighteenth-Century Bedroom and Boudoir

Edited by
Tara Zanardi and Christopher M. S. Johns

BLOOMSBURY VISUAL ARTS
LONDON • NEW YORK • OXFORD • NEW DELHI • SYDNEY

BLOOMSBURY VISUAL ARTS
Bloomsbury Publishing Plc
50 Bedford Square, London, WC1B 3DP, UK
1385 Broadway, New York, NY 10018, USA
29 Earlsfort Terrace, Dublin 2, Ireland

BLOOMSBURY, BLOOMSBURY VISUAL ARTS and the Diana logo
are trademarks of Bloomsbury Publishing Plc

First published in Great Britain 2023

Selection and editorial matter © Tara Zanardi and Christopher M. S. Johns, 2023
Individual chapters © their authors, 2023

Tara Zanardi and Christopher M. S. Johns have asserted their right under the
Copyright, Designs and Patents Act, 1988, to be identified as Editors of this work.

Cover design: Tjaša Krivec
Cover image: Thomas Chippendale, "Toilet Table", from *Chippendale Drawings*,
Vol. II., 1760, drawing. The Metropolitan Museum of Art. © Photo: Scala, Florence.

All rights reserved. No part of this publication may be reproduced or transmitted
in any form or by any means, electronic or mechanical, including photocopying,
recording, or any information storage or retrieval system, without prior
permission in writing from the publishers.

Bloomsbury Publishing Plc does not have any control over, or responsibility for,
any third-party websites referred to or in this book. All internet addresses given in
this book were correct at the time of going to press. The author and publisher regret
any inconvenience caused if addresses have changed or sites have ceased to exist,
but can accept no responsibility for any such changes.

A catalogue record for this book is available from the British Library.

A catalog record for this book is available from the Library of Congress.

ISBN: HB: 978-1-3502-7760-1
 ePDF: 978-1-3502-7761-8
 eBook: 978-1-3502-7762-5

Series: Material Culture of Art and Design

Typeset by Integra Software Services Pvt. Ltd.
Printed and bound in Great Britain

To find out more about our authors and books visit www.bloomsbury.com
and sign up for our newsletters.

Contents

Illustrations

Contributors

The Editors

Christopher M. S. Johns was the Normal L. and Roselea J. Goldberg Professor of Fine Arts and Professor of the History of Art and Architecture at Vanderbilt University. He published on Italian visual and material culture, including *China and the Church: Chinoiserie in Global Context* (2016), *The Visual Culture of the Catholic Enlightenment* (2014), and *Antonio Canova and the Politics of Patronage in Revolutionary and Napoleonic Europe* (1998). Christopher was a founding member of the Historians of Eighteenth-Century Art and Architecture.

Tara Zanardi is Associate Professor of Art History at Hunter College, CUNY. She publishes on eighteenth-century Spanish visual and material culture, including "Silver" (*Journal18* special issue, 2022), *Visual Typologies from the Early Modern to the Contemporary: Local Practices and Global Contexts* (co-edited with Lynda Klich, 2018), and *Framing Majismo: Art and Royal Identity in Eighteenth-Century Spain* (2016). She has received fellowships from NEH, the Metropolitan Museum of Art, the Fulbright Program, and the John Carter Brown Library.

The Contributors

Ashley Bruckbauer is an independent scholar specializing in European visual culture from 1600 to 1900. Her research focuses on objects related to cross-cultural exchanges between France and other nations during the long eighteenth century. She received her Ph.D. in Art History from the University of North Carolina at Chapel Hill, where she previously taught for the Department of Art History and the Ackland Art Museum.

Katherine Calvin is Assistant Professor of Art History at Kenyon College. She received her B.A. from Vanderbilt University and her Ph.D. from the University of North Carolina at Chapel Hill. Her research examines the intersections between early modern antiquarianism, mercantile speculation, and art collecting, particularly by British merchants, in the Middle East and West Africa. Calvin's first book, *Antiquarian Speculations*, is in preparation. Her work has also been published in *Journal18* and *Studies in Eighteenth-Century Culture*.

Sandra Gómez Todó is an independent scholar working on the visual representation of women in the entertainment culture of the long eighteenth century. She obtained her Ph.D. in Art History at the University of Iowa with her dissertation "The Visual

Culture of Women's Masking in Early Modern England," currently under revision for a book project. Sandra's work has been supported by the Fulbright Program and presented at various conferences. She has recently published on depictions of actresses in Spanish Romanticism.

Dorothy Johnson is Roy J. Carver Professor of Art History at the University of Iowa. She has written numerous articles on eighteenth- and nineteenth-century French art. Her books include *Jacques-Louis David: Art in Metamorphosis*; *Jacques-Louis David: The Farewell of Telemachus and Eucharis*; *David to Delacroix: The Rise of Romantic Mythology* (Choice Outstanding Academic Title Award, 2011), and *Jacques-Louis David: New Perspectives* (editor and contributing author). She is currently working on a book on art and anatomy in France from 1750 to 1850.

Hyejin Lee is an independent historian of eighteenth-century European art and architecture. She has published on subjects such as Jean-Siméon Chardin's food still-life paintings and French ballooning memorabilia from the late 1700s. In addition, she has produced videos about Western art for general audiences on YouTube in her channel called ArtStoryLab.

Christina K. Lindeman is an Associate Professor of Art History at the University of South Alabama, and the author of several essays specializing in the art and material culture of eighteenth-century German-speaking Europe. Her book *Representing Duchess Anna Amalia's Bildung: A Visual Metamorphosis from Personal to Political in Eighteenth-Century Germany* was published with Routledge in 2017. She is currently working on a critical monograph examining artworks by Anna Dorothea Therbusch (1721–82) under contract with Amsterdam University Press.

Maurie McInnis is President of Stony Brook University. She is most recently co-editor of *Educated in Tyranny: Slavery at Thomas Jefferson's University* (2019) and author of *Slaves Waiting for Sale: Abolitionist Art and the American Slave Trade* (2011).

Jorge F. Rivas Pérez is the Frederick and Jan Mayer Curator of Spanish Colonial Art and department head at the Denver Art Museum. He previously served as the curator of Spanish colonial art at the Colección Patricia Phelps de Cisneros, and as associate curator of Latin American art at LACMA. He received his architecture degree from Universidad Central de Venezuela, master's from the University of Florence, Italy, and his Master of Philosophy and Ph.D. from the Bard Graduate Center.

Wendy Wassyng Roworth is Professor Emerita of Art History at the University of Rhode Island and a specialist on the Austrian-Swiss painter Angelica Kauffman (1741–1807). She has lectured on Kauffman at national and international museums and conferences, and her publications include "The Angelica Kauffman Inventories: An Artist's Property and Legacy in Early Nineteenth-Century Rome," *Getty Research Journal 7* (2015): 157–68 and *Angelica Kauffman: A Continental Artist in Georgian England* (1992).

Foreword

Tara Zanardi
For Christopher M. S. Johns

In the winter of 2018, I phoned Christopher regarding an idea I had for an edited volume that would highlight bedrooms, boudoirs, and other intimate spaces as emblematic of the collective trend toward informality, privacy, and greater specificity in the design and materials of the eighteenth-century interior. Having been researching Philip V's and Isabel de Farnesio's lacquered bedroom from the Royal Palace of San Ildefonso de La Granja, I was struck by various commonalities the room shared with other palatial interiors outside of Spain and Europe. The sovereigns' motivations for intimacy in and control over their communal bedroom may have been particular to this couple and the circumstances of the Spanish court in the early 1700s, but they also paralleled other such patrons' desires for private quarters where sociable, political, or creative acts could take place. While my chapter treats an example from Spain, I was fascinated by the way in which such proclivities for privacy existed across the globe. The topic seemed worthy of investigation.

With the material turn in art history and the dynamic scholarly interest in eighteenth-century interiors, design, and decorative arts, it seemed that more attention needed to be directed toward specific kinds of spaces that privileged activities conducted by an individual, a couple, or a select group of family or associates often far from the prying eyes of visitors, courtiers, or bureaucrats. How did such rooms, whether actual lived interiors or imagined ones in paintings, and their architecture and décor dictate or enable certain behaviors, elicit particular sentiments, and embody a patron's multi-faceted identity? How was one's sense of self performed when alone or in intimate company? How did these spaces suggest a yearning for ease, secrecy, and respite from the outside world? How did these interiors hide certain acts and people that patrons wished to remain concealed? What might we learn from studying such interiors and how might we uncover what meanings they held for their occupants? How were such rooms central to a patron's control over courtly negotiations, familial gatherings, individual hobbies or aspirations, or the maintenance of certain pretenses? Ultimately, what do these interiors teach us about eighteenth-century design and conceptions of interiority, informality, and comfort?

Upon explaining my fascination with the topic and vision for the project, I fully anticipated that Christopher would decline the offer to be my co-editor considering he had been my doctoral advisor at the University of Virginia and might not want to work on a book with his former graduate student. To my incredible delight, however, Christopher said yes and told me he thought it sounded like an excellent project and

that his essay on Queen Maria Amalia's porcelain boudoir at Portici would be a perfect fit. He was totally game to participate and was excited for the prospect of working as collaborators. He even dubbed our crew of authors as "Team Sexy." It was a pleasure to chat about the book as it took shape over the past few years, especially once we got the project fully underway in 2020 despite the impact of COVID-19. Christopher seemed to enjoy serving as a co-editor, writing one of the volume's chapters, and actively engaging in discussion about its scholarly importance as the first study of its kind. He also sought out papers by esteemed academics, rounding out our roster of authors.

Such gestures were typical of Christopher. He was a robustly generous and thoughtful scholar and an enthusiastic promoter of his students. His mentorship was instrumental in the careers of countless undergraduates and graduates, including myself. Even if he did not directly teach some of the authors in this volume, he assisted them in other ways: serving on their dissertation committees, writing them letters of recommendation, or offering them supportive advice. Christopher has always been a champion of junior scholars joining the field. I first met Christopher when I entered graduate school at the University of Virginia where I dove deeply into the studies of the eighteenth century. Despite his incredible standing as a scholar like no other and his exceptional teaching skills, Christopher was without ego and pretense. He was witty, had a dry sense of humor, yet remained always humble.

During the different phases of this project, he was a wonderful presence, always lending his expertise to the process. Once we had secured the contract with Bloomsbury, we moved swiftly to ready the manuscript for submission. Unfortunately, it was at this moment (in June of 2021) that Christopher's condition worsened substantially. Despite the state of his health, he made a stellar effort to assist me with the final stage of the manuscript preparation whenever he was able. He never stopped caring about the project and offered as much aid as he could during this challenging time. While he is no longer with us to celebrate the book's publication, his enthusiasm, input, and spirit helped to spur on the project toward completion.

This volume features many of Christopher's former students, colleagues, and friends, many of whom have known him since graduate school or his early career days. What good fortune it was to have this excellent collection of scholars, many of whom studied and worked with Christopher over the years, come together in this volume! *Intimate Interiors* commemorates Christopher's illustrious career, collaborative attitude, and groundbreaking contributions to the field. The book's emphasis on spaces that provided refuge, secrecy, and imaginative inspiration for its inhabitants will engender further, lively conversation about what interiors meant, what they could do, and how they were constructed, decorated, and animated. This volume seeks to shed novel light on how eighteenth-century people lived, how they expressed and revealed themselves, and how they conceived of their own interiority through the built form.

Introduction

Tara Zanardi and Christopher M. S. Johns

In 2020, the duke and duchess of Sussex, Prince Harry and Meghan Markle, moved to Los Angeles. Their motivation, according to countless interviews and tweets, was a desire for increased privacy and a less formal lifestyle outside strict court etiquette. Resigning most of their titles and official duties, the couple pursued their individual aspirations and spoke at liberty about their passion projects. They also wanted to raise their children in a more intimate environment—one that was not surrounded by pomp and ceremony. Harry and Meghan spoke about their struggles with mental health, revealing a sense of isolation and frustration with the constant need to perform publicly as working members of the British royal family.

The yearning for greater autonomy, informality, and privacy that Harry and Meghan expressed is not a modern phenomenon nor a new trend; rather, it has been a paramount need of countless notable individuals since the early eighteenth century. King Louis XIV's (r. 1643–1715) flamboyant persona and flair for public performance set in grandiose spaces in front of large audiences at Versailles gradually lost favor to rulers who preferred to conduct their affairs in less formalized spaces. These individuals sought a retreat into solitude far from the court's prying gaze, moving away from an emphasis on total availability. Even if one must perform public duties, the ability to withdraw was essential.

The desire for intimacy, informality, and comfort was expressed by many—not just nobles and courtiers, nor was it specific to any one gender. In addition, one need not be wealthy to want a private space. Well before Virginia Woolf craved "a room of her own" to write, authors, artists, politicians, intellectuals, socialites, and others longed for secluded quarters or places within rooms that could be demarcated separately. These intimate sites helped their residents to establish boundaries, conduct private affairs, create, relax, consolidate power, and forge identities.

To complement these wishes for a less public existence, architects and artists designed interiors that emphasized seclusion and intimacy through a variety of mechanical, decorative, material, and architectural creations. Some of these strategies include chambers blocked off from the main rooms; private staircases to allow for clandestine movement to and from the accommodations; devices such as two-way mirrors that controlled visibility; hidden entrances; and personalized

designs with objects and furniture that foregrounded comfort and elegance; at the same time they encouraged sociability with one's family and close friends. In such environments, many nobles, for example, flourished so that their engagement with diplomats and courtiers was regulated. Leaving behind the stately formal spaces within palaces, nobles could escape to their secret quarters to relax in solitude or with intimates. Engaging in all forms of sociability, quiet contemplation, or study, royals and other public figures increasingly enjoyed time to themselves and their invited guests.

Eighteenth-century interior design saw an emphasis not only on spaces meant to provide privacy but also on those that were tailored to one or two activities. This sense of specific functionality of rooms and their corresponding furnishings realized the patron's individual needs and taste. This impulse stemmed from a variety of factors, including a growing sense of individualistic expression, an incentive to camouflage the labor (or enslavement) taking place within the home, and an appetite for solitude. While public pageantry continued in elite interiors and ecclesiastical buildings, rulers and others increasingly crafted spaces that granted reprieve from court protocols and ceremonies. The political nature of many of these spaces also points to the contradictions and complexities of such "private" interiors, many of which were highly performative despite their claims of intimacy and their focus on relaxation; however, political negotiations, courtly intrigue, and business need not take place in grand or formal spaces, but instead, were often confined to close quarters that fostered a more personal and sociable approach to intellectual discussion and matters of state. By customizing interiors and their decorative furnishings, architects and artists could better accommodate the need for privacy, seclusion, and sociable activities, such as reading novels, gossip, armchair travel, gaming, sex, and partisan debate. Thus, eighteenth-century designs worked in tandem with the roles of rooms to generate more individualized and efficient spaces.

Intimate Interiors is the first study of its kind to interrogate this multi-faceted desire for informality, comfort, privacy, and particularity on a global level. The chapters address this tendency via architectural, artistic, and material means using a variety of methodological approaches and interpretative models. The authors consider intimate spaces (both painted and architectural) to address the themes of privacy, domesticity, gender, power, authority, and sociability. The volume participates in a broader scholarly project focusing on the interior, but examines topics given to intimate spaces, including bedrooms and boudoirs, but not limited to them. The volume also emphasizes the connections among the multifunctionality of such intimate spaces, their performative roles, the materiality central to their design and decoration, and the aspirations and taste of their patrons. Our aim is to investigate the impulses for solitude and informality that existed on a global scale but with attention to specific locations. The chapters illustrate the conditions of a given site and culture that fostered a yearning for both quiet and intimate sociability. Many of these spaces created a sense of fluidity between traditional notions of private and public in which elites exerted greater control over their surroundings. Thus, even when spaces were secluded, they still provided opportunities to exchange and engage in court governance, academic endeavors, or pleasurable pursuits.

Intimate Interiors takes its cue from recent scholarship on the built environment's interiors as a subject for serious scrutiny. In Christina Smylitopoulos's *Agents of Space*, the authors examine the complexities and multiplicities of space and spatial representations in various contexts and media. Diana Cheng's contribution to this volume addresses the early modern boudoir and its shifting uses, making it an important reference for our book.[1] Denise Amy Baxter's and Meredith Martin's *Architectural Space in Eighteenth-Century Europe* investigates European examples of built spaces and considers the diverse yet key roles of patrons, architects, and artists in their creation. The chapters interweave connections between identity formation and the interior, a key theme for *Intimate Interiors*.[2] Kate Retford has contributed extensively to the theme of the interior, including essays on the depiction of domestic spaces and the objects and people within them in British conversation pieces and a co-edited volume, *The Georgian London Town House*. This book explores the understudied subject of the townhouse and the ways in which it was furnished.[3] Stephen G. Hague and Karen Lipsedge emphasize the eighteenth-century domestic space as a site of transformation and a place with multiple meanings and modes of design. The essays highlight key examples from Britain. This text posits the conception and function of the home as fluid.[4] Danielle Bobker scrutinizes the closet, a room meant for solitary activities or intimate conversation. She approaches the topic in an interdisciplinary manner to discuss the closet's symbolic weight in myriad literary examples.[5] Tita Chico's works, including *Designing Women*, inform many of our authors' focus on gendered spaces within homes. Chico examines the contradictions of the dressing room and its multiple associations as an interior linked to eroticism and learning, much like many of the rooms our contributors address.[6]

Despite the new interest in the interior, most publications have tackled the topic broadly, focusing on various kinds of rooms, or have highlighted different aspects of one specific space. Interiority, a related concept, has also been a subject of recent examination. Examining the interconnected issues of interiors and interiority, Ewa Lajer-Burcharth's and Beate Söntgen's text explores varying architectural expressions of interiority as they developed alongside new ideas about space, spatial constructions, and the self.[7] Our volume, instead, foregrounds themes of intimacy, privacy, and sociability in the context of the bedroom, boudoir, and similar interior spaces, such as dressing rooms and cabinets, lending greater specificity to the discussion of interiority. Our authors investigate the architectural design and material culture of intimate rooms. They explore themes of gender, politics, travel, exoticism, imperialism, sensorial experiences, and modernity in innovative ways, situating intimate encounters in direct relationship to notions of individual and collective identities and communal practices that took on greater importance during the eighteenth century.

Our volume's international thrust coincides with the global turn in art history. Mary Sheriff's *Cultural Contact and the Making of European Art* explores global networks of exchange from the early modern period through Modernism. This foundational study posits that the traditional art historical division of national schools obfuscates the various points of contact that existed across geographical and political borders.[8] The emphasis on cultural appropriation under discussion in this volume is directly relevant to several of the chapters in *Intimate Interiors* in which such practices

are addressed. In *The Eighteenth Centuries*, David Gies and Cynthia Wall investigate the interdisciplinarity of the diverse manifestations and complexities of globalization during the 1700s.[9] Probing the international nature of eighteenth-century visual culture, Stacey Sloboda and Michael Yonan, in *Eighteenth-Century Art Worlds,* bridge the disciplines of cultural geography and art history.[10] These various texts inform our exploration of interiors that are often the products of cultural contact.

Our authors consider scholarly examination of material objects as essential to the understanding of eighteenth-century interiors, visual culture, and their significance to the study of individual and collective identity. From incense burners, porcelain, lacquer, and skulls, our authors engage directly with various kinds of materials and their numerous cultural associations, political connotations, and artistic manipulations. Recent studies, such as Jon Stobart's and Andrew Hann's *The Country House*, highlight the relationship between material culture and consumerism, building on a wealth of resources that have examined consumption patterns during the 1700s.[11] Mimi Hellman's work on furniture and decorative arts has been pivotal in our understanding of the cultural value of tables, garnitures, and sofas.[12] In addition, Yonan's and Alden Cavanaugh's *The Cultural Aesthetics of Eighteenth-Century Porcelain* has proven essential for the development of material culture studies of the early modern period.[13]

These scholarly orientations on the interior, the global, and the material provide a solid foundation for our volume, which foregrounds new methods for addressing the complementary impulses for privacy and comfort. By inserting *Intimate Interiors* into this exciting framework, we expand on these contributions to examine critically the ways in which individuals across the globe desired interiors that better represented their personal and political agendas and their social aspirations. By focusing on the architectural, visual, and material culture of intimate spaces, from distinct methodological perspectives and geographical sites, our volume is the first of its kind, unpacking the subject from an international perspective. The chapters address the types of activities performed in such quarters and the corresponding decorative objects utilized to facilitate these actions.

We have structured *Intimate Interiors* into three main sections. While the chapters are specific to their contexts, the themes they address suggest commonalities and intersections across cultures. Architecturally, materially, and visually, the "interiors" our authors discuss may be different, but they elucidate powerful points of contact to indicate that the yearning for informality and sociability was commonly felt even if it was expressed in ways unique to particular locations. Widespread sentiments for privacy and comfort point to the intimate interior as a space to forge one's identity via design, control, seclusion, and preferred activities. The intimate interior is ripe for sustained scholarly focus.

Part 1, "Power, Authority, Agency, Privacy," tackles these broad topics by examining how aristocrats conveyed political and personal power through the built environment. Ashley Bruckbauer addresses the intersections among gender, privacy, *turquerie*, neoclassicism, and identity in the design and function of the comte d'Artois's Versailles *cabinet turc*. She investigates this space as one in which the nobleman expressed his intellectual pursuits and personal pleasures. Bruckbauer explores the myriad cultural meanings of an Ottoman-styled cabinet in a French palace. Christopher Johns considers

the employment of chinoiserie in southern Italy. He discusses Queen Maria Amalia's porcelain boudoir at Portici, an innovative interior she would have used for intimate gatherings or private contemplation. Johns evaluates the queen's role in establishing the Capodimonte porcelain factory and her patronage in the visual and musical arts. Christina Lindeman probes the creation, design, and implications of a *Hundezimmer* fabricated exclusively for hunting dogs owned by Maria Amalia, wife of Carl Albrecht, elector of Bavaria, at the Amalienburg Palace in Munich. This space features painted walls with a blue and white palette and alcoves at the base for the canines to rest after their strenuous work outside. Lindeman argues that this interior was meant to civilize these prized pups. Tara Zanardi analyzes the shared bedroom of Philip V and Isabel de Farnesio of Spain. Located at the Royal Palace of San Ildefonso de La Granja, the bedroom served as a multifunctional space that allowed the queen to participate in all aspects of political life as the king's equal partner. Juxtaposing black and red lacquer panels and large religious paintings by contemporary Italian artists, this assemblage elicited material, thematic, and spatial comparisons as it dazzled the sovereigns and their select guests.

In Part 2, "Staging Identity and Performing Sociability," the authors engage with the theme of performance as central to sociable behaviors. Jorge Rivas examines the implementation of the *estrado* (dais) in the home of Doña Rosa Juliana Sánchez de Tagle, first marchioness of Torre Tagle, in colonial Lima, Peru. This luxuriously adorned and intimate space was closely identified with women, providing a place for their individual contemplation or group activities, such as needlework and conversation. Rivas uncovers archival material to understand the ways in which her *estrados* were decorated and how they manifested her status and taste. Also looking to inventory records, Wendy Roworth addresses how the celebrated artist Angelica Kauffman's improving financial circumstances allowed for increasingly private and comfortable domestic spaces. She investigates Kauffman's bedrooms in London and Rome—their changes in size and decoration and how they corresponded to her public and commercial quarters in which she displayed works of art for potential clients. Sandra Gómez Todó examines the ritual of the *toilette* that took place in British dressing rooms and argues that it was the site of female self-fashioning. Such sartorial and cosmetic preparations were performed in anticipation of attending the masquerade. Gómez views this interior as mutable and one that increasingly took on pejorative gendered associations, linking women's makeup for the masquerade to the artificiality of women's characters.

Part 3, "Hidden Lives and Interiority," probes the private interiors of mythological characters and political figures whose desire for secrecy was paramount. Dorothy Johnson explores Jacques-Louis David's *The Loves of Paris and Helen* (1788) and the complex and ornate boudoir the artist depicted to set the scene for the lovers. She argues that David created an antique-style boudoir that combines contemporary elements and cultural associations with classicizing elements to generate a space simultaneously ancient and modern. Johnson suggests this conflation is essential for interpreting the room's symbolism. Katherine Calvin assesses interiority as key to the aesthetic and political conceptions of kingship in the kingdom of Dahomey in West Africa. Examining the location, architecture, and adornment of the Dahomean

sleeping room, Calvin highlights how this intimate space marked the royal body as the sacred and geographical focus. She places her discussion of these rooms as physical and metaphorical center in the context of the kingdom's mercantile and territorial expansion. Hyejin Lee examines the evocation of the Oriental harem in Queen Marie Antoinette's Turkish boudoir at Fontainebleau. She posits that the queen used the interior as an illusory realm in which to perform an alternate identity, one in which she had total agency. This secluded space employed perfume to create an aura of the Orient in the French imagination. Maurie McInnis proposes that Thomas Jefferson understood the public role he would continue to play despite his retirement from political life and so designed his Virginia house Monticello to have a clear separation between the public, private, and enslaved. While the public portion of the mansion displayed European and native American objects, maps, and specimens in a didactic fashion, his private quarters limited guests and was reserved for quiet study, reading, or sleeping. McInnis details the enslaved facet of Monticello, which was made nearly invisible so that visitors would not witness the labor taking place on the estate.

From Virginia to Peru and West Africa to France, the essays in this volume evidence a seismic shift from a public and ceremonial existence to a private and intimate one, for nobles, political figures, artists, courtesans, literati, and socialites. By investigating the visual, architectural, and material culture of intimate spaces through distinct interpretive lenses, the authors promote knowledge of what the interior meant to its inhabitants and how these spaces negotiated new social norms and customs, how they generated modern ideas about living spaces, and how they paralleled the trend toward individualism. This yearning for a secluded retreat—as an individual interior, suite of apartments, or demarcated space within a room—that offered comfort, control, and discretion away from the formal spaces of one's residence was experienced by many across social class, gender, culture, and geographical location. Although expressed in unique architectural, material, and artistic ways, the need for intimacy was paramount. Moreover, the desire for solitude marks a considerable departure from the early modern period and positions the eighteenth century in the modern era in which such sentiments are still felt. Although fluidity often existed between public and private, increasingly the eighteenth-century abode witnessed a greater emphasis on a division between formal and informal spaces. While the home continued to be a site for display and performance, the insistence on a separation between public and private, especially for notables and royals, was universal.

Notes

1 Christina Smylitopoulos, ed., *Agents of Space: Eighteenth-Century Art, Architecture, and Visual Culture* (Newcastle upon Tyne: Cambridge Scholars Publishing, 2016).
2 Denise Amy Baxter and Meredith Martin, eds., *Architectural Space in Eighteenth-Century Europe: Constructing Identities and Interiors* (Burlington, VT: Ashgate, 2010).
3 Kate Retford and Susanna Avery-Quash, eds., *The Georgian London Town House: Building, Collecting, and Display* (London: Bloomsbury, 2019).

4 Stephen G. Hague and Karen Lipsedge, eds., *At Home in the Eighteenth Century: Interrogating Domestic Space* (New York: Routledge, 2021).

5 Danielle Bobker, *The Closet: The Eighteenth-Century Architecture of Intimacy* (Princeton: Princeton University Press, 2020).

6 Tita Chico, *Designing Women: The Dressing Room in Eighteenth-Century English Literature and Culture* (Lewisburg, PA: Bucknell University Press, 2005).

7 Ewa Lajer-Burcharth and Beate Söntgen, *Interiors and Interiority* (Berlin: Walter De Gruyter GmbH, 2016).

8 Mary D. Sheriff, *Cultural Contact and the Making of European Art since the Age of Exploration* (Chapel Hill: University of North Carolina Press, 2010).

9 David Gies and Cynthia Wall, eds., *The Eighteenth Centuries: Global Networks of Enlightenment* (Charlottesville: University of Virginia Press, 2018).

10 Stacey Sloboda and Michael Yonan, eds., *Eighteenth-Century Art Worlds: Global and Local Geographies of Art* (London: Bloomsbury Visual Arts, 2019).

11 Jon Stobart and Andrew Hann, eds., *The Country House: Material Culture and Consumption* (Swindon: English Heritage, 2016).

12 Mimi Hellman has published extensively on eighteenth-century decorative arts. See, for example, "The Joy of Sets: The Uses of Seriality in the French Interior," in *Furnishing the Eighteenth Century: What Furniture Can Tell Us about the European and American Past*, ed. Dena Goodman and Kathryn Norberg (New York: Routledge, 2011), 129–53.

13 Alden Cavanaugh and Michael E. Yonan, eds., *The Cultural Aesthetics of Eighteenth-Century Porcelain* (Farnham: Ashgate, 2010).

Part One

Power, Authority, Agency, Privacy

Sex, Lies, and Books: Staging Identity in the Comte d'Artois's *cabinet turc*

Ashley Bruckbauer

In 1781, Charles Philippe, comte d'Artois, commissioned the construction of a new Turkish-style room (*cabinet turc*) for his apartments at the château de Versailles. This intimate, multifunctional interior was one of more than a dozen rooms in the south wing of the palace that formed the lavish living quarters of the French king's youngest brother and his wife, Marie Thérèse de Savoy, comtesse d'Artois. The creation of the *cabinet turc*, which served as the comte's private study and library, was among multiple ambitious renovations on the couple's apartments during the eighteenth century.[1] Work on the project unfolded over more than nine months, resulting in a highly personal retreat filled with luxurious furnishings and decorated with intricately painted panels that amalgamated the period's popular turquerie and neoclassical styles.[2]

While the comte d'Artois's *cabinet turc* does not survive, objects from the dismantled space, architectural plans, and textual records do, allowing for the construction of a vivid, if incomplete, picture of the room. Plans of the space show a rectangular chamber surrounded on two sides by an L-shaped hallway.[3] Two windows occupied the single exterior wall, providing the space with natural light and views of the south gardens. Between these two windows hung a sizable mirror that would have reflected the interior's contents.[4] On the opposite wall was a rectangular niche with mirrors on the two sides and a glass panel on the back that allowed light to pass from the room into the adjoining corridor. Two false bookcases disguising passages into the hallway flanked this niche.[5] The cabinet's lateral walls closely followed one another in their configuration. The south wall had a fireplace at the center with a mirror above and bookcases on either side. Similarly, the opposite wall contained a matching central mirror flanked by two additional bookcases. Four doors faced one another at either end of these two long walls. While those on the south wall led into the corridor, the door nearest the window on the opposite wall connected with the adjacent dining room and the other was false.

Elaborate marble and gilt bronze furnishings as well as dozens of inset panels (*boiseries*) filled the *cabinet turc*. These sumptuous decorations contained a mixture of turquerie and neoclassical motifs, including lyres, sabers, sirens, sultanas, amphorae, and incense burners. The four surviving upper door panels (Figure 1.1) feature paintings

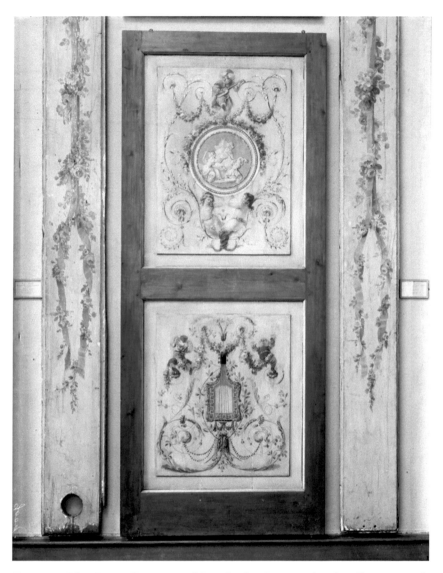

Figure 1.1 Jules-Hugues Rousseau and Jean-Siméon Rousseau (attributed), Door panels from the *cabinet turc* of the comte d'Artois at Versailles, 1781, oil on oak. Metropolitan Museum of Art, 07.225.458a-b. Public Domain.

of blue and white medallions depicting increasingly intimate episodes from the daily life of an Ottoman sultan at their center. Pairs of sirens and women issuing from foliage support each of these roundels imitating antique cameos, while male children in Turkish garb sit, stand, and dance atop them. Swirling vegetation emanating from the fantastical figures forms decorative frames around the edges of the rectangular

panels, following the arabesque ornament popular in such early modern decorations. Amphorae and lyre-guitars appear at the centers of the four corresponding lower door panels. The room's sumptuous furnishings, including a gilt bronze clock featuring two sultanas and a gilt wood console table decorated with sirens and antique vessels, echo the many luxury objects seen in the painted decorations by Jules-Hugues Rousseau (1743–1806) and Jean-Siméon Rousseau de la Rottière (1747–1820).[6]

The comte d'Artois's *cabinet turc* was part of the broader cultural phenomenon of turquerie in eighteenth-century Europe. This vogue for all things "Turkish" had spurred a vibrant body of aesthetic productions, which offered ample inspiration for the artists and patrons who created such rooms in the 1770s and 1780s. As multimedia projects incorporating painting, sculpture, and decorative objects, these interiors were ambitious and enormously expensive undertakings, explaining their limited number and elite patronage. Among the first to create such a space in France was Louis XV's mistress, Jeanne Antoinette Poisson, marquise de Pompadour, who in the 1750s decorated her bedroom at the château de Bellevue in the Turkish style, complete with paintings by Carle van Loo (1705–65) that picture her in the guise of a sultana.[7] Likewise, Marie Antoinette and the king's sister, Madame Elisabeth, had *boudoirs turcs* constructed at the château de Fontainebleau in 1777 and the château de Montreuil in the late 1780s.[8] Of the multiple members of the French royal family and their courtly circle to commission Turkish rooms during this period, the comte d'Artois was the most prolific. He created at least four such spaces during his lifetime. Prior to the construction of the 1781 *cabinet turc*, he had built two similar interiors, one at Versailles in 1774 and another at his Paris residence, the Palais du Temple, in 1776.[9] Additionally, in 1783, he would order a second Turkish room for this latter property. While only Marie Antoinette's *boudoir turc* at Fontainebleau remains intact, numerous objects, furnishings, and *boiserie* panels from these various rooms have been preserved and are now held in museums across Europe and the United States.

Turkish-style *boudoirs* and cabinets have received limited scholarly attention. The relative neglect of these interiors is likely due not only to their destruction and dismantlement in the nineteenth century but also to art history's traditionally dismissive attitude toward both exoticism and interior design. The recent global and material turns within the discipline have begun to erode such biases, however. Critical reassessments of chinoiserie and turquerie have uncovered the diversity and complexity of European exoticism, which actively participated in eighteenth-century discourses on taste, gender, commerce, and cultural identity.[10] Likewise, interrogations of early modern interiors have demonstrated how these spaces played an active role in constructing the identities of their inhabitants.[11] Such research forms the critical foundation for a growing number of studies on "exotically" appointed rooms commissioned by elite patrons in eighteenth-century Europe.[12]

This essay contributes to broader scholarly reassessments of turquerie while elucidating the specific cultural work performed by the comte d'Artois's *cabinet turc*. By foregrounding a Turkish room created for a male patron, it widens the lens of existing scholarship predominately focused on female patrons or chinoiserie décor. I critically analyze how this luxurious interior engaged with eighteenth-century discourses surrounding gender, sexuality, culture, and commerce by facilitating a

continuous interplay between masculine and feminine, French and foreign, as well as reality and illusion. I argue that such mixing and mingling relied upon both the carnivalesque quality of exoticism and the amorphous definition of cabinets as spaces where study, seduction, and sociability all occurred. In this sense, Turkish rooms (particularly *cabinets turcs*) were especially ripe settings for staging multifaceted identities.

The first part of this essay examines the complex expectations and understandings of cabinets in eighteenth-century France. It also considers how Turkish rooms generally, and the comte d'Artois's *cabinet turc* in particular, fit within this category of intimate interior. The remainder of the essay analyzes how the design and decoration of this site engaged with three distinct formulations of the prototypical cabinet and by extension three discrete facets of the comte's identity. Each section investigates the room under a different guise, including the scholar's cabinet, the lover's cabinet, and the collector's cabinet. The multivalence of the *cabinet turc* mirrors the performative nature of identity during the period and underlines how interiors—even those intended for individual or very private use—could not only reflect but also construct the identities of their patrons.

The Cabinet and Turkish Rooms

The eighteenth-century cabinet was a multifaceted space. Traditionally used as the general term for a room, the label took on additional meaning as interiors began to be further subdivided to create a variety of private spaces within a residence. Its flexible definition is illustrated in the 1762 edition of the *Dictionnaire de l'Académie française*, which applies the term to rooms with an array of purposes. Among the dozen examples listed are the *grand cabinet*, *petit cabinet*, *cabinet du Roi*, *cabinet de la Reine*, *cabinet de peintures*, and *cabinet de curiosités*.[13] Such rooms served as sanctuaries for work and study, the admiration of precious objects, or attending to private affairs.[14] In addition, there were cabinets dedicated to dressing (*cabinet de toilette*), playing games (*cabinet de jeu*), and midday naps (*cabinet de la méridienne*).

The diverse designs and decorations of eighteenth-century cabinets matched their increasingly specialized functions. In his extended entry on this type of room for the *Encyclopédie*, architect Jacques-François Blondel writes that the form of these spaces should align with their particular use. For example, he states that "cabinets intended for work or study should be regular in shape because of the amount of furniture they must contain," while those used for concerts or as dressing rooms could be irregular.[15] Likewise, Blondel notes that a cabinet's decoration should support its purpose, with visitors observing "seriousness in the arrangement of *cabinets d'affaires* or [*cabinets*] *d'étude*; simplicity in those decorated with paintings; and levity, elegance, and richness in those intended for society."[16] Such assertions derive from eighteenth-century French norms of *convenance*, or the appropriateness of a thing to its owner and a place to its inhabitant.[17] They also demonstrate period expectations that interiors both reflect and facilitate the activities that occurred there.

Regardless of their specific function, cabinets were among the most personal rooms in eighteenth-century French residences. Like the better-known *boudoir*, they were consistently described as private retreats with restricted access where one could retire to be alone or in the company of familiars.[18] The intimacy of these interiors was made clear by their diminutive size and protected locations. Typically situated at or near the end of a progressively private series of *enfilade* rooms, cabinets required visitors to traverse numerous chambers and sometimes scale narrow back staircases before entering.[19] The *grand cabinets* of the comte and comtesse d'Artois at Versailles, for example, were the innermost rooms in their first-floor living quarters. A plan of the couple's contiguous apartments shows these corresponding spaces at the center, where visitors accessing them would have been required to pass through the preceding guardrooms, antechambers, salons, and bedrooms.[20] While *grand cabinets* could be used for receiving and entertaining guests with games and concerts, most cabinets were exceedingly private spaces reserved for solitary activities or the gathering of one's closest confidants. For this reason, they were typically smaller and more secluded. The comtesse's *petit cabinet*, for example, was situated on the isolated mezzanine level far from her formal rooms and only accessible via a small private staircase located between her bathroom and *grand cabinet* on the first floor.

Cabinets decorated in the Turkish style were especially intimate. Such rooms were often among the smallest and most remote within an individual's apartments and admittance was strictly limited to the patron and their invited guests. The size and placement of the initial *cabinet turc* commissioned for the comte d'Artois's apartments at Versailles in 1774 illustrates this heightened level of intimacy. Situated between the couple's *grand cabinets* on the first floor, it was created by dividing the comtesse's *grand cabinet* into two distinct chambers. The result was an extremely narrow space a fraction of the size of the other rooms and only slightly larger than a closet or bathroom. Additionally, visitors could only access this interior after traversing the entirety of the couple's first-floor apartments. The second *cabinet turc*, which surpassed the first in both its size and splendor, was even further tucked away on the secluded mezzanine level. Positioned directly above the bedroom (*chambre à coucher*) of the comte d'Artois, it could only be reached via a shared staircase located off his *grand cabinet* on the first floor. Ascending the steps, visitors arrived at a small landing before entering a narrow L-shaped hallway containing a series of doors that led first into the comte's private dining room and then the Turkish room.

While the *cabinet turc* built for the comte d'Artois at Versailles in 1781 was often described as the patron's private study and library, its size, location, design, and contents reflected and facilitated multiple functions. Activities ranging from the erudite to the erotic and the social to the secret could be performed in the space, including the study of books, the meeting of lovers, and the admiration of precious objects. Just as the cabinet could serve numerous purposes, the comte could assume distinct roles in the space. Within the walls of this turquerie interior, he could simultaneously embody and seamlessly transition between the personas of scholar, lover, and collector.

The Scholar's Cabinet

In eighteenth-century France, the cabinet was widely understood as a place where men could retire to work or study in solitude. Associations of this type of room with such serious activities are evident in both the *Encyclopédie* and *Dictionnaire de l'Académie française*. Among the many possible purposes for such spaces, these sources list study (*étudier*) and work (*travailler*) before all others.[21] They also note that the cabinet is a place for keeping books, papers, and other items related to these tasks. Such interiors were so closely linked with scholarly pastimes that the *Dictionnaire* refers to a man immersed in his studies as a *homme de cabinet*. Indeed, eighteenth-century men of letters, including artists, writers, musicians, scientists, and mathematicians, regarded their cabinets with deep affection. Describing his increasing desire for solitude, the French *philosophe* Denis Diderot writes in a letter to his lover Sophie Volland, "I love my study [cabinet] and my books more than ever."[22] His essay "Regrets sur ma vieille robe de chambre" (1768) also takes the philosopher's cabinet as one of its primary subjects.[23]

Numerous artists underscored the conception of the cabinet as a sanctuary for the learned man by representing various male sitters at work in such spaces. A portrait of the French poet and playwright Prosper Jolyot de Crébillon (Figure 1.2) by Jacques-André-Joseph Aved (1702–66) is a typical example. It depicts the subject in an intimate interior surrounded by tools of learning. Standing at the center of the composition, Crébillon rests his right arm on the back of a chair. On the left is a desk covered with multiple richly bound books. One of these volumes lies open revealing a string of ancient Greek letters across the top of its pages, a reference to the classically inspired tragic poems and plays written by the sitter. With his left hand, Crébillon gestures toward the other side of the room, drawing our attention to a storage cabinet in the background, on top of which rest a pipe, a painted ceramic container, and a wooden box with a lock and key. These furnishings highlight the space's primary function as a private domain where the poet and playwright can work.

By operating as his private study and library, the comte d'Artois's *cabinet turc* aligned with eighteenth-century expectations of men's cabinets as retreats for erudite pursuits. Its rectangular shape also adhered to Blondel's requirements for *cabinets d'affaires* and *cabinets d'étude* outlined in the *Encyclopédie*. As the architect noted, this regular form enabled the installation of the numerous large furnishings necessary for a room devoted to both the study and storage of books. During the remodeling process, several partitions subdividing the room were removed to produce a larger unified space and a narrow L-shaped hallway wrapping around two of its sides was added.[24] The adjacent passage provided an area where bookcases could line the walls without interruption. As mentioned above, four additional bookcases were placed inside the cabinet flanking the central mirrors on the lateral walls. The significant expense of these large, glass-paneled furnishings meant to house the comte's library underscores their integral role in defining the room.[25]

While the *cabinet turc*'s regular form and many bookcases suited its ostensible function as a study and library, the room's lighthearted decorations were less typical of a space dedicated to scholarly pursuits.[26] The playful *boiseries* covering the walls and

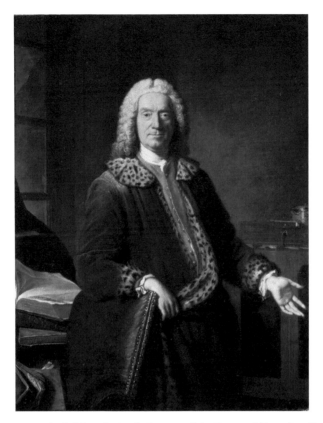

Figure 1.2 Jacques-André-Joseph Aved, *Portrait of the Poet and Tragedian Prosper Jolyot de Crébillon*, 1746. Found in the collection of the State A Pushkin Museum of Fine Arts, Moscow. © Photo: Fine Art Images/Heritage Images/Getty Images.

doors of the interior would have been considered better suited to a woman's *boudoir* or a cabinet devoted to social entertainment. In fact, these painted panels shared many similarities with those created for Marie Antoinette's *boudoir turc* at Fontainebleau in 1777. Executed by the Rousseau brothers only four years apart, both sets of decorations feature an abundance of Ottoman figures and motifs. Unlike the *boiseries* completed for the queen's Turkish room, however, those for the *cabinet turc* foreground a series of vignettes centered on a male protagonist.[27] They also marry elements of turquerie and neoclassicism, two supposedly disparate styles typically deployed in isolation.[28] While turquerie was mostly reserved for intimate spaces, neoclassicism could be found in a variety of contexts.[29] The pairing of the two styles in the *cabinet turc* not only intimates the versatility of the space as one where the traditional boundaries between the sensual and cerebral were elided but also invites a consideration of the understudied connections between Ottoman culture and Enlightenment ideals in the European imagination.

European conceptions of the Ottomans underwent major shifts in the eighteenth century. French elites gained familiarity with Ottoman society through first-hand encounters with ambassadors sent from Constantinople to France as well as a burgeoning number of travel books, costume albums, and aesthetic productions with Ottoman subjects.[30] These texts, images, and performances introduced audiences to despotic sultans and violent janissaries as well as generous pashas and civilizing sultanas. Among the cast of characters frequently depicted was the *efendi*. Similar to French men of letters and other European models of erudition, this Ottoman social type was a highly educated individual with extensive knowledge of history, languages, and international law.[31] Categorized as "men of pen" rather than "men of sword" in Ottoman culture, *efendis* were ideal choices for ambassadors to Europe and treated as members of the international nobility at eighteenth-century courts.[32] Ottoman embassies to France in 1721 and 1741–2 provided the opportunity for elite French audiences to interact with such figures. The ambassador Said Efendi, in particular, mesmerized the court during these two visits with his expert knowledge of French customs and language. French commentators praised him as possessing "great qualities," including natural "taste" and "insight" as well as "a superior education."[33] In fact, his embodiment of French ideals caused some to speculate that he was actually a Frenchman masquerading as a "Turk."[34]

Multiple portraits of Said Efendi, including a painting by Aved (Figure 1.3) from 1742, present the diplomat as a model Francophile. The artist underlines the erudition of the Ottoman sitter through his pose, setting, and accoutrements. At the center of the composition, Said stands upright gazing attentively at the viewer as he gestures toward a desk piled with books and papers. A globe, telescope, and bound atlas rest at his feet. The last references the ambassador's role in financing and establishing an Ottoman printing press in 1726.[35] The wood-paneled interior furnished with implements of learning resembles French men's cabinets such as the one seen in Aved's later portrait of Crébillon. The artist's selection of such a setting positions Said Efendi as a *homme de cabinet*, or studious man at work, claiming the Ottoman figure as part of a supposedly universal Enlightenment ideal.[36]

Erudite Ottoman officials like Said Efendi are referenced in one of the intricately painted door panels within the *cabinet turc* that contains a lively procession scene (Figure. 1.4). Situated inside a central roundel painted to appear as a carved cameo, a turbaned figure riding a horse or camel parades through a crowd. He is accompanied by an elaborate entourage, including two musicians on the left and multiple standard bearers in the background. Gathered on the right, several spectators bow and present gifts as the mounted figure passes. This vignette recalls the magnificent processions of the Ottoman embassies through Paris, which were commemorated in numerous eighteenth-century prints and paintings, including several important works commissioned for the royal collections.[37] Such significant diplomatic events are also referenced in Aved's portrait of Said Efendi. Seen through the portal on the far right of the composition, lines of Ottoman figures on horseback prepare for the ambassador's official entry into the city.

Ottoman embassies and the ceremonies surrounding them provided Europeans with a close-up view of a variety of extravagant costumes, spurring a vogue for dressing

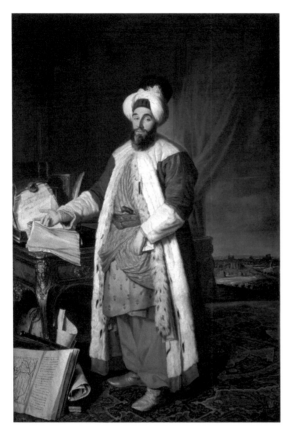

Figure 1.3 Jacques-André-Joseph Aved, *Portrait of Said Effendi*, 1742, oil on canvas, 239 × 162 cm. Château de Versailles, MV 3716. © Photo: Leemage/Corbis via Getty Images.

à la turque.[38] While the adoption of turbans and caftans for masquerades and fancy-dress portraits have received extensive scholarly attention, the wearing of dressing gowns (*robes de chambre*) and nightcaps (*bonnets de nuit*) resembling Ottoman attire in private spaces merit further consideration.[39] Elite men, such as artists, scientists, diplomats, and financiers, often assumed these garments while at work in their cabinets. Aved's portrait of Crébillon, for example, pictures the French writer clad in a long robe adorned with a spotted fur collar, cuffs, and lining that recalls the plush ermine-lined caftan donned by Said Efendi. Many items of apparel sported by European men in the privacy of their studies were imported from Asia or based on Asian forms like the caftan, banyan, and *japonsche rok*.[40] An engraving by Nicolas Bonnart I (1636–1718), *Homme en robe de chambre*, notes in the accompanying description that such robes were Armenian, one of the ethnic minorities ruled by the Ottomans.[41] The inscription goes on to state that no article of clothing was more serious (*grave*) than the *robe de chambre*, referencing both the learned activities and illustrious men associated with

Figure 1.4 Jules-Hugues Rousseau and Jean-Siméon Rousseau, Door panel with scene of procession, 1781, oil on wood, 86.5 × 65.7 cm., Château de Versailles, SSN 352. Photo: Thierry Ollivier. © RMN-Grand Palais/Art Resource, NY.

the garment. Indeed, intellectuals ranging from Descartes to Diderot mentioned their adoption of such clothing.[42] By the late eighteenth century, the *robe de chambre* and *bonnet de nuit* had become the unofficial uniform of French *philosophes*, with artists frequently picturing famous figures like Voltaire and Jean-Jacques Rousseau wearing these items.[43] The latter even touted Ottoman clothing as more natural than traditional

French attire, deploying such fashions as a marker of his commitment to Enlightenment ideals such as simplicity and equality.[44]

Given the prevalence of *robes de chambre* and *bonnets de nuit* in the wardrobes of elite men, it seems probable that the comte owned such articles of clothing and wore them while inside the *cabinet turc*. These garments' association with European intellectuals and erudite pursuits would have made them especially suitable sartorial choices for a room serving as both a study and a library. Moreover, the visual correspondences to Ottoman garb would have initiated a stimulating interplay between the dress of the occupant and that of the figures represented in the decorations. Considering the connections discussed between Enlightenment ideals and Ottoman culture, such a comparison may have been quite fitting, underlining the potential of turquerie to complement rather than contradict eighteenth-century European conceptions of the learned man.

The Lovers' Cabinet

In addition to its association with scholarly pastimes, the cabinet was considered a prime venue for sexual encounters. Eighteenth-century artists and writers reinforced perceptions of the room as a common destination for lovers. Libertine authors set their erotic novels in the boudoir or cabinet, providing characters with an ideal setting for indulging in private pleasures.[45] Dominique Vivant Denon's *Point de lendemain* (1777), for example, locates the climactic tryst between the young male narrator and an older woman known as Madame de T... in a remote cabinet with "exotic" decorations. Such intimate interiors were so closely associated with sexual intrigue that authors described the spaces themselves as inflaming desire. As he recounts moving through progressively more secluded areas with his companion, the main character in Vivant Denon's work remarks, "It was no longer Madame de T... that I desired, it was the cabinet."[46] Likewise, in Jean-François Bastide's *La Petite Maison* (1753–4), the marquis de Trémicour relies on the circuitous journey through the many sumptuous rooms of his house to seduce the young Mélite. Though she repeatedly rebuffs his sexual advances, she cannot ignore the charm of a small cabinet decorated with Chinese and Japanese lacquers and porcelains.[47] The room enchants Mélite to the point of distraction, causing her to momentarily forget Trémicour's wager that he can seduce her with the very interiors she is now enjoying.

Artists frequently provided views into enticing love nests like those described in eighteenth-century texts, as seen in *The Empty Quiver* (Figure 1.5), a 1775 etching by Nicolas Delaunay (1739–92) after Pierre-Antoine Baudouin (1723–69). This work pictures a young couple in a cozy interior filled with objects to facilitate their erotic activities. On the left, a male figure leans back on a low sofa situated within a small, canopied niche. He looks upward toward his female companion, who stands holding a makeup tin and brush. The room is lavishly decorated with a mixture of rococo and neoclassical objects. A chinoiserie folding screen separates the couple from a lit fireplace on the right, where a mounted porcelain and basket of flowers adorn the mantle. On the back wall, a gilt bronze clock hangs directly above a sculpture of Cupid

Figure 1.5 Nicolas Delaunay after Pierre-Antoine Baudouin, *Le Carquois épuisé* (The Empty Quiver), 1775, etching, 43 × 33 cm. Metropolitan Museum of Art, 54.533.23. Public Domain.

elevated on a tall pedestal. The sculpted figure holds an empty bow aimed in the couple's direction. This gesture, along with the overturned quiver at Cupid's feet, suggest that he has just released his last arrow, which has found its target in the lovestruck gentleman exchanging gazes with his lover.

The remote location and limited accessibility of the comte d'Artois's *cabinet turc* would have made it an ideal place for carrying out the types of seductions represented in these eighteenth-century texts and images. Separated from the main apartments on the first floor and isolated from his wife's rooms on the mezzanine, the interior promised the privacy necessary for a secret tryst. The seclusion of the space also meant that an extended journey through the palace would have been required to access the cabinet. As recounted in libertine novels of the period, such a protracted journey would have served to heighten a lover's desire and anticipation of what might occur once the room was reached.

Entering the interior, lovers would have found additional privacy inside the mirrored niche. Usually filled by a small bed or sofa and decorated with heavy curtains that could be pulled shut, as seen in *The Empty Quiver*, such architectural features created an inner sanctum that could be separated from the rest of the room.[48] Similar alcoves are present in Marie Antoinette's *boudoir turc* at Fontainebleau and her *cabinet*

doré and *cabinet de la Méridienne* at Versailles. They are also described in Sadean novels as sites for private libertine activities that can only occur away from prying eyes.[49] The ability to open and close the niche's curtains echoes the fragile security of the cabinet itself. While private affairs could be concealed within the room's four walls, there was always the looming risk of discovery with the simple drawing aside of a curtain or opening of a door.[50] The clear glass installed in the back of the niche to allow light to pass from the room into the hallway presented an additional means by which lovers could be caught in the act. The tension between desired concealment and possible discovery was an essential aspect of intimate interiors like the *cabinet turc* and only served to intensify their erotic charge.

The *cabinet turc*'s decorations repeatedly reference sensual pastimes, reflecting the space's potential use for sexual encounters as well as its facilitation of such amorous activities by arousing the desires of its occupants. Three of the room's door panels feature scenes of the Ottoman sultan alone with one or more female companions. Eighteenth-century French audiences would have recognized these women as occupants of the imperial harem. One of the vignettes (Figure 1.6), which pictures the ruler and a female figure seated on a divan beneath a canopy, makes explicit reference to an Ottoman seraglio while also recalling French spaces like the cabinet's own niche. The sultan leans over to embrace his lover, who gazes up at him as she reaches out to accept his handkerchief. This piece of fabric was a charged symbol in the French imagination. For decades, European travel writers had perpetuated the myth that the Ottoman leader would toss a handkerchief at the feet of whichever woman he had chosen for his nocturnal pleasures.[51] Afterwards, the selected concubine would reportedly be bathed and perfumed in preparation for her meeting with the ruler.

Knowledge of the handkerchief as a supposed marker of the sultan's favor was so widespread that European artists employed it as a visual shorthand to highlight the sexuality of their Ottoman subjects.[52] For example, the symbol is included in a turquerie genre scene by Étienne Jeaurat (1699–1789) known as *The Sultan's Favorite* (Figure 1.7). Likely the basis for the scene in the *cabinet turc*, this work shows an Ottoman couple embracing on a divan in a manner quite like that seen in the panel. Here, the male figure fingers an ivory handkerchief draped over the forearm of his female companion, who is ostensibly the favorite sultana referenced in the title for the printed version of the work. Smoke rises from an incense burner positioned on the floor directly below the lovers' spread legs, visually manifesting the burning sexual desire felt between them. In the *cabinet turc* scene, the dry incense burner and the woman's reaching gesture suggest that the relationship between sultan and concubine has not yet been consummated, an implication that would have incited anticipation in viewers who themselves may have been awaiting sexual satisfaction.[53]

By situating sexual desire and activities in an Ottoman setting, the decorations for the *cabinet turc* corresponded with long-standing European stereotypes of the amorous "Turk."[54] Europeans often portrayed Ottomans as either violent or languid figures like the merciless janissary or decadent sultan. While both types were highly sexualized, the latter was also rendered as effeminate. Enervated by a despotic over-indulgence in food, drink, and women, he was believed to have been lulled into a perpetual state of passivity. It is this sort of character that the *cabinet turc* scene

Figure 1.6 Jules-Hugues Rousseau and Jean-Siméon Rousseau, Door panel with scene of sultan and concubine, 1781, oil on wood, 87.5 × 66.3 cm. Château de Versailles, SSN 351. © Photo: Thierry Ollivier. RMN-Grand Palais/Art Resource, NY.

evokes. In the painted vignette by the Rousseau brothers and the source scene by Jeaurat, the male figures recline with their legs spread open, creating sinuous curves with their recumbent bodies. They gaze adoringly into the eyes of their female companions, who assume more active positions, either sitting erect or leaning forward to grasp the coveted handkerchief. Stripped of their masculine vigor, these men recall the castrated eunuchs of the harem rather than the virile master of the seraglio.

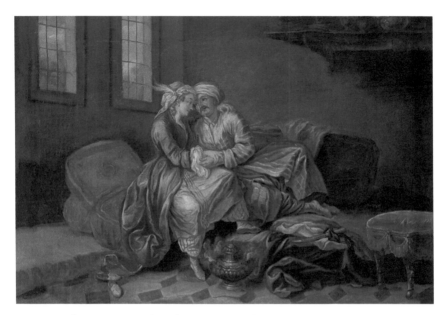

Figure 1.7 Étienne Jeaurat, *The Sultan's Favorite*, eighteenth century. Found in the collection of the Pera Museum, Istanbul. © Photo: Fine Art Images/Heritage Images/Getty Images.

While the turquerie decorations placed the effeminizing effects of sex in a foreign context, they spoke to fears about the dangers imprudent lovemaking posed to French men. These anxieties are visible in depictions of French couples like *The Empty Quiver*, which presents flexible gender roles similar to those observed in scenes of Ottoman lovers. The reclining pose and limp limbs of the male figure in this print emphasize his physical exhaustion, while his hat and sword lying forgotten on the floor at his feet symbolize his post-coital impotence. His passivity is contrasted with the erect stance and active gesture of his female companion, who he lazily observes as she retouches her makeup. Like the representations of Ottomans discussed above, this image suggests that the French gentleman has been emasculated by his consort, highlighting the supposed threat female sexuality posed to unsuspecting men.[55] The etching alludes to such feminine wiles through the makeup tin and brush the female figure holds poised in her hands.[56] This mortal seductress has also received supernatural assistance from Cupid, whose released arrow has seemingly pierced the heart of her lover. The dangers of the enchantress, whether French or Ottoman, human or divine, are further referenced in the *cabinet turc* panel by the two sirens who support the cameo depicting the Ottoman lovers. Greek and Roman writers described these mythological figures with human torsos and fishtails instead of legs as causing shipwrecks by luring sailors toward rocky coastlines with their songs.[57] As seen in these representations of lovers, similarly perilous fates were believed to befall men who overindulged in the cabinet's sensual pleasures.

The remote location, sumptuous furnishings, and erotic decorations of the *cabinet turc* resemble those of lovers' cabinets represented in eighteenth-century texts and

images. While it is uncertain if the space was used for such ends, these similarities would have presented the possibility for the comte d'Artois to shift from engaging in the scholarly affairs typical of a study and library to enjoying more carnal delights. The seclusion of the *cabinet turc* from the rest of the couple's apartments would have afforded the privacy required for such activities. Additionally, the titillating paintings of Ottoman lovers would have assisted in inflaming the desires of the interior's occupants, while the plush sofa inside the mirrored niche would have provided an effective spot for lovemaking. At the very least, the room would have encouraged connections between the comte and the ideal lover and enabled him to imagine himself as a powerful sultan awaiting the delivery of his favorite concubine.

The Collector's Cabinet

The cabinet was also a common site for storing and admiring objects. Immediately after describing this room as an intimate retreat for work and study, the *Dictionnaire de l'Académie française* notes that it is also a place for keeping works of art and other precious items.[58] In fact, six of the twelve examples of cabinets it lists are rooms entirely devoted to showcasing art, including the *cabinet de peintures*, *cabinet de tableaux*, *cabinet de curiosités*, *cabinet de médailles*, *cabinet de raretés*, and *cabinet d'antiques*. The association of this particular type of interior with the storage, display, and contemplation of objects led to the term cabinet standing in for an entire collection. Eighteenth-century catalogs for estate sales refer to the larger collection of the deceased individual as the "cabinet de feu." Likewise, the phrases "Il vend son cabinet" and "On estime le cabinet d'un tel vingt mille écus" were common parlance according to the *Dictionnaire*. The term cabinet also was applied to pieces of furniture outfitted with numerous drawers and secret compartments for holding small precious items, including medals and jewelry. Often secured with a lock and made of gilded and painted wood panels inlaid with porcelains, these luxury furnishings functioned as miniature versions of the finely decorated interiors with which they shared a name.

Beyond housing the library of the comte d'Artois, the *cabinet turc* contained a myriad of luxury objects that highlighted both the patron's discerning taste and the strength of French manufacturing. Among the surviving furnishings are gilded bronze candelabras with ostriches at the base, a marble and gilded bronze clock decorated with camels and sultanas, and a console table with a pale blue marble top and gilt wood base ornamented with sabers and incense burners.[59] These items showcased the renowned skills of French craftsmen, such as the furniture-maker Georges Jacob and the *bronzier* François Rémond. Heavily patronized by the court, these individuals contributed to numerous interior design projects for the royal family at Versailles and beyond. They also supplied objects to members of the Parisian merchant guild (*marchands-merciers*) like Dominique Daguerre, who served an elite roster of national and international clients including the queen, the prince regent of Britain, and the empress of Russia.[60] Such mercantile networks spread French luxury goods across Europe, both satisfying and stimulating demand for the nation's finest bronzes, porcelains, and furniture. As global trade burgeoned, nations jockeyed for market dominance, exporting as much

as possible while limiting imports and encouraging their populations to purchase national products. In this competitive context, interiors like the *cabinet turc* became sites for patrons to perform allegiance to national commercial interests.

The cabinet's *boiseries* feature painted representations of additional precious objects that underscore eighteenth-century patterns of collecting and the power of French production. Lyre-guitars, mounted amphorae, and blue and white cameos are depicted at the center of the room's eight rectangular door panels. Such objects associated with ancient Greece and Rome reflect the intense interest of eighteenth-century Europeans in the classical world, which only increased following the rediscovery and excavations of the ancient cities of Pompeii and Herculaneum in the 1730s and 1740s. Grand Tourists from across Europe began visiting these Italian archeological sites as part of a larger circuit through the continent's major cultural centers. In addition to commissioning portraits documenting their travels, these wealthy individuals often returned home with antiquities purchased abroad. Such collections, which filled cabinets in residences throughout Italy, France, and Britain, became essential markers of the learned man of taste in eighteenth-century Europe.

As information about the latest archeological discoveries disseminated to broader audiences, a substantial market arose for replicas and imitations of ancient originals. National manufactories across Europe quickly responded to this demand by creating an enormous variety of neoclassical objects inspired by antique forms, materials, and subjects. The items painted on the door panels of the *cabinet turc* represent such productions. The blue and white circular medallions decorating the four upper door panels (Figures 1.4 and 1.6) recall both ancient Roman cameos and eighteenth-century imitations created at Sèvres and elsewhere. While the antiques were made of glass, shells, ceramics, or gemstones carved in low relief to reveal contrasting layers of material, the eighteenth-century versions relied on layers of painted or stained porcelain to achieve a similar effect. Unlike ancient cameos, which were rarities accessible to only the wealthiest collectors, early modern imitations were available to a much wider class of consumer. Such objects were commonly inlaid into furniture or incorporated into jewelry and accessories in the 1780s.[61] Likewise, the vessels depicted at the center of two of the lower door panels resemble eighteenth-century imitations of antique amphorae. Copying the distinctive oval body, narrow neck, and flared handles of these ancient storage containers, such vases made by Sèvres and other ceramics manufactories were often decorated with scenes drawn from antiquity. The gilt bronze mountings used to ornament the arms, feet, and bodies of the objects, however, clearly identified them as eighteenth-century French designs. Similarly, the stringed instruments portrayed in the two remaining door panels (Figure 1.1) are fanciful versions of a lyre-guitar. Invented in France in 1780, these musical objects recalled ancient Greek lyres in both their curved shape and multiple central strings, a connection underlined by the Greek key design decorating the base of those represented in the *cabinet turc*.

The period's competitive commercial environment meant that eighteenth-century replicas were measured against not only the ancient originals they mimicked but also other imitations manufactured throughout Europe. Fierce rivalries arose between nations seeking to capture the international market for luxury goods. Perhaps the most contentious competition in the late eighteenth century was between Sèvres in

France and Wedgwood in Britain. Both of these porcelain manufactories produced enormous numbers of neoclassical ceramics for national and international distribution. Wedgwood became particularly well known during the period for its jasperware objects, which used a secret patented formula to closely imitate ancient Roman glass sculptures. To entice international collectors, the manufactory created portrait medallions of foreign monarchs and provided British ambassadors with objects to take to foreign courts as diplomatic gifts that would be widely seen and admired.[62] Understanding the threat such imported ceramics posed to French production, France placed high tariffs on jasperware and other Wedgwood objects. In addition, Sèvres began producing imitations of jasperware, including neoclassical cameos and vases in the signature Wedgwood blue ground with white mounted designs.[63] The painted cameos in the *cabinet turc* likely represent such French objects copying eighteenth-century British ceramics that themselves mimicked Roman antiquities. The portrayal of these fakes would have further underlined the power of French manufacturing, which had the ability to convincingly imitate items from different periods and cultures.[64]

The objects represented in the decorations also underscored the skilled artifice of the many French designers who participated in the creation of the *cabinet turc*. Entering the room, visitors could have easily mistaken the *trompe l'oeil* paintings for actual cameos. Integrating such items into interiors was not uncommon in the late eighteenth century, as seen in the Wedgwood Room at the Palazzo Pucci in Florence. While the paintings of cameos, mounted amphorae, and lyre-guitars would have been juxtaposed with physical objects in the cabinet, the difference between reality and representation would often have been difficult to distinguish. The interior's three large mirrors would have reflected its contents, collapsing all occupants, furnishings, and decorations onto a single plane. Moreover, the strategic placement of these looking glasses at the centers of three adjacent walls would have created reflections within reflections that gave the impression of the room's contents multiplied ad infinitum. These disorienting visual effects would have been heightened at night when the room was illuminated by flickering candlelight, which would have created a sense of constant movement (*papillotage*) compounded by the motion of individuals circulating around or entering and exiting the space.

Visitors activated the interior by both mistaking and uncovering its true nature. For example, two of the doors connecting the room to the hallway were hidden, camouflaged as stationary bookcases flanking the niche. Likewise, one of the two doors on the wall shared with the adjacent dining room was false. The unexpected discovery of these faux doors and secret passages would have delighted those entering, occupying, and exiting the space.

Such playful deception was at the heart of turquerie itself, which often involved disguising French scenes and sitters as Ottoman ones while simultaneously providing clues allowing initiated viewers to detect the ruse. In fact, the Europeanization of the supposed "Turks" populating the room's decorations would have hinted at the broader artificiality of the *cabinet turc*. Though the depicted sultan's beard, turban, and caftan provide him with the conventional trappings of Turkishness, the cultural identities of his female companions are less certain. The costumes of these women read as vaguely Ottoman in style, but their facial features are indistinguishable from those of their French counterparts in works such as *The Empty Quiver*. The dozen children in Ottoman garb

who adorn the eight door panels also have the pale skin, rosy cheeks, and rotund bodies typical of putti in European art. Additionally, the represented furnishings, including canopies, divans, and incense burners, recall those found in French interiors.[65] This amalgamation of European and Ottoman features and furnishings in the room's boiseries suggests that the figures depicted in the *cabinet turc* are not Ottomans at all but French men and women masquerading *à la turque.*

Costume play was common among eighteenth-century elites, and the comte d'Artois would have dressed in various guises for royal masked balls and theatrical performances at Versailles. A talented amateur actor, he was frequently cast opposite Marie Antoinette in palace plays. While typical roles for the prince included valet, farmer, and shepherd, a large number of eighteenth-century productions with Ottoman subjects allows the possibility that he also played sultans, eunuchs, or janissaries.[66] Both acting and masquerade involved assuming characters with identities that diverged from one's own in terms of sex, culture, and social status. Dressing as a figure antithetical to oneself, such as a notorious rake costumed as a pious priest or a Frenchman disguised as an Ottoman, provided immense pleasure to both performers and audiences.[67] Likewise, the process of uncovering the layers of illusion and innuendo within the *cabinet turc* would have stimulated the comte and his guests.

By containing a multitude of real and represented luxury objects, the *cabinet turc* operated as a collector's cabinet and positioned the comte d'Artois as the ideal collector. The room enabled him to display both his refined taste and national pride. The mixture of turquerie and neoclassical elements indicate his deep knowledge of new and established styles as well as his willingness to experiment with striking juxtapositions. Likewise, the interior's reliance on French craftsmen and representation of objects created by French manufactories casts the comte as a loyal patron of national goods. Finally, the *boiseries*' focus on items that could be defined as fakes, replicas, and imitations suggests his critical discernment as a connoisseur and initiation into the world of French artifice.

Conclusion

The *cabinet turc* built for the comte d'Artois at Versailles in 1781 was a complex site serving multiple purposes. The room's design and decorations actively engaged this complexity. While certain aspects of the space aligned with its stated function as the comte's private study and library, others positioned the interior as a spot for meeting lovers, admiring objects, or entertaining guests. This multiplicity echoes the versatile definition of the cabinet itself, a type of room associated with activities ranging from the solitary to the social and the serious to the sensual. The chamber's flexibility is further referenced by its decorations' mixture of turquerie and neoclassicism, two supposedly disparate styles that were nevertheless connected by their negotiation between self and other, collapsing the traditional boundaries between French and foreign as well as ancient and modern. By focusing on scenes of "Turks" and imitations of antiquities, the interior highlights both the artifice of identity generally and the role of the *cabinet turc* specifically in staging the comte d'Artois's deft performances as a scholar, lover, and collector.

Notes

1 Jean-Jacques Gautier, "Les appartements du comte et de la comtess d'Artois à Versailles. Distribution et décor intérieur (1773–1792)," *Versalia: Revue de la Société des Amis de Versailles* 13 (2010): 29–54.
2 Archives nationales (AN), Paris, O¹ 1174.
3 "Plan des entresols du premier étage, second état, vers 1788," AN, O¹ 1780/4 no. 11.
4 "État des Glaces à fournir par la Manufacture pour le service du Roi au château de Versailles; nouvelle bibliothèque, nouveau cabinet de M. le Comte d'Artois," AN, O¹ 1174.
5 AN, O¹ 2002B2.
6 These objects designed by George Jacob (1739–1814), François Rémond (1747–1812), and Urbain Jarossay (active 1788) are in the Louvre Museum (OA 5234) and the château de Versailles (B 366).
7 Perrin Stein, "Madame de Pompadour and Harem Imagery at Bellevue," *Gazette des Beaux-Arts* 78 (1994): 29–45.
8 Christian Baulez, "Le Goût Turc: François Rémond et le goût turc dans la famille royale au temps de Louis XVI," *Objet d'Art* 2 (1987): 34–45.
9 Gautier, "Les appartements," 46–7.
10 Nebahat Avcıoğlu, *"Turquerie" and the Politics of Representation, 1728–1876* (Burlington, VT: Ashgate, 2011); Stacey Sloboda, *Chinoiserie: Commerce and Critical Ornament in Eighteenth-Century Britain* (Manchester: Manchester University Press, 2014).
11 Katie Scott, *The Rococo Interior: Decoration and Social Spaces in Early Eighteenth-Century Paris* (New Haven: Yale University Press, 1995); Denise Baxter and Meredith Martin, eds., *Architectural Space in Eighteenth-Century Europe: Constructing Identities and Interiors* (Burlington, VT: Ashgate, 2010).
12 Notable among these are Michael Yonan, "Veneers of Authority: Chinese Lacquers in Maria Theresa's Vienna," *Eighteenth-Century Studies* 37, no. 4 (2004), 652–72; and Tara Zanardi, "Kingly Performance and Artful Innovation: Porcelain, Politics, and Identity at Charles III's Aranjuez," *West 86th* 25, no. 1 (2018): 31–51.
13 "Cabinet," in *Dictionnaire de l'Académie française* (Paris: Veuve de Bernard Brunet, 1762), 229.
14 Ibid.
15 Jacques-François Blondel, "Cabinet," in *Encyclopédie, ou Dictionnaire raisonné des sciences, des arts et des métiers, etc.*, ed. Denis Diderot and Jean le Rond d'Alembert. University of Chicago: ARTFL Encyclopédie Project (Autumn 2017 Edition), 488–9, Robert Morrissey and Glenn Roe (eds), http://encyclopedie.uchicago.edu/ (accessed May 28, 2021).
16 Ibid.
17 Eighteenth-century etiquette manuals and architectural treatises explicate this idea.
18 For more on the emergence of the boudoir in eighteenth-century France, see Ed Lilley, "Name of the Boudoir," *Journal of the Society of Architectural Historians* 53, no. 2 (June 1994): 193–8.
19 For more on the locations and privacy of rooms including the cabinet in French residences, see Robert Neuman, "French Domestic Architecture in the Early 18th Century: The Town Houses of Robert Cotte," *Journal of the Society of Architectural Historians* 39, no. 2 (May 1980): 128–44.

20 While this would have been the path for most visitors, servants would have often moved between these spaces using the series of small, connected rooms adjacent, including closets and bathrooms.

21 "Cabinet," *Dictionnaire*; Blondel, "Cabinet," in *Encyclopédie*.

22 Denis Diderot, *Lettres à Sophie Volland* (Paris: Gallimard, 1984), 291.

23 This essay appeared in the 1769 issue of Fréderic-Melchoir Grimm's newsletter, *Correspondance littéraire, philosophique et critique*.

24 Gautier, "Les appartements," 47.

25 AN, O¹ 1174.

26 Men of letters were expected to eschew such lavish displays of wealth. While such luxury would have been expected in the apartments of a member of the royal family like the comte d'Artois, the lighthearted theme of the decorations would have seemed out of place in a cabinet intended for serious study.

27 The queen's *boudoir turc* features heads of sultanas. Likewise, many genre painters focused on the figure of the sultana rather than the sultan. Perrin Stein, "Amédée Van Loo's Costume turc: The French Sultana," *Art Bulletin* 78, no. 3 (1996): 417–38.

28 David Pullins examines a similar combination of "exotic" and classical elements in "Robert Adam's Neoclassical Chinoiserie," *West 86th* 24, no. 2 (Fall–Winter 2017): 177–200.

29 The comte d'Artois had commissioned the château de Bagatelle, a neoclassical pleasure palace, in 1777.

30 Fatma Müge Göçek, *East Encounters West: France and the Ottoman Empire in the Eighteenth Century* (New York: Oxford University Press, 1987).

31 For more on the *efendi*, see Fatih Yeşil, "How to Be(come) an Ottoman at the End of the Eighteenth Century," *Osmanlı Araştırmaları/The Journal of Ottoman Studies* 44 (2014): 123–39.

32 Ambassadors like Said Efendi were invited to accompany the king on hunts and were received at court each week alongside European residential ambassadors.

33 *Lettre au sujet du portrait de son excellence Saïd-Pacha, ambassadeur extraordinaire du Grand-Seigneur à la Cour de France, en 1742/Exposé au Salon du Louvre le 25 Août de la même année* (Paris: Chez Prault père, 1742), 5–6.

34 Matthieu Marais, *Journal et mémoires sur la régence et le règne de Louis XV 1715–1737*, 4 vols., ed. Adolphe de Lescure (Paris: Didot, 1863), II, 101–2.

35 *Explication des peintures, sculptures, et autres ouvrages de Messieurs de l'Académie Royale/; Dont l'exposition a été ordonnée, suivant l'intention de Sa Majesté, par M. Orry, Ministre d'Etat, Contrôleur General des Finances, Directeur General des Bâtiments, Jardins, Arts & Manufactures du Roy, &.* (Paris: Chez Prault père, 1742), 20.

36 Several scholars have noted the portrait's universalist perspective. Perrin Stein, "Exoticism as Metaphor: 'turquerie' in Eighteenth-Century French Art," Ph.D. diss., New York University, 1997, 130–1.

37 See Charles Parrocel's paintings of the entry (Versailles, MV 177) and exit of the 1721 Ottoman embassy, which were later woven as a set of Gobelins tapestries.

38 Julia Landweber, "Celebrating Identity: Charting the History of Turkish Masquerade in Early Modern France," *Romance Studies* 23, no. 3 (November 2005): 175–89.

39 This phenomenon has been discussed in Ariane Fennetaux, "Men in Gowns: Nightgowns and the Construction of Masculinity in Eighteenth-Century England," *Immediations* 1 (2004): 77–89.

40 For more on the Asian origins of and associations with such robes, see Martha
 Hollander, "Vermeer's Robe: Costume, Commerce, and Fantasy in the Early Modern
 Netherlands," *Dutch Crossing* 35, no. 2 (2011): 177–95.

41 British Museum, I,7.159.

42 René Descartes, *Meditations, in Oeuvres et lettres* (Paris: Gallimard, 1953), 268;
 Diderot, *Lettres à Sophie Volland*, 281.

43 See Allan Ramsay's 1766 portrait of Jean-Jacques Rousseau (National Galleries
 Scotland, NG 820) and Jean-Baptiste Michel's 1764 engraving after P. A. Danzel of
 Voltaire (Bibliothèque nationale de France, De Vinck 4116).

44 See Ian Coller, "Rousseau's Turban: Entangled Encounters of Europe and Islam in
 the Age of Enlightenment," *Historical Reflections* 40, no. 2 (Summer 2014): 56–77,
 and Yolande Crowe, "Le manteau arménien de Jean-Jacques Rousseau," *Festschrift en
 honneur de Dickran Kouymjian* (Mazda: Fresno, CA, 2007), 155–69.

45 Melissa A. Deininger, "'Il est de certaines choses qui demandent absolument des
 voiles': The Space of the Boudoir in the Marquis de Sade," *Style* 48, no. 4 (Winter
 2014): 563–76; and Diane Berrett Brown, "The Female 'Philosophe' in the Closet:
 The Cabinet and the Senses in French Erotic Novels, 1740–1800," *Journal for Early
 Modern Cultural Studies* 9, no. 2 (Fall/Winter 2009): 96–123.

46 Dominique Vivant Denon, *Point de lendemain* (Paris: Flammarion, 1995), 34.

47 Jean-François Bastide, *La Petite Maison* (Librairie des Bibliophiles, 1879), 31–4.

48 Often, the furniture placed inside niches was inspired by Ottoman forms. These
 pieces carried an especially erotic charge in the French imagination, as seen in the
 erotic novel *Le Sopha* by Claude Prosper Jolyot de Crébillon.

49 Deininger, "'Il est de certaines choses,'" 564–5.

50 The possibility of being discovered or spied upon in the cabinet was a common trope
 in eighteenth-century erotic novels. Brown, "The Female 'Philosophe,'" 110–11. It
 was also captured by artists such as Pierre-Antoine Baudouin in *L'Amour à l'épreuve*
 (National Gallery, D.C., 1942.9.2186).

51 Stein, "Exoticism as Metaphor," 191.

52 It appears multiple times in the *Recueil Ferriol* as well as in numerous European
 portraits *à la turque*.

53 This same vessel is shown smoking in the bedroom scene for the *cabinet turc* doors.
 The room's occupants would have presumably moved from one scene to the next,
 following the sultan on his journey from public parade to sexual encounter.

54 This stereotype was popular in the visual arts and seen in works such as Carle
 van Loo's series of works depicting the Ottoman sultan and his mistress (Virginia
 Museum of Fine Arts, 59.20).

55 Eighteenth-century representations of gender fluidity and the effeminizing effects
 of lovemaking have been discussed at length in Melissa Hyde, *Making Up the
 Rococo: François Boucher and his Critics* (Los Angeles: Getty Research Institute,
 2006), especially chapters 4–6; Mary Sheriff, "The Transformations of Armida," in
 Enchanted Islands: Picturing the Allure of Conquest in Eighteenth-Century France
 (Chicago: University of Chicago Press, 2018), 137–80.

56 Makeup was a common symbol of both the supposed artificiality of women and the
 artifice of representation itself. Hyde, *Making Up the Rococo*, 83–105.

57 The most well-known example is perhaps in Homer's *Odyssey*, when Odysseus
 narrowly escapes the sirens' enchanting call by having his crew plug their ears and tie
 him tightly to the mast of their ship.

58 "Cabinet," *Dictionnaire*.

59 Versailles, OA 5315, B 366; Louvre, OA 5234.
60 Baulez, "Le Goût Turc," 42.
61 The master cabinet-maker Adam Weisweiler, for example, designed multiple *secrétaires* with front panels that include blue and white Sèvres medallions.
62 N. McKendrick, "Josiah Wedgwood: An Eighteenth-Century Entrepreneur in Salesmanship and Marketing Techniques," *The Economic History Review* 12, no. 3 (1960): 425–8.
63 Musée de la Cité céramique at Sèvres (MNC 2173 and MNC 8248).
64 Michael Yonan discusses a similar example of Viennese lacquers passing as French lacquers based on Chinese originals. Yonan, "Veneers of Authority," 660–1.
65 Several eighteenth-century French furniture types were inspired by Ottoman forms and given names such as *sofa, ottomane,* and *lit turque.* An example of the last resides in the Getty Museum (86.DA.535).
66 In the decade leading up to the construction of the *cabinet turc,* multiple plays with Ottoman subjects were performed in Paris and at the royal theaters at Versailles and Fontainebleau, including André Gréty's and Marmontel's *Zémire et Azor* in 1771 and Sébastien-Roch Chamford's *Mustapha et Zéangir* in 1776.
67 Terry Castle, *Masquerade and Civilization: The Carnivalesque in Eighteenth-Century English Culture and Fiction* (London: Methuen, 1986), 5.

Bibliography

Bastide, Jean-François. *La Petite Maison.* Paris: Librairie des Bibliophiles, 1879.

Baulez, Christian. "Le Goût Turc: François Rémond et le goût turc dans la famille royale au temps de Louis XVI." *Objet d'Art* 2 (1987): 34–45.

Blondel, Jacques-François. "Cabinet." In *Encyclopédie, ou Dictionnaire raisonné des sciences, des arts et des métiers, etc.,* edited by Denis Diderot and Jean le Rond d'Alembert. University of Chicago: ARTFL Encyclopédie Project (Autumn 2017 Edition), edited by Robert Morrissey and Glenn Roe. http://encyclopedie.uchicago.edu/ (accessed May 28, 2021).

Brown, Diane Berrett. "The Female 'Philosophe' in the Closet: The Cabinet and the Senses in French Erotic Novels, 1740–1800." *Journal for Early Modern Cultural Studies* 9, no. 2 (Fall/Winter 2009): 96–123.

"Cabinet." In *Dictionnaire de l'Académie française.* Paris: Veuve de Bernard Brunet, 1762.

Deininger, Melissa A. "'Il est de certaines choses qui demandent absolument des voiles': The Space of the Boudoir in the Marquis de Sade." *Style* 48, no. 4 (Winter 2014): 563–76.

Descartes, René. *Meditations, in Oeuvres et lettres.* Paris: Gallimard, 1953.

Diderot, Denis. *Lettres à Sophie Volland.* Paris: Gallimard, 1984.

"État des Glaces à fournir par la Manufacture pour le service du Roi au château de Versailles; nouvelle bibliothèque, nouveau cabinet de M. le Comte d'Artois." Archives Nationales, Paris. O^1 1174.

Explication des peintures, sculptures, et autres ouvrages de Messieurs de l'Académie Royale/; Dont l'exposition a été ordonnée, suivant l'intention de Sa Majesté, par M. Orry, Ministre d'Etat, Contrôleur General des Finances, Directeur General des Bâtiments, Jardins, Arts & Manufactures du Roy, &. Paris: l'Imprimerie de Jacques-François Collombat, 1742.

Gautier, Jean-Jacques. "Les appartements du comte et de la comtess d'Artois à Versailles. Distribution et décor intérieur (1773–1792)." *Versalia: Revue de la Société des Amis de Versailles* 13 (2010): 29–54.

Lettre au sujet du portrait de son excellence Saïd-Pacha, ambassadeur extraordinaire du Grand-Seigneur à la Cour de France, en 1742/Exposé au Salon du Louvre le 25 Août de la même année. Paris: Chez Prault père, 1742.

Marais, Matthieu. *Journal et mémoires sur la régence et le règne de Louis XV 1715–1737*, 4 vols., edited by Adolphe de Lescure. Paris: Didot, 1863.

"Plan des entresols du premier étage, second état, vers 1788." Archives Nationales, Paris. O^1 1780/4 no. 11.

Stein, Perrin. "Exoticism as Metaphor: 'turquerie' in Eighteenth-Century French Art." Ph.D. diss., New York University, 1997.

Vivant Denon, Dominique. *Point de lendemain*. Paris: Flammarion, 1995.

Enlightenment Naples Imagines Imperial China: Queen Maria Amalia's Chinoiserie Boudoir

Christopher M. S. Johns

The proliferation of European collections of East Asian porcelain that began in the late sixteenth century and intensified during the Baroque era continued well into the eighteenth century. This enduring phenomenon, far from being a fad or simply an indulgence of elite taste, was arguably one of the most important features of global material cultural transfer in the early modern era. Displays of porcelain were ubiquitous and almost *de rigueur* in luxurious domestic settings, and they took many forms. Two examples will suffice here. One is the *horror vacui* approach that appropriated interior spaces provided with brackets and shelving and then covered the walls with imported porcelain (Figure 2.1). The second is the cabinet assemblage that created a new type of interior designed exclusively to display copious quantities of imported porcelain, often mixed with inferior ceramics such as Delftware, to increase the sense of abundance. These two display strategies often coexisted, along with many others.

Assembling quantities of Asian porcelain was such a fevered obsession that it was given a diagnosis, rather like a disease: *manie de porcelain*. Many notables were infected with the disorder during the seventeenth and eighteenth centuries, including Queen Mary II of England (r. 1689–94); the Grand Dauphin (1661–1711), son of King Louis XIV (r. 1643–1715); King John V of Portugal (r. 1706–50); a vast cadre of aristocrats, clerics, and members of the wealthy bourgeoisie; and even Pope Benedict XIV Lambertini (r. 1740–58). The most spectacular sufferer of *manie de porcelain*, however, was Augustus II of Saxony-Poland, usually called Augustus the Strong.[1] He assembled extensive collections of East Asian porcelain in the electoral capital of Dresden. His government was nearing bankruptcy until he established his own porcelain factory in the nearby Saxon town of Meissen. Meissen was the first European manufactory to produce hard-paste porcelain of the Chinese type, and it was earning Augustus an enviable income by the time of his death in 1733. The most notorious example, possibly apocryphal, of his ceramic frenzy was the acquisition in 1717 of 151 early Qing dynasty blue and white porcelain vessels consisting largely of temple jars and beaker vases. Augustus II exchanged a regiment of 600 Saxon dragoons to the more bellicose King Friedrich Wilhelm of Prussia (r. 1713–40) in order to add the coveted Chinese works to his collections. They are the so-called "Dragoon Vases," or the "Soldier Vases," and are

Figure 2.1 View of the Porcelain Gallery, Staatliche Kunstsammlungen, Dresden. © Photo: Art Resource ART413419.

still displayed in the Dresden Staatliche Kunstsammlungen. Alas, we have no record of the reaction of the dragoons to being bartered for Chinese pots.

Maria Amalia Christina Xaveria Flora Walburga (born November 24, 1724) was Augustus II's granddaughter, and she inherited his fascination with porcelain, but with greater restraint (Figure 2.2). In 1738, she married by proxy Charles of Bourbon (born January 20, 1716), the recently enthroned King of the Two Sicilies—that is to say, Naples and the island of Sicily—a nuptial coup for the Wettin dynasty of which she was a princess.[2] All Europe was surprised by the king's choice, expecting the Bourbons to turn to another branch of their family for a royal consort. Augustus III and the former Habsburg archduchess, Maria Josepha (1699–1757), Maria Amalia's parents, were eager for their children to marry into more prestigious dynasties in order to elevate the hierarchical status of their own. The realization of such ambitions was largely dependent on religion.[3] In 1697, in order to be elected king of Poland, Augustus the Strong converted to Roman Catholicism and saw to it that most of the Wettin family did likewise. A champion of Lutheranism since the Reformation, the Wettin electors of Saxony would have never been able to marry Catholic Habsburgs or Bourbons without swimming the Tiber to Rome. Confessional affiliation was still fundamentally important in Enlightenment Europe.

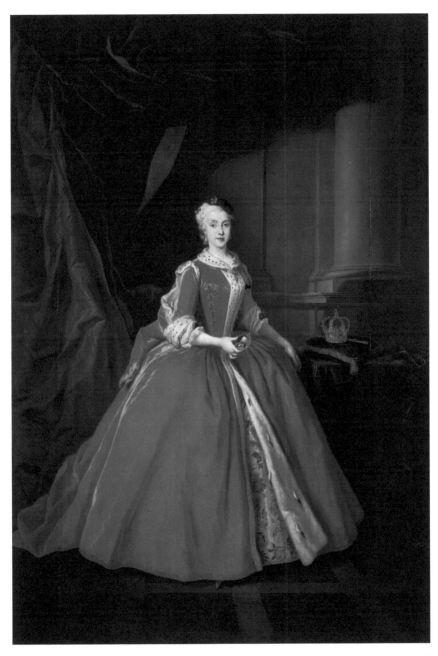

Figure 2.2 Louis de Silvestre, *Portrait of Queen Maria Amalia of Naples in Polish Attire*, oil on canvas, 260 × 181 cm, 1738. Madrid: Museo del Prado. © Photo: Art Resource orz128936.

Maria Amalia's journey from Dresden to Naples was most triumphant. When she met her husband for the first time at the border of the Papal States and the kingdom of Naples, it was love at first sight, and the marriage was immediately consummated. The bridegroom wrote ecstatic letters to his parents, King Philip V (r. 1700–46) and Queen Elizabeth Farnese (r. 1714–46) of Spain, extolling his teenage bride's beauty. As eighteenth-century royal marriages went, it was a successful one in almost every way. After the birth of a male heir, Prince Philip of the Two Sicilies, duke of Calabria (1747–77), the queen assumed a position on the Council of State. By all accounts, she was Charles's most trusted advisor even before that date. As a perceptive young monarch reared in the politically fraught courts of Dresden and Warsaw, Maria Amalia was a major asset to the new Neapolitan Bourbon dynasty. Her local popularity, initially based on her blonde hair and fine figure, was hugely enhanced by her obvious love of Naples and its people as well as her extensive charitable activities. The fact that she brought stability to the dynasty by producing four sons was also much in her favor. Maria Amalia's political aptitude is well demonstrated by her support for the progressive reformer Bernardo Tanucci (1698–1783), a Tuscan lawyer of common birth who became one of the great progressive politicians of eighteenth-century Europe. The extensive correspondence between the queen and Tanucci is filled with political wisdom, sound advice, keen insight, and mutual respect.[4]

In addition to her unofficial role as advisor to Charles of Bourbon, Maria Amalia was also a dedicated patron of the arts, architecture, and culture. As a monarch deeply interested in music, she encouraged the opera and was a patron of the celebrated theater of San Carlo, her husband's first major architectural initiative after he came to the throne in 1734. Music was one of the unifying factors that made Maria Amalia's move from Dresden to Naples easier. As a child she was trained in music by Italians, and she both spoke and sang Italian. Charles is often dismissed by modern historians as being uninterested in music, especially opera, and it is claimed that his construction of the San Carlo Theater was done for political purposes and to please his music-loving bride. It is true that musical performances were frequently tied to court politics—dynastic births and marriages, name days of members of the extended royal family, *Te Deum* masses to celebrate military achievements and treaties, cantatas and oratorios to honor various saints and religious feasts, and other royal and ecclesiastical occasions. The monarchs often attended these public spectacles together, in addition to hosting private performances at the small theater in the palace at Portici for select company; Charles often commented on the musical settings, stage design, singers, and composers.[5] Although the king is not known to have played or sung even in private, his love of music was genuine and it was one of many interests shared with his wife.

Music was arguably the most important conduit of cultural exchange between the Wettin and the Neapolitan Bourbon courts during the reign of Charles and Maria Amalia. The most significant connection was the Italian composer and court musician Giovanni Alberto Ristori (1692–1753). He worked for Augustus III, Maria Amalia's father, and was possibly her music teacher before her marriage. They almost certainly were well acquainted, and he followed her to Naples a few months after her departure from Dresden. His close association with the queen led to his employment by the Saxon minister, Count Joseph Anton Gabaleon Wackerbarth-Salmour (1685–1761), as

an unofficial correspondent who was able to provide important information about life at Charles's court. Ristori's daughter Cecilia was a maid of the queen's bedchamber and was on intimate terms with her employer. In 1739, when Maria Amalia was recovering from smallpox, it was Ristori alone who was allowed into her private apartments to entertain her with music.[6] Several of Ristori's works were performed at the Teatro di San Carlo, with mixed reviews, including music to celebrate the princess's fourteenth birthday and an opera, *Temistocle*, in honor of the birthday of her father-in-law King Philip V.

The musical link between Naples and Dresden worked in both directions. The celebrated Johann Adolf Hasse (1699–1783) from Hamburg was Augustus III's court composer and *kapellmeister* when Maria Amalia was growing up; his opera *Alfonso* was performed at the proxy marriage in Dresden. Hasse had extensive musical training in Naples in the 1720s, where he earned the sobriquet "Il Sassone," and from 1737 to 1747 more than a dozen of his operas debuted at the Teatro di San Carlo. In 1758, Hasse came to Naples to escape the parlous situation in Prussian-occupied Dresden during the Seven Years War (1756–63), the highlight of his Neapolitan sojourn being the performance of his setting for Metastasio's *La Clemenza di Tito*.[7] In addition to composers, singers and musicians also went back and forth between the courts. In sum, music was the cultural connection *par excellence* between Dresden and Naples, and between Charles and Maria Amalia.

In addition to her passion for music, the queen was also active in planning and decorating the ambitious royal residences in and around Naples, above all the palaces at Portici and Capodimonte as well as the Neapolitan version of Versailles: the royal palace at Caserta north of the capital (Figure 2.3). It was her vision for and encouragement of a royal porcelain manufactory in the gardens of the palace at Capodimonte, however, that was her most notable cultural achievement. For about fifteen years, Capodimonte porcelain competed with the finest European soft-paste manufactories and created a proud tradition for Italian ceramic production that survives to this day. Maria Amalia has, in my opinion, not received nearly as much credit for the establishment and promotion of the institution as is her historical due.

Figure 2.3 Luigi Vanvitelli et al., Palace of Caserta, Naples, façade, begun 1752. © Photo: FrDr, Wikimedia Commons. Public Domain. https://commons.wikimedia.org/wiki/File: Caserta_1000_01.jpg.

This is in part due to the limitations placed on queen consorts, as opposed to queens regnant, in lived experience and in the historical record.

The Capodimonte porcelain manufactory opened in 1743, five years after Maria Amalia's marriage. It was located in the gardens of the eponymous palace and served as both a factory for porcelain production as well as living quarters for a small army of arcanists, designers, painters, and their families. The structure already in existence was a two-story quadrangular edifice, with the residential section on the upper floor. The common workers lived nearby in rented apartments. In 1746, a wing was added to one of the sides to form a P-shaped design, and this is where the artists and administrators resided. It functioned rather like a working commune internally organized and administered by the various elite artists employed by the king.[8] Initially, production was limited to crockery, snuffboxes, and small figurines, but soon became more ambitious, encompassing such complex objects as picture frames, candelabra, and figural compositions of both sacred and sacred genre subjects. By 1754, there were eight sculptors at the factory, working under the direction of the Tuscan artist Giuseppe Gricci (1700–70), a designer of remarkable distinction who left a major imprint on both Capodimonte and, later, Buen Retiro porcelain.[9]

Although the Bourbon ruler was keen to promote tapestry works and glass production in his new capital, there is no evidence that he had an interest in porcelain manufacturing until his marriage to the granddaughter of the founder of the Meissen porcelain factory in Saxony.[10] Maria Amalia is usually mentioned in the historical sources along with her husband as founders of the Capodimonte factory, but other than the anecdote that she brought seventeen tea, coffee, and chocolate Meissen porcelain services to Naples as a part of her dowry, the Wettin princess's name is rarely encountered in relation to it. In part, this neglect may be attributed to the fact that the manufactory was folded into the broader luxury arts initiatives promoted by her husband as part of an enlightened program of fiscal and commercial reform. I would also argue, however, that as queen consort rather than queen regnant, Maria Amalia has left a smaller historical footprint than she actually made because accomplishments by such women are traditionally either overlooked or simply discounted by historians, the pioneering work of Helen Watanabe-O'Kelly and a few others excepted. Queen Maria Amalia's frequent pregnancies (thirteen in twenty-two years), the deaths of five of her children, and various illnesses related to reproduction make it more difficult to assess her direct impact on art patronage.[11] There can be no doubt, however, that her arrival in Naples helped to create a vogue for porcelain, which in and of itself is fundamentally important to the establishment of the Capodimonte porcelain works. Given the strong Meissen influence on Capodimonte porcelain and what must have been Queen Maria's considerable knowledge of the medium, it is hard to believe that Charles was the prime mover in the founding of a porcelain factory, the dearth of documentary evidence notwithstanding.

The art historian Maureen Cassidy-Geiger has aptly labeled Meissen porcelain as "the Saxon gift of national identity." One of the numerous porcelain services brought to Naples as part of the queen's dowry was a table service with the arms of Saxony-Poland and the kingdom of the Two Sicilies (commonly called the kingdom of Naples)

intertwined to celebrate the dynastic nuptials. As queen, she often sent requests back to Dresden for porcelain, both objects for her own use and items to serve as presents.[12] Perhaps the most spectacular *porcellana di Sassonia* sent to Naples was a toilet service for the queen's personal use, each item packed in a leather box. It consisted of three or four dozen pieces, now scattered, and the Saxon envoy in Naples claimed: "Their Majesties greatly admired the porcelain's beauty and everyone who saw it was astonished to see the heights of perfection to which our factory has taken this art." This gift was to celebrate the birth of an heir to the throne, although work on the project began in 1745 when Maria Amalia was pregnant with her second child, Princess Maria Luisa. Perhaps it was thought to be too splendid to celebrate the birth of a second girl or else it was wishful thinking for the birth of a son. The toilet service was executed in the "Green Watteau" pattern, a copper green monochrome palette being a reference to the royal Saxon-Polish color that was reserved to members of the ruling family (Figure 2.4). The vignettes were executed by Gottlob Siegmund Birckner (1712–71) after engravings by Antoine Watteau (1684–1721), Nicolas Lancret (1690–1743), and other French rococo genre painters and printmakers.[13]

* * *

Figure 2.4 Gottlob Siegmund Birckner, Gold-mounted oval snuff box, *c.* 1745–7, Meissen porcelain, "Green Watteau" pattern. © Photo: Bonhams, London.

The Portici Palace, which in practice could arguably be called a villa, was in part designed for Charles of Bourbon by the prominent Roman architect Antonio Canevari (1681–1764) (Figure 2.5). Unlike the palace at Caserta, it was not a unitary plan but a mixture of preexisting and new construction. Individual rooms and even wings are not always the work of a single architect.[14] The palace was intended to be a private residence for receiving intimate friends, visiting dignitaries who were often traveling incognito, and for less formal diplomatic audiences where strict court protocol could be avoided or at least minimized. The palace's private spaces were distributed along the axis facing the sea, while the more formal, semi-public areas had views of Mount Vesuvius. Rococo domestic interior design inspired by French models was much in evidence in the building's domestic spaces. The floor plan was not laid out in the traditional enfilade manner, but rather small chambers and salons (*salottini*) were more casually distributed to promote intimate conversation and personal comfort. Despite the more private nature of the Portici Palace, the king wanted it to have a visual impact in keeping with other royal residences, using architecture to visualize the legitimacy of his new dynasty.[15]

Begun in 1738, shortly after Charles's accession to the throne, the seaside retreat was completed in early 1745, the year the couple's second surviving child Maria Luisa was born in the queen's apartments there. Portici was the preferred residence of the

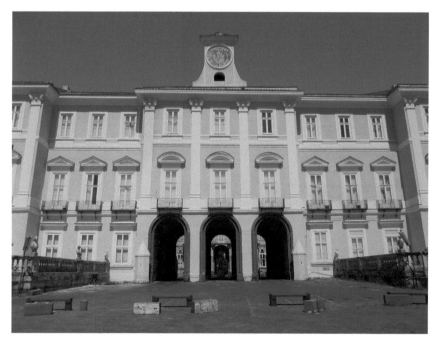

Figure 2.5 Antonio Canevari et al., Palazzo Portici, Naples, façade, 1738–42. © Photo: Ferdinando Scala, Wikimedia Commons. Public Domain. https://commons.wikimedia. org/wiki/File:Reggia_di_Portici1.jpg.

king and queen, especially in summer. It was attractive in part because it was so convenient—only a two-hour coach ride from the royal palace in central Naples. Seven of the twelve royal children were born at Portici, attesting to its importance in the life of the dynasty. This may suggest that the queen preferred the relative privacy of Portici for her confinements, following a wider eighteenth-century trend among elite women to minimize the number of spectators present during childbirth.

The Porcelain Boudoir at Portici, generally referred to in Italian sources as the Salottino di Porcellana, was intended to be a part of Maria Amalia's private apartments, and its use as a small salon off her bedchamber indicates that she would have been interested in its decoration (Figure 2.6). It was a bit over 22 feet long, almost 16 feet wide, and about 17 feet high (approx. 6.7 × 4.8 × 5 m). The published documents only mention the queen on one occasion. After the installation of the porcelain panels on the walls and the completion of the stucco ceiling that is also punctuated with soft-paste porcelain (Figure 2.7), she apparently asked for changes in the decoration of the carved wooden doors that led to her bedchamber. Unfortunately, these doors were dismantled when the room was moved from Portici to the Capodimonte Palace, so it is difficult to assess Maria Amalia's intervention. It should be noted, however, that even though her name appears only once in the documents related to the room's construction and decoration, her husband's name does not appear at all.[16] The document in question

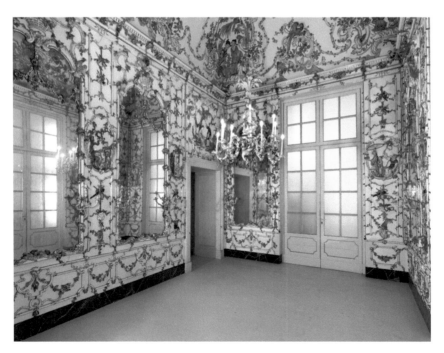

Figure 2.6 Giuseppe Gricci et al., View of the Porcelain Boudoir from Palazzo Portici, 1757–9. Naples: Museo e Real Bosco di Capodimonte. © Photo: MIC-Ministero della Cultura, Museo e Real Bosco di Capodimonte, Naples.

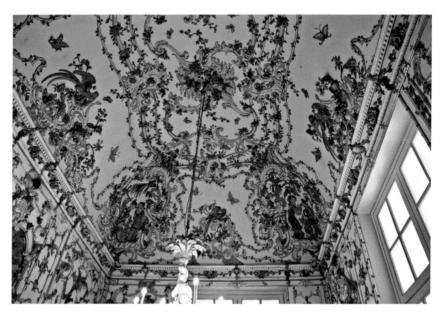

Figure 2.7 Giuseppe Gricci et al., Porcelain Boudoir from Palazzo Portici, view of the ceiling, 1757–9. Naples: Museo e Real Bosco di Capodimonte. © Photo: Mentnafunangann, Wikimedia Commons. Public Domain. https://commons.wikimedia.org/w/index.php?curid=50420774.

dates April 28, 1759, shortly before her departure to Madrid as queen of Spain, so her interest in the room continued, even though she knew that she would likely never be able to occupy it.

Charles's half-brother Ferdinand VI (r. 1746–59), king of Spain, fell into a deep depression and took to his bed after the death of his beloved wife Queen Barbara of Braganza (r. 1729–58) in late 1758. By early 1759, it was widely believed he would not survive the year, and he satisfied expectations by dying on August 10. My point here is that Charles and Maria Amalia likely knew that they would soon be summoned to Madrid as monarchs because Ferdinand and Barbara were childless and Charles was next in line of succession to the Spanish throne. Nonetheless, the Porcelain Boudoir was almost finished by the time the royal couple departed Naples for Madrid via Barcelona in late August 1759. I believe this argues for its prominent place in Maria Amalia's personal patronage and attests to her continuing interest in porcelain production that is shown to advantage in her highly imaginative and engaging Salottino di Porcellana.

With the exception of the Porcelain Boudoir, Maria Amalia's apartments at the Portici Palace were ready for occupancy in late 1756. Unfortunately, few of the original decorations survive *in situ*, but contemporary descriptions give the idea that it must have been one of one of the most remarkable private spaces of the Neapolitan Settecento. Chinoiserie had an important function in the overall design of the queen's apartments and throughout the palace. In the third chamber off Maria Amalia's

bedchamber there was a considerable amount of East Asian lacquer paneling and porcelain vases as well as figural groups of Saxon porcelain in the chinoiserie mode displayed on consoles and brackets. There was also a porcelain chandelier with twelve arms designed at the Capodimonte factory by Giovanni Battista Natali (1698–1765), but it is not known if it was decorated *à la chinois*. East Asian porcelain and chinoiserie decorative objects were also a feature of the king's apartments. In the Stanza della Tavola Pubblica, where Charles sometimes dined in public, there was a display of Japanese porcelain. In the Blue Cabinet (Gabinetto Blò), so-called for the blue color of the porcelain, an inventory describes objects placed against blue lacquered walls, evidence that the Gabinetto Blò was a porcelain cabinet.[17] By the mid-1740s, the Capodimonte manufactory was producing increasing quantities of chinoiserie objects, above all floral and foliage decorative elements inspired by Meissen and East Asian objects. By the late 1740s, the factory was also producing figural groups and large vessels; the spectacular achievement in the Porcelain Boudoir did not emerge from a vacuum.[18] In sum, there was a broader context of chinoiserie decoration and the display of East Asian and Saxon porcelain at the palace that has perhaps been underestimated because little of it survives.

The queen's Porcelain Boudoir's remarkable chinoiserie installation, its place in Capodimonte production, and the fact that it was the last important achievement of the Neapolitan factory, should be taken seriously as a manifestation of Maria Amalia's cultural patronage. When Charles and his consort set up their factory, they entered into competition with other porcelain producers in Saxony, Bavaria, the United Provinces, Austria, France, and the Grand Duchy of Tuscany, not only for market share but also for the best arcanists, modelers, and porcelain painters.[19] They were fortunate that Charles had already secured the services of Giuseppe Gricci, a Florentine sculptor originally recruited as a designer for table-top decorations but who assumed the direction of the Capodimonte factory in 1743. The Florentine artist served the establishment with innovative brilliance and administrative acumen until he left for Spain with his sovereigns in 1759. In Madrid, he continued his innovative and eye-catching porcelain designs at the Buen Retiro factory until his death in 1770. The queen's boudoir was among the most ambitious and complex European porcelain installations until it was surpassed by Gricci's achievements in the Aranjuez Royal Palace outside Madrid.

When the monarchs departed forever from the kingdom of the Two Sicilies, they took with them most of the leading Capodimonte artists and artisans, all of the factory's designs, and over five tons of modeling clay, with the intention of establishing a porcelain factory in their new Spanish realms. But they did not stop there. The manufactory was dismantled and all the equipment they did not take away was destroyed. Their purpose in so doing was to ensure that the factory they intended to establish in Madrid would not have to face competition from Naples, which had a new king—Ferdinand IV, Charles and Maria Amalia's third-born son, who was only eight when he came to the Neapolitan throne. He was placed under a regency led by Bernardo Tanucci. Charles of Bourbon was compelled by treaty to surrender the Neapolitan throne when he inherited its Spanish counterpart, it being forbidden for one monarch to occupy both at the same time. It is worth noting that shortly after Ferdinand reached his majority he established his own porcelain works—the Naples Royal Porcelain

Manufactory—which produced high-quality ceramics until it was seized by French invaders after Ferdinand's family fled Naples for Palermo. Joseph Bonaparte, imposed as ruler of Naples by his brother Napoleon in 1806, was ordered to shut the factory down so that it could not compete with the French imperial porcelain works at Sèvres. Like his Saxon mother, Ferdinand IV was keenly interested in porcelain and was aware of its economic and political value.

It may be useful to consider the reasons why many European polities were so eager to set up porcelain factories in their domains. As with most things, one only has to follow the money. From the late sixteenth century, tremendous quantities of bullion, especially silver, left Europe and its American colonies in order to buy Japanese and Chinese porcelain. Literally millions of individual pieces of what was called "white gold" were brought to the West during the next two centuries. Because the Chinese were uninterested in exchanging porcelain for European wares, it had to be paid for with silver, which the Chinese valued more highly than gold. The amazing cloak and dagger business of finding the "secret" to East Asian hard-paste porcelain is the subject of another essay, but suffice it to say here that many European rulers believed that if they could discover how to make vendible porcelain of a quality equal to the East Asian imports, they could not only sell it to others who did not know the secret, but could also stem the tide of specie leaving their realms. Moreover, many Europeans, especially the British and the Dutch, were ultimately seeking to set up a new trade relationship with China based more on the global colonialist model of mercantilism in which their manufactured goods were sold to colonial or colonialized places in return for raw materials, a system already in place in Europe's rapidly expanding global empires in Africa, South Asia, and the Americas.

If one considers the Porcelain Boudoir in the broader context of global and colonial commerce, newly emerging notions of Western cultural superiority *vis-à-vis* Qing China, and the Catholic missionary impulse to evangelize the planet, the choice of chinoiserie as the decorative theme of Maria Amalia's Porcelain Boudoir at Portici comes into greater focus. The fanciful, creative, and innovative aspects of Gricci's spectacular creations should not be overlooked, but rarely is a work of eighteenth-century art innocent of political, commercial, spiritual, or racial engagement. To sophisticated Europeans in the age of Enlightenment, chinoiserie denoted modernity—it was a decorative mode expected to be encountered in the more private and domesticated settings designed for upper-class social exchange.[20] Many royal and aristocratic residences built or remodeled during the first half of the eighteenth century included chinoiserie sitting rooms, galleries, tea rooms, dressing chambers, music rooms, libraries, and boudoirs. In addition to the Salottino di Porcellana and the Blue Cabinet, the Sala della Musica at Portici was also decorated *à la chinois*. In addition, the newly wealthy bourgeoisie, frequently enriched by colonial commerce, emulated the nobility in embracing chinoiserie as evidence of their cultural sophistication and appreciation of *le goût modern*. Décor *à la chinois* not only signified the good taste of the proprietor, but it also visualized Western ideas of cultural and political dominance over the once admired and highly respected Chinese Empire. China, too large to conquer and too xenophobic to participate in equal commercial relations with "barbarian" Europe, was an alien Other that could only be subordinated through visual and textual culture.

Chinoiserie, viewed through this lens, depicted Chinese subordination. At Portici, "Chinese" figures are visually caged in elaborate decorative schemes that render them whimsically interesting, but harmless (Figure 2.8). Men are feminized, social distinctions are blurred, and Chinese mores are denigrated.[21] Combining "Chinese" people with monkeys (*singerie*) is another indication of ridiculing a culture that could not be subordinated in any other way (Figure 2.9). It is as if architecture and design have conspired to downgrade a powerful empire and venerable civilization to conform to a Western narrative of innate racial and technological superiority, coupled with a "civilizing impulse," what nineteenth-century imperialists self-servingly called "the white man's burden."

Queen Maria Amalia's Porcelain Boudoir measures 6.75 meters (22.1 feet) by 4.8 meters (15.74 feet) with a 5.13 meters (16.8 feet) ceiling at its highest point, as it now is configured. These are fairly close to the dimensions of the Salottino at Portici after its transferal to the royal palace at Capodimonte. The walls are entirely covered with porcelain panels punctuated by six large mirrors and a stucco ceiling articulated with applied porcelain figural and vegetal motifs (Figure 2.10). The chamber's sheer complexity indicates that many types of artists and artisans were employed in its construction and decoration. The general plan was formulated by the *quadratura* artist Giovanni Battista Natali from Piacenza (where Charles of Bourbon likely made his acquaintance when he was duke of Parma and Piacenza) and the porcelain decorations were designed by Gricci. Modelers and painters were responsible for the execution of the panels and figural decoration as well as the *stuccatori* who constructed the ceiling (Figure 2.7). The large candelabra that dominates the room is one of Gricci's most remarkable inventions (Figure 2.11). The walls are composed of porcelain panels about a centimeter thick attached to a warp of wood and held in place by screws. These are concealed by the cornice and by the higher relief porcelain decorations. The ornaments are composed of floral and vegetal motifs, fruit, musical instruments, landscapes, simians, buildings, and variously sized vignettes of "Chinese" figural groups. These last objects recall similar figures in the work of Antoine Watteau and François Boucher, but in explicitly chinoiserie forms.[22]

Perhaps the most unusual feature of the Salottino's decorations are the cartouches bearing actual Chinese characters, real and fictive. There are over a score of them, five containing "Chinese" text, but the crucial one, composed by an expert linguist, reads: "To Charles, who has reached the highest place, currently reigning, magnanimous and illustrious prince, the Lord has bestowed on him fortune, blessings, and virtues worthy of being memorialized in bronze and marble in order to spread his fame everywhere." It is signed: "The maker of this comes from afar, the innocent man from deepest China has inscribed this as an encomium" (Figure 2.12).[23] The author is unknown, but it is virtually certain that the text was provided by a Chinese Catholic convert who had come to Naples to study for the priesthood at the Collegio dei Cinesi. This remarkable seminary was established in 1724 by the Jesuit Matteo Ripa (1682–1746), who served on the China mission for over a decade. Father Ripa had largely met indifference from Naples's Habsburg rulers, Charles's immediate predecessors, but the new monarch made it a priority. Ripa's idea was to train converted Chinese priests in Naples so that they could return to Asia to evangelize the Chinese in their own language. An

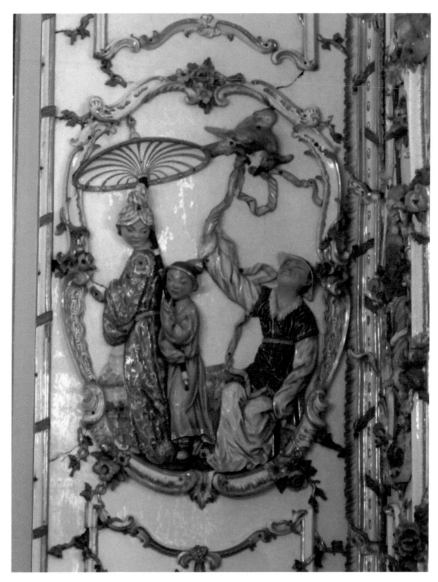

Figure 2.8 Giuseppe Gricci et al., Porcelain Boudoir from Palazzo Portici, "Chinese" figures, 1757–9. Naples: Museo e Real Bosco di Capodimonte. © Photo: Sailko, Wikimedia Commons. Public Domain. https://commons.wikimedia.org/w/index.php?curid=30696856.

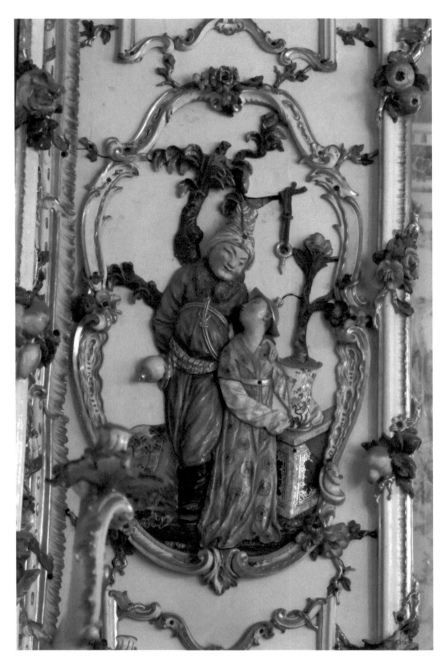

Figure 2.9 Giuseppe Gricci et al., Porcelain Boudoir from Palazzo Portici, "Chinese" figures, 1757–9. Naples: Museo e Real Bosco di Capodimonte. © Photo: Sailko, Wikimedia Commons. Public Domain. https://commons.wikimedia.org/w/index.php?curid=30696852.

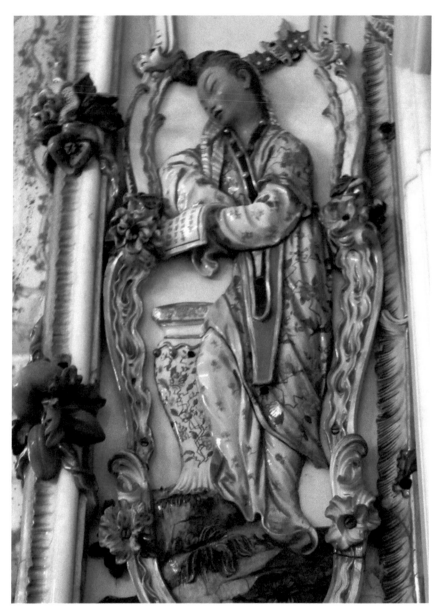

Figure 2.10 Giuseppe Gricci et al., Porcelain Boudoir from Palazzo Portici, "Chinese" figures, 1757–9. Naples: Museo e Real Bosco di Capodimonte. © Photo: Sailko, Wikimedia Commons. Public Domain. https://commons.wikimedia.org/wiki/File:Salottino_di_porcellana_della_regina_amalia,_1757-59_ca._10.JPG.

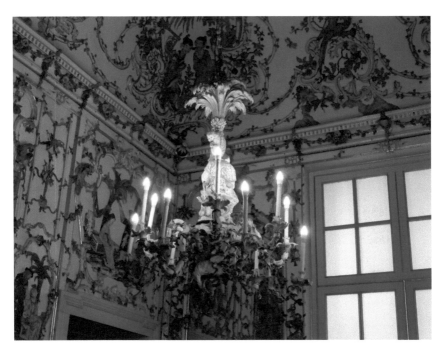

Figure 2.11 Giuseppe Gricci et al., Porcelain Boudoir from Palazzo Portici, candelabra, 1757–9. Naples: Museo e Real Bosco di Capodimonte. © Photo: Sailko, Wikimedia Commons. Public Domain. https://commons.wikimedia.org/w/index.php?curid=30696842.

important by-product of the college, however, was the provision of educated priests who could translate Chinese into Latin.[24] When Lord George Macartney (1737–1806) led a British embassy to the court of the Qianlong emperor (r. 1735–96) in Beijing in 1793, he hired two Chinese Jesuits from the Neapolitan college to accompany him as interpreters. Command of the Chinese language was so rare in Europe that the Collegio dei Cinesi gave the Bourbon court a considerable profile in East–West exchange, and the institution was supported generously by Charles and his successor Ferdinand IV.

My point in calling attention to the cartouches in the queen's Porcelain Boudoir is that it is a rare instance where authentic Chinese writing is included in a chinoiserie object or interior space. When East Asian characters do appear in European chinoiserie, they are almost invariably meaningless doodles intended to evoke Chinese writing but more valued for their decorative qualities and "exotic" charm. This is rather like the "Hebrew" and "Egyptian" texts that appear in some Old Testament biblical subjects and current products related to Egyptomania. The fact that the representation of the Chinese themselves in much eighteenth-century chinoiserie is frivolous, inauthentic, and "Other" demonstrates the low opinion in which the Chinese were held by waxing numbers of Europeans. The physical and cultural debasement of China and the Chinese was thought to be essential to their eventual subordination, however far removed from reality this notion was in the middle of the eighteenth century. Even in a kingdom without direct colonializing interests and with only indirect trade with

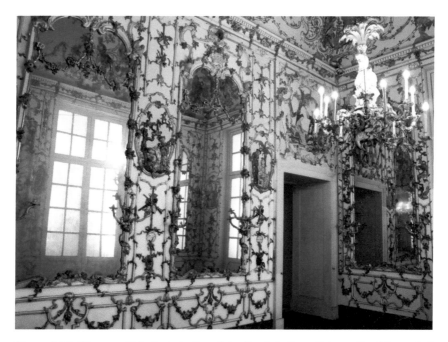

Figure 2.12 Giuseppe Gricci et al., Porcelain Boudoir from Palazzo Portici, musical instruments and cartouche, 1757–9. Naples: Museo e Real Bosco di Capodimonte. © Photo: Sailko, Wikimedia Commons. Public Domain. https://commons.wikimedia.org/w/index. php?curid=32747473.

East Asia, Bourbon Naples visualized itself as a global player in the queen's Salottino di Porcellana, imagining Qing China as a wonderfully exotic land but one that was hardly a threat to European hegemony. When this ideology pioneered at the royal palace at Portici arrived in Spain with Charles and Maria Amalia, it took root and flourished, largely owing to the fact that the Spanish Empire did have an active interest in establishing colonies and commercial dominance in a part of the world whose potential for profit and eventual conquest was virtually unlimited. Spain was already established in the Philippines and the Mariana islands, including Guam, a vital conduit of East–West exchange. The Spanish empire's colonial ambitions also extended to other parts of Asia and the Pacific.[25] The British subjugation of large parts of India had shown other colonialist powers what was possible in eighteenth-century circumstances.

Queen Maria Amalia's Porcelain Boudoir is a deeply meaningful royal space created for intimacy and private conversation, but its chinoiserie décor speaks volumes about the position of Naples in Enlightenment Europe. As a style denoting modernity, chinoiserie was a signifier of elite status and legitimacy that the new Bourbon dynasty in Naples wished to communicate to other Bourbon courts and to those of the increasingly interrelated dynasties such as the Wettins in Poland-Saxony and even the

Imperial Habsburgs. The Salottino di Porcellana, displaced from its original setting and now decontextualized as a museum display, still bears mute witness to these ambitions and to the significant role visual culture can play in the broader political context.

Notes

1 Born in 1670, Augustus became Frederick Augustus I, elector of Saxony, in 1697. That same year, he was elected king of Poland, a throne he occupied from 1697 to 1706 and again from 1709 until his death in 1733. His spectacular physical strength (he could bend horseshoes with his bare hands) earned him the sobriquets "the Strong," "Iron Hand," and "the Saxon Hercules." In addition to his obsession with porcelain that led in about 1710 to the discovery of the hard-paste formula that he employed at the manufactory at Meissen, he fathered scores of illegitimate children.

2 Charles, infante of Spain, was the eldest son of King Philip V and his second wife, the Italian princess Elisabetta Farnese (Isabel de Farnesio; 1692–1766). At the death of the last Farnese ruler of the duchy of Parma and Piacenza in 1731, Charles inherited *Le due piazze* from his Farnese mother. As a result of the War of the Polish Succession (1733–8), the Spanish conquered Naples and Sicily from the Habsburg emperor Charles VI (r. 1711–40) and he was crowned king of the Two Sicilies. Technically, Charles was the seventh ruler of that name to reign in Naples and Sicily. He styled himself Charles of Bourbon (Carlo di Borbone). He was a popular king and the first reigning monarch in centuries to reside in Naples. Sicily and Naples were separate entities under the same ruler, hence the name kingdom of the Two Sicilies. Many historians simply refer to the polity as the kingdom of Naples.

3 Helen Watanabe-O'Kelly, "Cultural Transfer and the Eighteenth-Century Queen Consort," *German History* 34, no. 2 (2016): 284. A major factor in Maria Amalia's popularity was her notable piety, an aspect of her personality inculcated in her by her deeply religious Habsburg mother Maria Josepha (1699–1757).

4 There is much evidence to suggest that Charles had full confidence in his wife long before the birth of the duke of Calabria and that he listened to her advice. After she went to Madrid as queen of Spain in 1759, she carried on an extensive correspondence with Tanucci, left behind to head the Regency Council for the young Ferdinand IV, in which she reveals her personal esteem and friendship for the able minister. She once wrote: "Oh how much I feel it not to have nearby an old friend to whom one could open one's heart and thoughts, as we used to do with you in my private apartment in Naples." Although such discussions could not have taken place in the Porcelain Boudoir, which was still unfinished when Maria Amalia departed for Spain, it does indicate that intimacy and privacy went hand in hand in the small chambers of the various palaces she occupied and that serious matters were discussed in such spaces. See Helen Watanabe-O'Kelly, "The Consort in the Theatre of Power: Maria Amalia of Saxony, Queen of the Two Sicilies, Queen of Spain," in *Queens Consort, Cultural Transfer and European Politics, c. 1500–1800*, ed. Helen Watanabe-O'Kelly and Adam Morton (London and New York: Routledge, 2017), 51–4. The translation given above is found on p. 54. For the Maria Amalia/Bernardo Tanucci letters, see Pablo Vázquez Gestal, *Verso la Riforma della Spagna: Il Carteggio tra Maria Amalia di Sassonia e Bernardo Tanucci, 1759-1760*, 2 vols. (Naples: Istituto Italiano per gli Studi Filosofici, 2016), with additional bibliography.

5 Hanns-Bertold Dietz, "The Dresden-Naples Connection, 1737–1763: Charles of Bourbon, Maria Amalia of Saxony, and Johann Adolf Hasse," *International Journal of Musicology* 5 (1996): 98–102.

6 Jóhannes Agústsson, "Giovanni Alberto Ristori at the Court of Naples, 1738–1740," *Studi Pergolesiani/Pergolesi Studies* 8 (2012): 76–90. Wackerbarth often acknowledged Ristori's good services in Naples, but the composer still struggled with poverty and the scandal surrounding his daughter Cecilia's socially problematic marriage to a Neapolitan aristocrat. In time, and with Maria Amalia's strong support, the couple were wed.

7 Watanabe-O'Kelly, "Cultural Transfer," 283–8. Hasse retained his post as *kapellmeister* at the Saxon court until his death in 1783.

8 Silvana Musella Guida, "La manifattura di Capodimonte: Storie, produzione e fonti documentarie," in *Porcellane di Capodimonte: La Real Fabbrica di Carlo di Borbone 1743–1759*, ed. Nicola Spinosa et al. (Naples: Electa Napoli, 1993), 11–12.

9 Paola Giusti, "La manifattura di Capodimonte: Caratteri e tipologie della produzione," in *Porcellane di Capodimonte: La Real Fabbrica di Carlo di Borbone 1743–1759*, ed. Nicola Spinosa et al. (Naples: Electa Napoli, 1993), 24–6.

10 Clare de Corbeiller, *Eighteenth-Century Italian Porcelain* (New York: The Metropolitan Museum of Art, 1985), 20–1. The Neapolitan monarchs wished to attract the best artists and artisans to work in their factory. They lured the arcanists Livio and Gaetano Schepers and the sculptor Giuseppe Gricci from Tuscany. The primary painter at Capodimonte was Giovanni Caselli (1698–1752), whose chinoiserie designs are brilliantly colored and inventively various; they likely influenced the designs in the Salottino di Porcellana begun after his death.

11 Watanabe-O'Kelly, "Cultural Transfer," 289–91. The author's claim that the queen "was an instrument of cultural transfer rather than an active agent" in the promotion of porcelain production in Naples in my opinion does not give her enough credit for the establishment of the Capodimonte manufactory. In her role as a principal advisor to the king, there can be little doubt that she greatly encouraged the initiative.

12 Ibid., 285–6.

13 Maureen Cassidy-Geiger, "Princes and Porcelain on the Grand Tour of Italy," in *Fragile Diplomacy: Meissen Porcelain for European Courts, ca. 1710–63*, ed. Maureen Cassidy-Geiger (New Haven and London: Yale University Press, 2007), 237–9.

14 Maria Luisa Margiotta, *Il Real Sito di Portici* (Naples: Paparo, 2008), 19–26. The Portici Palace was little used after the departure of Charles and Maria Amalia for Madrid, and it was later made the seat of the Accademia Ercolanese. Antiquities from the excavations at Pompeii and Herculaneum were displayed there. Much of the interior was dramatically altered, and the rococo character of the design was largely displaced by the new vogue for Nneoclassicism. See also idem., "La Reggia e il Sito Reale," in *Herculanense Museum: Laboratorio sull'antico nella Reggia di Portici*, ed. Renata Cantilena and Annalisa Porzio (Naples: Electa Napoli, 2008), 16–33. For an excellent study of Charles's public architecture, see Robin L. Thomas, *Architecture and Statecraft: Charles of Bourbon's Naples, 1734–1759* (University Park, PA and London: Penn State University Press, 2013).

15 Gabriella D'Amato, "Una 'maison de plaisance' all'ombra del Vesuvio, 1738–1806," in *Il Real Sito di Portici*, ed. Maria Luisa Margiotta (Naples: Paparo Edizioni, 2008), 205–9.

16 Silvana Musella Guida, "Precisazioni sul Salottino di Porcellana in Portici," *Antologia di Belle Arti* 5 (1978): 76. For the French origins of the term boudoir and a discussion

of some of its architectural features, see Diana Cheng, "Lord Chesterfield's Boudoir: A Room without the Sulks," in *Agents of Space: Eighteenth-Century Art, Architecture, and Visual Culture*, ed. Christina Smylitopoulos (Newcastle upon Tyne: Cambridge Scholars Publishing, 2016), 154–73.

17 Annalisa Porzio, "Gli interni della Villa di Portici nel Settecento: L'appartamento reale al tempo di Carlo Borbone," in *Il Real Sito di Portici*, ed. Maria Luisa Margiotta (Naples: Paparo Edizioni, 2008), 125–33. The Porcelain Boudoir is part of a suite of cabinets, and at least one of them, the Gabinetto a Cantone, had porcelain walls, cornices, and wall hangings, perhaps anticipating the more profuse use of porcelain in the Salottino next to the queen's bedchamber.

18 Giusti, "La manifattura di Capodimonte," 31–2.

19 An arcanist was a craftsman with special, secret knowledge of a manufacturing process, especially of porcelain. The notion goes back to European attempts to discover the "secret" of East Asian hard-paste porcelain production.

20 For the connections between chinoiserie and modernity in art and diplomacy at a rival Italian court, see Christopher M. S. Johns, "Chinoiserie in Piedmont: An International Language of Diplomacy and Modernity," in *Turin and the British in the Age of the Grand Tour*, ed. Paola Bianchi and Karin Wolfe (Cambridge: Cambridge University Press, 2017), 281–300.

21 The deployment of chinoiserie as cultural ordnance against an otherwise unassailable China is a major theme of my *China and the Church: Chinoiserie in Global Context* (Oakland: University of California Press, 2016).

22 Silvana Musella Guida, "Il Salottino di Maria Amalia," in *Porcellane di Capodimonte: La Real Fabbrica di Carlo di Borbone 1743–1759*, ed. Nicola Spinosa et al. (Naples: Electa Napoli, 1993), 88–90.

23 Ibid., 90–2. Guida's Italian translation reads: "A Carlo, che è al primo posto, attualmente regnante, principe magnanimo e preclaro, il Signore elargì fortuna, benedizioni, virtù degna di essere tramandata nel bronzo e nel marmo e fama che si diffonde ovunque. Il suddito venuto da lontano, l'uomo candido della Cina centrale incise come elogio."

24 For the Collegio dei Cinesi, Father Ripa, and the role of the Society of Jesus in its establishment and promotion, see especially Gennaro Nardi, *Cinesi a Napoli: Un uomo e un'Opera* (Naples: Edizioni Dehoniane, 1976).

25 The most important conduit of Chinese-Spanish contact was via the Manila galleons, Spanish armed merchant vessels that made an annual voyage from Manila in the Philippines (named for King Philip II; r. 1556–98) to Acapulco in Spanish Mexico. Its principal cargo was Chinese luxury goods such as porcelain and lacquer furniture imported from China by Manila merchants. Silver from the Mexican and Peruvian mines owned by Spain was exported to pay for the Chinese goods.

Bibliography

Barbera, Filippo. "I projtti della Regia di Portici: Da Medrano a Canevari, da Vanaitelli a Fuga." In *Il Real Sito di Portici*, edited by Maria Luisa Margiotta, 69–103. Naples: Paparo Edizioni, 2008.

Cassidy-Geiger, Maureen. "Princes and Porcelain on the Grand Tour of Italy." In *Fragile Diplomacy: Meissen Porcelain for European Courts, ca. 1710–63*, edited by Maureen Cassidy-Geiger, 209–55. New Haven and London: Yale University Press, 2007.

Corbeiller, Clare Le. *Eighteenth-Century Italian Porcelain*. New York: The Metropolitan Museum of Art, 1985.

D'Amato, Gabriella. "Una 'maison de plaisance' all'ombra del Vesuvio, 1738–1806." In *Il Real Sito di Portici*, edited by Maria Luisa Margiotta, 199–224. Naples: Paparo Edizioni, 2008.

Dietz, Hanns-Bertold. "The Dresden-Naples Connection, 1737–1763: Charles of Bourbon, Maria Amalia of Saxony, and Johann Adolf Hasse." *International Journal of Musicology* 5 (1996): 95–130.

Giusti, Paola. "La Manifattura di Capodimonte: Carattere e tipologie della produzione." In *Porcellane di Capodimonte: La Real Fabbrica di Carlo di Borbone, 1743–1759*, edited by Nicola Spinosa et al., 23–37. Naples: Electa Napoli, 1993.

Guida, Silvana Musella. "Precisioni sul Salottino di Porcellana in Portici." *Antologia di Belle Arti* 5 (1978): 73–6.

Guida, Silvana Musella. "Il salottina di Maria Amalia." In *Porcellane di Capodimonte: La Real Fabbrica di Carlo di Borbone, 1743–1759*, edited by Nicola Spinosa et al., 88–93. Naples: Electa Napoli, 1993.

Guida, Silvana Musella. "La manifattura di Capodimonte: Storie, produzione e fonti documentarie." In *Porcellane di Capodimonte: La Real Fabbrica di Carlo di Borbone, 1743–1759*, edited by Nicola Spinosa et al., 9–22. Naples: Electa Napoli, 1993.

Johns, Christopher M. S. "Chinoiserie in Piedmont: An International Language of Diplomacy and Modernity." In *Turin and the British in the Age of the Grand Tour*, edited by Paola Bianchi and Karin Wolfe, 279–80. Cambridge: Cambridge University Press, 2017.

Margiotta, Maria Luisa, ed. *Il Real Sito di Portici*. Naples: Paparo Edizioni, 2008.

Nardi, Gennaro. *Cinesi a Napoli: Un uomo e un'opera*. Naples: Edizioni Dehonianae, 1976.

Porzio, Annalisa. "Gli interne della Villa di Portici nel Settecento: L'appartamento reale al tempo di Carlo Borbone." In *Il Real Sito di Portici*, edited by Maria Luisa Margiotta, 105–41. Naples: Paparo Edizioni, 2008.

Watanabe-O'Kelly, Helen. "Cultural Transfer and the Eighteenth-Century Queen Consort." *German History* 34, no. 2 (2016): 279–92.

Watanabe-O'Kelly, Helen. "The Consort in the Theatre of Power: Maria Amalia of Saxony, Queen of the Two Sicilies, Queen of Spain." In *Queens Consort, Cultural Transfer and European Politics, c. 1500–1800*, edited by Helen Watanabe-O'Kelly and Adam Morton, 37–63. London and New York: Routledge, 2017.

Who Let the Dogs In?: The *Hundezimmer* in the Amalienburg Palace

Christina K. Lindeman

Long before Jay Pritchett's obsession with designing elaborate dog beds for his French bulldog Stella and photographs of celebrities' pampered pooches relaxing in the modern home, portraits of beribboned and bejeweled eighteenth-century lapdogs appeared among the luxurious and intimate trappings of the rococo interior.[1] Small dogs were bred as a sensual delight to be viewed and treated very much like other costly material possessions within the domestic sphere. By the mid-eighteenth century, the lapdog, like the fashionable French boudoir, was associated with aristocratic and upper-class women. Both epitomized the owner's good taste. Before the term "boudoir" was labeled on plans and well before its transformation into an eroticized female space, it was a small cabinet.[2] According to the *Encyclopédie* (1751), a cabinet was a multi-use space for both men and women dedicated to private study, collecting, dressing, napping, and meditating.[3]

It seems surprising, then, that a small cabinet was built for an entire pack of large hunting dogs to rest and recover from a day of sport. Unlike the beribboned and coiffed lapdog, these animals were covered in sweat, mud, and the blood of their quarry, yet they would still be found lounging among the satins and velvets of a rococo interior designed exclusively for their use. What is more, the iconic Amalienburg Palace in Munich, famous for its beautiful rococo decorative elements designed by François de Cuvilliés, is also home to a *Hundezimmer*, a cabinet specifically constructed for the rest of its four-legged occupants. This essay examines the exceptional *Hundezimmer* in the private apartments of Amalienburg Palace and raises questions not only about how the built environment with its lavish and ornate interior décor masks the hunting dogs' animalistic nature, but also about the role of interior architecture in the civilizing process. This dog "boudoir" or cabinet offers a quiet and intimate space for the dogs to recover, rest, and observe the types of activities they performed during the hunt visualized in decorative scenes throughout the room.

Built in 1734 under the direction of Carl Albrecht, elector of Bavaria, the small hunting palace or *Lustschloss* in the style of a French *maison de plaisance* (pleasure house) is located in the vast gardens at Nymphenburg Palace (Figure 3.1). In honor of his wife Maria Amalia, Carl Albrecht named the Amalienburg in her honor. The

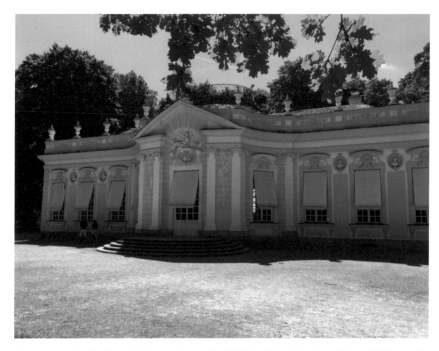

Figure 3.1 Amalienburg Palace in the park of Schloss Nymphenburg, Munich. Photo: the author.

contemporary travel accounts of Johann Georg Keyssler in his *Deutschlandreise* (1729) reveal that hunting was a pastime that the royal couple enjoyed together: "[The Elector] is very much loved by his wife and he spends little [time] away from her. She eats and plays with him, drives with him to the stables, shoots very well at the target and at wild game, and often goes on hunts down to the knees in mud."[4] Keyssler's comment on the princess's pursuit of hunting notes her lack of courtly decorum and etiquette, almost as if she were swept up in the passion of the hunt. Amy Freund notes that French women, and among them a few foreign-born princesses, did not actively participate in the hunt and instead followed it on horseback or in carriages.[5] German aristocratic women hunted less rarely, so it was perhaps the manner in which the electress engaged with the ritual that most raised eyebrows.[6] The image of her wading in mud to the perfect vantage from which to shoot or track wild game is vivid. Keyssler's comment, however, is at odds with the controlled image of the royal couple portrayed in a series of hunting scenes by Peter Jakob Horemans located in the Amalienburg *Jagdzimmer*. Within the palace's interior, Maria Amalia and Carl Albrecht are depicted statically in the foreground, dressed in the traditional blue and silver uniform of the Bavarian court. Their stillness contrasts with the bustling courtiers who swarm to their left and right and convey the energetic and frenzied tone of the hunt. Each painting in the series is illustrated at a different hunting palace scattered across the House of Wittelsbach's territories in Bavaria. Unlike these larger summer hunting palaces, the small and

intimate Amalienburg in the gardens of the Nymphenburg Palace was the primary location where the royal couple could pursue their love of hunting, entertaining, and personally tending to their dogs. The pleasure palace was an in-between space remote from the spaces of daily life that catered to the world of fantasy.[7]

Within the *Lustschloss*, the electress of Bavaria acted out her role as Diana with real-life hunting hounds at her feet. In Roman mythology, the chaste goddess was a lunar deity and sister to the sun god, Apollo. She was both a champion of the hunt and childbirth. Throughout the seventeenth and eighteenth centuries, noble women had themselves depicted in allegorical portraits in the guise of the Roman goddess because of her associations with both beauty and virtue.[8] Instead of fashioning herself on painted canvas as Diana dressed in classical garb with a moon crescent crowning her head, the electress more actively took up the role both within and outside of the architectural spaces of the Amalienburg Palace. In other words, Maria Amalia's noble birth and mastery of untamed nature were made apparent each time she went out hunting pheasants while accompanied by her well-trained dogs. Here, the ideology of absolute power is demonstrated on a small scale within an intimate pleasure palace and adjacent gardens.

The Amalienburg Palace took five years to complete (1734–9) under the direction of French architect Cuvilliés, who was himself a student of the architectural theorist Jacques-François Blondel at the Académie Royale in Paris. The palace was designed in accordance with the French architectural theory of *bon gout*, which encompassed three distinct components: *l'ordinance*, *la proportion*, and *la convenance*. The theories of aesthetic design, order, and practicality are embodied in the arrangement of the interior rooms and eighteenth-century concepts of public and private. These spaces were divided on the southern and northern sides of the central and largest room in the palace, the famous *Spiegelsaal* (Hall of Mirrors) (Figure 3.2). The mirrored hall is a primary example of the French rococo style in a German state. An abundance of silver gilded rocailles gracefully collide into the figures of birds, nets, hunting horns, and grapevines. The goddesses Ceres and Diana look down from their placements on the cornices above the reflecting mirrors to the human performers below. The entirety of the surface between the stucco frames of the mirrors to the doors is filled with bountiful and mythological imagery.[9] Although Cuvilliés was at the helm of this architectural project, German artist and architect Johann Baptist Zimmerman (1680–1758) also contributed his skills for its interior and exterior stuccowork, which further develops the theme of Diana the Huntress.

Before entering the east doors of the *Spiegelsaal*, Zimmerman's sculptural image of Diana would greet hunting parties from her exterior perch over the doors. Although the iconography on the exterior of the building consistently illustrates its function as a space for entertaining and hunting, Zimmerman's sculptural program above the east doors facing the garden façade merits special attention (Figure 3.3). The bare-breasted goddess is lying prone within the alcove and accompanied by two putti to either side. The putto to her right holds a hunting horn in the shape of a French horn while the putto to her left is shown physically restraining two of the goddess's energetic hunting dogs as they pull against their woven leashes. Diana's right hand is raised, and a bird is perched there. With her left hand, she points down to the spoils of the hunt, where deer

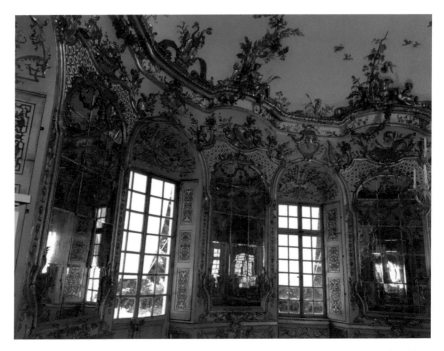

Figure 3.2 *Spiegelsaal* (Hall of Mirrors), Amalienburg Palace in the park of Schloss Nymphenburg, Munich. Photo: the author.

and boar heads are assembled in a playful rococo trophy comprising a French horn hung by a ribbon, a net, a spear, a sword, and a few oak branches. Tondos that contain the sculptural busts of smiling satyrs, as well as swags composed of vegetation and grapevines, are arranged along the east side of the building and between each massive window to further allude to the festivities after the hunt.

The bird perched high in Diana's right hand is significant. Birds were both hunted prey and tamed predator. In eighteenth-century Germany, falconry was almost as popular with the aristocratic classes as hunting with dogs.[10] When the Amalienburg was first constructed, it was situated in a *Fasanerie* (pheasantry) that had been laid out in 1734. These colorful birds, so admired for their beautiful, multicolored feathers that a group of them is called a "bouquet," are native to Asia and first recorded in Germany in the seventeenth century.[11] Pheasants were kept and bred specifically for the aristocratic hunt. They were considered the highest echelon of noble hunting, and were sought out as a culinary delicacy. Only the wealthiest and uppermost nobles had the means to maintain a flock. The most common breed was the silver pheasant, which also appears in the lacquered linen wall panels of the *Fasanzimmer* in the Amalienburg Palace.[12]

The roof of the palace offers a platform with a balustrade rail upon which Maria Amalia's initials are intertwined; it is here that the royal couple stood while shooting at pheasants as their pack of hunting dogs eagerly waited on the ground to fetch them.

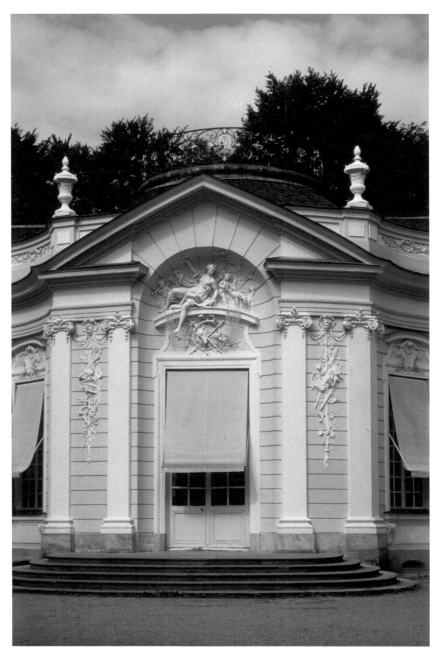

Figure 3.3 Amalienburg Palace hunting pavilion in the park of Schloss Nymphenburg, Munich: exterior, detail of east entrance. https://quod.lib.umich.edu/a/aict/x-rma325/rma325. University of Michigan Library Digital Collections. Accessed January 29, 2022.

While visiting the Munich court in 1737, the Bamberger architect Michael Kuchel wrote, "a garden house called the Amalienburg is also being laid out, something completely new … built on the roof is a curved gallery, whereupon the Elector can shoot many pheasants on the building without going into the garden or outside of the building."[13] The author's praise of the innovative architectural design signifies how modern the *maisons de plaisance* were at the first half of the eighteenth century. Aesthetic design and practical function are demonstrated both in the hunting platform on the building's roof and in the hunting dog cabinet inside the palace. I imagine, too, that the platform had symbolic value as well—it literally elevated the royal couple above both the hunting dogs and members of the court below.

The private apartments in the Amalienburg comprise a suite of four rooms: the *Ruhezimmer* (the princess's bedroom), the *Blaues Kabinett* (a writing room), the *retirade* (a lavatory), the *Hundezimmer* (the dogs' boudoir), and the *Garderobe* (wardrobe). The dogs remained with their master and mistress in the *Lustschloss* instead of in a separate kennel on the grounds of the Nymphenburg Palace, as was conventional for palatial architecture throughout Europe. The eccentrism, however, is also apparent in other European royal palaces of the mid-eighteenth century. Concurrently to the construction of the Amalienburg, Louis XV created a room for his two hunting dogs, the *antichambre des chiens*, at Versailles in 1738, where they would rest in sleeping boxes and he could tend to them personally.[14] The boxes likely resembled the dog box created by furniture designer Claude I Sené for Marie Antoinette's beloved dog, Coco; the box is now in the collection of the Metropolitan Museum of Art in New York City (Figure 3.4). Coco's lavish box has a niche opening through which a dog could easily enter and exit. Constructed of gilded wood and luxurious velvets, it is adorned with the same neoclassical motifs that were sought out in the second half of the eighteenth century. One can imagine that Louis XV's dog boxes were as richly adorned with rococo design elements. Unlike the room in Versailles with its two semi-built-in dog boxes, the Amalienburg Palace's *Hundezimmer*'s alcoves are an integral part of the room's architecture. The purpose-specific space for a pack of twelve establishes a permanent cabinet or resting room (Figure 3.5).

Maria Amalia and Carl Albrecht appear not to have limited the dogs' access to the interior of their palaces. Visitors like Johann George Keyssler observed their regular presence outside the *Hundezimmer*: "At the table there are *a good number of them* around the Electress …" (emphasis mine).[15] The author's tone is one of both fascination with and distaste for the spectacle. Indeed, the author repeatedly noted the presence of dogs in his accounts of the different palaces in and around Munich. While touring the Nymphenburg Palace, for example, he observed: "At the Elector's bed there is a box for a dog, and the like for twelve others in the next adjoining beautiful writing-room."[16] While at the summer palace at Schleissheim, he commented that near Maria Amalia's bed was a dog's bed in the shape of a tent with a cushion. These more ephemeral furnishings could be moved in and around the grand palaces. The specific architectural design for the dogs' *Hundezimmer* in the Amalienburg Palace was the first of its kind.

When entering the dog cabinet from either the *retirade* or *garderobe*, the visitor is welcomed by blue on white monochrome paintings that engulf the entirety of the space. The choice of colors throughout the palace reminds the viewer of the House

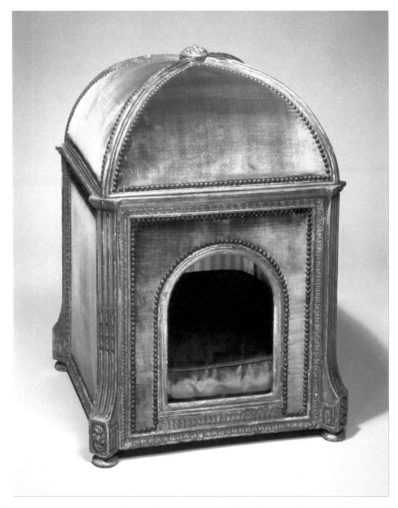

Figure 3.4 Claude I Sené, Dog kennel, *c.* 1775–80. Metropolitan Museum of Art, New York. Open Access/Public Domain.

of Wittelsbach coat of arms, an escutcheon comprising white and blue fusils. The images in the *Hundezimmer* were completed by the German painter Joseph Pascalin Moretti (1700–58), court painter to Elector Max Emanuel and later to his son, Carl Albrecht. Moretti was sent to Paris to study the "goût chinois" and became acquainted with the chinoiserie decorative grotesques by Claude Gillot (1673–1722), Claude Audran III (1658–1734), and Jean-Antoine Watteau (1684–1721). Upon returning to Munich, he painted fanciful chinoiserie ceiling paintings in the Pagodenburg pleasure palace in Nymphenburg park. Another clear influence on the Amalienburg designs was the Augsburg printmaker Elias Baeck (1679–1747), whose chinoiserie engravings

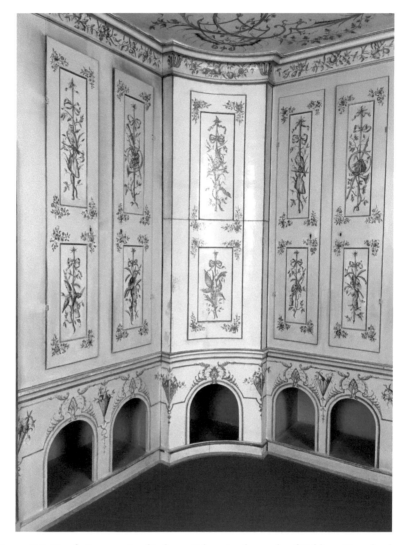

Figure 3.5 *Hundezimmer*, Amalienburg Palace in the park of Schloss Nymphenburg, Munich. Photo: the author.

were also used to decorate Meissen porcelain.[17] Moretti's technique of applying blue onto ground ivory or tusk created a sheen that gives the impression of Delft tiles, which were themselves emulations of Chinese porcelain. The artist created this illusion within several pleasure palaces in the Nymphenburg gardens, and his designs are juxtaposed with tiles imported from the manufacturing cities of Delft and Rotterdam. The Amalienburg kitchen is perhaps the most striking instance of this combination of the two mediums in the same space.[18]

Max Emanuel began building the Nymphenburg Palace in 1701 after his many years spent fighting abroad in both the Turkish wars (1683–8) and the Spanish Netherlands (1692–1701). The elector became fascinated with orientalism and the blue and white Ming dynasty porcelain imported into the Netherlands, and the chinoiserie decorative elements in the Amalienburg dog cabinet established connections both to the origins of the pheasant and to the prestige of exoticism at the Bavarian court. In the *Hundezimmer*, the visual program is consistent with the rest of the palace. It emphasizes the richness of the natural bounty that surrounds the garden and park. Above the alcoves of the dog kennels, the hunting guns, associated with masculinity and extensions of male bodies, are hidden in decorated cabinets.[19] Each gun cabinet door has a recessed panel on which are painted different trophies neatly assembled with horns, nets, spears, guns, dead pheasants, hare, boar's head, and foxes. Delicate ribbons and flowers suspend each trophy. At the four corners of the recessed panel, more floral arrangements help to frame the scene. The refined images on the closed door obscure the weapons of the hunt stored behind them.

Each of the dogs' alcoves is outlined with fantastical rocailles shaped like butterfly wings and reminiscent of grotesques by Watteau. Swags of elegant flowers and shell-like cornucopias filled with fruits, flowers, and vines separate the nooks. The visual delights permeating the lower level of the room and the hunting dogs' resting spaces are repeated on the cornice. The ceiling is covered with elaborate rocaille scrolls that terminate into vegetal or floral vines. The occasional perched squirrel or bird is painted on vine segments in a naturalistic manner. Symbols associated with the goddess Diana, namely a quiver with arrows and a single arrow creating an X pattern behind the convex and concave form of a rocaille, occupy the center of the ceiling. Its negative space expresses movement through the animated figures of flying birds and floating butterflies. Owls are depicted both on a cabinet door and on the ceiling, perhaps an allusion to the innate wisdom of the hunting dogs. The owl in Jean La Fontaine's *Fables* (1688, 1678, 1694) was likely a metaphor for an animal's intelligence.[20] In her analysis of the use of grotesques in eighteenth-century French palaces, Katie Scott argued that they attempted to bypass the "intellect and addressed itself directly to the senses, to 'visual pleasure.'"[21] The *Hundezimmer*'s visual program also addresses itself to the particular and heightened sensory receptors of its four-legged occupants with its array of fruits, flowers, insects, and animals.

Unlike the gun cabinet doors, alcoves, cornice, and ceiling, the recessed panels of the window shutters and entry doors depict picturesque landscapes painted in loose, sketch-like brushstrokes that maintain the blue on white monochrome color scheme. The scenes apply a compositional pattern common among seventeenth-century landscape painters who placed something larger in the foreground and middle ground of the painting to lead the eye further back. The picturesque landscapes present a variety of different views and vistas that also include birds (Figure 3.6).

While the overall theme of the *Hundezimmer* is of peaceful picturesque landscapes and bucolic pleasures, clear reminders of the dogs' violent nature appear above the doors exiting to the *garderobe* and *retirade*. The vignette above the door to the *garderobe* depicts three dogs chasing down a stag. One of the hounds has Carl Albrecht's initials branded into its side. The overdoor to the *retirade* has a similarly dramatic scene: two

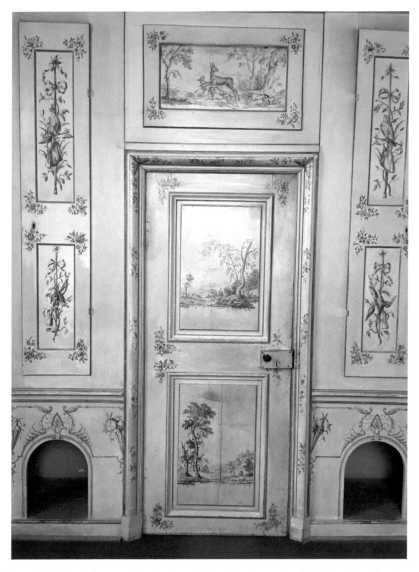

Figure 3.6 *Hundezimmer*, Amalienburg Palace in the park of Schloss Nymphenburg, Munich. Photo: the author.

dogs tear apart a wolf while another dog lunges forward eagerly to join the frenzy. The images remind the viewer why the dogs were bred—as a vehicle for the hunt. A dog's obedience when properly trained, its reliable immobility, "as unobtrusive as a piece of furniture," when hunting is like no other animal's.[22] The domesticated dog was only allowed inside the palace because it is passive and akin to the other furnishings of the interior. Representations of the docile nature of the dog resting among the trappings

of luxury had become more commonplace in the early eighteenth century in large part due to the influence of animal portraits as well the published work of printmaker Johann Elias Ridinger (1698–1767).[23]

Humanizing the Hunting Dog

In 1734, German printmaker Johann Elias Ridinger was commissioned to illustrate one of Carl Albrecht's hunting dogs stalking a bird within the gardens of the Nymphenburg Palace. The dog is captured pointing towards a green leafy plant under which a bird is barely visible. The hunting scene is no real wilderness, but an elevated natural setting suitable for princely pursuits. An active spurting fountain and a glimpse of the palace are depicted above the scene. A column with an urn is partly hidden by an overgrowth of foliage to signify, perhaps, that nature is making an attempt to occupy the manicured space. Text appears under the image: "In the Year 1734 this Well-Trained Pointer has been drawn from Nature during his Action inside the Pheasantry by the Imperial Pleasure Seat Nymphenburg at Munich." Ridinger specialized in animal images, not only wildlife but also different breeds of horses and hunting scenes. The artist who began his early eighteenth-century career creating allegorical images of animals later turned to the more scientific imagery found in books and treatises on zoology and hunting. Of the 1600 prints produced during his lifetime, many were printed in published series on animals. This deep knowledge and intense observation of animals is evident in Ridinger's portrayal of Carl Albrecht's favorite hunting dog. Placing the dog within a garden setting is a reminder that these are "in-between spaces … open landscapes transformed into stages in miniature for ritualized courtly hunt performances."[24] These liminal spaces extend from the garden into the *Lustschloss*.

Before the late eighteenth-century and nineteenth-century proliferation of treatises on dog anatomy and breeding guides, Ridinger's *Neues Thier Reis-Büchl. Erster Theil Allerley Art Hunde vorstellend* (1728) was a key instructional book for artists, depicting a variety of hunting breeds. The graphic title page depicts two hunting dogs ripping apart a wolf in a dense forest in an image quite similar to that of the *Hundezimmer*. Although the brutality of the hunting dogs' actions is made prominent by its depiction on the title page, what follows are several plates that depict dogs in a variety of poses and settings with different expressions. These plates are reminiscent of Charles LeBrun's *Expressions des passions de l'Ame* (1732). In other words, Ridinger adopts a format and composition in the interior folios of the book that humanizes the dogs.[25] Plates 2, 3, and 7 depict expressions of dogs that are likened to the emotional range of humans, from anger to happiness. Plates 4 and 5 illustrate the legs of different breeds, whilst Plates 8 and 9 show a variety of hunting dogs resting in a wilderness landscape. Plate 10 portrays a hunting dog showing curiosity by sniffing at a large insect on the ground. Here, the artist depicts the animal as having an innate exploratory behavior that contradicts Cartesian claims that they are mere automatons. Indeed, eighteenth-century ideas about animals turned against this understanding of beasts as machines. Rousseau and Voltaire, for example, argued that animals had some degree of sentimental feelings, even if these were inferior to those of human beings.[26]

By the eighteenth century, it was not unusual for artists to depict dogs as pets surrounded by interior objects. Plate 11 from Ridinger's text illustrates a pair of hunting dogs resting in a landscape that includes drapery, namely an ornate tassel. This technique of bringing the outside elements to the inside was also used and admired in seventeenth-century painter Anthony van Dyck's portraits of noblemen and noblewomen in exterior settings. Eighteenth-century artists Watteau and Boucher also applied it in their *fêtes galantes* and mythological scenes. French painter Jean-Baptiste Oudry, a contemporary of Ridinger and also a renowned animal painter, also represented hunting dogs in a curated landscape with such interior decorative elements as Venetian glassware and lavish table settings in his 1721 pendant paintings, *The Dead Wolf* and *The Dead Roe*. The latter image depicts an elaborate stone stairwell on which the hunter's gun and powder case with a pastel blue ribbon are resting to indicate that this hunt is taking place in the vast garden of a nobleman's estate (Figure 3.7). Oudry captured a hunting dog's excitement at the presence of a living pheasant as it springs into action and jumps onto the landing of the stairwell. Both Oudry's garden scene and Ridinger's print set in the gardens at Nymphenburg emphasize the aristocratic privilege of the hunt.

In portraiture, the relationships between aristocrats and their dogs signified the former's good breeding and refinement. In the private apartments of the Amalienburg Palace, portraits of Maria Amalia and Carl Albrecht hang on each side of the yellow

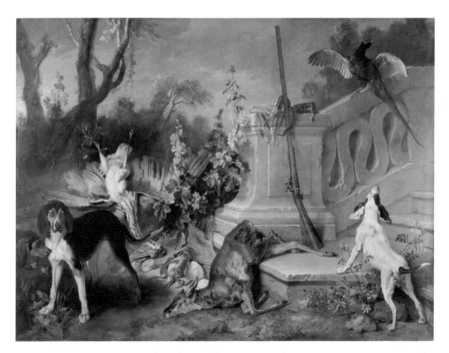

Figure 3.7 Jean-Baptiste Oudry, *The Dead Roe*, 1721, oil on canvas, 193 × 260 cm. The Wallace Collection, London. © Wallace Collection, London, UK/Bridgeman Images.

damask niche bed in the *Ruhezimmer*. The couple are depicted at leisure and in coordinating hunting costumes with their favorite dogs at their feet after a hunt. Elaborate silver rocailles that seem to spill from the *Spiegelsaal* frame the images that continue into the room with the added details of birds, nets, and putti.

Keyssler recounts seeing a similar portrait of the princess at Schleissheim Palace: "She goes on the hunts in men's green clothes with a little white wig."[27] He is again focused on the princess's unorthodox, masculine dress. Both portraits show the royal hunters with dogs who admiringly look up at their owners after placing the vanquished prey at their feet. Although the convention in royal portraiture was to depict the sitter with a stoic expression, the energy and excitement of the hounds acts as a surrogate for the couples' exuberance about hunting. As Martin Wallen notes, "sporting hounds could serve as agents sharing in humans' aesthetic joy."[28] The large black hound in Maria Amalia's portrait jumps up excitedly as a child would with their parents. It is happy with its accomplishments and eager to display the spoils of the hunt.

In France, the tradition of hunting dog portraiture was already well developed by the middle of the eighteenth century. Images of hounds without their owners often appeared in the most intimate rooms of a palace. In his examination of Louis XV's hunting dogs' portraits, Robert Rosenblum noted that "[they] have become players in an elegant theatrical tableau" and that some portraits do not include the "blood, fang, and claw … that we might almost forget that these creatures have their root in nature."[29] The same can be said of the intimate setting of the Amalienburg interior. Both the palace as a whole and its remarkable decorative dog cabinet create a tableau in which one might forget the animalistic nature of the twelve hunting dogs nestled within their rococo alcoves among painted fruits, flowers, and other fauna.

Bringing the Outside Inside

The *Hundezimmer* or cabinet of the hunting dog is a built environment that civilizes dogs by minimizing their animalistic nature and disciplining their bodies. The private cabinet of the hunting dog was an individualized space, expressly created for each of the elector and electress's hounds to retreat within and rest. Cabinets were always designed to encourage retreat, relaxation, and privacy, but the sense of intimacy created by each of the individual niches is remarkable. Not only is each of the twelve spaces decorated with a floral rocaille that evokes a more pleasant smell than that of wet dog but also the shell images echo a sense of closure and security from the untamed world.[30] When the luxurious yellow silk curtains of the daybed in the *Ruhezimmer* are pulled aside, the same patterns are revealed: silver vines, rocailles, and bird shapes cover the entirety of the interior walls, except for a central section where the goddess of the hunt, Diana, and her four-legged companions are depicted resting.

The intimacy of the *Hundezimmer* alcove is reverberated in its scale and location. Tucked away within the private spaces of the palace away from the formality of the *Spiegelsaal*, the hunting dog has an individualized space to rest and recover. The windows of the dog kennel overlook the gardens and offer a similar view to the naturalistic vignettes on the window shutters. This creates further continuity between

the manicured grounds outside and the interior occupied by imagery of birds and animals and the corporality of the dogs.

Indeed, the decorative space acts very much like the personalized bows and jewels visible on lapdogs including in portraits with their owners.[31] Within the dog cabinet, the hunting dog is not a working beast covered in mud and blood, but a pampered pet surrounded by fanciful ornamentations and basking in sensory pleasure. In her book on petkeeping in nineteenth-century Paris, Kathleen Kete noted the role of the interior as a means of control, a way of denying animals their natural instincts.[32] These interiors were fantasy spaces where pets were transformed into "living dolls" and considered part of the family. Just as the elite couple would retreat to the Amalienburg to pursue their own passion away from the restrictions and etiquette of court, the *Hundezimmer* provided rest and relaxation for their beloved hounds away from the dirt, grime, and mud of the gardens.

The dog boudoir was a part of Maria Amalia's masquerade as Diana, goddess of the hunt. In 1734, the same year as construction began, French architect Germain Boffrand (1667–1754) began promoting an approach to buildings that focused on "character," meaning that their structure and decoration should be viewed as a stage set.[33] The Amalienburg's architectural configuration with the *Fasangarten* and the visual program inside the building achieved harmony with its natural surroundings and mythological fable. The dog cabinet may be eccentric, but it is consistent with and contributes much to the visual language employed to assert the royal couple's exquisite breeding, taste, and superiority.

Notes

1 On the history of the lapdog as a symbol of aristocratic privilege and excess, see Jodi L. Wyett, "The Lap of Luxury: Lapdogs, Literature, and Social Meaning in the 'Long' Eighteenth," *Lit: Literature Interpretation Theory* 10, no. 4 (June 2008): 275–301.

2 Ed Lilley examines the emergence of the boudoir in the early eighteenth century. He argues that the term existed in 1730 despite not being found on extant plans from before the 1760s. The word is not found in the 1751 edition of d'Alembert and Diderot's *Encyclopédie*. Ed Lilley, "The Name of the Boudoir," *Journal of the Society of Architectural Historians* 53, no. 2 (June 1994): 193–8.

3 Nicole Reynolds, "Boudoir Stories: A Novel History of a Room and its Occupants," *Lit: Literature Interpretation Theory* 15, no. 2 (August 2010): 106.

4 Johann Georg Keyßler, *Neueste Reisen durch Deutschland, Böhmen, Ungarn, die Schweiz, Italien und Lothringen*, Theil 1 (Hannover, 1751), 57: "Dieser wird von seiner Gemahlinn sehr geliebet, und wenig von ihr allein gelassen. Sie speiset und spielet mit ihm, fährt mit ihm in die Marställe, schießt sehr gut nach der Scheibe und dem Wildprat, und geht öfters in Jagden bis an die Kniee im Moraste." Translations from German are my own unless otherwise indicated.

5 Amy Freund, "Good Dog! Jean-Baptiste Oudry and the Politics of Animal Painting," in *French Art of the Eighteenth Century: The Michael L. Rosenberg Lecture Series at the Dallas Museum of Art*, ed. Heather MacDonald (New Haven and London: Yale University Press, 2016), 67–79.

6 Cecilie Holberg, Gerhard Quaas, and Hans Ottomayer, *Hofjagd: aus den Sammlungen des Deutschen Historischen Museums* (Wolfratshausen: Edition Minerva, 2002).

7 In her examination of pleasure dairies, Meredith Martin notes that garden buildings, because of their vicinity to the edge of royal gardens and parks, gave architects and their clients freedom from "palace protocol and design restrictions" to "be more creative and experimental." See Meredith Martin, *Dairy Queens: The Politics of Pastoral Architecture from Catherine De' Medici to Marie Antoinette* (Cambridge: Harvard University Press, 2011), 7.

8 On elite women in the guise of Diana, see Kathleen Nicholson, "Beguiling Deception: Allegorical Portraiture in Eighteenth-Century France," in *French Art of the Eighteenth Century*, ed. Heather MacDonald (New Haven and London: Yale University Press, 2016), 25–37.

9 Michael Yonan notes how German rococo is an "exaggerated version of its French counterpart." Michael Yonan, "The Uncomfortable Frenchness of the German Rococo," in *Rococo Echo: Art, History and Historiography from Cochin to Coppola*, ed. Melissa Lee Hyde and Katie Scott (Oxford: Oxford University, 2014), 33–51.

10 Cecilie Holberg, Gerhard Quaas, and Hans Ottomayer, *Hofjagd: aus den Sammlungen des Deutschen Historischen Museums* (Wolfratshausen: Edition Minerva, 2002).

11 On the introduction of the pheasant to Western Europe, see Harro Strehlow, "Zoological Gardens of Western Europe," in *Zoo and Aquarium History: Ancient Animal Collections to Zoological Gardens*, ed. Vernon N. Kisling (Boca Raton: CRC Press, 2001), 75–116.

12 Referred to in the eighteenth century as the *Indianische Cabinet*.

13 Ulrika Kiby, "Die Küche der Amalienburg im Schlossgarten von Nymphenburg zu München," *Keramos* 108 (April 1985): 48. The author focuses on the kitchen adjacent to the *Hundezimmer* on the northern side of the palace. While visiting Munich in 1763, Nannerl, the sister of Wolfgang Amadeus Mozart, wrote that the princess cooked in the kitchen. Kiby argues that it was not a *Prunkkuche* (splendid kitchen), designed to be viewed not used.

14 Sarah Cohen, *The Enlightened Animal in Eighteenth-Century Art: Sensation, Matter and Knowledge* (London: Bloomsbury Press, 2021), 15. See also Sarah Cohen, "Animals as Heroes of the Hunt," in *Sporting Cultures, 1650–1850*, ed. Daniel O'Quinn and Alexis Tadié (Toronto: University of Toronto Press, 2018), 120. Thanks to Sarah Cohen for sharing information on dog spaces.

15 Johann Georg Keyßler, *Neueste Reisen durch Deutschland*, S. 57: "Bey der Tafel stehen eine gute Menge derselben um die Churfürstinn …."

16 Ibid., S. 57–62: "Bey des Churfürsten Bette ist eine Loge für einen Hund, und dergleichen für zwölf andere in dem nächst anstoßenden schönen Schreibsaale."

17 On Moretti's painting in the Amalienburg that imitates Elias Baeck, see Friederike Ulrichs, "Von Nieuhof bus Engelbracht: Das Bild Chinas in süddeutschen Vorlagenstichen und ihre Verwendung in Kunsthandwerk," in *Die Wittelsbacher und das Reich der Mitte. 400 Jahre China und Bayern*, ed. Renate Eikelmann (München: Hirmer Verlag), 292–302. For a discussion on the role of engravings as a source of porcelain decoration, see Maureen Cassidy-Geiger, "Graphic Sources for Meissen Porcelain: Origins of the Print Collection in the Meissen Archives," *Metropolitan Museum Journal* 31 (1996): 99–126.

18 The same tile exporters were used for Carl Albrecht's brother's hunting lodge, Schloss Falkenlust, in Brühl. See Wilfried Hansmann, *Schloss Falkenlust in Brühl* (Worms: Wernersche Verlagsgesellschaft, 2001), 86–8.

19 For a discussion and detailed analysis of the hunting gun in French society, see Amy Freund, "Men and Hunting Guns in Eighteenth-Century France," in *Materializing Gender in Eighteenth-Century Europe*, ed. Jennifer G. Germann and Heidi Stobel (Burlington, VT: Ashgate, 2016), 17–33.

20 Sarah Cohen, "Animals as Heroes of the Hunt," in *Sporting Cultures, 1650–1850*, ed. Daniel O'Quinn and Alexis Tadié (Toronto: University of Toronto Press, 2018), 127.

21 Katie Scott, *The Rococo Interior: Decoration and Social Spaces in Early Eighteenth-Century Paris* (New Haven: Yale University Press, 1995), 134.

22 Yi-Fu Tuan, *Dominance and Affection: The Making of Pets* (New Haven and London: Yale University Press, 1984), 107.

23 For a discussion on animal portraits, see Cohen, *The Enlightened Animal in Eighteenth-Century Art*.

24 Nadir Weber, "Liminal Moments: Royal Hunts and Animal Lives in and around Seventeenth-Century Paris," in *Animal History in the Modern City: Exploring Liminality*, ed. C. Wischermann, A. Steinbrecher, and P. Howell (London: Bloomsbury Academic, 2018), 42.

25 Sarah Cohen also makes this observation about Jean-Baptiste Oudry's drawings of animal heads. Cohen, "Animals as Heroes of the Hunt," 127.

26 Nathaniel Wolloch, "Rousseau and the Love of Animals," *Philosophy and Literature* 32, no. 2 (October 2008): 294–5.

27 Keyßler, *Neueste Reisen durch Deutschland*, S. 57: Auf den Jagden geht sie in grüner Mannskleidung mit einer kleinen weißen Perrücke.

28 Martin Wallen, "Well-Bred is Well-Behaved: The Creation and Meaning of Dog Breeds," in *Dog's Best Friend?: Rethinking Canid-Human Relations*, ed. John Sorenson and Atsuko Matsuoka (Montreal: McGill-Queen's University Press, 2019), 67.

29 Robert Rosenblum, "From the Royal Hunt to the Taxidermist: A Dog's History of Modern Art," in *Best in Show: The Dog in Art from the Renaissance to Today* (Houston: Houston Museum of Fine Arts, 2006), 42.

30 See Mimi Hellman's discussion of floral motifs in Madame de Pompadour's bedchamber: Mimi Hellman, "Staging Retreat: Designs for Bathing in Eighteenth-Century France," in *Interiors and Interiority*, ed. Ewa Lajer-Burcharth and Beate Söntgen (Berlin: De Gruyter, 2016), 64.

31 Joanna M. Gohmann, "The Four-Legged Sitter: A Note on the Significance of the Dog in Jean-Marc Nattier's La Marquise D'Argenson," *Journal of the Walters Art Museum* 73 (2018): 99.

32 Kathleen Kete, *The Beast in the Boudoir: Petkeeping in Nineteenth-Century Paris* (Berkeley: University of California Press, 1994), 85. The author also notes that books on petkeeping gave instructions about making them "quasi-human."

33 Katie Scott, "The Interior Politics of Mme De Pompadour," *Art History* 28, no. 2 (April 2005): 269.

Bibliography

Kete, Kathleen. *The Beast in the Boudoir: Petkeeping in Nineteenth-Century Paris*. Berkeley: University of California Press, 1994.

Keyßler, Johann Georg. *Neueste Reisen durch Deutschland, Böhmen, Ungarn, die Schweiz, Italien und Lothringen*. Theil 1. Hannover, 1751.

Rosenblum, Robert. "From the Royal Hunt to the Taxidermist: A Dog's History of Modern Art." In *Best in Show: The Dog in Art from the Renaissance to Today*, edited by Edgar Peters, Carolyn Rose Rebbert, Robert Rosenblum, and William Secord, 39–99. New Haven and London: Yale University Press, 2006.

Scott, Katie. *The Rococo Interior: Decoration and Social Spaces in Early Eighteenth-Century Paris*. New Haven and London: Yale University Press, 1995.

Tuan, Yi-Fu. *Dominance and Affection: The Making of Pets*. New Haven and London: Yale University Press, 1984.

Wallen, Martin. "Well-Bred is Well-Behaved: The Creation and Meaning of Dog Breeds." In *Dog's Best Friend?: Rethinking Canid-Human Relations*, edited by John Sorenson and Atsuko Matsuoka, 59–83. Montreal-Quebec: McGill-Queen's University Press, 2019.

Weber, Nadir. "Liminal Moments: Royal Hunts and Animal Lives in and around Seventeenth-Century Paris." In *Animal History in the Modern City: Exploring Liminality*, edited by Clemens Wischermann, Aline Steinbrecher, and Philip Howell, 41–54. London: Bloomsbury Academic, 2018.

Material Temptations: Isabel de Farnesio and the Politics of the Bedroom

Tara Zanardi

In Fray Matías de Irala's engraving of the queen of Spain (Figure 4.1), Isabel de Farnesio wields a musket. The queen commands attention with her erect form, stern facial expression, and elegant hunting attire. At right, the long end of her weapon points toward a landscape where the hunt is taking place. Below Isabel's feet are three dead animals—the fruits of Isabel's successful hunting expedition. At left, framed by a curtain, is an opulent interior with a table elaborately carved with garlands, rocailles, and claw feet that provides support for a portrait of Philip V (r. 1700–46) in armor. Isabel rests her right hand on a hat and a pair of gloves to indicate she has just removed these items and entered the space. A violin, a palette with brushes, various artist's tools, and treatises by Francisco Pachecho and Vicente Carducho, suggest the queen's artistic erudition.[1] The ornate cartouche below complements the scrolls and leafy design of the table. It includes an inscription that reads, "The Queen of Spain, Doña Isabel de Farnesio, Princess of Parma born on October 25, 1692 and married to Philip V, King of Spain September 16, 1714." Flying above Isabel are two putti who bring forth the crown, sealing her sovereign identity as queen of Spain.

While the engraving participates in a long tradition of monarchical portraiture of Spanish royals at the hunt, Irala's representation is strikingly different from standard court imagery. Irala positions Isabel in the center of the print with an authoritative stance, grasping her musket in a believable manner. As an image that helped to set the tenor of her reign, Irala's print portrays the queen as tenacious, highly educated, poised for leadership, and active in the shaping of her royal identity—a sovereign ready to rule with or without the king, but always tethered to him. From the moment she assumed the crown, Isabel was a tactician at court in the realms of collecting, interior design, and politics, despite her ineligibility to rule alone. Once a male heir was secured from Philip V's first wife, Maria Luisa of Savoy, the king imposed Salic Law of Succession in Spain, imported from France along with the Bourbon dynasty. Dating to France's Frankish period, this law prevented women from exclusive rule, granting only male heirs the crown. After Maria Luisa died, and considering Philip V's depression, the court quickly sought out a new bride. It set its sights on Isabel (Elisabetta Farnese) from Parma, a politically astute match to strengthen Spain's ties to this formidable

Figure 4.1 Fray Matías de Irala, *Queen Isabel de Farnesio in Hunting Dress*, 1715, engraving by Diego de Cosá. Museo de Historia, Madrid. © Photo: Album/Art Resource, NY.

Italian family and region. Such a connection was especially important for Spain in 1714, a date marking the end of the War of the Spanish Succession in which the French Bourbons triumphed over the Holy Roman Empire and its allies, but lost many of its Italian territories. Thus, the beginning of Isabel's reign transpired at a pivotal moment in Spanish history.

To buttress the young queen's power at this historic juncture, Irala includes a portrait of Philip V. Both king and queen don the same wig and look outward with

equally austere gazes, but more compelling is the artist's depiction of their nearly identical faces. As Pablo Vázquez Gestal argues, Irala's portrait "remade feminine portraiture models of courtly iconography … to offer an image" of the queen "charged with significant political connotations. Isabel is shown … as a competent masculine hunter." To solidify her sovereignty and the king's support, Philip and Isabel are "made to look like the perfect mirror in which figured two faces of majesty. Erect and firm, Isabel appears to insinuate her intentions of assuming without any vacillation."[2] Philip and Isabel are made one and the same, but it is she who brandishes the weapon. While Philip's presence provides the necessary political decorum, Isabel is the monarch represented in action and surrounded by her interests—the arts, the hunt, and modern design. The mirror-like effect positions her center stage, a foreshadowing of her rule on behalf of the king.

Such a masculinized image of the queen in a print that widely circulated in the early years of her queenship anticipated the dominance she exerted at court as partner to the king, often ruling in his stead. While some regarded Isabel's intelligence and ambitions in a positive light, others vilified her, considering her "interference" in political discussions unsuitable for a woman. Adopting the part of supreme monarch when Philip was too ill to govern, Isabel appropriated a masculinized self when it served her needs. Such political discussions typically happened in suites of rooms shared by the royal couple in the palaces in which they resided. These semi-private spaces offered a stage for the sovereigns or the queen herself to conduct the government's affairs. Taking on such an imposing persona proved useful for Isabel in developing her agenda in politics: Isabel limited access to the king and arranged a mutual schedule, including hunting excursions, small social gatherings, and daily consultations with the three governing ministers in interiors the couple occupied, so that they would rarely be separated. Such maneuvering allowed for greater privacy between the royal family and their trusted network, and more importantly granted Isabel decision-making powers in spaces she dominated or shared with Philip.

This essay focuses on one specific room, the monarch's bedroom (Figure 4.2) designed by Filippo Juvarra in 1735–6 and located at the palace of San Ildefonso de La Granja (Figure 4.3). The interior—both imagined, as in Irala's print, and real, as in the couple's bedroom—became an essential site for molding her queenly identity and an opportunity to perform her authority, whether next to the king or on his behalf. La Granja was the favored setting for the display of her vast collection of art, books, and prized heirlooms. Here, she demonstrated her passion for designing interiors according to modern taste. Isabel was actively involved in the planning of the palace's rooms, including their configuration and style and the myriad objects exhibited within them. Fluent in German, French, and Italian[3] and familiar with "art" history, Isabel could talk intelligently about art and architecture with those she employed and entertained.[4] Her desire to honor her heritage through patronage and showcase contemporary Italian art and classicizing motifs relates to her political initiatives to regain the Italian territories Spain lost during the War of the Spanish Succession, laud her husband's achievements on the battlefield and in diplomatic matters, and place her children in well-appointed positions in Italian and other European courts.

Figure 4.2 Filippo Juvarra, Bedroom for Philip V and Isabel de Farnesio, Royal Palace, San Ildefonso de La Granja, 1735–6, Segovia, Spain. © Patrimonio Nacional. Photo: Patrimonio Nacional.

Within the context of Isabel's artistic and political ambitions, I consider the bedroom in two interrelated ways. Firstly, I examine it as a closely guarded space that typified the royal couple's shared experiences in politics and domestic life. Primarily built for the private enjoyment of the monarchs as a place to sleep, socialize, and reflect, the bedroom also served as the main meeting chamber between the royals and their ministers to strategize policy. As such, the bedroom took on overt political overtones as a space to impress through its dazzling material display, albeit in less bombastic fashion than customary council chambers. As the backdrop for courtly diplomacy, the bedroom commanded attention despite its small scale. Neatly organized into a modern composition in which individual materials shine and, simultaneously, complement one another to form a unified whole, the room evoked imperialist grandeur and championed Italian art.

Secondly, I interrogate the concept of surface and the dialogues created among the varied material parts as central to room's aesthetics and political importance. Despite the obvious material differences among the silk damask, lacquer panels, and oil paintings, these components produce an agreeable rhythm of alternating patterns, textures, and sheen effects. The paintings and the lacquer panels share a color palette, with bold reds, blacks, blues, and greens, while the gilded wood accentuates the yellows and golds in both objects. The gilt frames unify the disparate materials set against the blue walls. The two main media, Chinese Coromandel lacquer and Italian oil paintings, originate in distinct geographical locations. Placed together in the same interior, they pair Chinese and Italian artistic traditions. Thus, I address the relationships and meanings garnered

Figure 4.3 Teodoro Ardemans, Andrea Procaccini, Filippo Juvarra, and Giovanni Battista Sacchetti, Royal Palace, San Ildefonso de La Granja, 1721–40, Segovia, Spain. © Photo: Album/Art Resource, NY.

from their proximity fashioned into an ensemble meant to project monarchical power, stability, and permanence. Deployed in the room, the objects' unique qualities play to Isabel's strength as collector of diverse objects, patron of modern design, and astute politician.

Such harmonious amalgamations in which distinct components were juxtaposed in order to engender material dialogues were common to interiors in the first half of the eighteenth century, like the fashionable design modes of the rococo and chinoiserie. The rococo was highly imaginative in its playfulness of design and material richness. Because of the rococo's fluidity, it was adaptable to the interior in which diverse materials could be manipulated in original ways. It was the first self-consciously modern style.[5] The rococo's malleability, materiality, and innovation would have appealed to Isabel as a novel manner to represent her eclectic taste and political aspirations. That chinoiserie was often used as a visual strategy for rococo interiors and was "also perceived to be cosmopolitan and progressive" would have made it doubly attractive for Isabel who enthusiastically collected East Asian and Asian-inspired objects for innovative displays.[6]

The queen's calculated approach to collecting and her insistence on modern spaces are central tenets of La Granja's artistic program. La Granja exemplifies Isabel's patronage, including the employment of an international cadre of artists and

architects. That Isabel and Philip lived and worked together in some of these spaces was unprecedented according to Spanish customary court decorum and purposeful so that the queen could participate in all political discussions and maintain proximity to the king. As Charles Noel suggests, Philip V and Isabel "lived and worked informally, with business brought into the most intimate spaces."[7] The bedroom's emphasis on informality and intimacy suggest a rupture in the traditional organization of palatial spaces; here, the bedroom offered a semi-public space that was multifunctional, serving both as a site of respite and governance. The bedroom was employed as a space of influence, particularly for Isabel.

In order to evaluate the bedroom as a site of political negotiation, sociability, and surface splendor, I look to multiple sources as points of departure. Recent scholarship has begun to investigate the eighteenth-century interior from various methodological perspectives, but little of it has been dedicated to Spanish examples. My aim is to foreground this bedroom as a model in the royal interior's gradual shift toward increased privacy and domestication; such provisions allowed Isabel as a female sovereign within the Bourbon system to wield power.

Architects accommodated this domestic innovation in the design of the couple's chambers located in the southwest part of the garden façade of La Granja (Figure 4.4). Constructed *en enfilade*, the apartments include several antechambers, the Queen's Dressing Room—a large room decorated in red lacquer at the very end of the quarters, hence the most hidden, a private staircase, and the couple's bedroom located next to the Queen's Dressing Room. Considering its location was inaccessible to most, the bedroom offers a glimpse into the private lives of the monarchs and a backdrop for political theater.

Figure 4.4 Plan, Royal Palace, San Ildefonso de La Granja, Segovia, Spain. © Patrimonio Nacional. Photo: Patrimonio Nacional.

The bedroom (Figure 4.5), situated as the penultimate space in the shared suite of rooms, features twelve black lacquered pilasters encased in gilt frames with volutes, floral garlands, and masks; irregularly shaped black and red lacquer panels also framed by gilt wood; polychrome marble wainscoting, blue silk damask, four large paintings by Giovanni Paolo Panini, and two overdoor paintings by Andrea Locatelli, all of sacred themes. The original design included a large mirror placed opposite the room's sole window. The couple's bed was placed in front of the mirror to maximize the garden view complemented by other furniture. In the mid-1700s a lacquer panel replaced the mirror.[8] Prior to a 1918 palace fire, Bartolomeo Rusca's *Diana and Endymion* graced the ceiling. Light entered the bedroom from the window during the day. At night, candles illuminated the interior, enhancing the varnished surfaces of the lacquer and oil paintings. Portable treasures, such as lacquer and porcelain, would have adorned the space. From floor to ceiling, the room inundated visitors with visual spectacle and engulfed them in material glory.

By utilizing luxury materials, such as lacquer, porcelain, marble, and damask, traditionally associated with elite interiors, such as small cabinets or grand reception spaces, and combining them with contemporary religious paintings, Juvarra and Isabel reimagined the customary lacquer room as a sumptuous and intimate bedroom, allowing for pleasurable experience, pious reflection, and political discourse at once. No single element dominates the space; rather, it is Juvarra who produced the modernity of the interior by his judicious arrangement of these complementary materials.

The bedroom was overtly political in its purpose to coincide with Philip's new system of governance that emphasized informality and intimacy at its core (see below).

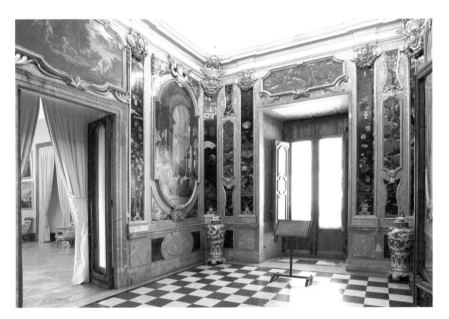

Figure 4.5 Filippo Juvarra, Bedroom for Philip V and Isabel de Farnesio, Royal Palace, San Ildefonso de La Granja, 1735–6, Segovia, Spain. © Patrimonio Nacional. Photo: Patrimonio Nacional.

The couple's apartments had limited access for members of court and visitors alike. As part of these chambers, the bedroom was thus a highly regulated space. There, the monarchs conducted political negotiations, demonstrated their personal devotions, and exemplified a more relaxed courtly protocol, far from the French Bourbon model, but closer to Italian and some Habsburg practices.[9] In his discussion of Schönbrunn Palace outside of Vienna, Michael Yonan states that, since the 1600s, Habsburg tradition dictated that the emperor and empress inhabit separate quarters, which would be conjoined by a shared bedroom.[10] Like the shared bedroom at La Granja, the Austrian example under Franz I (d. 1765) and Maria Theresa held multiple functions: "it served as a private dining room, lounge, and conference space," and "remained inaccessible to most visitors."[11] The Austrian shared bedroom makes for an instructive comparison to the one occupied by Philip V and Isabel thirty years earlier.

The assertion of familial privacy and acts of religious sentiment within the bedroom and other spaces of their quarters recalled La Granja's monastic heritage and modest beginnings, while simultaneously embracing an innovative courtly model that encouraged a new form of sociability and the monarchs' solidarity. The bedroom's design "narrates" a story of monarchical strength and partnership: the room references Spain's empire, which facilitated the royal acquisition of East Asian luxuries, such as lacquer, and the architectural tradition of employing these goods in elite spaces. Through the ensemble, Philip V and Isabel, neither of whom was Spanish born, assume this imperial legacy with its significant political implications.

Situated outside Segovia, northwest of Madrid, the palace of San Ildefonso de La Granja began as a humble residence on the farm and chapel belonging to Hieronymite monks. After purchasing the land, Philip V commissioned his Master of Royal Works, Teodoro Ardemans, in 1720 to build a secluded retreat.[12] Conceived initially as the location of the king's retirement after his abdication in 1724, the modest structure would have housed the royal family. Philip V had suffered from depression throughout his adulthood and desired a life free from court responsibilities, including daily consultations with his governing ministers. Luis I, his son from the marriage to his first wife, assumed the throne, but died seven months later, forcing Philip V out of retirement.

Once Philip V and Isabel were thrust back into the political limelight, La Granja took on a decidedly robust role as a fundamental site for displaying the monarchs' restored power. No longer a sanctuary for reflection, La Granja transformed into a modern stage for the couple's political aims and for Isabel's design ambitions. Ardemans' sober plans were cast out, and Isabel, reinvigorated, hired a new team, including Andrea Procaccini,[13] Sempronio Subissati, Domingo Maria Sani, Filippo Juvarra, Giovanni Battista Sacchetti, René Carlier,[14] and Étienne Boutelou.[15] These figures amplified the original plans with elegant façades, majestic gardens, and luxurious interiors. In contrast to the Habsburg palaces the sovereigns occupied and redecorated throughout Spain, La Granja stood out as a modern residence.

Isabel's decision to renovate the palace plans not only had political implications but also artistic ones. La Granja was the main location she displayed her collections, including Old Master and contemporary paintings; Chinese and Japanese porcelain; Queen Christina of Sweden's antique Roman sculptures;[16] jewel-encrusted glassware;

East Asian and European fans; and East Asian and European lacquerware.[17] Isabel inherited many of these objects from Habsburg, French Bourbon,[18] Neuburg, and Farnese collections.[19] As Teresa Lavalle-Cobo suggests, Isabel's "Farnese" heritage made her acutely aware that art had the power to amplify the prestige of family dynasties.[20] As she states, "Isabel proposed to house the majority of her collection in the new palace as a statement of her refined and cultured taste."[21] Combined with objects the queen actively acquired once in Spain, being the first monarch to collect paintings by Bartolomé Esteban Murillo, Isabel's collection proved she was strategic in the works she obtained.[22] Isabel was equally possessive of her treasures by branding them with the Farnese fleur-de-lis. Inventory records indicate that Isabel's collection was archived separately from the king's ensuring that her inheritance and acquisitions were not merely subsumed into Philip's.[23]

Although the monarchs' collections were recorded separately, their spaces of governance where such objects were displayed were shared. This conception of unofficial joint leadership was, in many respects, unique. Under Habsburg rule in Spain, the court's grandees and council members enjoyed substantial power and easy access to the king. In the early years of Philip V's reign, in part to maintain a sense of dynasty continuity, the king followed this custom, convening with the courtiers in the council's chambers in the Habsburg palaces. But Philip V disliked this arrangement. With his depression sometimes lasting months at a time, the king preferred solitude over these large gatherings, which motivated him to relocate these meetings to his private chambers and limit the number of visitors. Vázquez Gestal argues that Philip V "transformed the practice of Spanish monarchical identity with the idea of adapting it to his own needs, diminishing and amalgamating the dictates of tradition," a process that entailed the reorganization of the court, its rules, and ceremonies.[24] In 1717, Philip enacted a royal decree abolishing the Habsburg system in which power resided with many of the esteemed families who held important posts in the council and replacing it with a centralized government in which authority rested with three ministers— War and the Navy; State; and Justice and Finance. These ministers possessed the only direct contact with the king. At La Granja, the meetings were held in the joint royal apartments, including the bedroom, cutting off courtiers, who had previously exerted great influence, from the monarchs. Henry Kamen views the 1717 decree as the catalyst for a fundamental transformation at court that fashioned a modern style of governing.[25] This new mode of ruling emphasized informality and privacy, offering respite from courtly protocol. The practice was continued by subsequent Spanish sovereigns, such as Charles III (r. 1759–88), who met with his ministers in his semi-private studies.

At all their palaces Isabel governed by Philip V's side, with the ministers arriving to their bedroom once they completed morning prayers; thus the model first established in the former Habsburg palaces before La Granja was near completion was then replicated and amplified at their new residence.[26] This domestication of politics positioned their bedroom as the center of the couple's authority and alliance as they moved from one royal seat to the other during the year. By holding their meetings away from the public spaces of the palaces, they controlled who could visit, including family, governing ministers, and emissaries. Separating themselves physically and limiting

access in these intimate spaces were powerful tools in the reshaping of politics and court life. In turn, the objects exhibited in the couple's shared quarters (and throughout the palace) testified to Isabel's reputation as a collector and exalted her public image as queen.[27]

As Catholic monarchs at the helm of the Spanish Empire, Philip and Isabel also needed a space to pray. Thus, the bedroom witnessed devotional acts by the monarchs who preferred the privacy of their shared bedroom to public displays of piety (in part out of necessity because of Philip's condition). Unlike her predecessors, Isabel chose not to partake in established public religious ceremonies and rejected the custom of visiting convents and monasteries. Instead, the monarchs prayed and read orations together in their bedroom, further privatizing their partnership and domestic life.[28] To underscore the pious nature of such acts, Juvarra commissioned Panini and Locatelli to paint sacred subjects.[29] Locatelli's overdoor paintings, *Jesus and the Samaritan Woman* and *Jesus in the Desert*, feature a pastoral style ideal for such contemplation. They depict stories with essential Christian themes, including reflection, patience, faith, and kindness.

Distinct from these idyllic scenes that facilitate meditation, Panini composed grand illusionistic images, each with its own architectural settings, such as coffered ceilings, barrel vaults, and Solomonic columns (Figure 4.6). Located in the main section of the walls, their theatricality complemented the political performance taking place on the interior "stage," providing important moral instruction. Set within irregularly shaped gilt frames with rocailles, these paintings feature dramatic compositions with massive vaulting, elongated columns, and heroic bodies in action. While two of the paintings depict violent subjects, *The Expulsion of the Merchants from the Temple* and *Jesus Stoned in the Temple*, the other two illustrate Jesus as teacher and healer, *Jesus and the Miracle of the Paralytic* and *Jesus Among the Doctors in the Temple*, appropriate themes for a room in which the king and queen offered their council and negotiated policy. Panini's paintings highlight the many roles of Jesus, from miracle worker to teacher. These crucial roles parallel the many duties of the monarchs and lend sacred authority to the Catholic sovereigns in their bedroom.

For the bedroom to fulfill these multiple roles, the design had to embody powerful messages of the monarchs' prestige and legitimacy. Looking to her Italian roots, in 1735 Isabel successfully petitioned to bring Juvarra, a celebrated Sicilian architect and set designer, to Spain. As chief architect in Turin under Vittorio Amedeo II and Carlo Emmanuelle III for the enormous building programs they promoted, Juvarra had constructed palaces and churches.[30] In 1732 while attending an auction in Rome, Juvarra viewed some East Asian lacquer and recommended that this lacquer, combined with porcelain and other media, would make for a delightful interior.[31] For the Chinese Room in Turin's Royal Palace, he employed black lacquer, four large mirrors in irregular frames, and gilt carving, complemented by Claudio Francesco Beaumont's *Judgement of Paris* on the ceiling (1737). The combination of lacquer and painting serves as an important precedent for his work in Spain.

In the bedroom at La Granja, Juvarra employed a similar combination of media, including the destroyed ceiling depicting Diana and Endymion, an amorous subject appropriate for the bedroom. The paintings by Locatelli and Panini occupy a significant

Figure 4.6 Giovanni Paolo Panini, *Jesus Stoned in the Temple, c.* 1736–7, Bedroom for Philip V and Isabel de Farnesio, Royal Palace, San Ildefonso de La Granja, Segovia, Spain. © Photo: DeA Picture Library/Art Resource, NY.

portion of the main walls. Juvarra designed an alternating pattern of oil paintings and lacquer against the damask (Figure 4.7). This repeating design would have encouraged a material and visual *paragone*. Variations in materials, subject matter, and surface effects would have elicited exciting comparisons between Chinese and Italian artistic traditions.

While the monarchs would have appreciated the paintings' Catholic symbolism and scenographic arrangements, the lacquer employed on the walls would have afforded them a different kind of sensorial delight. Juvarra used primarily Coromandel lacquer, known as *kuancai*, a Chinese lacquer technique in which patterns are carved out of a smooth lacquer surface, revealing the neutral ground coating that is then colored with oil or lacquer pigments.[32] This lacquer technique emerged in the sixteenth century and was first aimed at a domestic market, generally used for large screens. When exported, Coromandel lacquer was either kept in its original screen format or appropriated to furniture and walls so that only one side of the panels was exposed, highlighting the intricate and grooved surface as central to its design function. That is, the screens would be reformatted as parts of desks or bureaus, or as flat wall panels as is the case in Juvarra's La Granja bedroom. Thus, the wall panels would be fashioned from preexisting

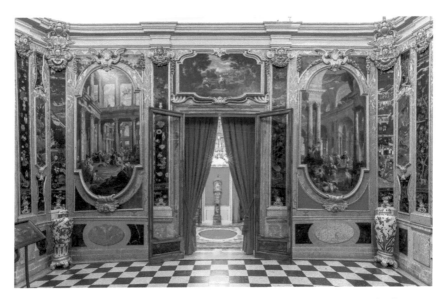

Figure 4.7 Filippo Juvarra, Bedroom for Philip V and Isabel de Farnesio, Royal Palace, San Ildefonso de La Granja, 1735–6, Segovia, Spain. © Patrimonio Nacional. Photo: Patrimonio Nacional.

Chinese screens to create a wholly European invention. With the disassembly of the screens' original sequence, the panels were embedded in a novel design.

The panels at La Granja, many of which have been identified as originating in the same seventeenth-century Coromandel screen, feature birds, flowers, figures, seals, fans, and more (Figure 4.8).[33] Placed in gilt frames of various sizes and shapes and set against the same blue damask as the paintings, the panels are adapted to a new composition. Valued for their "exotic" motifs and their surface variations, the panels were transformed to accommodate this interior's multiple functions. Although the monarchs might not have understood the symbolism of the Chinese motifs, they would have appreciated the lacquer's colors and shimmer. Because Juvarra used Coromandel lacquer, the different layers exposed a sense of depth, offering visual delight, especially as light bounced off the flat sections and ridges.

In the eighteenth century, it was fashionable to employ panels from lacquered screens as wall treatments. Earlier rooms often cannibalized lacquer furniture to make displays, but in the late 1600s and throughout the 1700s, designers used the panels from screens to cover whole walls. At Schönbrunn Palace Maria Theresa redesigned much of the interior after Franz died in 1765 in part to facilitate her full participation in government. She also had a special affinity for lacquer, including a sizable collection of lacquer boxes. As part of her reconstruction of the palace, she had Franz's former office transformed into the Vieux-Laque Zimmer (Figure 4.9). Like the bedroom at La Granja, this room held multiple functions, most importantly, as a reception space before meeting the empress. This spectacular interior includes Chinese black lacquer (not Coromandel) fitted into rococo gilt frames and three large paintings of her family.

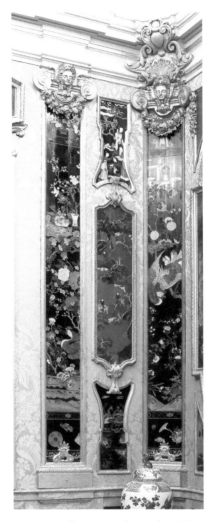

Figure 4.8 Filippo Juvarra, Detail of lacquer, Bedroom for Philip V and Isabel de Farnesio, San Ildefonso de La Granja, 1735–6, Segovia, Spain. Copyright © Patrimonio Nacional. Photo: Patrimonio Nacional.

Interspersing these portraits among lacquer panels created a unified program that combines Eastern and Western objects, similar to the Spanish bedroom completed thirty years earlier.[34]

Yonan considers this juxtaposition of objects in the Vieux-Laque Zimmer in a specific Austrian context; that is, how a chinoiserie interior made in mid-eighteenth-century Austria differed from its counterparts in Western Europe. He promotes the existence of multiple chinoiseries, not one unified standard, and rather than viewing the Chinese lacquer panels as mere backdrop for the oil paintings, Yonan reads them as

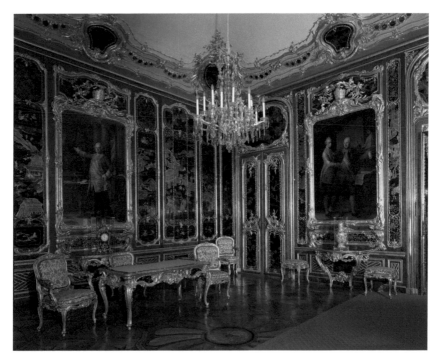

Figure 4.9 Vieux-Laque Zimmer, Schönbrunn Palace, Vienna, Austria, *c.* 1765–72.
© Photo: Erich Lessing/Art Resource, NY.

essential. The overall design works together to convey decorative pleasure, imperialist connotations, and powerful messages about familial lineage that buttressed Maria Theresa's position as empress.[35]

In Spain, imperialist imagery was grounded in history. Spain began its colonial expansion in the fifteenth century, establishing territories in the Americas and the Philippines. Once Spaniards designated Manila its commercial hub in Asia, galleon ships connected Spain's empire as they transported silver, lacquer, porcelain, and other goods between Manila and Acapulco, complemented by land and sea routes throughout South America, Mexico, the Caribbean, and Spain. By the early eighteenth century, Spain's empire had experienced various vicissitudes, but held historic weight for the new ruling dynasty.

At La Granja, Isabel did not choose lacquer merely for its fashionability. Lacquer connected Isabel and Philip to their families' collections (Farnese and French Bourbon) and to the Habsburg's coffers. While the Bourbon court was stationed in Andalusia (1729–33), Isabel purchased and commissioned lacquer in Cádiz—thus the lacquer employed in her interiors came from multiple sources but were conjoined under her direction.[36] The Habsburgs had been avid collectors of East Asian goods. Philip II (1556–98) had a penchant for porcelain, obtaining over 3,000 pieces during his reign. His inventories indicate lacquerware, including two suits of Japanese armor, brought to

Madrid during the embassy of 1585.[37] During her tenure, Isabel employed lacquer from the Habsburg collection, including lacquer screens formerly in Charles II's collection for her Madrid rooms.[38] By utilizing the former dynasty's lacquer (among other objects) into Spanish Bourbon rooms, Isabel appropriated these Habsburg items in new spaces according to current design modes. In many respects, such appropriation serves as a form of double conquering—that is, the Bourbons over the Habsburgs (especially after the War of the Spanish Succession ended in 1714) and Spain over its competitors for colonial territories. Considering the many changes Philip V enacted in Spain, utilizing Habsburg objects in Bourbon spaces legitimized the monarch's rightful authority.

The lacquer panels at La Granja link the monarchs to Spain's empire and dynastic past and provide a material means to sanction their rule, notions especially significant for Isabel who could not govern alone because of Salic Law and for the first Bourbon king whose modifications at court were disliked by the once powerful courtiers whose influence carried great weight during the Habsburg dynasty. As the inheritors of Spain's colonial legacy, the sovereigns put these decorative and imperial connections on display in the site in which political discourse transpired. Reconfigured to accommodate modern design and paired with European paintings, the lacquer panels can be seen in novel ways specific to Philip and Isabel.

The appropriation of lacquer to a European interior was typical for chinoiserie designs, but it was uncommon to arrange Chinese goods with religious paintings. Isabel's employment of chinoiserie in a room in which she performed devotional, sociable, and political acts was tactical, to buttress her partnership with Philip V. As Meredith Martin proposes, the interior was a key site for the cultivation of elite identity, an idea Isabel utilized for her own promotion, particularly in a room in which she governed.[39] Thus, the juxtaposition of East and West, as it was understood in the 1700s, and secular and sacred, was appropriate to the room's embodiment of its many functions and a testament to Isabel's eclectic collection.

That lacquer provided an integral component in this interior as well others she commissioned, including rooms in Madrid's old Royal Palace (burned to the ground in 1734), suggests that Isabel had a particular affinity for this material and its versatility. Her 1746 inventory lists various objects, such as writing desks, partitions, and trays, and points to the astounding quantity of lacquer she possessed.[40] Isabel's fondness for lacquer placed her in line with other groundbreaking female patrons, such as Amalia von Solms (1602–75) and Mary II (r. 1689–94).[41] These elite women ushered in new ways to incorporate luxury materials into interiors to showcase their taste, status, and wealth. Isabel may have looked to early modern examples, such as these and others, but she also championed new modes for exhibiting objects and designing interiors.

At La Granja, Spanish lacquer artisans polished and restored Chinese lacquer and manufactured imitation lacquer. For the bedroom, master lacquer artisan Antonio Hurtado prepared the Chinese screens for placement in the room. Because there was not enough in the queen's possession and new shipments of lacquer were sometimes difficult to acquire, he also composed the remaining panels according to Juvarra's design (Figure 4.10). He looked to guides, such as Bernardo Montón's treatise, *Secretos de artes liberales y mécanicas* (Madrid, 1734), for the best methods for cleaning lacquer and making varnish.[42] Montón's treatise offers recipes to heighten surface effects;

Figure 4.10 Antonio Hurtado, Spanish red lacquer panel, Bedroom for Philip V and Isabel de Farnesio, Royal Palace, San Ildefonso de La Granja, 1735–6, Segovia, Spain. © Patrimonio Nacional. Photo: Patrimonio Nacional.

from distinct color applications to gilding materials, an object's luster was key. He repeatedly uses the words "*pulir*" (to polish) and "*barnizar*" (to varnish), emphasizing the importance of obtaining the correct gleam or glint, which would be crucial in generating the necessary opulence in the surfaces of porcelain, gold, and lacquer. Indeed, it is their surface that affords them their primary appeal, whether glittery, reflective, matte, or translucent.

In the case of Coromandel lacquer, like those used at La Granja, surface is far more complicated since it is not a flat like other forms of lacquerware. In

considering the issue of surface, I want to problematize the dichotomy in assessing the oil paintings and lacquer panels in terms of surface and depth. Panini's canvases promote an illusionistic mode of looking and give the impression of a larger room by amplifying its space with optical trickery, a different form of visual play than the reflective shimmer and ridged grooves of the lacquer. Panini's and, to a lesser extent, Locatelli's illusionism produced through perspectival techniques is deceptive since the paintings are flat with varnished surfaces that fool the eye into perceiving grand vistas. The Coromandel lacquer panels, however, may seem surface rich only with an emphasis on patterning and flatness; up close, however, they show their surface complexity—the grooves and ridges penetrate the surface so that the images are created through elaborate carving and painting. The comparisons between these distinct surfaces also point to distinct tactile experiences, from the slick smoothness of the paintings in contrast to the hard-edged painted incisions of the lacquer panels. Thus, both sight and touch are activated with the contrasting alternating surfaces.

The room's fashionable chinoiserie design negates some of the impact of the panels' "Easternness," since no such combination of oil paintings and panels fitted into classicizing pilasters or irregular shaped frames with rocaille motifs would exist in China. Thus, despite its multiple temporal, geographic, and material references, the room is a product of European fabrication, even if the panels were understood as "exotic" in a Spanish context. While the room pairs Eastern and Western artistic traditions and materials, this comparison could also be seen as a pairing of early modern and contemporary art by juxtaposing (mostly) seventeenth-century lacquer panels with eighteenth-century Italian paintings.

These early modern lacquer screens specifically linked the royal couple to the previous dynasty under whose control much of Spain's empire was established, including the Philippines. Thus, they carry with them imperial and dynastic weight— the grandeur of China and the legacy of the Habsburgs. In contrast, the contemporary paintings point to Isabel's Italian heritage, her diplomatic engagement in politics, and the couple's use of the room for devotional purposes, positioning these sovereigns as a modern Catholic couple with the power to rule over Spain and its territories. In this room's schema, the paintings, classicizing framing devices, and rococo motifs temper the lacquer's "foreign" characteristics, thoroughly integrating them into a European decorative program.

In part because of the difference in surfaces, the objects placed together not only form an alternating rhythm but also a tension—a delightful push and pull dialogue as one moves from panel to painting to panel. This pattern enhances the surface richness of the room. Jonathan Hay refers to the principal feature of Chinese decorative objects as "a topography of sensuous surface—a *surfacescape*." In a Chinese interior, "surfacescapes resonate with each other, in sympathy or in counterpoint, creating a pleasurable enveloping environment."[43] In a European context, such as that of La Granja's bedroom, an object's distinctive surface was also valued, and when many different objects were placed together to form a unified design, comparisons among distinct media and surfaces could generate visual and tactile pleasures and material dialogues. The delight and surprise they engendered were fundamental to their decorative and potential political purposes.

Rather than viewing surface as something lacking depth in material and discursive terms, Glenn Adamson and Victoria Kelley propose that surface, through the framework of design history, can be seen as a "site where complex forces meet" and a "condition" for the apprehension of content, not a barrier to it.[44] Juvarra's arrangement of the lacquer framed panels along the walls seems purposeful; a way to emphasize their shimmering surfaces in sunlight and candlelight and their semantic properties. These lacquered panels articulate social and political attitudes important in the first half of the eighteenth century and to the court of Philip and Isabel. They are decorous in their visualization of the material riches of empire. The technique of Coromandel lacquer reveals the multiple layers of the wood, paint, and varnish simultaneously. The cuts and indentations give this type of lacquer a greater sense of depth within the surface. Thus, visitors standing in the bedroom in the presence of the king and queen could be bedazzled by the diverse visual stimulation. Such a space sought to impress, astound, and even bewilder. But it was most significantly a room employed by the monarchs to affirm their absolute authority.

Isabel's profound interest in the interior as a site to express her eclectic taste and to display her vast collections is well documented. But the interiors she patronized served as more than just decorative spaces to showcase her objects. They offered her a channel for the shaping of political strategies and the molding of her domestic life as queen alongside Philip V. The primary narrative told by the lacquer bedroom was their marital and political alliance. In its richly decorative surfaces, imperial connotations, Catholic piety, and modern design, the bedroom at La Granja embodied the fashionability, erudition, and cultured taste of this couple.

By combining lacquerware and other objects from the Habsburgs with those she bought and inherited and appropriating them in interiors in which she conducted governmental affairs, Isabel sought to forge connections between Philip's reign and that of the former dynasty. In the bedroom, such an association would be useful to legitimize her own position as sovereign who often acted in her husband's place. By sharing the space with Philip V, regardless of his participation, Isabel could enact reform, enjoying the power extended to her by the king. While chinoiserie has been linked to women's spaces and female patronage, the bedroom at La Granja amplifies this relationship—as queen, Isabel participated in a zeal for Asian luxuries and saw the political potential of employing lacquer to convey notions of empire, including stability, strength, and permanence—attributes generally associated with kings, to stake her claim. The lacquered bedroom presents her authority in a similar manner to that of Irala's print at the beginning of her reign. In the print and bedroom, she takes on the roles of both queen and king.

Notes

1 The treatises are Francisco Pachecho's *Grandezas de la pintura* (1649) and Vicente Carducho's *Dialogo de la pintura* (1633).
2 Pablo Vázquez Gestal, *Una nueva majestad. Felipe V, Isabel de Farnesio y la identidad de la monarquía (1700–1729)* (Madrid: Marcial Pons, 2013), 176.

3 Henry Kamen, *Philip V of Spain: The King who Reigned Twice* (New Haven and London: Yale University Press, 2001), 103.
4 Antonio Bonet Correa,"Filippo Juvarra y la gran arquitectura borbónica en España," in *Filippo Juvarra, 1678–1736: de Mesina al Palacio Real de Madrid*, ed. Antonio Bonet Correa and Beatriz Blasco Esquivias (Madrid: Electa: Centro Nacional de Exposiciones y Promoción Artística, Ministerio de Cultura, 1994), 29.
5 Melissa Hyde, "Rococo Redux: From the *Style Moderne* of the Eighteenth Century to Art Nouveau," in *Rococo: The Continuing Curve, 1730–2008*, ed. Sarah D. Coffin, Gail S. Davidson, Penelope Hunter-Stiebel, and Ellen Lupton (New York: Cooper-Hewitt, National Design Museum, 2008), 12–21.
6 Christopher Johns, "Chinoiserie in Piedmont: An International Language of Diplomacy and Modernity," in *Turin and the British in the Age of the Grand Tour*, ed. Karin E. Wolfe and Paola Bianchi (Cambridge and London: Cambridge University Press and the British School at Rome, 2017), 2–3.
7 Charles C. Noel, "'Bárbara succeeds Elizabeth …': The Feminisation and Domestication of Politics in the Spanish Monarchy, 1701–1759," in *Queenship in Europe 1660–1815: The Role of the Consort*, ed. Clarissa Campbell Orr (Cambridge: Cambridge University Press, 2004), 158–69. See Vázquez Gestal, *Una nueva majestad*, 123–4.
8 Francisco Manuel de Mena wrote the 1774 inventory in which the large black *bastidor* (lacquer panel) was included. See María Soledad García Fernández, "Les panneaux en lacquer de la chambre de Philippe V au palais de La Granja de San Ildefonso," in *Philippe V d'Espagne et l'Art de son temps. Actes deu Colloque des 7, 8 et 9 juin 1993 a Sceaux*, vol. 2, ed. Yves Bottineau and Sylvie Osorio-Robin (Paris: Conseil regional Ile-de-France, 1995), 197.
9 Johns, "Chinoiserie in Piedmont," 9.
10 Michael Yonan, *Empress Maria Theresa and the Politics of Habsburg Imperial Art* (University Park, PA: Pennsylvania State University Press, 2011), 73.
11 Yonan, *Empress Maria Theresa*, 83.
12 See Beatriz Blasco Esquivias, "El Madrid de Filippo Juvarra y las alternativas locales a su proyecto para el Palacio Real," in *Filippo Juvarra, 1678–1736*, 85. While Felipe's Secretary of State at the time, José de Grimaldo, insisted that the monarchs include spaces for official court employees, Vázquez Gestal states that the king wanted to avoid all courtly protocol. See Vázquez Gestal, *Una nueva majestad*, 284–95.
13 Procaccini was summoned to La Granja to decorate the monarchs' rooms with the help of Sempronio Subissati and Domenico Mari Sani. See Teresa Lavalle-Cobo, "Biografía artística de Isabel de Farnesio," in *El Real Sitio de La Granja de San Ildefonso. Retrato y Escena del Rey*, ed. Antonio Bonet Correa (Madrid: Patrimonio Nacional, 2000), 185–7.
14 See María Jesús Herrero Sanz, "Los jardines de la Granja de San Ildefonso: Felipe V entre Marly y Versalles," *Bulletin du Centre de recherche du château de Versailles* (2012), http://archive.org/details/MariaJesusHerreroSanzLesJardinsDeLaGranja DeSanIldefonsoPhilippe
15 Even before Philip's abdication and subsequent renewal of his kingly duties, Isabel was already in planning mode to retool some of Ardemans' designs, especially in the private rooms she and the king were to occupy. See Lavalle-Cobo, "Biografía artística de Isabel de Farnesio," 186–7.
16 The sculptures arrived at La Granja in 1725. See Lavalle-Cobo, "Biografía artística de Isabel de Farnesio," 186.

17 Besides Chinese lacquer, Isabel de Farnesio collected lacquer from England and employed lacquer makers at La Granja. The queen's impressive lacquer collection was recorded in the 1746 inventory. See García Fernández, "Les panneaux en lacquer," 196.

18 Many of the decorative treasures came from Philip V's father, the Grand Dauphin, the heir to the French throne. See Letizia Arbeteta Mira, *El Tesoro del delfín. Alhajas de Felipe V recibidas por herencia de su padre Luis, Gran Delfín de Francia* (Madrid: Museo Nacional del Prado, 2001), 20–30.

19 During her journey to Spain, Isabel spent time in Bayonne with her maternal aunt, the dowager queen of Spain, widow of Charles II, Maria Anna of Pfalz-Neuburg (1667–1740), who was exiled during the War of the Spanish Succession. See Noel, "'Bárbara succeeds Elizabeth,'" 163. Maria Anna bequeathed many objects to her niece, including paintings and two lacquered screens with mother of pearl. Domingo Maria Sani conducted an inventory upon Isabel's death in 1766, including the location of objects throughout La Granja. See Lavalle-Cobo, "El coleccionismo oriental de Isabel de Farnesio," in *Oriente en Palacio. Tesoros Asiáticos en las colecciones reales españoles*, eds. Marina Alfonso Mola and Carlos Martínez Shaw (Madrid: Patrimonio Nacional, 2003), 212–13.

20 Lavalle-Cobo, "El coleccionismo oriental de Isabel de Farnesio," 211.

21 Lavalle-Cobo, "El coleccionismo oriental de Isabel de Farnesio," 211–12.

22 Noel, "'Bárbara succeeds Elizabeth,'" 171.

23 See Ángel Aterido, Juan Martínez Cuesta, and José Juan Pérez Preciado, *Inventarios reales. Colecciones de pinturas de Felipe V e Isabel Farnesio*, 2 vols. (Madrid: Patrimonio Nacional, 2004).

24 Vázquez Gestal, *Una nueva majestad*, 47.

25 Kamen states the new system was called the *via reservada* (executive mechanism). It enabled the king to make decisions after consulting with his ministers and not the full council. See Kamen, *Philip V of Spain*, 108–9.

26 As Vázquez Gestal discusses, the practice of the couple's prayers in their shared chambers followed by conferences with the ministers was quoted by the duke of Saint-Simon in the daily lives of royals from 1721. In addition, the Secretary of State, José de Grimaldo, was permitted to enter the room after the monarchs prayed to review government business. See Vázquez Gestal, *Una nueva majestad*, 215.

27 Vázquez Gestal, *Una nueva majestad*, 233.

28 Vázquez Gestal, *Una nueva majestad*, 230–1.

29 Locatelli was paid 300 scudi and Panini 1,500 scudi. In August 1736, Locatelli's canvases and two of Panini's arrived at La Granja for installation. The following July, Panini sent his final two canvases to Spain. See García Fernández, "Paneles de laca para las habitaciones de Felipe V en La Granja, proyectadas por Juvarra," in *Filippo Juvarra, 1678–1736*, 283.

30 Vittorio Amedeo II held several positions—as duke of Savoy (r. 1675–1730), king of Sicily (r. 1713–20), and king of Sardinia (r. 1720–30).

31 Johns, "Chinoiserie in Piedmont," 11.

32 Wilfried G. De Kesel and G. Dhont, *Coromandel Lacquer Screens* (Gent: Snoeck-Ducaju & Zoon, 2002), 19. The technique was first described in the "Xiu Shi Lu," a sixteenth-century text about the lacquer industry that was adapted by Yang Ming in 1625.

33 García Fernández, "Paneles de laca," 284.

34 Yonan, "Veneers of Authority: Chinese Lacquers in Maria Theresa's Vienna," *Eighteenth-Century Studies* 37, no. 4 (Summer 2004): 654.

35 Yonan, "Veneers," 655–7.
36 Lavalle-Cobo, "El coleccionismo oriental," 212.
37 Filip Suchomel and Marcela Suchomelová, *A Surface Created for Decoration: Japanese Lacquer Art from the 16th to the 19th Centuries* (Prague: The National Gallery, 2002), 45.
38 García Fernández, "Las colecciones de muebles de Felipe V," in *El arte en la corte de Felipe V*, ed. José Miguel Morán Turina (Madrid: Patrimonio Nacional, 2002), 377.
39 Meredith Martin, "The Ascendancy of the Interior in Eighteenth-Century French Architectural Theory," in *Architectural Space in Eighteenth-Century Europe: Constructing Identities and Interiors*, eds. Denise Amy Baxter and Martin (Farnham, UK and Burlington, VT: Ashgate, 2010), 15.
40 García Fernández, "Paneles de laca," 279–81.
41 See Virginia Treanor, "'*Une abundance extra ordinaire*': The Porcelain Collection of Amalia van Solms," *Early Modern Women: An Interdisciplinary Journal* 9, no. 1 (Fall 2004): 141–54, and Susan Broomhall and Jacqueline Van Gent, *Dynastic Colonialism: Gender, Materiality and the Early Modern House of Orange-Nassau* (London: Routledge/Taylor & Francis Group, 2016).
42 García Fernández, "Muebles y paneles decorativos de laca en el siglo XVIII," *Oriente en Palacio*, 342.
43 Jonathan Hay, *Sensuous Surfaces: The Decorative Object in Early Modern China* (London: Reaktion Books, 2010), 67–8.
44 Glenn Adamson and Victoria Kelley, "Introduction," in *Surface Tensions: Surface, Finish and the Meaning of Objects*, ed. Adamson and Kelley (Manchester: Manchester University Press, 2013), 1.

Bibliography

Adamson, Glenn, and Victoria Kelley. "Introduction." In *Surface Tensions: Surface, Finish and the Meaning of Objects*, edited by Adamson and Kelley, 1–10. Manchester: Manchester University Press, 2013.

Blasco Esquivias, Beatriz. "El Madrid de Filippo Juvarra y las alternativas locales a su proyecto para el Palacio Real." In *Filippo Juvarra, 1678–1736: de Mesina al Palacio Real de Madrid*, edited by Antonio Bonet Correa and Beatriz Blasco Esquivias, 45–112. Madrid: Electa:, Centro Nacional de Exposiciones y Promoción Artística, Ministerio de Cultura, 1994.

Bonet Correa, Antonio. "Filippo Juvarra y la gran arquitectura borbónica en España." In *Filippo Juvarra, 1678–1736: de Mesina al Palacio Real de Madrid*, edited by Antonio Bonet Correa and Beatriz Blasco Esquivias, 25–44. Madrid: Electa: Centro Nacional de Exposiciones y Promoción Artística, Ministerio de Cultura, 1994.

De Kesel, Wilfried G., and G. Dhont. *Coromandel Lacquer Screens*. Gent: Snoeck-Ducaju & Zoon, 2002.

García Fernández, María Soledad. "Paneles de laca para las habitaciones de Felipe V en La Granja, proyectadas por Juvarra." In *Filippo Juvarra, 1678–1736: de Mesina al Palacio Real de Madrid*, edited by Antonio Bonet Correa and Beatriz Blasco Esquivias, 277–89. Madrid: Electa: Centro Nacional de Exposiciones y Promoción Artística, Ministerio de Cultura, 1994.

García Fernández, María Soledad. "Les panneaux en lacquer de la chambre de Philippe V au palais de La Granja de San Ildefonso." In *Philippe V d'Espagne et l'Art de son temps*.

Actes deu Colloque des 7, 8 et 9 juin 1993 a Sceaux, vol. 2, edited by Yves Bottineau and Sylvie Osorio-Robin, 193–207. Paris: Conseil regional Ile-de-France, 1995.

García Fernández, María Soledad. "Las colecciones de muebles de Felipe V." In *El arte en la corte de Felipe V*, edited by José Miguel Morán Turina, 373–84. Madrid: Patrimonio Nacional, 2002.

Hay, Jonathan. *Sensuous Surfaces: The Decorative Object in Early Modern China*. London: Reaktion Books, 2010.

Hyde, Melissa. "Rococo Redux: From the *Style Moderne* of the Eighteenth Century to Art Nouveau." In *Rococo: The Continuing Curve, 1730–2008*, edited by Sarah D. Coffin, Gail S. Davidson, Penelope Hunter-Stiebel, and Ellen Lupton, 13–21. New York: Cooper-Hewitt, National Design Museum, 2008.

Johns, Christopher. "Chinoiserie in Piedmont: An International Language of Diplomacy and Modernity." In *Turin and the British in the Age of the Grand Tour*, edited by Karin E. Wolfe and Paola Bianchi, 281–300. Cambridge and London: Cambridge University Press and the British School at Rome, 2017.

Kamen, Henry. *Philip V of Spain: The King who Reigned Twice*. New Haven and London: Yale University Press, 2001.

Lavalle-Cobo, Teresa. "Biografía artística de Isabel de Farnesio." In *El Real Sitio de La Granja de San Ildefonso. Retrato y Escena del Rey*, edited by Antonio Bonet Correa, 182–93. Madrid: Patrimonio Nacional, 2000.

Lavalle-Cobo, Teresa. "El coleccionismo oriental de Isabel de Farnesio." In *Oriente en Palacio. Tesoros Asiáticos en las colecciones reales españoles*, edited by Marina Alfonso Mola and Carlos Martínez Shaw, 211–14. Madrid: Patrimonio Nacional, 2003.

Martin, Meredith. "The Ascendancy of the Interior in Eighteenth-Century French Architectural Theory." In *Architectural Space in Eighteenth-Century Europe: Constructing Identities and Interiors*, edited by Denise Amy Baxter and Martin, 15–34. Farnham, UK and Burlington, VT: Ashgate, 2010.

Noel, Charles C. "'Bárbara succeeds Elizabeth …': The Feminisation and Domestication of Politics in the Spanish Monarchy, 1701–1759." In *Queenship in Europe 1660–1815: The Role of the Consort*, edited by Clarissa Campbell Orr, 155–85. Cambridge: Cambridge University Press, 2004.

Suchomel, Filip, and Marcela Suchomelová. *A Surface Created for Decoration: Japanese Lacquer Art from the 16th to the 19th Centuries*. Prague: The National Gallery, 2002.

Vázquez Gestal, Pablo. *Una nueva majestad. Felipe V, Isabel de Farnesio y la identidad de la monarquía (1700–1729)*. Madrid: Marcial Pons, 2013.

Yonan, Michael. "Veneers of Authority: Chinese Lacquers in Maria Theresa's Vienna." *Eighteenth-Century Studies* 37, no. 4 (Summer 2004): 652–72.

Yonan, Michael. *Empress Maria Theresa and the Politics of Habsburg Imperial Art*. University Park, PA: Pennsylvania State University Press, 2011.

Part Two

Staging Identity and Performing Sociability

A Stage for Wealth and Power in Eighteenth-Century Lima: The *Estrado* of Doña Rosa Juliana Sánchez de Tagle, First Marchioness of Torre Tagle

Jorge F. Rivas Pérez

The method they use at home, is to sit in cushions along the wall, with their legs across on a estrado, *or part of the room raised a step above the rest, with a carpet on it, after the Turkish fashion. They spend almost the whole day in this manner, without altering their posture, even to eat: for they are served apart, on little chests which they always have before them to put up the work they do …*[1]

Amédée François Frézier, Lima, 1714

When the French traveler and spy Amédée François Frézier visited Lima in 1714, he was surprised to find women receiving male guests in the *estrado*, a space normally reserved for women (Figure 5.1). Habituated to French uses and styles in which guests were typically received in the reception room, Frézier took detailed notes of what he considered an unusual custom. Spanish and Peruvian *estrados* were unlike anything he had seen in France. The *estrado*, usually a wooden raised platform with a precious carpet on top and furnished with cushions, low tables, and small case furniture, was known as the ultimate feminine space at home in the Spanish world. The concept of the *estrado* originated in medieval Islamic Spain, and was later adopted across the Iberian Peninsula. By the early 1300s, the *estrado* was clearly identified as the woman's intimate place in domestic settings, where ladies would spend the day doing needlework, reading, praying, or entertaining close acquaintances.[2] The bed was always located in close proximity to the *estrado* and was often in the same room. Frézier indicated in his notes that Lima houses were organized following the traditional Spanish arrangement in which the *estrado* was adjacent to the bedroom, in what he describes as "two other chambers, one within another," preceded by a large hall.[3]

Estrados in Spanish America had a lifespan of nearly three centuries. Arising as an expression and embodiment of the Spanish ideals of the feminine world at home in the 1500s, they also serve as an example of how long-established Iberian practices were transplanted and adapted in the Americas. The *estrado* was an elite lady's private space

Figure 5.1 "A Spanish Woman of Peru in Waistcoat and Petticoat …," from Amédée François Frézier, *Relation du voyage de la mer du Sud aux côtes du Chily et du Perou, fait pendant les années 1712, 1713 & 1714* (Paris: Chez Jean-Geoffroy Nyon, Étienne Ganeau, and Jacque Quillau, 1716), pl. VI-3.

within the home, to which only intimate acquaintances were admitted: a gendered territory that guaranteed continuity in women's social roles. It is not an overstatement to claim that nearly every home in Spanish America had an *estrado*. The poor only had a *petate* mat and rustic furniture set up in a corner, whereas the upper classes and the titled nobility had lavishly decorated rooms set apart for the specific purpose of repose and social interaction with close friends and family. *Estrados* became an expression of distinction, status, and fine taste.

The exceptionally detailed 1762 inventory of the *estrado* and related rooms of Doña Rosa Juliana Sánchez de Tagle, one of the wealthiest noblewomen in eighteenth-century Lima, provides a portrait of the intimate material world of a powerful woman who was at the apex of colonial society in Peru.[4] The gendered nature of the *estrado*

responded to the moral values of the time on which women's honor and respectability were central. In this context, the *estrado* offered a safe and protected stage for both social functions and moments of familial intimacy. As a wife, the marchioness had the duty of adequately governing the house, educating her children, caring for her husband, managing her estate, and representing her family among peers. Because her *estrado* was directly associated with her position in Lima's elite colonial society, it had to showcase a material world of wealth and style which aligned with the family's status and reflected her taste and proper education.

Doña Rosa Juliana Sánchez de Tagle

Daughter of Corregidor (crown administrator of a province) Don Francisco Sánchez de Tagle y Castro Velarde and Doña María Josefa Hidalgo Sánchez y Velázquez Gómez, the future marchioness of Torre Tagle was born in 1687 in San Jerónimo de Sayán, province of Huaura (Figure 5.2). Her father was a Spaniard of noble origin from Santillana del Mar, Cantabria, who settled in Peru and made a fortune in commerce. Her mother was a wealthy heiress descended from a Spanish family long established in Huaura in the seventeenth century, about 120 kilometers from Lima.

Doña Rosa Juliana Sánchez de Tagle lived in a time of rapid change. In the 1700s, noble and upper-class women across the Spanish Empire benefited from new freedoms, as the dynastic change from the Habsburgs to the Bourbons in 1713 brought along new female consumption habits and sociability practices influenced by aristocratic customs in France and Bourbon Italy. Elite practices such as promenades, intimate gatherings, informal visits, and later in the century *cortejos* (male escorts of married women) found their way to Lima and Spanish America in general.[5] To understand the Tagle's family prominence in Peru during the 1700s, and the importance of the material world that surrounded the first marchioness of Torre Tagle, a brief introduction to the social context that framed the life of the protagonist of this essay would be helpful.

The Economic and Social Rise of the Tagle Family

Throughout the colonial era in Peru, elite groups' power and patronage were sustained thanks to strategic alliances and kinship networks among the different notable families of the viceroyalty, generally through marriages of convenience. These connections guaranteed access and continuity to the highest spheres of economic, political, and religious power, and the preservation and concentration of family wealth and social status.[6]

The marriage of Don Francisco Sánchez de Tagle, the father of the marchioness, with a wealthy heiress from Huaura in 1677, shows how the social mechanics through which Spaniards of notable social ranking with little time residing in the Americas— and often without financial resources—related to local families with long-standing roots and great economic power. The subsequent wedding of his daughter, Rosa Juliana, to Don José Bernardo de Tagle-Bracho and Pérez de la Riva a distant cousin

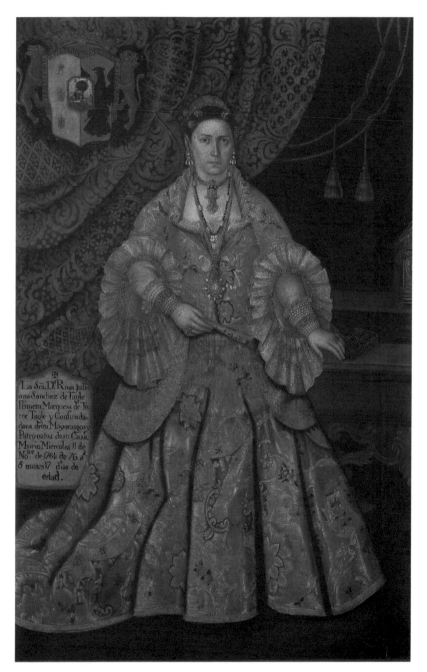

Figure 5.2 Cristóbal de Aguilar, *Portrait of doña Rosa Juliana Sánchez de Tagle, First Marchioness of Torre-Tagle*, about 1756, oil on canvas, Palacio de Torre Tagle, Lima. Photography courtesy Archivo Digital de Arte Peruano.

born in 1684 in Ruiloba, Spain, reiterates the importance of marriages of convenience among elite families.[7] The couple married in the cathedral of Lima on Sunday, November 13, 1707. Rosa Juliana's dowry was considerable; a sum of 11,000 pesos. In contrast, José Bernardo brought no tangible assets to the marriage. However, the young Spaniard had, in addition to his noble origins, the trust and support of his father-in-law.

José Bernardo de Tagle-Bracho quickly made a fortune thanks to his business acumen and his in-laws' help. He also relied on relatives who had settled in Peru, particularly his uncle Don Juan Antonio de Tagle-Bracho, count of Casa Tagle de Trasierra. But his real stroke of luck came in 1725 when, under the protection of the viceroy, Don José de Armendáriz y Perurena, first marquis of Castelfuerte, formed a privateering company in partnership with Don Ángel Calderón.[8] They had the ship *Nuestra Señora del Carmen*, whose mission was to apprehend three armed Dutch vessels that were prowling along the Peruvian Pacific coast.[9] The enterprise was successful. They captured the first ship near Coquimbo, and the second in front of Nazca. The third ship was badly battered off the coast of Chile and escaped via Cape Horn.[10] The enterprise produced enormous profits for both partners and the Royal Treasury because the Dutch vessels were loaded with high-value goods, probably intended for smuggling.

In addition to his good fortune, Don José Bernardo quickly rose in the ranks of colonial administration. He was governor of the war expeditions in the South Seas, prior to the Lima Consulate, perpetual general payer of El Callao fortress, and treasurer of the Royal Navy.[11] However, the pinnacle of his brilliant social ascent was a Castilian title of nobility, the marquisate of Torre Tagle, granted by King Felipe V (r. 1700–46) by royal decree of November 26, 1730 as a reward for his services to the crown.[12] This important honor markedly increased the already distinguished social position held by the Tagle family in Peru.

A Mansion for the Marquises

The Tagles' new social status demanded a house that lived up to their high rank and that was capable of accommodating their large family, which included the couple and their ten children, in addition to slaves and servants. A total of twenty-four people resided at the manor house.[13] Although definitive documentation has yet to be found, the house was likely built between 1729 and 1738.[14] The two-story mansion with a roof terrace, wood balconies, and a carved stone portico, now the headquarters of the Peruvian Foreign Ministry, was located in the former San Pedro street, today Jirón Ucayali (Figure 5.3). The house was built using typical materials found in Lima buildings of the period: stone foundations, thick brick masonry walls on the ground floor, and even adobes in some instances. In anticipation of earthquakes, upper-floor walls were made to be lighter using reeds and mud, while the stairs and structural arches were made of brick. The second-floor corridors, floors, decks, and balconies were all made of fine wood; in many areas, the walls were lined with tile wainscoting.

Following the uses and models of Lima's patrician dwellings, the Tagle mansion was designed around two courtyards. The most important rooms were organized around

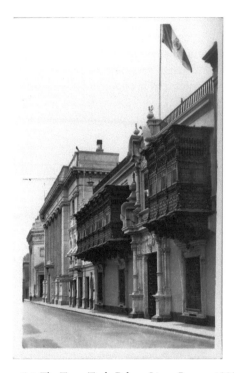

Figure 5.3 Unknown artist, The Torre Tagle Palace, Lima, Peru, *c.* 1920, postcard. © Photo: the author.

the first one, designed to be larger and with a square design. On the upper floor, there were spaces for social functions and the family's private rooms. Commercial premises on the ground-floor areas faced the street, and several rooms for different uses faced the courtyard. The less important dependencies were organized around the second courtyard, and the service areas were located facing the back of the property. Unfortunately, the first marquis of Torre Tagle had little time to enjoy such his magnificent new residence, due to his sudden death in Lima in August 1740.[15] The dowager marchioness fulfilled her late husband's will, and in August 1743 she established two separated entitled states benefiting the heir to the marquisate Don Tadeo José de Tagle y Bracho. She continued to oversee family finances and live in the house until her death at age 73 on November 11, 1761.

The Marchioness's Apartment

According to the inventory recorded at the time of her death in 1761, the marchioness's apartment occupied the most important top-floor rooms, those facing the street and others overlooking the first courtyard. It had five interconnected rooms, organized following the traditional sequence found in grand Spanish homes: reception room

(*sala*), study (*estudio*), estrado (*cuadra de estrado*), bedroom (*cuadra de dormir*), antechamber (*antecuadra*), plus an additional chamber not directly connected to the others called the courtyard room (*cuarto del patio*). In the 1600s and 1700s, both in Spain and its overseas territories, no expense was spared when it came to furnishing the mistress's rooms, in particular the *estrado* and the bedroom. In the Torre Tagle mansion, there was an additional room next to the bedroom, the so-called *antecuadra*, which was part of the marchioness's private space.

The *Estrado* Room

In Spanish, the word *estrado* designates a type of large dais, which is a low wooden platform that would typically be covered with carpets, and sometimes cushions, on top of which the women of the house would sit to receive guests. The word also names the room on which it was placed. In the 1732 *Diccionario de Autoridades*, *estrado* is defined as "The set of precious things that serve to cover and adorn the place or piece in which the ladies sit to receive visitors, which consists of carpet or mat, cushions, stools or low chairs."[16] The *estrado* was the quintessential female social space in Spanish and Spanish American dwellings. These rooms segregated by sex (the dais was for the exclusive use of women and their female guests) are heirs to Islamic culture and customs in Spain and Portugal.

Social protocol dictated that male guests invited to visit the *estrado* could only sit on chairs outside the platform. The distance between the chairs used by male guests and the platform often indicated the degree of closeness with the hostess.[17] In Spain in the early 1700s, the *estrado* fell into disuse, mostly as result of French court etiquette and social practices brought by the new Bourbon king. However, in Spanish America, the *estrado* was kept in use well into the 1830s. For example, in his travel memoir, the British diplomat John Potter Hamilton (1777–1873) recalled a visit to Bogotá in 1825. He writes: "In my morning visits to the ladies I frequently found them sitting on cushions placed on a mat after the oriental fashion, and employed at tambourwork; a little female Negro slave squatted comfortably in one corner of the apartment, ready to obey the orders of her mistress," also mentioning that *criollos* (Creoles) treated their household slaves "with great kindness and indulgence."[18]

The Torre Tagle dais in the *estrado* room was quite large and sumptuously furnished. It consisted of three raised wooden platforms covered with *petate* (woven grass) mats, and a colorful rug on top.[19] The marchioness also had an additional *estrado* platform next to her bed.[20] The existence of two *estrados* in a grand house was not uncommon and pointed to her elite status and wealth. The number of *estrados* and their dimensions were symbols of power and prestige. In *Día de fiesta por la tarde* (1659), the Spanish writer Juan de Zabaleta indicates that the wealthy homes deployed three different types of *estrados* in their residences: of respect (*de respeto*), of courtesy (*de cumplimiento*), and of affection (*de cariño*).[21] The large luxurious dais in the *estrado* room likely functioned as the more formal type, of respect and of courtesy, while the bedroom *estrado* next to the bed undoubtedly corresponds to Zabaleta's description of the *estrado* of affection, the place where the ladies received their closest female friends and spent most of the day.

The inventory does not provide information on the exact location of the three raised platforms listed in the *estrado* room. It is very likely that they were placed one next to the other against a long wall because such an arrangement was customary. A green damask *rodaestrado* (a low fabric wall hanging) served as a backdrop for the *estrado*, and is listed in the death inventory among the furniture.[22] It matched the curtains made of the same material that adorned the doors leading to the bedroom and those of the studio. Green, the dominant color in the room, was a rare choice in Peruvian interiors of the period. Maybe there were personal or historical reasons behind the choice of color, or perhaps green was selected to add a surprising and sophisticated element to an otherwise traditional design. Atop of the *estrado*, the marchioness placed a small chest inlaid with mother of pearl, tortoiseshell, and ivory, probably used to house needlework and related objects. She also had a "dozen antique crimson velvet cushions with gold ribbon trimming (*sevillaneta*)" for female guests to sit on. Visiting gentlemen would use the four "side chairs with tanned calfskin (*vaqueta de Moscovia*) seat and back," that likely were placed on the floor in front of the platform as protocol dictated (Figure 5.4).

Additional furniture and decorative objects embellished the *estrado*—often in identical pairs, as was fashionable in the early 1700s. These additions included a pair of small Chinese black lacquer chests adorned with metal locks placed on top of wood tables,

Figure 5.4 Unknown artist, Armchair, 1700s, Ecuador or Colombia, wood, leather, and metal. Denver Art Museum: Gift of the Stapleton Foundation of Latin American Colonial Art, made possible by the Renchard Family, 1990.291. © Photo: Denver Art Museum.

a pair of antique Chinese blue and white porcelain vases, and a three-sided glass case containing a sculpture of Our Lady of Mount Carmel, all displayed on top of the lacquer chests. The abundance of Chinese imports showcases the importance of the trade with Asia via the Manila Galleon. Two "old wood writing desks (*escritorios*)" with matching cabinets (*contadores*) on top, each on their respective tables, confirm that, as late as the 1730s, it was fashionable to display a profusion of writing desks and cabinets, placed one on top of the other in tower-like compositions. These "towers of riches" were extremely popular in Spanish decorative programs in the colonial era, and undoubtedly sought to impress visitors and demonstrate their owners' wealth and good taste.[23] A sumptuous chest inlaid in tortoiseshell, ivory, and mother of pearl was another remarkable piece in the room.[24] A small writing chest (*escritorio*) with three drawers—in which the marchioness kept some novenas and other little books of devotion—rested on top of a table in front of one of the windows, and completed the room's furniture (Figure 5.5). Metal chandeliers with glass pendants and oil lamps provided lighting; the estate appraiser found several chandeliers of the same style in other rooms throughout the house.

Twenty-nine paintings of different sizes and genres with their respective gilded frames as well as two mirrors hung on the *estrado*'s walls. The artworks included fourteen "*países de pintura del reino*" (landscape paintings by local artists), four religious subjects—Saint Augustine, Saint Mary Magdalene, Saint Francis, and Saint

Figure 5.5 Unknown artist, Chest (*escritorio*) decorated with chinoiserie, *c.* 1740, Ecuador, painted wood, iron. Denver Art Museum: gift of Mr. and Mrs. Robert S. Black. 1993.113A-I. © Photo: Denver Art Museum.

Barbara—one *vara* each (about 33 inches), three canvases "slightly larger than two *varas*" whose subjects were the Immaculate Conception (*Purísima*), Saint Rose of Lima (Figure 5.6), and Our Lady of Guadalupe of Mexico. Eight small "*láminas*" (oil paintings on copper sheets) completed the room's painting collection. This abundance of sacred-themed painting is typical of Peruvian and Spanish American domestic settings. It signaled the piety and devotion of the women of the house. The presence of images of Saint Rose of Lima, canonized in 1671, becoming the first female saint of the Americas and patron saint of Peru, and Our Lady of Guadalupe, patron of New Spain, Spanish America, and the Philippines, indicates a strong personal connection with local devotions. The images also speak to a sense of belonging to the rest of Spanish America.

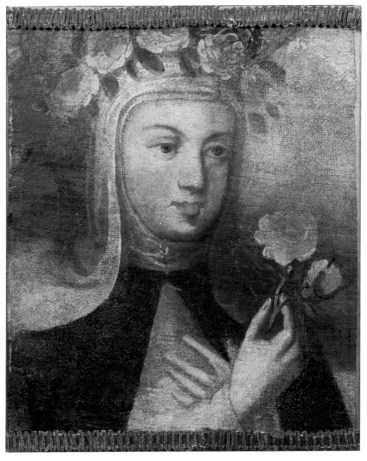

Figure 5.6 Unknown artist, *Saint Rose of Lima*, 1700s, oil paint on canvas, Ecuador. Denver Art Museum: gift of the Stapleton Foundation of Latin American Colonial Art, made possible by the Renchard Family, 1990.516. © Photo: Denver Art Museum.

The Bedroom

In an age of blurred distinctions between public and private spaces at home, the main bedroom was customarily attached to the *estrado*, and was usually furnished in grand style. The bed was among the household's most expensive items because of the precious textiles that dressed it. Chests and other case furniture for storage, chairs, a small writing table, and a folding screen—to enclose the bed for privacy—would complete the ensemble. Bedroom inventories often list a crucifix, religious images, small tabernacles, and small-scale precious sculptures. These items assisted the devout during intimate moments of private devotion. Upscale homes included a small *estrado* close to the bed, as was the case with the Torre Tagle mansion.

The first inventoried object in the marquise's bedroom is the bed, described as "an old cocobola [*sic*] bed with its fine canopy of Macana de Quito."[25] Luxurious beds and their fine hangings were expensive; that of the marchioness was appraised at 25 pesos and its textiles at 16 pesos. Beds made of cocobolo wood and other tropical hardwoods, with turned supports, balusters, and decorative elements were fashionable in the seventeenth and eighteenth centuries. Hence, it is possible that the bed was an heirloom or part of the furniture that came from their earlier residence. Considering Tagle's fondness for fine silks and Asian textiles, as we see throughout the inventory, the use of "Macana de Quito" fabric (a present-day Ecuadorian textile like ikat) for the canopy, rather than some imported cloth, is surprising. However, Macana is a costly, labor-intensive textile, hand-woven on backstrap looms using techniques that predate the Spanish conquest. Besides the Macana hangings, the inventory lists other high-end objects made in the Americas, indicating that in addition to Asian imports, the marchioness had a penchant for fine local pieces. As usual, accompanying the bed was a folding screen that served to guarantee some privacy. In this case, the screen was a locally manufactured eight-panel painted piece.

In front of the bed was the second *estrado*, that of affection, which consisted of a large wooden platform covered with a *petate* and "a small antique carpet" (Figure 5.7). Additional furniture in the bedroom included a small antique Chinese black lacquer *estrado* table with a tray top, a low antique armchair (*silla poltrona*) with scroll feet (*pies volteados*) upholstered in *vaqueta* leather. Also, two English side chairs with woven mesh backs, four locally made side chairs with *tafilete* upholstery (very fine, burnished, and polished leather), and a black, four-legged round table with a drawer. Additional furniture included a little flask case with ten Chinese porcelain flasks, a Chinese large antique red chest, likely lacquer, with two embellished locks with metal studs, "which was open and empty" and possibly used to store textiles and clothing. The last piece listed is an antique Chinese black writing desk (*escritorio*) adorned with metal pulls and lock, with an antique Chinese porcelain vase on top. According to the inventory, the marchioness kept part of her extensive jewelry collection and two small tortoiseshell caskets inlaid in mother of pearl with silver locks and keys in that writing desk.

An object of special relevance in the bedroom was a crimson damask canopy. It housed a crucifix, and below it a small Roman painting on copper under glass with a

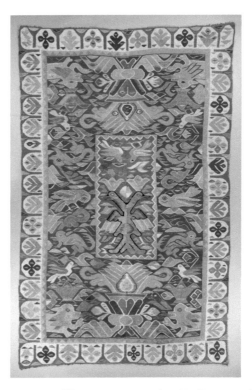

Figure 5.7 Unknown artist, Wall hanging or rug, mid-1700s, Peru, camelid wool. Neusteter Textile Collection at the Denver Art Museum: Neusteter Institute Fund, 1970.347. © Photo: Denver Art Museum.

gilded frame depicting "Our Lady, Saint Joseph and the Child Jesus" (Figure 5.8), and another painting representing "The Face of Our Lord" from Paita. The canopy was a place for personal devotion and shows the intense piety of the marchioness in her most intimate spaces.

To complete the decoration, a large number of paintings in gilded frames decorated the walls. Artworks included two large (about two *varas*) landscape paintings (*países*), depicting the Fall of Saint Paul and Jesus Nazarene, and two still lifes (*fruteros*) of "slightly more than one *vara*." There were also fourteen canvases of "two *varas* each," including "the Four Doctors of the Church, the Mary Magdalena, the Purísima (Immaculate Conception), Saint Peter, Saint Cristopher, Saint Michael [Figure 5.9], the Mystery of the Birth of Our Lord, Saint Jude Taddeo, another of Jesus Nazarene, the Child Jesus, and our Lady of Solitude." In total there were eighteen canvases.

A review of the furniture and objects listed showcases the cosmopolitan and eclectic character that distinguished the bedroom. While most of the furnishings were likely Peruvian, imported items such as the pair of English side chairs, the Chinese lacquer case furniture, porcelain objects from China, and the Roman painting on copper stand out.

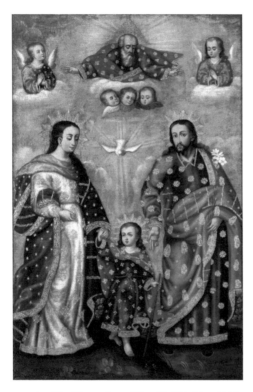

Figure 5.8 Unknown artist, *The Heavenly and Earthly Trinities*, 1700s, oil paint on canvas, Cuzco, Peru. Denver Art Museum: gift of Mr. and Mrs. Philip W. Amram, 1979.182. © Photo: Denver Art Museum.

The varied range of furniture types listed, several recorded as "antique," corresponded to those usually found in Peruvian aristocratic houses from the period. At the time of the marchioness's death in 1761, they looked old-fashioned to the appraiser. In any case, filled with luxurious furniture, fine Asian ceramics, and numerous paintings, the bedroom was likely an impressive and lavish room that undoubtedly reflected its owner's wealth and high social status. It should be noted that bedrooms had a social function during the Hispanic period, hence the commitment and resources used in its decoration. To the best of their ability, Peruvian nobles emulated the uses and styles of the court in Madrid. Following a medieval tradition, in the 1600s, the king and queen's bedrooms were extremely luxurious and regularly visited by courtiers.[26] At the beginning of the following century, taste evolved as French styles were favored. Still, the semi-public character of the royal bedrooms was maintained, especially after Felipe V's marriage to Isabel de Farnesio in 1714. The queen was especially fond of luxury with a particular penchant for Oriental furniture and objects.[27] As in Madrid, bedrooms across all of Spanish America were social spaces, and only distinguished visitors had access. With abundant Oriental furniture and objects, the marchioness's

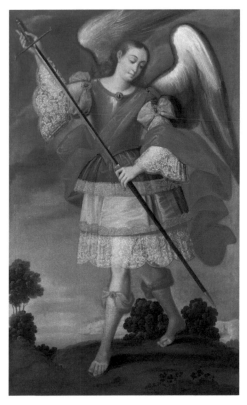

Figure 5.9 Unknown artist, *Archangel Michael*, 1700s, oil paint on canvas, southern Andes. Denver Art Museum: Gift of Patricia Phelps de Cisneros in honor of Gabriel Pérez Barreiro. 2017.122. © Photo: Denver Art Museum.

bedroom perfectly reflects Madrid's prevailing tastes and fashions. In a way, the decoration aligned with the queen's preferences sends a very clear political message to the visitors indicating unrestricted support to the royal family.

The Antechamber

Next to the bedroom was a small room designated the antechamber (*antecuadra*), which served as a storage and display space. The marchioness kept and exhibited many of her most precious possessions here. Six paintings with gilded frames decorated the walls (Figure 5.10).[28] A large antique carved cedar display cabinet (*escaparate*) adorned with silver decorative plaques, pulls, corners, and braces stands out among the furniture listed. This piece, later valued at the considerable sum of 150 pesos, functioned as a cabinet of wonders serving to display countless precious objects and curiosities from different parts of the world. The goods exhibited included a large

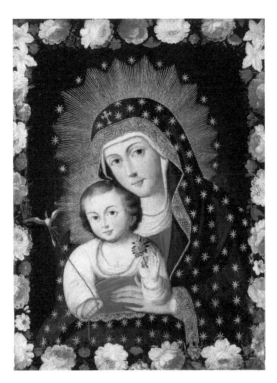

Figure 5.10 Unknown artist, *Madonna and Child with Bird*, *c.* 1730–40, oil paint on canvas, Cuzco, Peru. Denver Art Museum: gift of Engracia Freyer Dougherty, 1972.390. © Photo: Denver Art Museum.

group of Chinese porcelain wares, among them 12 antique plates with blue flowers, 20 antique chocolate cups, a small salt cellar, 8 dessert plates, 4 sauceboats, 6 large and 4 small lion figurines, 4 large and 2 small dog figurines, 2 small flower pots, and a large lidded vessel. The crystal objects listed—likely European—included 24 glasses, 2 cups, 2 mugs, 4 rosewater sprinklers, and 2 small blue glass barrels. The marchioness also owned 10 pieces of fine unglazed earthenware (*barro fino*), some from Chile, others from Guadalajara (Figure 5.11), and others from Spain. She also possessed a gilt silver rosewater sprinkler, 6 small silver perfume burners, an ivory sculpture of the virgin (Figure 5.12), 2 small ivory candlesticks, a black wooden tray from China, a small round enameled metal tray, and 2 rosaries, one of them with jet beads. Although some broken pieces were not appraised, the objects totaled 122 pesos, a significant sum of money for the time.[29]

Cabinets of curiosities such as that of the marchioness served to showcase the interests and tastes of their owners, and as social devices that contributed to establishing and sustaining the roles of arbiters of good taste and erudition at the highest levels of society. Inspired by the princely *wunderkammers*, which were very popular among the European nobility, this cabinet with its collection

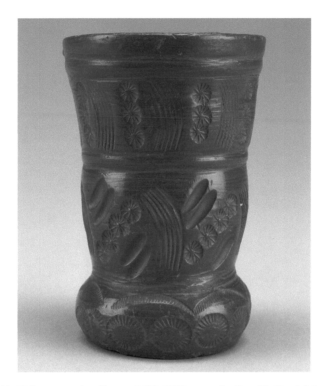

Figure 5.11 Unknown artist, Cup, *c.* 1650–1750, ceramic, Tonalá, Guadalajara, Mexico. Denver Art Museum: funds from Carl Patterson in honor of Jorge Rivas. 2018.304. © Photo: Denver Art Museum.

essentially had a representational function guided more by aesthetic concerns than by scholarly or scientific purposes. The objects that it housed exhibited a marked preference for exotic and valuable pieces that were easily recognizable to ensure the attention of potential audiences. It was a type of personal collecting, guided by curiosity, wonder, and ostentation. However, the marchioness's extraordinary collection must be read in Lima's context as the capital of the viceroyalty of Peru, as such objects in a Spanish or even Mexican collection would not hold the same meanings. The abundance of crystal, a very fragile material, for example, showcases great wealth, as it was imported from Spain at great expense. The pieces from Asia, made of mainly porcelain and ivory, indicate a sophisticated taste and a means of fortune. Asian imports were quite expensive in Lima as they came from Acapulco, the exclusive port of entry for Asian goods during the Spanish age. That was also the case of fine unglazed earthenware from Chile, Guadalajara, and Spain, all costly and fragile imports. On the contrary, silverware was common in elite Peruvian households; the appraiser valued it by its weight.

 In addition to the display cabinet, there were also three mahogany chests, one large and two smaller (Figure 5.13), which were inventoried in the antechamber.[30]

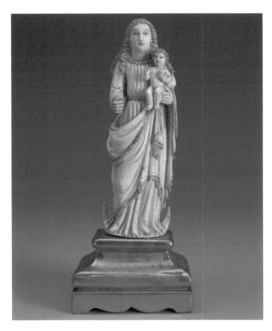

Figure 5.12 Unknown artist, *Virgin and Child*, 1700s, ivory, paint, and wood, Goa, India. Denver Art Museum: gift of Olive Bigelow, 1971.474. © Photo: Denver Art Museum.

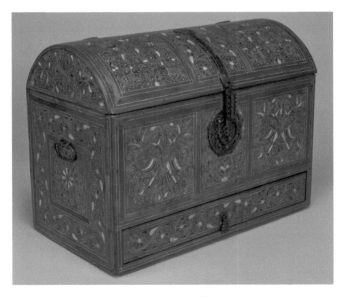

Figure 5.13 Unknown artist, Chest, 1700s, wood, iron, and silver, Peru. Denver Art Museum: Gift of the Stapleton Foundation of Latin American Colonial Art, made possible by the Renchard Family, 1990.293. © Photo: Denver Art Museum.

Until the mid-1700s, chests and trunks were the primary types of case furniture for storing dresses, bedding, and all kinds of textiles and other valuables. The wealthy in Lima favored chests made with tropical woods resistant to xylophagous insects brought from Central America at exorbitant cost, chief among them Spanish cedar and Nicaraguan mahogany. The inventoried chests served to store and secure objects of all sorts. The record lists several textiles, including clothing, tablecloths and napkins, and fine bed linens. Outstanding among the last are two sumptuous bedspreads, one from China, which was blue, embroidered with silk and a fringe. The other was crimson, embroidered with silk, gold, and silver threads, also with a fringe of the same materials. The marchioness used one chest to store silverware for the table.

Objects listed include serving pieces, salvers, platters (Figure 5.14), serving dishes, saucers, and plates, as well as cutlery. It should be kept in mind that dining rooms, understood as rooms exclusively intended for eating, only began to appear in Peruvian inventories in the last decades of the eighteenth century. Previously, the practice was to set up dining tables in any room according to preference or occasion. Hence, it made sense to keep fine dinnerware along with other valuables in the antechamber. As previously mentioned, the marchioness's table service included costly porcelain from China, crystal, and silver. Only wealthy individuals could afford to set such an elegant table. Servants and slaves used ordinary pottery or wooden dishes and bowls and ate in the kitchen.

Figure 5.14 Unknown artist, Platter, 1725–50, silver, Bolivia. Denver Art Museum: Gift of the Robert Appleman family, 1986.456. © Photo: Denver Art Museum.

Final Thoughts

The inventory record of the marchioness's residence gives an excellent idea of the taste of one of the most important Peruvian aristocrats of the first half of the eighteenth century. However, when in early 1762 the executors and appraisers prepared the inventory and valuation of her assets, a good portion of the listed items were described as "old" or "antique," even though most of the objects had been in her possession for only a generation. The appraisal includes numerous notes, indicating many damaged or broken pieces—some in such a poor condition that they were not appraised. The image that the document transmits is that of a luxurious dwelling that was already somewhat shabby and neglected. Undoubtedly, to the appraisers' eyes, the furniture and objects fashionable in the 1730s looked outdated. In 1760s Lima, it was fashionable to decorate furniture and objects with sinuous lines, embellished with carved rocaille, flowers, and leaves of French inspiration. This style sharply contrasted with the severity of the heavier furniture that was favored in previous decades. For example, the Spanish-style writing desks (*escritorios*), typical of late Baroque interiors—of which the marchioness had so many examples—were replaced in the 1760s by the so-called "English writing desks," what we know today as a fall-front secretaire.

Lima's excessively humid climate likely contributed to the accelerated decay of textiles such as curtains, hangings, upholstery, and rugs, particularly those woven in silk. Silk degrades rapidly in conditions of high ambient humidity. Despite the perceived image of domestic decay—we must consider the fact that due to her advanced age and widowhood, the marchioness would have largely withdrawn from an active social life—the inventory showcases opulence. She lived in a magnificent set of private rooms designed to display wealth and power to the selected guests allowed access to them.

Beyond offering us a window into the marchioness de Torre Tagle's intimate spaces, a study of her inventory makes it possible to better understand female domestic material culture in colonial Peru. The remarkable document offers a detailed survey of the types of furniture and objects women used in aristocratic houses, also indicating the location and spatial sequence of the set of rooms that composed her private quarters, important information rarely encountered in colonial documents. We can confirm that the organization, arrangement, and use of the *estrado* and bedroom of a noble house in Lima differed very little from those in Mexico City, Seville, or Madrid. This case study also confirms the gendered nature and social importance of those spaces in Spanish American houses.

Another notable aspect showcased in the inventory is the importance of religious art in the Peruvian elites' homes in the early modern colonial era. The list indicates how essential the possession of sacred images was to elites. The abundance of paintings and sculptures of religious subjects speaks to the diurnal devotional practices promoted by ecclesiastical authorities in Spanish America. They also highlight the symbolic importance of devotion, piety, and religion as elements associated with women and family status. A strong connection with the Catholic Church was important for noble families and added to their prestige and social standing. It was frequent among Peruvian elites to have family members serving the church. In the Torre Tagle family, two sons of the marchioness took the habits, Fray Ramón and Fray Juan Antonio.[31]

As was usual in high-end metropolitan domestic settings across the Spanish global empire, the marchioness's domestic decorations included an assortment of Asian and European luxury goods. The remarkable quantities of imported furniture, textiles, and objects listed in the Torre Tagle mansion reflect the circulation patterns of luxury goods throughout the vast Hispanic overseas commerce networks, and highlight Lima's importance as a commercial hub, and the massive scale and profitability of transoceanic trade. As previously mentioned, the Asian objects listed include lacquer furniture, porcelain objects, ivory carvings, and textiles. They indicate strong trans-Pacific commercial ties between viceregal Peru and the Philippines via the Manila Galleon. The marchioness also owned luxury goods imported from Europe. Spanish and Italian paintings, glass and crystal objects, and fine textiles stand out among European imports. But perhaps what is more interesting is the presence of fine objects from other regions in Spanish America. Considering trade restrictions among Spanish American territories and the complex logistics involved, it is remarkable to see listed fragile earthenware vessels from Mexico and Chile, as well as Ecuadorian textiles.

Like most elite women of her time, the marchioness of Torre Tagle was likely raised out of the public's sight. Women of her social position seldom ventured outside, perhaps only to attend mass or to pay a visit to relatives and close friends. As her will showcases, as a woman, a matriarch, and a member of the local elite, she had her family's honor, and economic and dynastic interests at heart. Her house was her kingdom, and her two different *estrados* backgrounds for social representation and daily life. The marchioness did use her *estrados* at more intimate and private moments when, one presumed, she would be alone or with family and close friends. The inventory of her *estrados* allows us to glimpse the refined atmosphere that surrounded one of the wealthiest women in Peru. The Torre Tagle *estrados* were intimate spaces where furniture and objects were both functional and decorative. They showcased the conspicuous consumption of some of the most fashionable and luxurious goods of the time, a stage for wealth and power, and the private domains of privilege to which only family, and their distinguished peers, had access.

Notes

1 Amédée François Frézier, *A Voyage to the South-Sea, and along the Coasts of Chili and Peru in the Years 1712, 1713, and 1714* (London: Jonah Bowyer, 1717), 255.

2 Sofía Rodríguez Bernis, "El Mueble Medieval," in *Mueble Español: Estrado y Dormitorio* (Madrid: Dirección General de Patrimonio Cultural, Comunidad, 1990), 42–8.

3 Frézier, *A Voyage*, 261.

4 *Inventario y tasación de los bienes de doña Rosa Juliana Sánchez de Tagle, marquesa de Torre-Tagle*, Archivo General de la Nación del Perú. Protocolos, Agustín Jerónimo Portalanza, 1761–3, fols. 312r–352r.

5 On social uses of eighteenth-century upper-class ladies and their escorts in Spain, see Carmen Martín Gaite, *Love Customs in Eighteenth-Century Spain* (Berkeley: University of California Press, 1991).

6 On Cantabrian families in Peru and their marriage practices, see Rafael Sánchez-Concha Barrios, "Los montañeses en el Perú del siglo XVIII," *BIRA: Boletín del Instituto Riva-Agüero* 23 (1996): 287–302.

7 Mark A. Burkholder, *Spaniards in the Colonial Empire: Creoles vs. Peninsulars?* (Malden: John Wiley & Sons, 2013), 104.

8 See *Relación y diario de las operaciones del navío Nuestra Señora del Carmen …* (Lima: n.p., 1725).

9 Ibid.

10 Ibid.

11 María Dolores Crespo Rodríguez, *Arquitectura doméstica de la Ciudad de los Reyes (1535–1750)* (Sevilla: Escuela de Estudios Hispano-Americanos, Universidad, Diputación, 2006), 250.

12 Ibid.

13 In addition to Tadeo José, firstborn and heir to the title, the couple's issue included Fray Ramón, María Josefa, Serafina, Francisco, José, Águeda, Rosa Isabel, Pedro, and Fray Juan Antonio. See Vicente de Cadenas Y Vicent, *Maestros de la Orden de Calatrava que efectuaron sus pruebas de ingreso durante el siglo XVIII* (Madrid: Hidalguía, 1987), IV: 571. Slaves belonging to her property are also listed and appraised in the marchioness's inventory, as was common practice in inventories of the time. That is why we know that apart from the family, a black woman named Sebastiana lived with her two children, Dominga and Severino, the black Joseph, Bernardo, *cuarterón*, Juan de Mata, *mulatillo*, the *zambo* Simón, the blacks María Rosa, Leonor, Anastasia, Juana, and another María Rosa who was the cook, all together they were valued at 3,150 pesos. This group of people constituted an important family asset; some were possibly born in the house, like the children of Sebastiana. The presence of so many slaves working in the house, surely in charge of all kinds of servitude, also helps us imagine what the bustling daily life must have been like in elite eighteenth-century Lima households. *Inventario y tasación*, fol. 341v.

14 Crespo Rodríguez, *Arquitectura*, 251.

15 Carlos Escudero Ortiz de Zevallos, "La familia Tagle Bracho en del Perú: apuntes genealógicos," *Revista del Instituto Peruano de Investigaciones Genealógicas* 20 (1994): 79–93.

16 "El conjunto de alhajas que sirve para cubrir y adornar el lugar o pieza en que se sientan las señoras para recibir las visitas, que se compone de alfombra o tapete almohadas, taburetes o sillas baxas," Real Academia Española, *Diccionario de la lengua castellana en que se explica el verdadero sentido de las voces, su naturaleza y calidad, con las phrases o modos de hablar, los proverbios o rephranes, y otras cosas convenientes al uso de la lengua …* (Madrid: Francisco del Hierro, 1732), 644.

17 María Ángeles Sobaler Seco, "Espacios femeninos en la Castilla del Antiguo Régimen. Cultura material y sociabilidad en el estrado," in *Portas adentro: comer, vestir e habitar na Península Ibérica, ss. XVI–XIX*, ed. Isabel dos Guimarães Sá and Máximo García Fernández (Valladolid: Universidad de Valladolid; Coimbra: Universidade de Coimbra, 2010), 161.

18 John Potter Hamilton, *Travels through the Interior Provinces of Columbia* (London: J. Murray, 1827), 1: 147.

19 *Inventario y tasación*, fol. 340v.

20 Ibid., fol. 338v.

21 Juan de Zabaleta, *El día de fiesta por la tarde en Madrid: y sucesos que en el pasan* (Madrid: En la imprenta de Juan de San Martín, y a su costa, 1754), 58.
22 For the Torre Tagle *estrado* section, see *Inventario y tasación*, fols. 340v–341r.
23 See Jorge F. Rivas Pérez, "Spanish Magnificence," in *Art and Empire: The Golden Age of Spain*, ed. Michael Brown (San Diego: San Diego Museum of Art, 2019), 118.
24 For case furniture and paintings lists, see *Inventario y tasación*, fols. 340v–341r.
25 For the bedroom inventory, see ibid., fols. 338v–339r.
26 María Paz Aguiló Alonso, "Mobiliario en el siglo XVII," in *Mueble Español: Estrado y Dormitorio*, ed. Sofía Rodríguez Bernis (Madrid: Dirección General de Patrimonio Cultural, Comunidad, 1990), 110–11.
27 Juan José Junquera Mato, "Mobiliario en los siglos XVIII y XIX," in *Mueble Español: Estrado y Dormitorio*, ed. Sofía Rodríguez Bernis (Madrid: Dirección General de Patrimonio Cultural, Comunidad, 1990), 146–7.
28 For the antechamber, see *Inventario y tasación*, fol. 338r.
29 Ibid., fol. 346v.
30 For the chests and their contents, see ibid., fol. 337r.
31 Cadenas y Vicent, *Maestros*, IV: 571.

Bibliography

Aguiló Alonso, María Paz. *Mueble Español: Estrado y Dormitorio*. Madrid: Dirección General de Patrimonio Cultural, Comunidad, 1990.

Burkholder, Mark A. *Spaniards in the Colonial Empire: Creoles vs. Peninsulars?* Malden: John Wiley & Sons, 2013.

Cadenas y Vicent, Vicente de. *Maestros de la Orden de Calatrava que efectuaron sus pruebas de ingreso durante el siglo XVIII*. Madrid: Hidalguía, 1987.

Crespo Rodríguez, María Dolores. *Arquitectura doméstica de la Ciudad de los Reyes (1535–1750)*. Sevilla: Escuela de Estudios Hispano-Americanos, Universidad, Diputación, 2006.

Escudero Ortiz de Zevallos, Carlos. "La familia Tagle Bracho en del Perú: apuntes genealógicos." *Revista del Instituto Peruano de Investigaciones Genealógicas* 20 (1994): 79–93.

Frézier, Amédée François. *A Voyage to the South-Sea, and along the Coasts of Chili and Peru in the Years 1712, 1713, and 1714*. London: Jonah Bowyer, 1717.

Hamilton, John Potter. *Travels through the Interior Provinces of Columbia*. London: J. Murray, 1827.

Inventario y tasación de los bienes de doña Rosa Juliana Sánchez de Tagle, marquesa de Torre-Tagle. Archivo General de la Nación del Perú. Protocolos, Agustín Jerónimo Portalanza, 1761–3, fols. 312r–352r.

Junquera Mato, Juan José. "Mobiliario en los siglos XVIII y XIX." In *Mueble Español: Estrado y Dormitorio*, edited by Sofía Rodríguez Bernis, 133–61. Madrid: Dirección General de Patrimonio Cultural, Comunidad, 1990.

Martín Gaite, Carmen. *Love Customs in Eighteenth-Century Spain*. Berkeley: University of California Press, 1991.

Real Academia Española. *Diccionario de la lengua castellana en que se explica el verdadero sentido de las voces, su naturaleza y calidad, con las phrases o modos de hablar, los proverbios o rephranes, y otras cosas convenientes al uso de la lengua … Madrid: Francisco del Hierro, 1732.

Relación y diario de las operaciones del navío Nuestra Señora del Carmen … Lima: n.p., 1725.

Rivas Pérez, Jorge F. "Spanish Magnificence." In *Art and Empire: The Golden Age of Spain*, edited by Michael Brown, 111–26. San Diego: San Diego Museum of Art, 2019.

Rodríguez Bernis, Sofía. "El Mueble Medieval." In *Mueble Español: Estrado y Dormitorio*, 23–58. Madrid: Dirección General de Patrimonio Cultural, Comunidad, 1990.

Sánchez-Concha Barrios, Rafael. "Los montañeses en el Perú del siglo XVIII." *BIRA: Boletín del Instituto Riva-Agüero* 23 (1996): 287–302.

Sobaler Seco, María Ángeles. "Espacios femeninos en la Castilla del Antiguo Régimen. Cultura material y sociabilidad en el estrado." In *Portas adentro: comer, vestir e habitar na Península Ibérica, ss. XVI–XIX*, edited by Isabel dos Guimarães Sá and Máximo García Fernández, 149–70. Valladolid: Universidad de Valladolid; Coimbra: Universidade de Coimbra, 2010.

Zabaleta, Juan de. *El día de fiesta por la tarde en Madrid: y sucesos que en el pasan*. Madrid: En la imprenta de Juan de San Martín, y a su costa, 1754.

An Artist's Bedrooms: Angelica Kauffman in London and Rome

Wendy Wassyng Roworth

Descriptions, images, and records of artist studios, galleries, academies, and social spaces provide information about where and how artists created artworks, received clients, and conducted business. Much less is known about artists' domestic spaces, especially bedrooms, although details about where an artist spent private time may help to reveal the artist as a once living person apart from their professional and public life. The most famous artist's bedroom is probably Vincent van Gogh's in his house in Arles, which he portrayed in three paintings in 1888–9.[1] The artist's narrow wooden bed, washstand with basin and jug, bottles and brushes, his clothes hanging on pegs, and portraits of his family and friends on the wall depict Van Gogh's humble, though apparently orderly, life while calling out for interpretation to understand the troubled, creative man described in biographies and letters. The poignant details of private life enhance and complicate views of the artist.

Angelica Kauffman (1741–1807) is one well-documented eighteenth-century artist who can serve as a case study in addressing issues related to an artist's bedroom. Her letters and biography provide limited but useful information about her modest bedroom early in her career in London, and the inventory of her house in Rome includes descriptions with appraisals of furnishings in her bedchamber and other bedrooms in the house that provide a glimpse into the personal lives, values, and living conditions of a celebrated woman artist, her female servants, and her devoted male cousin at the end of a long, successful, and financially rewarding life in Italy.

London

Angelica Kauffman spent several years in Italy during the early 1760s with her artist father Joseph Johann Kauffmann (1707–82) traveling in Naples, Rome, Venice, and other cities to study artworks, copy paintings and drawings, and make paintings.[2] The British travelers she met in Venice were impressed with her work and persuaded Kauffman that in Italy her fortune would always be middling, but if she ventured a trip to London, she would find generous patrons and more than words and praise.

She took their advice, and since her father planned to join her later in London, Kauffman was accompanied on the journey by Lady Bridget Wentworth, wife of John Murray, the British Resident in Venice.[3] The two women arrived in London on June 22, 1766, and within the first weeks of her arrival she had visited several artists' studios and received an introduction to Joshua Reynolds (1723–92), a prominent, influential and well-connected painter, whose praise and support helped to launch her career (Figure 6.1).[4]

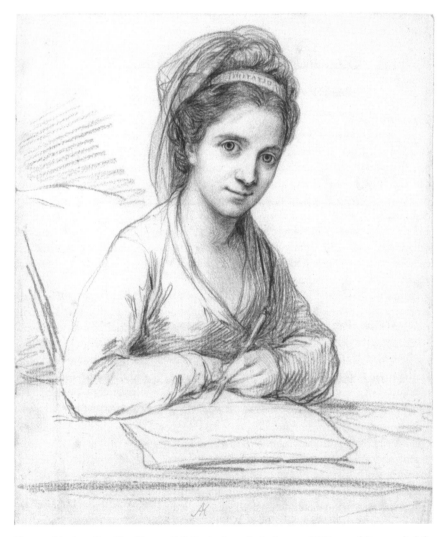

Figure 6.1 Angelica Kauffman, *Self Portrait as Imitation*, *c.* 1767, graphite on slightly textured cream laid paper, 7 7/8 × 6 5/8 inches (20 × 16.8 cm). Yale Center for British Art, Paul Mellon Collection. Public Domain.

On October 10, 1766, Kauffman described her situation in a long letter to her father.[5] She was living in lodgings in the house of surgeon Robert Home at 27, Suffolk Street, Charing Cross, and the Home family, she reported, was very kind. She gave painting lessons to Home's teenage son Robert Home (1752–1834), who went on to have a career as a painter in India, and his daughter, poet Anne Home, became a good friend and modeled for one of Kauffman's first paintings in London.[6]

Kauffman told her father she had four rooms: one for painting, one for showing her work, a little bedroom scarcely big enough for her bed, and an even smaller room to keep her clothes and trunk. She explained it was the custom in London for portrait painters to have a room to show their pictures that was separate from the room where they worked, so people could come to sit or see her paintings. She followed this practice by arranging the larger rooms for painting and display of finished work to visitors, and her tiny bedroom was just a place to sleep. There is nothing more about the bedroom, but it must have been very small if she did not even have space to keep her clothes.

A foreign woman painter newly arrived from Italy would have been an intriguing addition to the London art world, and, as Kauffman proudly related in the same letter, she had already received visits from the Dowager Princess of Wales, Countess Spencer, and other notable ladies and gentlemen. Everything was going well, though she felt restricted in her current living situation and wanted to move to larger accommodation. It was important to have a house in the right area suitable for visits from ladies and gentlemen who might be potential clients. However, she noted, London was expensive.[7]

Artists' residences in Georgian London were primarily located in the squares and streets around Soho, Covent Garden, and the neighborhood of St James Piccadilly, which were frequented by fashionable society. In addition, the locale was conveniently located near the paint and canvas suppliers and framemakers around St. Martin's Lane.[8] Most houses in these areas had a standard two-room plan with a rear wing, and painters generally took over what would be the best bedroom at the front on the first floor for their studio. The front rooms were larger and most had two windows that provided indirect, non-reflecting light, which was the best for painting, preferably facing northeast or northwest.[9]

Royal Academician James Barry, for example, used the ground floor and most of the first floor of his house on Little Castle Street near Oxford Market, for storage, painting and printmaking.[10] A room on the second floor at the back of his residence was intended as a bedroom, though the presence there of two easels, a table, chairs, and a "miserable truckle bed" suggests he used it primarily for work. Barry slept in a small, crowded garret room in a four-poster bed with two mattresses, bolster, and blanket surrounded by a variety of plaster casts and loose prints.[11] James Barry was eccentric in his old age, but, like Kauffman and other artists, space for his work was more important than a comfortable place to sleep.

Golden Square, London

By the spring of 1767, Kauffman was earning enough to lease a house at 16, Golden Square, Soho, though most foreign artists in London, including Royal Academicians Francesco Bartolozzi (1727–1815) and Giovanni Cipriani (1727–85), could only afford

rented rooms.[12] Kauffman's house was one of the larger ones in the middle of the south side of the square. The tall front windows faced north for the best light, so it is likely she used the front rooms for her painting studio and showroom. The house was large enough to accommodate her father and young cousin, Rosa Florini, who accompanied him to London, as well as her painting studio and rooms for the display of pictures and entertaining.[13] Kauffman and her father lived and worked in the Golden Square house for the next fourteen years as her career prospered. Unfortunately, there is no description of the house interior or information about her bedroom, though no doubt it was more commodious than her small, cramped chamber on Suffolk Street.

Rome

During the time she lived in England, Kauffman achieved critical acclaim and financial success, but as early as 1779 she was considering returning to Italy. Though she made a very good living in London, she missed Rome and the prospect of increased patronage, especially for history paintings. Kauffman was one of the few history painters in England, but, except for a few devoted patrons, the British were more interested in portraits than historical or literary subjects. In addition, her aging father was in poor health and wished to return to the Continent. Kauffman and her father left England on July 19, 1781, just five days after her marriage to Venetian artist Antonio Zucchi (1726–95), a painter of imaginative views of classical ruins and other decorative subjects, who had been the Kauffmanns' close friend in London for many years.[14]

The family spent several months in Venice where Johann Joseph Kauffmann's condition worsened until he died in January 1782.[15] A few months later Kauffman and Zucchi resumed their journey southwards, and as soon as they arrived in Rome they secured the services of an agent, Gioacchino Prosperi, to find a large house with fifteen rooms, a stable, storerooms, and a garden.[16] He located a suitable house at 72, via Sistina near the church of S. Trinità dei Monti at the summit of the Spanish Steps, an area where many artists lived.[17] Kauffman was pleased with Prosperi's choice and commissioned him to furnish and decorate the two upper floors for their residence, to hire servants, and make sure all would be ready for their return after a two-month stay in Naples. She left the agent to carry out her orders, which included a request for silk faille wall hangings for the *salon di conversazione*. He employed two male servants— an Italian and a German—and two women to carry out the work of the household (Figure 6.2).[18]

During the years Kauffman and Zucchi lived in the via Sistina they entertained international travelers, royalty, and other dignitaries, as well as writers, artists, and friends. She was constantly employed on commissions for portraits and history paintings. Zucchi had suffered from a tremor for many years, and as his physical condition deteriorated Angelica's cousin Johann Kauffmann (1751–1829) came from Schwarzenberg, the Kauffmann family's home village, to live with them in 1792 (Figure 6.3).[19]

After Zucchi died in December 1795, Johann took over the household as well as his cousin's business affairs, responsibilities Zucchi had previously handled, until Angelica passed away on November 15, 1807.

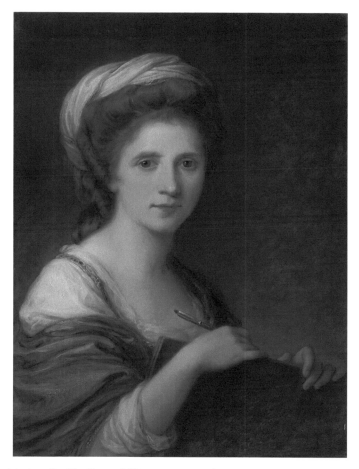

Figure 6.2 Angelica Kauffman, *Self Portrait*, 1784, oil on canvas, 64.8 × 50.7 cm. Bayerische Staatsgemäldesammlungen - Neue Pinakothek München (CC BY-SA 4.0).

Johann Kauffmann was the primary heir to Kauffman's estate and served as one of three executors who commissioned an inventory of the contents of her house that was conducted by Filippo Romagnoli over several days in January, 1808, less than two months after her death.[20] The brief descriptions and appraisals of furniture and household items provide evidence of Kauffman's wealth and comfortable circumstances. The salon, for example, was lavishly furnished, including a pianoforte brought from England, and the walls were covered with green faille, the ribbed silk material she had ordered when they first came to Rome or possibly a similar later replacement.[21]

Inventories can reveal aspects of bourgeois life and values through appraisals of furniture and other items. For example, assorted fabrics of silk, cotton, and other materials Kauffman used for draping mannequins were valued together at 50 *scudi*, while a large Brussels tapestry was only worth 6 *scudi*. Kauffman's books included five volumes of Giuseppe Vasi's *Le Magnificenze di Roma* valued at 5 *scudi*, while a single

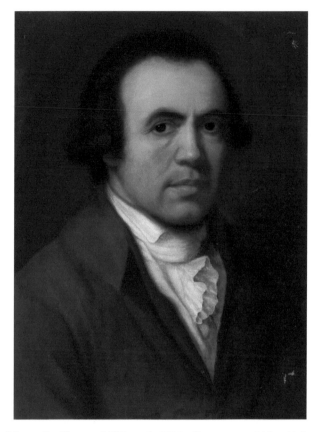

Figure 6.3 Johann Kauffmann, *Self Portrait*, 1793, oil on canvas, 56.8 × 43.3 cm. Angelika Kauffmann Museum, Schwarzenberg (Inv. 2166).

volume of engravings after Raphael's paintings was worth three times as much for 15 *scudi*. Two small tables of Sicilian jasper with carved and gilded feet, one with a low relief profile head in marble, were appraised together at 11 *scudi*. In comparison, a male servant's bed with two mattresses, sheets, and quilted cover was worth almost as much at 10 *scudi*.

Angelica Kauffman's Bedroom

Kauffman's bedroom, according to the inventory, was next to the dining room.[22] The room had two windows with drapes of bombazine (*bambacina*), a heavy mixed fabric of silk and worsted wool, and the window bays provided recesses for a small dressing table in one and a washstand with a bowl in the other. A scallop front chest of drawers between the two windows contained various pieces of clothing, towels, and other items the deceased left to her female servants. Near the room's entrance there was a half

bureau (*mezzo burrò*) and a writing desk with small drawers containing miscellaneous items: paste jewelry, various cards and letters, and a packet of *piastre* (Neapolitan silver coins) (Figure 6.4). A copper pot for boiling water to brew tea was on top of the bureau next to a small terracotta jar "like those of the *Etruschi di Napoli*," a reference to the ancient vases excavated near Naples and illustrated in William Hamilton's *Collection of*

Figure 6.4 Angelica Kauffman inventory, Bedroom, p. 18. Getty Research Institute, Los Angeles (890237).

Etruscan, Greek, and Roman Antiquities (Naples, 1766–76) (Figure 6.5).[23] Kauffman's interest in classical antiquity can be seen in her paintings and engravings as well as the books she owned, which included seven volumes of the *Antichità di Ercolano*, valued at 21 *scudi*, with engravings and description of frescoes, bronzes, statues, and other objects excavated at Herculaneum, Pompeii, and other sites around the bay of Naples.[24] Additional items for her comfort included a small box with jars for medicines (*cassetta per Speziaria*) and a lamp for the bed (Figure 6.7).

Figure 6.5 Angelica Kauffman inventory, Bedroom, p. 19. Getty Research Institute, Los Angeles (890237).

Kauffman's iron bedstead had two mattresses and heavy bombazine bedcurtains to keep out drafts. Her bedclothes included two green satin bedspreads, two muslin (*lenzole di pelle*) sheets, another curtain of *panno verde* (pressed wool), and additional linens kept in a corner cupboard of white poplar. A folding screen created a private area for Kauffman to undress, and a large sideboard (*credenzone*) behind the screen was used to store some of her clothing. Two ordinary mattresses in poor condition "used by the coachman," may have been brought into the room after Kauffman died for a servant's use (Figure 6.6).[25]

Figure 6.6 Angelica Kauffman inventory, Bedroom, p. 20. Getty Research Institute, Los Angeles (890237).

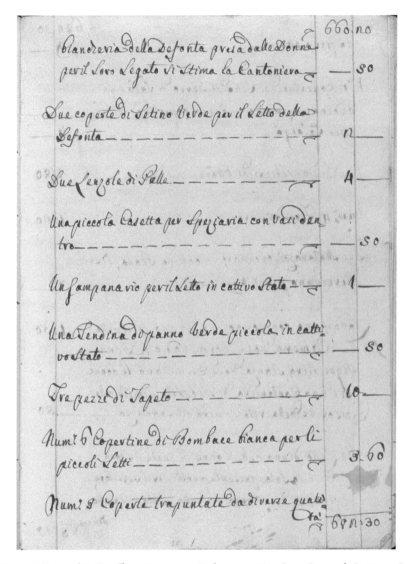

Figure 6.7 Angelica Kauffman inventory, Bedroom, p. 21. Getty Research Institute, Los Angeles (890237).

Kauffman's bedroom must have been fairly large, for in addition to the partitioned space and other furniture, there were five cane chairs and two armchairs with cushions of bombazine and *"galanga"* (Figure 6.8). The term *galanga* appears elsewhere in the inventory, sometimes capitalized, to identify a type of cloth, such as Kauffman's bedspread of ordinary *"Galangà"* in a cover of the same *"Galangà."*[26] *Galanga* appears to have been the Italian term at that time for calico, a plain-woven cotton textile

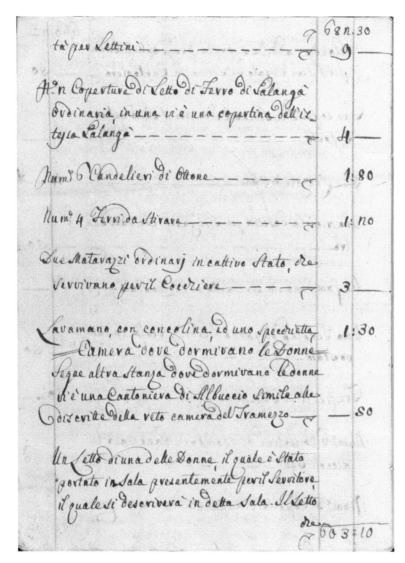

Figure 6.8 Angelica Kauffman inventory, Bedroom and Women's Bedroom (bottom of page), p. 22. Getty Special Collections (890237).

imported to Europe from Calicut (modern Khozhikode), India, a center for the cotton trade. The word *galanga* derives from the Asian plant *Alpinia galanga*, the source of a yellow, yellow-green, or yellow-brown natural dye used for printing calico.[27]

Two puzzling entries in the bedroom inventory refer to *piccoli letti*, little beds: "six white covers of twill fabric for the little beds" and "three quilted blankets of varied quality for the little beds" appraised for a total of 12.60 *scudi*, more than Kauffman's own bed, bedcurtains, and mattresses that valued together at 12 *scudi* (Figure 6.7).[28]

Piccoli letti, little beds, may refer to dog beds, and small lap dogs were popular pets for ladies. However, while the appraisal included blankets and covers for "little beds," there are no *piccoli letti* in the bedroom inventory nor are there any references to dogs in Kauffman's letters, biographies, or visitors' accounts, so such an idea must remain speculation.

The only artworks in the bedroom inventory were three small painted sketches in oval format, though there may have been more sketches or paintings that had been removed by the executors. Additional items in the bedroom included a commode with a wood veneer, a small washbasin and mirror, six brass candleholders, and four irons.

The Women's Room

A room adjacent to Kauffman's bedroom was for her maids: "*camera dove dormivano le Donne*," the room where the women slept (Figure 6.8).[29] This bedroom, next to their mistress's room, appears to be have been more comfortable, better lighted, located, and furnished than typical servants' quarters. There were two windows with curtains and a dresser between them with a mirror in a simple tin frame. A large cupboard or dresser made of beechwood similar to the one in Kauffman's bedroom held additional items.

There was only one bed in the room, which, according to the inventory, was one of the women's beds that had been brought into the room for, "*il servitore*," a male servant, for his use while the inventory was being conducted.[30] There is no appraised value for this bed because, as the inventory notes, it was a bequest to the servant together with the bedlinens and blankets. Based on appraisal of other beds in the house it would have been worth close to 10 *scudi*. This *servitore* must have been Kauffman's long-serving manservant Antonio Brandimarte, who was bequeathed his bed and 1,000 *scudi romani* in Kauffman's will.

A second bed, the inventory notes, had already been removed by the servant who received it as a bequest. This servant was Maria Pericoli, who looked after Kauffman for about thirteen years. Maria's devoted care was additionally rewarded with 1,000 *scudi romani*, as well as her bed, pillow, blankets, and sheets.[31] In addition, she received half of Kauffman's personal linen and clothing. Kauffman's housekeeper inherited the other linens and 25 *scudi* for each year of her service. Kauffman's generous bequests to servants suggest she remembered her own humble beginning and ensured her long-serving domestic retainers lived comfortably and were well compensated after her death.

The women's room was decorated with four painted sketches in oval format and two small empty frames which may have once held additional sketches by Kauffman. The most interesting picture "attached to the wall" was a large drawing on "*carta da Imperatore*," that is, paper approximately 50 × 40 inches, of a *Deposition* in ruined condition.[32] This may have been one of the drawings Kauffman acquired in 1787 when she purchased a painting of Christ at the sepulcher from the monastery of Santa Maria della Popolo in Rome as an investment in partnership with her friend, artist Wilhelm Tischbein. They believed the painting was by Daniele da Volterra, a much admired artist in the eighteenth century, though it was actually by sixteenth-century painter Jacopino del Conte, a picture variously described as a *Deposizione*, *Pietà*, or

Trasporto alla Sepolcro.[33] The painting actually represents Christ at the sepulcher, "*Cristo al Sepolcro*," as noted in Kauffman's account of expenses.[34] In the foreground Christ's limp body is supported upright by Nicodemus and two soldiers next to the Madonna fainting in the arms of two women. The cave with burial chamber appears in the background. Kauffman, the only one among her artist friends who could afford the 1,000 *scudi* the monks demanded, paid for the painting along with an additional 200 *scudi* for the artist's large-scale drawings "in poor condition." The following year she paid Tischbein the same amount so she could gain full ownership. In spite of her vow to keep this treasured painting forever, she sold it to King Ferdinand IV of Naples in 1802. The king's agent, Domenico Venuti, asked Antonio Canova to persuade his friend Kauffman to part with the *Deposizione* by Daniele da Volterra, and she reluctantly agreed to the sale only because it was for King Ferdinand.[35] It is likely the damaged drawing of a *Deposizione* in the women's bedroom was one of the "Daniele da Volterra" drawings. Despite its poor condition, it served as a devotional image for the women.

The descriptions and appraisals in Kauffman's bedrooms and the room for her women servants, along with bequests in her will, reveal that beds, bedlinens, quilts, and blankets were highly valued items, even those for the *piccoli letti*, the presumed dog beds, in early nineteenth-century Rome.

The Room Next to the Women's Bedroom

This room was used to store additional bedlinens and cloth items used in the dining room and kitchen, including those inherited by Maria Pericoli and other servants. Nine fine damask tablecloths of various sizes were kept in two large sideboards, and a smaller sideboard held ordinary tablecloths for everyday use, forty-one napkins, and eleven towels. A chest of drawers provided storage for more tablecloths, napkins and towels in poor condition, dishcloths, tea towels, bedsheets, and slipcovers.[36]

The large number of table linens suggests Kauffman's dinner parties held in the dining room on the other side of her bedroom must have been frequent and well attended. She had many friends, particularly artists, poets, and writers, who would have been among the guests surrounded by Kauffman's portraits of friends and family on the dining room walls.[37] The inventory of paintings in storage included her portraits of artists Antonio Canova and Johann Friedrich Reiffenstein, *improvvisatrici* Teresa Bandettini and Fortunata Fantastici, her father Joseph Johann Kauffmann, Antonio Zucchi, and his nephew Dr. Francesco Zucchi.[38] The proximity of the dining room to Kauffman's bedroom suggests she would have received some of her friends, at least her women friends, in her private room, a common practice among intimate acquaintances in the eighteenth century.

Johann Kauffmann's Room

The inventory of Johann's bedroom, "*Camera del Sig^re Giovanni*," did not include appraisals because, as noted, everything was given to him by Kauffman during her life.[39] There is no mention of windows or drapes, and the room was simply furnished

for his personal needs. Johann's iron bedstead had bombazine twill bedcurtains, and there were two chests of drawers, a trunk, a little ordinary dressing table, a washstand, mirror, and *una cassetta di commodo*, a nightstand. A walnut sideboard (*credenza*) with little doors and windows would have been used to store documents and small personal items. This may have been the same piece of furniture as, or one similar to, a bureau or desk Kauffman purchased in Rome on November 1782, described in the *Account of Expenses* as a used bureau with small drawers in the lower half and little doors and windows in the top part.[40]

There were five ordinary chairs in Johann's bedroom, but no armchair or sofa, and only one framed print whose subject was the crucifixion. This may have been the engraving in Angelica Kauffman's collection by Gérard Edelinck (1640–1707) after Charles LeBrun's 1661 painting of the *Crucifixion with Angels*, a notable work.[41] The most significant item in Johann's room was a marble bust of his famous cousin executed by the Irish sculptor Christopher Hewetson (1737–99) in 1795/6 (Figure 6.9).[42]

After Kauffman's death, Johann remained in Rome, where he was a print dealer and collector until his death on March 6, 1829 at the age of seventy-eight. He occupied an

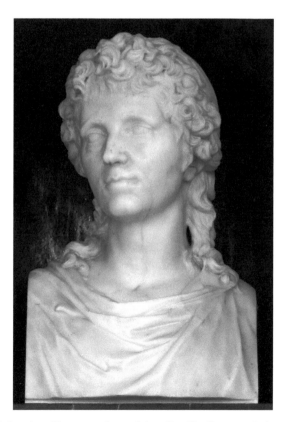

Figure 6.9 Christopher Hewetson, Bust of Angelica Kauffman, 1795/6, marble, 56 cm, Parish church, Schwarzenberg, Austria. © Photo: Andreas Praefke on 2010-06. CC 3.0.

apartment on the top floor in a house at 47, via di San Nicola Tolentino, a few hundred meters up the hill from the Piazza Barberini. His will and death inventory included the artworks left to him by Angelica in addition to many more paintings, drawings, and prints. His estate was divided between two nephews, his brother's son Johann Kauffmann, designated as "*Giovanni juniore*" in the estate documents, and Alessandro Ramerio, his younger sister's son, who stayed with his uncle during the latter's final illness and inherited his furniture. Johann, *Giovanni juniore*, received several artworks originally from Angelica Kauffman's collection, including the Hewetson bust and a framed oval late self-portrait painted *c.* 1802 (Figure 6.10).[43] *Giovanni juniore* took both artworks when he returned to Schwarzenberg, where the bust was installed in the parish church over an earlier 1809 memorial epitaph dedicated to the deceased painter by her friends.[44]

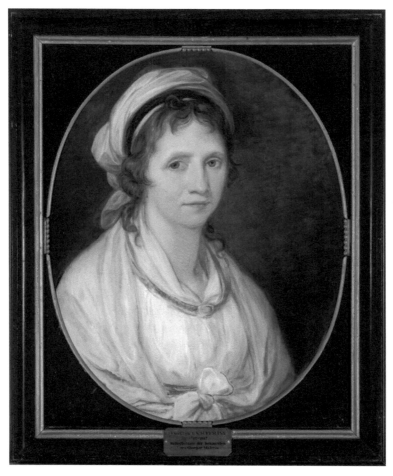

Figure 6.10 Angelica Kauffman, *Self-Portrait*, *c.* 1802, 63.3 × 51.5 cm. © Vorarlberg Museum Bregenz/Austria, Markus Tretter.

Johann Kauffmann's Bedroom, 1829

Johann's bedroom was furnished to accommodate the needs of an elderly and probably infirm gentleman. His bed was a *canapè di ferro*, a divan with wooden wheels (*Rote di legno*), a canvas-covered straw mattress, two ticking mattresses and cushions stuffed with wool and covered with tassels or fringe. His bedding included cotton and linen sheets, eight cotton covers, two of muslin, and one of calico (*tela di Galangà*). A small, veneered commode near the bed held a majolica urinal (*orinale di majolica*), a crystal flask, and a glass. A table covered with a German carpet had drawers that contained four copper plates, two primed for painting and two left untreated (*grezzi*). A large mirror in a black wooden frame with gold filigree hung on the wall along with two crucifixes, one of brass and one of wood.

A sideboard with shelves held various crystal carafes, beakers, two small earthenware vessels, and other trifles (*bazzecole*), and on a bureau a small storage box with a brass handle contained three jars for tea and coffee. Other furniture included a dressing table with a mirror, a veneered bureau, and an armoire filled with clothing. There were only two chairs in the room, both with cane backs and only one with arms, which suggests he did not receive many visitors.[45] Johann Kauffmann's bedroom was suitable for the needs of a well-off, pious old man who lived in a retired manner.

Angelica Kauffman and Rosalba Carriera

During the quarter century that Kauffman lived in Rome, she was almost always working or entertaining clients and friends, though she would have found time to be alone in the quiet privacy of her bedroom seated comfortably in an armchair or at her writing desk with a cup of tea. Her situation may be compared with another successful eighteenth-century woman artist, Rosalba Carriera (1673–1757).[46] The inventory of Carriera's house on the Grand Canal in Venice suggests that she also had a large, well-furnished bedroom, most likely a chamber on the second floor facing the canal.[47] There were two wardrobes with drawers for her clothing, a bureau and a mirror in four pieces with a crest, a writing desk, a small table, and a stool. Two walnut chairs, a small armchair, and two sofas with flounces provided seating for herself and friends. Carriera's bed had two mattresses, one of wool and one of feathers and straw. Her commodious bedroom had enough wall space to display four pastels and nineteen oil paintings of varying sizes. Unfortunately, we do not know the subjects of these works, but it is likely they were portraits of friends and possibly some made for her own pleasure.

The furniture and other items in Carriera's and Kauffman's bedrooms suggest that both women used their rooms as private sitting spaces, boudoirs as well as bedrooms, to spend time reading, writing, perhaps sketching, and informal visits with close friends. In contrast, Johann Kauffmann's room in his cousin's house, as well as his bedroom in his later years, did not seem as comfortable or suitable for visitors. This may have been his personal preference as a busy, serious, and apparently devout man, but there were

also different expectations for privacy and sociability for women. Angelica Kauffman's bedroom, as well as Carriera's, may not have been typical for artists, even other women artists, but as wealthy celebrities and independent professionals, both were able to enjoy comforts earned through their own labor in the style of well-off bourgeois and aristocratic ladies.

The contents of Kauffman's bedroom and the other bedrooms in her house reveal not only her affluence and taste for fine furnishings but also her generosity and concern for the comfort of others in her household. She was proud of her achievements, which had not always been easy to accomplish. She stated in her will:[48]

> All I possessed of having been acquired by my Labour having wholly dedicated myself to the Study of Painting from my Infancy it is perfectly fit for me to dispose of the fruits of my Labours to distinguish and benefit … those who either by Duty or attention to me deserve to be so distinguished …

In November 1807, as Kauffman lay dying in her bedroom, she asked her cousin Johann to read aloud to her Christian Gellert's spiritual ode for the infirm, *In Krankheit*:[49]

> I have felt happiness in good hours / life's happiness; and joys without number: / so I will then let go / I also feel suffering / What life does not have its torments?

She had overcome the obstacles, gossip, and criticism women artists faced in the eighteenth century, but with persistence, along with talent, she earned acclaim and income to support her father, husband, cousin, and servants. Kauffman practiced her profession and lived on her own terms, which included a large well-furnished bedroom that served as both a private retreat away from her studio and a space for intimate companionship.

Notes

1 These paintings were the subject of an exhibition at the Chicago Art Institute in 2016, https://www.artic.edu/exhibitions/1865/van-gogh-s-bedrooms (accessed March 21, 2021).

2 Joseph Johann Kauffmann, like other members of the extended Kauffmann family, spelled his last name with two "n"s. Angelica Kauffman dropped the final "n" early in her career and always signed her paintings, etchings, and letters as "Kauffman."

3 Giovanni Gherardo De Rossi, *Vita di Angelica Kauffmann, pittrice* (Florence: Molini Landi e Comp, 1810), 23. Bridget, Lady Wentworth (1714–74) retained her title as the widow of her first husband Sir Butler Cavendish Wentworth (1709–41).

4 De Rossi, *Vita*, 24–5; Letter from Angelica Kauffman in London to her father in Schwarzenberg, Austria, July 12, 1766 in Waltraud Maierhofer, ed., *Angelica Kauffman, "Mit traümte vor ein paar Nächten ich hätte Briefe von Ihnen empfangen" Gesammelte Briefe in den Originalsprachen* (Lengwil am Bodensee: Libelle Verlag, 2001), 14.

5 Maierhofer, *Angelica Kauffman*, 16–18.

6 Anne Home Hunter (1742–1821) married surgeon John Hunter in 1771. Kauffman's painting of Anne as a mourning figure with an urn was the model for her 1767 etching with verses by Anne Home that was engraved in 1774 by W. W. Ryland with the title *In Memory of General Stanwix Daughter who was Lost in her Passage from Ireland.*

7 Maierhofer, *Angelica Kauffman*, 17.

8 Giles Walkley, *Artists' Houses in London 1764–1914* (Aldershot, UK and Brookfield, VT: Scolar Press, 1994), 5; Stacey Sloboda, "London," in *Hogarth and Europe*, ed. Martin Myrone and Alice Insley (London: Tate Publications, 2022).

9 Walkley, *Artists' Houses*, 7.

10 Michael Phillips, "No. 36 Castle Street East, a reconstruction of James Barry's house, painting, and printmaking studio and the making of *The Birth of Pandora*," *British Art Journal* IX, no. 1 (2008): 15–27. The manuscript inventory of Barry's house is in the Walpole Library, CT.

11 Phillips, "No. 36 Castle Street East," 17–19.

12 Walkley, *Artists' Houses*, 8.

13 Rosa Florini (1755–1812) married architect Joseph (Giuseppe) Bonomi (1739–1808) in 1775.

14 De Rossi, *Vita*, 53.

15 De Rossi, *Vita*, 55.

16 Gioacchino Prosperi in G. Castellani, "Gli ultimi 26 anni di Angelica Kauffmann in Roma, 1781–1807," *Strenna dei romanisti* 27 (1966): 75–9.

17 See Wendy Wassyng Roworth, "'The Residence of the Arts:' Angelica Kauffman's Place in Rome," in *Italy's Eighteenth Century: Gender and Culture in the Age of the Grand Tour*, ed. P. Findlen, W. W. Roworth, and C. M. Sama (Stanford: Stanford University Press, 2009), 159–66.

18 Prosperi in Castellani, "Gli ultimi 26 anni di Angelica Kauffmann," 77; Friedrich Noack, *Deutsches Leben in Roma, 1700 bis 1900* (Stuttgart, 1907), 367.

19 De Rossi, *Vita di Angelica Kauffmann*, 86. On her relationship with her cousin, see Roworth, "Die römischen Jahre: Angelika Kauffmann und ihr Vetter Johann Kauffmann," *Angelika Kauffmann: Residenz Rom* (Schwarzenberg: Angelika Kauffmann Museum, 2015), 12–29.

20 Filippo Romagnoli, *Descrizione di tutto ciò, che vi è rinvenuto nell Abitazione ritenuta dalla defonta Angelica Koffman* [sic] *e chè come spettante all' Eredità della Medesima*, Papers relating to the estates of Johann Kauffmann and Angelica Kauffmann, 1808–29, manuscript in Getty Research Institute, Special Collections (890237): Johann Kauffmann's inventory pages are numbered consecutively; Angelica Kauffman's inventory pages are not numbered. I cited her page numbers for convenience. Roworth, "The Angelica Kauffman Inventories: An Artist's Property and Legacy in Early Nineteenth-Century Rome," *Getty Research Journal* no. 7 (2015), 157–68.

21 Kauffman inventory, 16–21.

22 "*Segue altra Camera del Letto della Defonta*," inventory, 16.

23 "*Sopra del Medemo un vaso di Rame per fare bullire l'acqua per fare il Tè ed altra piccolo vaso di Terra cotta à somiglianza di quelle Etruschi di Napoli*," inventory, 17.

24 "*Num° 7 Tomi delle Pitture Antiche dell' Ercolano compreso il Catalogo due de medemi di Bronzo.*" Other books with engravings of ancient monuments and views in Rome included works by Francesco Piranesi, Tommaso Piroli, Giuseppe Vasi.

25 "*Due matarazzi ordinarj in cattiva stato, che servivano per il Cocchiere*," inventory, 21.

26 *"Due Poltrone parimenti di paglia con cuscino di Bambacina o sia galanga ...,"*
 inventory 19; *"copertura di Letto di Ferro di Galangà ordinaria in una copertina dell'*
 istessia Galangà," inventory, 20.

27 On *Alpinia galanga* as the source of dye for printing calico, see S. B. Gokhale,
 A. U. Tatiya, S. R. Bakliwal, and R. A. Fursule, "Natural Dye Yielding Plants in India,"
 Natural Product Radiance 3, no. 4 (July–August 2004): 229; and B. Sutradhar, D. Deb,
 K. Majumdar, and B. K. Datta, "Traditional Dye Yielding Plants of Tripura, Northeast
 India," *Biodiversitas* 16, no. 2 (October 2015): 123. I wish to thank Nancy Britton,
 Conservator Emerita, Metropolitan Museum of Art and Professor Linda Welters,
 Department of Textiles, Fashion Merchandising and Design, University of Rhode
 Island for their help identifying *"galanga."*

28 *"Num: 6 Copertine di Bombace bianca per li piccoli Letti," "Num: 3 Coperte trapuntate*
 da diverse qualità per Lettini," inventory, 20.

29 Inventory, 21–2.

30 *"Un Letto di una delle Donne, il quale è Stato portato in Sala presentemente per il*
 Servitore," inventory, 22.

31 Kauffman's will dated June 17, 1803 with 1807 codicil is in the Vorarlberger
 Landesarchiv, Bregenz (Oberamt Bregenz, 394). Italian and English translations from
 the original Latin are in the Public Record Office, London, Prob 1/76, proved July 5,
 1805.

32 *"Attacato al Muro vi è un disegno in carta da Imperatore di una deposizione di Croce*
 guastato," inventory, 22.

33 The Jacopino del Conte painting is now in the Musée Conde, Chantilly (PE5). See
 Antonio Vannugli, "La Pietà di Jacopino del Conte per S. Maria del Popolo: dall'
 identificazione del quadro al riesame dell' autore," *Storia dell' Arte* 71 (1991): 59–93,
 especially 65 on Kauffman's acquisition of the painting. Johann Wolfgang von
 Goethe, *Italian Journey*, June 16, 1787, translated by Robert R. Heitner (Princeton:
 Princeton University Press, 1994), 278, described the transaction for a painting of
 "Christ at the Sepulcher."

34 Kauffman's *Account of Expenses*, fol. 17v, November 11, 1788 (British Library, Egerton
 MS 2169) recorded her payment to Tischbein for his share of their partnership,
 including 200 *scudi* for the drawings, so she could have sole ownership.

35 Vannugli, "La Pietà di Jacopino del Conte per S. Maria del Popolo," 64–5. The
 painting by Jacopino del Conte has been identified as a *Deposizione*, *Pietà*, or
 Trasporto alla Sepolcro, 59.

36 Inventory, 22–3.

37 *"Num:4 ritratti in tela da testa copie di rittratti di amici della Defonta*
 Num:6 piccoli fondi circa mezzo palmo con ritrattini in cera," inventory, 17.

38 Inventory, 37–46.

39 *"Tutta la descritta Robba è Stata Regalata dalla Defonta in sua Vita,"* inventory, 26.

40 *"Credenza di Noce con sportelli e tiratore,"* inventory, 25; Account of Expenses, Roma,
 li 16 (1782): *"un Buro usato, parte inferiore con tirattori e parte superiore con portelli e*
 cristallii."

41 Johann Kauffmann oversaw the sale of Kauffman's art collection. The Edelinck
 Crucifixion was purchased by Luigi Fabri in 1813. Account of Expenses, sales
 (unpaginated), 16 *gennaro* 1813.

42 De Rossi, *Vita*, 105, note. See Oscar Sandner, *Angelica Kauffman e Roma*, Accademia
 di San Luca (Rome, 1998), 104.

43 Johann Kauffmann inventory, 27: "*un Busto in Marmo statuario rappresentante la defonta Madam Angelica lasciato in Legato dal Testatore al Sig. Giovanni Kaufmann Giuniore suo Nipote*" and 93: "*un quadro di misura di palmi tre per alto in forma ovale, con cornice dorata ed intagliata moderna, rappresentante un Ritratto che fù asserito di Madama Angelica lasciato in Legato al detto Sig. Giovanni Kaufman Giuniore.*"

44 De Rossi, *Vita*, 105, note; Claudia Helbok, *Miss Angel, Angelika Kauffmann, Eine Biographie* (Vienna: Verlag Brüder Rosenbaum, 1968), 284, n. 24; Sandner, *Angelica Kauffmann e Roma*, 104. The self portrait is in the Vorarlberg Museum, Bregenz, and Gemeinde Schwarzenberg (inv. Gem. 2868).

45 Johann Kauffmann inventory, 58–75.

46 Angela Oberer, *The Life and Work of Rosalba Carriera, the Queen of Pastel* (Amsterdam: University Press, 2020).

47 Lino Moretti, "Rosalba Carriera: l'inventario dei suoi beni e alcuni minuzie marginali," *Arte Veneta* 68 (2012): 308–19; see Oberer, *Life and Work*, 259–71, on Carriera's house in Venice.

48 On Kauffman's will, see note 31.

49 De Rossi, *Vita*, 103–4; Christian Fürchtegott Gellert (1715–69), *Geistliche Oden und Lieder* (Leipzig: M. G. Weidmanns, Erben und Reich, 1757), 128–9. "Ich hab in guten Stunden/Des Lebens Glück empfunden;/Und Freuden ohne Zahl:/So will ich denn gelassen/Mich auch in Leiden fassen;/Welch Leben hat nicht seine Quaal?"

Bibliography

Castellani, G. "Gli ultimi 26 anni di Angelica Kauffmann in Roma, 1781–1807." *Strenna dei romanisti* 27 (1966): 75–9.

De Rossi, Giovanni Gherardo. *Vita di Angelica Kauffmann, pittrice*. Florence: a Spese di Molini, Landi e Comp., 1810.

Maierhofer, Waltraud, ed. *Angelica Kauffman, "Mit traümte vor ein paar Nächten ich hätte Briefe von Ihnen empfangen" Gesammelte Briefe in den Originalsprachen*. Lengwil am Bodensee: Libelle Verlag, 2001.

Moretti, Lino. "Rosalba Carriera: l'inventario dei suoi beni e alcuni minuzie marginali." *Arte Veneta* 68 (2012): 308–19.

Romagnoli, Filippo. *Descrizione di tutto ciò, che vi è rinvenuto nell Abitazione ritenuta dalla defonta Angelica Koffman [sic] e chè come spettante all' Eredità della Medesima*. Papers relating to the estates of Johann Kauffmann and Angelica Kauffmann, 1808–29, Getty Research Institute, Special Collections (890237).

Roworth, Wendy Wassyng. "The Angelica Kauffman Inventories: An Artist's Property and Legacy in Early Nineteenth-Century Rome." *Getty Research Journal* 7 (2015): 157–68.

The Mask in the Dressing Room: Cosmetic Discourses and the Masquerade Toilet in Georgian Print Culture

Sandra Gómez Todó

Women's increasing presence in the public and entertainment spheres of urban London during the seventeenth century led to growing concerns about their "true" nature, particularly the relationship between this "authentic" character and their appearance. The controversial use of makeup and varied cosmetics among women from different social classes only heightened social anxiety about the legibility of their countenance and the possibilities for deception that such a "cosmetic mask" might constitute. In fact, masks not only became a frequent trope in the anti-cosmetic literature of the period to allude to the deceitful veil created by face painting, but were also popularized as fashion accessories in different spaces of urban life. Both metaphorical and physical masks encoded a vast array of often ambivalent ideas concerning the definition of female identity that ranged from deception and moral corruption to fashionability and cultural legitimacy. The vitriolic arguments against women's use of masks and makeup, generously nurtured by state and religious institutions, did not prevent their usage from reaching new heights during the eighteenth century.

Women's appearance and self-fashioning were consumed, read, and displayed in many of the urban spaces and venues that satisfied society's taste for public entertainment, like pleasure gardens, theaters, and, especially, masquerades. Women's attendance at London's masked balls, an essential element of Georgian entertainment culture and sociability, required an elaborated ritual of beauty and sartorial preparations, which took place in the intimacy of the dressing room. This ambiguous room, which could function as a strictly private space or as a privileged semi-public place of reunion, depending on the moment of the day and the activity taking place, acquired a key status within English domestic interiors as the century advanced, and became the daily scenario for beautifying rituals and other female pastimes. Even if upper-class men tended to have a similar space, the representation or discussion of the dressing room—often called boudoir, as a result of French influence, or "a lady's closet"—came to be closely associated with female identity and cosmetic practices. While the morning toilet became the most depicted and discussed of such practices,

having received significant scholarly attention as a result, this chapter focuses on a later part of the day: the masquerade toilet, typically performed in the evening hours.[1]

The ritual entailed a combination of makeup and sartorial choices, crafted usually in private with the help of a maid, to dazzle London's masquerade-going public. This masquerade toilet turned into a popular subject for pictorial representations, especially satirical prints, in which the space of the dressing room and its material surroundings acted as the catalyzers for a woman's creation of her masquerade persona and projection of her identity and self-fashioning. In such depictions, physical masks are prominently displayed not only as a reference to the masquerade itself, but as a powerful index of the cultural narratives and expectations that tied women's beauty rituals and masking with their alleged natural inclination towards disguise, vanity, and deceit. After tracing the origins of such discursive relations between masks and cosmetics in the early modern debate, this chapter analyzes the representation of the masquerade toilet and the dressing room in relation with the discourses surrounding women's self-fashioning and beauty practices. Such analysis will offer clarity on how print culture's rendering of the masquerade toilet and the dressing room replicated deeply rooted beliefs on female nature and deception, keeping in mind that such biting discourses responded mainly to women's increasing agency in Georgian society, often irradiated from the space of the dressing room as a major sphere of female influence.

"Women are books, and men the readers be:"[2] Masking and Deceit in the Early Modern Cosmetic Debate in England

The early modern discourse on women's mastery of the cosmetics arts was an essential portion of the period's social, philosophical, and religious project to regulate prescriptive ideas of womanhood. Patricia Philippy divides this corpus into two coexisting textual traditions that promulgated opposing ideas about cosmetic practices. Instructional manuals contained recipes for a variety of beautifying and healing concoctions which encouraged women to modify their appearance and comply with the defined ideals of female beauty.[3] Alongside these didactic texts, moralizing treaties authored by numerous polemists, theorists, and moralists continued to elaborate on the arguments of the early Christian fathers, condemning those women who decided to change their God-given appearance and countenance.[4] As Philippy states, ultimately the goal of both textual genres was the same: women's compliance with men's dictated ideals of femininity, either physical or ethical, and the promulgation of women as "flawed, corrupt, and corrupting" beings.[5] The conflict between nature and artifice was another of the main lines in the debate. Usage of the cosmetics arts conferred women with the status of creators of their own image, one based in artifice. Frances E. Dolan explains how many of these texts underscored women's refusal to accept God's creation and their determination to remake their own countenance.[6]

Even if anti-cosmetic rhetoric associated these customs with prostitutes and corrupt women, both masks and makeup operated as widespread markers of social class and rank among aristocratic women at court. A beautiful female complexion was

associated with the whiteness of the skin and redness of cheeks and lips, respectively signs of purity and youthful innocence and modesty. Both colors, along with blue vein-painting and black beauty patches to accentuate the skin's pallor, came to encode the ideal of female beauty until the final decades of the eighteenth century.[7] These ideals, however, translated into the use of products that resulted from chemical and organic ingredients that yielded dramatically toxic results. Lead-based white pigments (ceruse) were spread throughout face, neck and upper chest, and vermillion, fabricated from cinnabar or mercury sulfide, was generously applied to cheeks and lips.

This combination of white and red did not respond exclusively to a beauty ideal, but was also an essential aspect of a woman's social legibility. The popularization of cosmetics led to increasing anxiety about the falsity of bodily class markers, as well as of women's outer expressions.[8] Men's consumption of women's outward appearances had reached new levels during the Restoration period, when the exterior of the female body and the looks of its attire were deemed symbols in need of interpretation. The legibility of women's appearance, as determined by Will Pritchard, was both a source of pleasure and concern for male society.[9] Early modern imagination conceived the human countenance not only as a readable text but also as the most trustworthy sign of an individual's inner workings.[10] Hence, Restoration society relied on the readability of the female face as a way to monitor, foresee, sanction, and constrain women's behavior. Their cosmetic and fashionable use of both makeup and vizard masks altered such readability, which allowed women to conceal or change their appearance at will.[11]

"His majestie & the Gallants standing about her:" Contextualizing the Practice of the Female Toilet and its Early Visual Representations

Cosmetic discourses during the second half of the seventeenth century responded in part to the dissemination all over Europe of the ritual of the morning toilette or *levée*. Established at the court of Louis XIV (r. 1643–1715), the royal ceremony of grooming and dressing of the king or queen came to be imitated by courtiers and nobility and expanded to the rest of Europe. The already established practice for elite and upper-class women to devote privately their morning routine to their dress and adornment evolved in many cases into an extended semi-public ceremony for embellishment, self-display, conversation, and, quite often, the discussion of intellectual and business affairs. Even if an intimate morning toilet remained in place for many women, a continuation of its initial steps in a second, semi-public toilet followed for many court and fashionable women. This second toilet opened the privacy of the female boudoir to the presence of friends and acquaintances to dispatch different matters and cultivate conversation, transforming it into a space of semi-public sociability and female agency used by a woman to construct and promote her public persona.[12] As Kimberly Chrisman-Campbell underscores, a key element of theatricality dominated this process, since the second and public toilet restaged in a seductive, choreographed, and sophisticated manner several of the cosmetic steps already taken in the initial

one.[13] Thus, the lady created the illusion of an already made-up natural appearance for the attendees, which she further elaborated by the continuation of the toilet in the presence of selected guests, providing a source of admiration and entertainment to them.[14] The surroundings of the lady's performance not only enhanced its enticements, but acted as well as a projection of her identity. Parisian interiors were, simultaneously to the consolidation of the toilette as a social practice, undergoing a significative transformation towards unprecedented levels of luxury and grandeur. The elegance of interiors like Mme. de Rambouillet's blue velvet and silver boudoir became also part of the spectacle, as well as a major influence on the English, who made comments of these spaces either through travelers' accounts or engraved representations.[15]

In 1656, the author of *A Discourse of Auxiliary Beauty* seemed to dismiss the practice of the public toilet among Englishwomen by stating how "in *England* a commendable discretion is used by women in *concealing* both their *native defects*, and their *artificiall* additaments of beauty or com|plexion ... yet in other countries nothing is more frequently done and freely owned."[16] Nonetheless, the court of Charles II (r. 1660–85) swiftly adopted its French counterpart's custom of the *levée*, popularizing the rituals of the toilet in England among the elite.[17] The presence of influential French figures at the English court also contributed to the spread not only of these cosmetic customs but also of a significant attention to the furnishing of court interiors. In 1683 the diarist John Evelyn recorded his visit in the king's company to the Whitehall apartments of Louise de Kérouaille, duchess of Portsmouth and royal mistress, where they witnessed her toilet:

> Following his Majestie this morning through the Gallerie [at Whitehall], [I] went (with the few who attended him) into the Dutchesse of Portsmouths dressing roome, within her bed-chamber, where she was in her morning loose garment, her maides Combing herm newly out of her bed: his Majestie & the Gallants standing about her; but that which ingag'd my curiositie, was the rich and splendid furniture of this woman's Appartment, now twice or thrice, puld downe, and rebuilt, to satisfie her prodigal and expensive pleasures, whilst her Majestie does not exceed, some gentlemens Ladies furniture and accommodation: here I saw the new fabrique of French Tapissry, for designe, tendernesse of worke, and incomparable imitation of the best painting; beyond any thing, I had ever beheld: some pieces had Versailles, St. Germans and other Palaces of the French King with Huntings, figures, and Landscips, Exotique fowle and all the life rarely don: Then for Japon Cabinets, Skreenes, Pendule Clocks, huge Vasas of wrought plate, Tables, Stands, Chimny furniture, Sconces, branches, Braseras etc they were all massive silver, and without number, besides of his Majesties best paintings ... Lord what contentment can there be in the riches & splendor of this world, purchas'd with vice & dishonor.[18]

Evelyn's dismay at the duchess's opulent apartments shows the key role of interior decorations in the construction of the French royal mistress's status at court at the time that exemplifies how women's aesthetic and collecting interests—often displayed and cultivated at their boudoirs—often came to be read as a sign of female frivolity and vice, a matter later replicated in satirical print culture.

The increasing sophistication and attention paid to such beautification rituals led progressively to a more specialized configuration and crafting not only of the instruments employed but also of the setting and space where the routine was performed. In origin, the term toilette designated the piece of fabric or tablecloth protecting and embellishing the dressing table where cosmetics and a variety of beauty aids and accessories were arranged along with a mirror. The appearance of the setting and instruments gained in sophistication, becoming as important as the beauty they produced. Thus, the fabric could range from white linen to satin, be edged with lace matching the woman's attire *en dishabillé* and combine different layers of material upon the table to create an elaborate aesthetic effect that often covered a regular piece of furniture. The dressing table, nonetheless, would also evolve into a specialized and luxuriously crafted furniture piece during the eighteenth century with a variety of compartments that stored, along with cosmetics, many other female accoutrements.[19] As Aileen Ribeiro explains, during the second half of the seventeenth century the term toilette or toilet came to stand for the entire setting, its instruments (the toilet set), and the performance itself.[20] A wide range of shapes and materials were available for cosmetic boxes and containers, whose embellished exteriors tried to convey, in more expensive or affordable ways, the cosmetic promises contained within. In England, a taste for the japanning technique and chinoiserie decorations, as well as for the use of silver, was in vogue for these sets in the late seventeenth century.[21] They were usually displayed along with brushes, combs, perfumes, patch boxes, small basins, pitchers, and other accessories. Among them, the mirror came to be largest and most essential element of the set, turning into a symbol of women's self-contemplation, vanity, and moral corruption that later was often deployed in satirical print culture.

The institutionalization of the morning toilet as a public ceremony and a major component of daily life partially shadowed the other occasions of the day when women engaged more privately with the space of the dressing room and the toilet. Vincent Cochet has pointed at the common practice of carrying out more than one toilet a day, between two or three in fact, given that different activities required different preparations and changes of attire.[22] Attending the theater or a masquerade ball required specific arrangements beyond the morning ritual and, therefore, a second or third toilet took place in the early evenings in preparation for such events. Even if much less information is recorded in regard to the private toilet as a result of its more utilitarian and intimate nature, its alluring secrecy and material enticements, in the form of cosmetic containers, textiles, jewelry, and other furnishings, made it a recurrent theme in eighteenth-century visual culture. Nevertheless, the pictorial treatment of the subject of the toilet always came to be mediated by the circulating discourses on women's natural propensity to coquetry and vanity and its condemnation by moralists and authors, which persisted despite it being common practice.[23] As Ribeiro explains, as a primarily French custom in origin, the most factual representations of the toilet during the late seventeenth and early eighteenth centuries are to be found in the incipient genre of the fashion plate in France.[24] Even if the morning toilet is one of the scenes most commonly represented in fashion plates, this genre also recorded the masquerade toilet.[25]

The allure of the masquerade toilet, which brought together the sensual lavishness of dress, makeup, and jewelry with the secrecy of the masks, acted as well as a favorite subject of the rococo *tableaux de mode*. Jean François de Troy's *Before the Ball* (1735) showed a lady's masquerade toilet, whose seductiveness reverberates in the interior where it takes place.[26] The ornamental nature of the walls, rococo sconces, and furniture hints at the elegance of the lady's boudoir, where she is receiving a select group of fellow masqueraders while her maid sees to the final details of her attire. The fancy dresses and dominos, or masquerader cloaks, shimmer in the candlelight and the attendees hold their masks close to their faces among whispers, anticipating the secrecy of the ball and contributing to the mood of the scene. These types of lavish and seductive scenes of elite daily life were widely published and consumed across Europe, making their way into the English print market, where they would influence incipient genres like the fancy picture and contribute to the discourse on the morality of the masquerade (Figure 7.1).

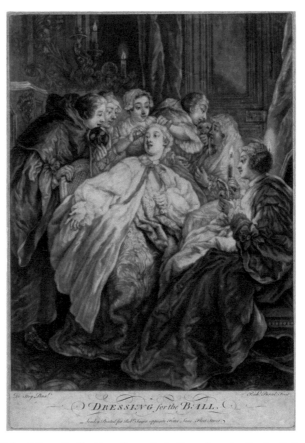

Figure 7.1 Richard Purcell after Jean François de Troy, *Dressing for the Ball*, 1760s–1799, mezzotint, 38.5 × 25.3 cm. © The Trustees of the British Museum.

"Their Great Scene of Business": The Female Toilet and Dressing Room in Georgian Culture

In 1711 *The Spectator* designated the space of the toilet as women's "Great Scene of Business," underlining not only the importance of this ritual for women's daily routines but also stating the value of the space of the dressing room—here identified with the toilet—as a woman's sphere of influence.[27] The performance of the public toilet established itself as a staple of urban sociability and an arena for women to deploy their increasing cultural agency in London's society. The configuration of the dressing room as the setting of the toilet and a private female realm within the domestic space played a substantial part in women's pursuit of personal and private interests during the eighteenth century. It not only allowed women to craft their appearance and persona carefully at the toilet but also to pursue other activities for their own pleasure, including playing cards, taking tea, reading, writing, or engaging with their own artistic collections.[28] The architectural definition of this space in England was underway during the second half of the seventeenth century, as a change of paradigm was taken place in family relations within the domestic space, leading to emphasis on the individual's necessity for privacy.[29] In the eighteenth century, different configurations of the dressing room would follow, and women not only from the aristocracy but also from the upper and rising middle classes would come to have access to some form of dressing room or boudoir.

As a space adjacent to or part of the bedroom chamber, it was defined by an attention to its decorative scheme and to the comfortability of its furnishings, often also furbished with wallpaper, paintings, prints, and other collected items that displayed the inhabitant's taste and interests. The purpose of these decorative schemes was not only to embellish the room for the lady's comfort and that of the selected visitors that such space was designed to host, but also to provide a subject for conversation and contemplation. The conception of the space evolved, as did the taste in interiors decoration during the century: from the stately elegance and pomp of the early Georgian dressing rooms at Houghton Hall or Holkham Hall by William Kent in the 1730s to Robert Adam's whimsical take on neoclassical motives at the Etruscan dressing rooms of Derby House and Osterley Park in the 1770s, examples of historical interiors that have not, however, been kept fully intact. Nonetheless, the designs of figures like William Ince and John Mayhew or Thomas Chippendale (Figure 7.2) hint towards the increasing fanciful character often invested in these feminine spaces during the central decades of the century, when the rococo and chinoiserie styles became widely employed within interior spaces associated with pleasure and leisure. The elaborate ornamental stucco accompanied by gilded sconces and mirrors created lavish effects that contributed to the visual enticements of the beauty rituals performed in the room. Such attention to detail was mirrored, as mentioned earlier, in the many accoutrements that constituted toilet sets, often also inspired by exotic and luxurious motives in boxes imported or nationally produced, and ranging from japanned wood or silver to porcelain.

During this time, the principles governing beauty became deeply intertwined with national ideals and a classically inspired definition of British femininity as unaffected,

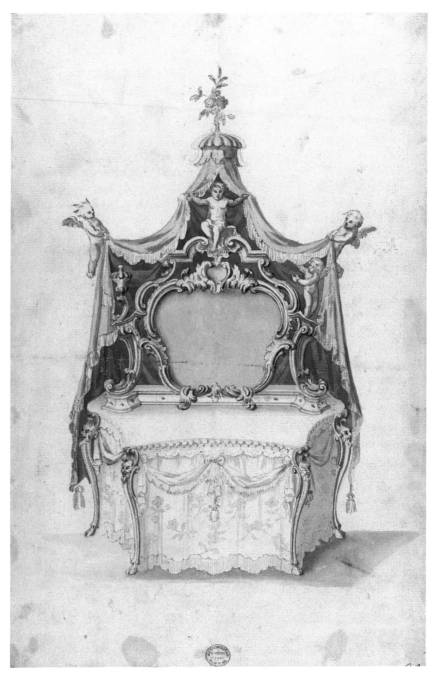

Figure 7.2 Thomas Chippendale, Toilet table, from *Chippendale Drawings*, Vol. II (1760), drawing, 32.9 x 21.9 cm. The Metropolitan Museum of Art. © Photo: Scala, Florence.

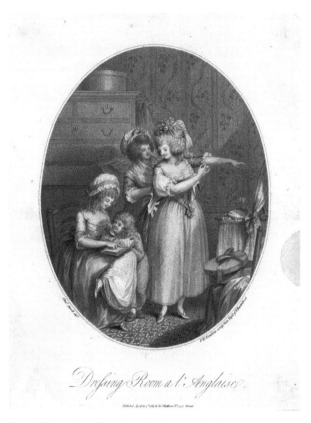

Figure 7.3 Peltro Williams Tomkins after Charles Ansell, *Dressing room à l'Anglaise*, 1789, stipple engraving, 33 × 25 cm. Courtesy of The Lewis Walpole Library, Yale University.

which translated into the celebration of long and graceful limbs and a natural pallor, solely illuminated by a modest flush of the cheeks. A clear skin was associated with purity and the transparency of the woman's inner workings, while the natural blush, that rouge imitated artificially, acted as a marker of a woman's virtue.[30] In practice, many of these ideals were achieved by means of makeup, which women strived to render invisible, gaining for themselves the accusation of deceivers. As a matter of fact, the definition of English beauty had long been a matter of national identity, with a variety of authors delineating the English beauty ideal as innocent, modest, and unaffected by opposition to Frenchwomen's artificial use of cosmetics. Thus, the cosmetic debate became profoundly intertwined with the nationalistic argument for British simplicity and virtue against foreign taste, a dialectic associated not only with women's cosmetic practices but also with their behavior in the dressing room. Charles Ansell's *Dressing Room à l'Anglaise* (Figure 7.3) and *Dressing Room à la Française* (1789) (Figure 7.4) displayed contrasting attitudes of English modesty and French coquetry respectively and commented on the Englishwoman's taste for privacy and domesticity as opposed to her French

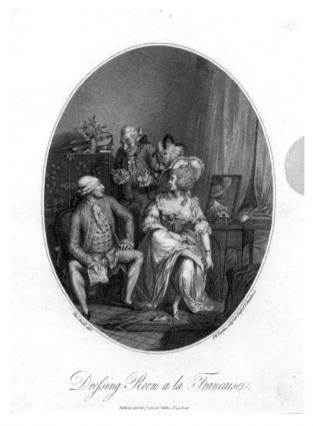

Figure 7.4 Peltro Williams Tomkins after Charles Ansell, *Dressing Room à la Française*, 1789, stipple engraving, 33 × 25 cm. Courtesy of The Lewis Walpole Library, Yale University.

counterpart's leniency towards male company and conversation.[31] These attitudes were equally projected into the interiors where the respective scenes took place: while the English room evokes a sense of order and simple taste, in which its inhabitant attends to her children during her toilet, the French dressing room hints to a more extravagant taste and self-indulgent lifestyle. This emphasis on British moral and aesthetic values did not prevent Francophilia from dominating diverse sectors of London's society, and therefore women from adopting similar cosmetic trends. However, as Lynn Festa proves in her analysis of the period's debate, these practices came to be read differently in each national context: while in France makeup maintained its associations with aristocratic class, in England its overuse came to be seen as a mark of sexual and moral deviance.[32] Furthermore, in those cases when women endeavored for their makeup to create a "natural" appearance, the impossibility of distinguishing real from painted beauty and the threat for men to be tricked into marriage continued to foster the notion of the mask as a metaphor for cosmetic usage. Authors like Oliver Goldsmith perpetuated this notion, affirming how "Most ladies here ... have two faces: one face to sleep in, and

another to show in company ... this is always made at the toilet, where the looking-glass and toad-eater sit in council, and settle the complexion of the day."[33] While the ideal features of English female beauty came to be a motive for national pride over foreign extravagance, the moralist and satirical debate that dominated the century continued to perceive the female face as a fabricated mask or façade that obscured not only a woman's true features but also her true intentions.

These ideas materialized in satirical print culture, which portrayed makeup, the toilet, and the space of the dressing room as symptomatic of a long list of feminine faults. William Hogarth demonstrated once more his acute perception of Georgian society by encapsulating many of these narratives and concerns in the fourth painting of his series *Marriage A-la-Mode*, titled *The Toilette* (*c*. 1743) (Figure 7.5) and later disseminated as a set of prints.[34] While the scene did not strictly represent a masquerade toilet but a morning one, the occasion allows for the plotting of an adulterous encounter at the masquerade. Such intentions, along with the ill-fated Countess Squander's indulging taste in cosmetics and foreign trends, fleshes out contemporary ideas about women's frivolity and deceitful nature. The group formed by the countess and counselor Silvertongue in her dressing room is isolated from the rest of the visitors, suggesting an echo of intimacy within the semi-public setting of the countess's dressing room. Through the lavish dressing-table, mirror, and toilet set Hogarth unequivocally recalls the toilet's association with the debate of female beauty's artificiality in the form of

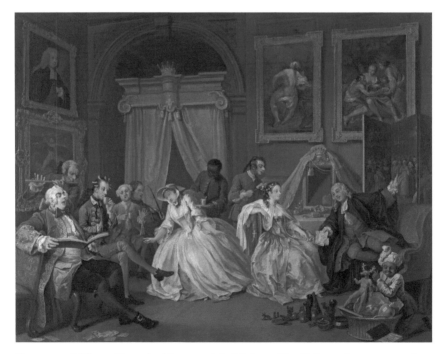

Figure 7.5 William Hogarth, *Marriage A-la-Mode: 4, The Toilette*, about 1743, oil on canvas, 70.5 × 90.8 cm. © The National Gallery, London.

face paint, and connects it with the masquerade as epitome of deception and disguise. Silvertongue delivers his proposal in the form of a masquerade ticket to the countess, which acts as the material vehicle of adultery and enabler of Lady Squander's deviant behavior.

Hogarth's painstaking attention to detail in the construction of interiors, a major narrative resource in his storylines, underwrites Charles Saumarez Smith's remarks on the role of satirical scenes as a major source for the study of eighteenth-century interiors, making Lady Squander's dressing room no exception.[35] Her response to the counselor's proposal is implied by her belongings and hedonistic taste in furniture: the masquerade screen signaled by Silvertongue confirms her disposition and sexual readiness, while it serves him to communicate his erotic intents. A "low-life" scene with masqueraders and orchestra is depicted; the foreground presents a gallery of typical characters, among them a friar and a nun engaged in conversation in the very center. These religious figures—pointed at by the lawyer—stood in visual and literary culture for the bawdy behavior associated with masquerades and for the lewdness of their sexual encounters. In the midst of this display of leisure, the presence of a neglected coral baby rattle underneath her elbow extends the boundaries of the countess's mischief. Lady Squander is depicted as a negligent mother whose lack of virtue is directly inscribed in the space of her dressing room and its furnishings, among which the opulent bed crowned by a coronet hints further at the adulterous narrative of the scene. Likewise, her collecting taste, represented in the luscious history paintings that preside over the couple and the sexual connotations of the bric-a-brac at her feet underlines once more the titillating nature of the encounter.

As Caroline Palmer explains, in contrast with the popularity of toilet portraiture in France, examples of this genre are extremely rare in the British case, where such representations belong mainly to the satirical realm.[36] Johann Zoffany's *Queen Charlotte with her Two Eldest Sons* (c. 1765) (Figure 7.6) provides an exception to this rule by offering a virtuous representation of aristocratic femininity and a response to the theme of motherhood and the toilet as set out in Hogarth's work. The Hanoverian court did not carry a leading role in the fashion for cosmetics in eighteenth-century England, a position held by the *bon ton*, the elites, and the celebrity beauties and courtesans who populated pleasure gardens, gambling halls, and masquerades. As a matter of fact, Queen Charlotte was known to keep a measured although thorough toilet.[37] Zoffany's conversation piece presents an intimate scene in which the elegant figure of the queen is seated by a lavish dressing table that looks over the gardens at Buckingham Palace, embellished with lace and satin ribbons that frame a splendid toilet set and a large mirror. Despite the sumptuous setting, the queen's chair, body, and gaze are turned away from such a magnificent display and from her own reflection. Her toilet finalized in private, she attends to her playful children without lingering any longer on the beauty of her features, which the artist reminds us of through the mirror. No coral baby rattle is neglected here, and the queen in her primary role as a mother devotes her sole attention to her children and their dog, a symbol of her fidelity to the king and her family. Despite "the considerable liberties with the decoration" taken by Zoffany according to Saumarez Smith, these seem to have been aimed towards reinforcing the virtuous elegance of the scene.[38] While the chinoiserie

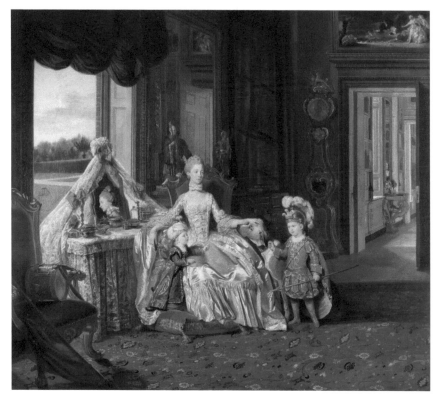

Figure 7.6 Johan Joseph Zoffany, *Queen Charlotte with her Two Eldest Sons*, 1764, oil on canvas, 11.2 × 128.3 cm. Royal Collection Trust © Her Majesty Queen Elizabeth II 2021.

decorative statues behind her evoke the queen's contemporary taste, the grandeur of the furniture, which seems to continue down the enfilade, the elaborate rug, and the luxurious clock, symbol of an orderly living, contribute to the solemnity and dignified representation of the queen as a woman and a mother. According to Desmond Shawe-Taylor, Zoffany is here indebted to the moralizing tradition of Dutch genre painting, whose toilet scenes acted as a reminder of the dangers of vanity and the fleeting nature of beauty.[39] The queen thus embodies the expectations of British ideals of femininity: the transparency and pallor of her white skin, which blends into the white silk and lace of her dress, the modest blushing of her cheeks, and her pink lips. Nonetheless, her devotion and duty lay not with the image of such beauty, but with her children and household. Zoffany's composition puts forward nascent ideas about natural and loving motherhood promoted by the incipient cult of sensibility, instructing women to follow the queen's model and set aside their vanities.

Hogarth's utilization of masquerading and cosmetic embellishing as distinctively feminine traits in his influential work during the central decades of the century laid the foundation for the popularization of the dressing room, the toilet, and the

masquerade as preeminent themes in satirical print culture. These representations consistently attacked women's self-fashioning and participation in the burgeoning public and entertainment sphere of Georgian London, and became society's way to grapple with such a phenomenon. Although printmakers cautioned against and publicly chastised these practices, their work equally substantiated their popularity. From inventive commentaries on the extravagance reached by wigs and headdresses— that could turn into dressing tables themselves to point at the vacuity of a woman's intellect—to lampooning the aging vanity of intellectuals like Catharine Macaulay, the toilet and the dressing room provided eloquent and fruitful motives to materialize such discourses.[40] The masquerade followed closely, quite often referenced only by the presence of a ticket or a mask, which stood clearly as signifiers of the many evils it evoked in relation to women's behavior. Such condemning and biting scenes, not only collected and consumed privately but also openly displayed in the window galleries of print shops, consolidated these narratives surrounding women's self-fashioning.

"She herself makes her own faces":[41] Depictions of the Mask at the Toilet in Georgian Satirical Print Culture

In May 1749, the preeminent bluestocking Mrs. Elizabeth Montague gave a detailed account to her sister of her costume preparations for a masquerade:

> I was some days preparing for the subscription masquerade, where I was to appear in the character of the Queen Mother, my dress white satin, fine new point tuckers, kerchief and ruffles, pearl necklace and earrings, and pearls and diamonds on the head, and my hair curled after the Vandyke picture.[42]

As Chrisman-Campbell indicates, the arrangement and selection of sartorial pieces was a key moment of the regular toilet to be portrayed in visual culture, one that showed the lady's good taste and fashionable judgment, at the same time anticipating the act of undressing.[43] The weight of such decisions would have been even greater in the process of the masquerade toilet, since the combination of costume and accessories aimed to bring to life either a specific character or a dazzling fancy dress. Ladies and maids endeavoring to find the right accessories and putting the final touches for the night's attire were scenes commonly chosen by satirical printmakers to portray the masquerade toilet and its frivolities, which echoed in the interiors where they took place.

Print sellers and publishers such as Carrington Bowles tapped into the titillating tones of the subject, which undoubtfully responded to the rage for the subscription masquerade that took over London's *beau monde* during the 1770s. After its mid-century decay as a result of the Seven Years War and heavy moral accusations against it, the masquerade was reintroduced in the early years of the 1760s to become a staple of the city's sociability, dominated by a number of entertainment venues such as Teresa Cornely's Carlisle House or the Pantheon.[44] Scenes like *Lady Betty Bustle and her Maid*

Lucy Preparing for the Masquerade at the Pantheon (1772) (Figure 7.7) mockingly displayed the hastiness of the final touches of the evening toilet. While Lady Bustle turns to watch herself in the mirror, mask already in hand, her maid endeavors to adjust the back of her dress. Despite the comfortable appearance of the dressing room and her toilet setting, her name hints at her active social life and puts into question her respectability. In fact, many of these plates concerned themselves, either more explicitly or subtly, with the presence of courtesans and other disreputable women at the masquerade.

The public concern with prostitutes' use of masks went beyond the deceiving qualities of the material object and extended to the application of makeup to dissimulate the physical signs of the sex trade. As a result, satirical prints insisted on the toilet as a main event in the prostitute's preparation for the masquerade. Thomas Rowlandson's *Dressing for a Masquerade* (1790) (Figure 7.8) offers a glimpse into a masquerade toilet of fervent activity and chaotic disarray, with fabrics, clothing, masks, shoes, and all sorts of beauty instruments scattered throughout the room. In the interior of a brothel, several old women identifiable as bawds attend a group of four young women in their preparations for attending a masked ball. Rowlandson's composition offered a catalog of the vices and faults of the female character: from

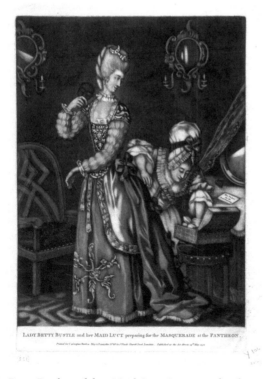

LADY BETTY BUSTLE and her MAID LUCY preparing for the MASQUERADE at the PANTHEON

Figure 7.7 *Lady Betty Bustle and her Maid Lucy Preparing for the Masquerade at the Pantheon,* 1772, hand-colored mezzotint, 42 × 31 cm. Courtesy of The Lewis Walpole Library, Yale University.

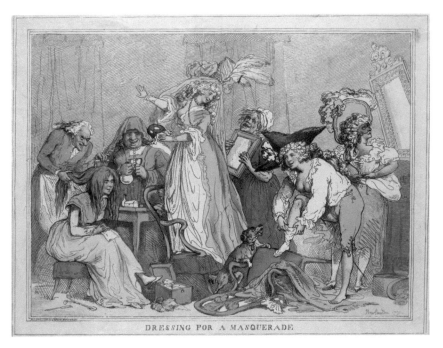

Figure 7.8 Thomas Rowlandson, *Dressing for a Masquerade*, 1790, hand-colored stipple and etching, 36.2 × 50.2 cm. Courtesy of The Lewis Walpole Library, Yale University.

the vanity suggested by their poses and the abundance of mirrors, to the deceiving intent of their masks and the wearing of rouge. The satirist employed the negligent and vulgar state of their undressed attire, not staged in the sophisticated and careful *dishabillé*, along with their unladylike gestures and demeanors to label these women unequivocally as prostitutes. Such attitudes were echoed by the state of chaos of the space itself and its scarcity: the bare walls and simplicity of the curtains point to a humble interior, where only a table with not enough chairs appears, and while a gilded mirror hangs from the wall, a second smaller and made out of wood is required. The accoutrements of the toilet are not carefully arranged on a dressing table, and hair tongs, unadorned wooden boxes, and masks are scattered throughout the room. Nonetheless, Rowlandson's print stands out for its careful and accurate depiction of costumes and different hair styles, as well as masks. While some printmakers opted for simplified versions of the mask, Rowlandson depicts here different types: one formed of a single fragment of black cloth covering the eyes and the nose, worn by the lady looking in the mirror, and a more popular model that included an additional piece of loosened cloth that covered the mouth, often made out of silk and used to further hinder identification of the masquerader.[45] In contrast with the performance of grace and ease of the staged morning toilet, satirists employed the pragmatism and privacy of the evening or masquerade toilet to mock women's intimate behavior behind closed doors.

What lay behind that mask was a pressing concern of both masquerade and cosmetic detractors, exploited by the print market through scenes and compositions that exposed and mocked women's cosmetic tricks. Never was the treachery more blatant that when the one sitting in front of the toilet was an aged woman. In *The Old Female Macaroni* (*c.* 1760–79) (Figure 7.9) the mirror frames the composition and returns the reflection of an older woman elegantly dressed in a fur-trimmed gown. She looks up from the hand mirror to see herself and her beautiful young maid who suggests adding a feather to her dressed hair. The scene brings to the fore the stark contrast between both figures, chastising the old woman's lack of decorum by ridiculing her use of cosmetics at an advanced age and comparing her vain actions with the youthful and natural beauty of her maid. Not only is she referred to mockingly as a *macaroni*, but the presence of the mask on the dressing table, and thus her identification as masquerade-goer, contributes to her caricaturizing. While multiple examples of this type circulated in London's print market, targeted attacks against individuals from the *beau monde* were also frequent. That type of criticism was true in the case of Lady Sarah Archer in *Six Stages of Mending a Face* (1792), a

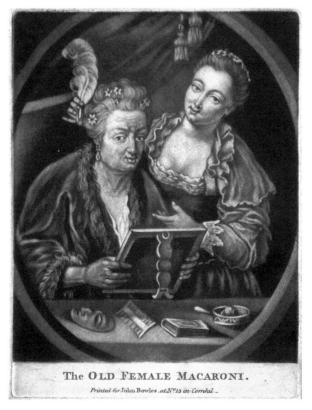

The OLD FEMALE MACARONI.

Printed for John Bowles *at N°.13 in Cornhil*.

Figure 7.9 *The Old Female Macaroni*, *c.* 1760s–1779, mezzotint, 14.8 × 11.3 cm. © The Trustees of the British Museum.

fashionable figure in London's sociability and gambling circles, especially known for her abuse of cosmetics, and the subject of a myriad of satirical prints.[46]

In the many narratives constructed by the British print market around female masquerade-goers at the end of the century, masks and makeup not only functioned as symbols of vanity and corruption but also as its vehicles. George Morland's series *Laetitia, or The Progress of Seduction*, engraved and published originally by John Raphael Smith in 1789, showcases the influence of the cult of sensibility in the public taste, moving away from the satirical representation of the young woman's fall from virtue into a sentimental and didactic account of her misfortunes and fate. After being seduced and taken away from the love of the parental home by a rake, with whom she elopes in the second plate, the young, modest, and beautiful heroine dives into worldly pleasures in the company of her lover. The fourth plate in the series, *Dressing for the Masquerade* (Figure 7.10), includes a narrative subtitle: "Laetitia flies from reflection

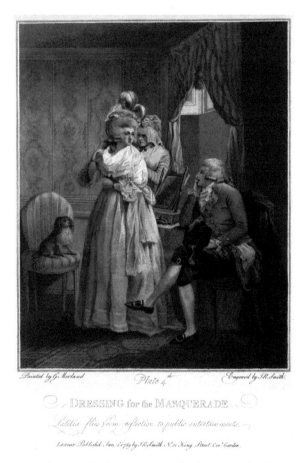

Figure 7.10 John Raphael Smith after George Morland, *Dressing for the Masquerade*, Plate 4 from *Laetitia*, 1789, stipple, 46.3 × 35.2 cm. © The Trustees of the British Museum.

to public entertainments." Morland replicated the *topos* of the lady, the lover and the looking glass, which Elise Goodman-Soellner argues had been recovered by rococo amatory imagery and often appeared in eighteenth-century French print culture.[47] The theme was already present in Hogarth's composition of Countess Squander and Silvertongue's group, on that occasion re-elaborated in satirical undertones. Morland, however, employed the image of the contemplating lover by the toilet as a sign of Laetitia's moral downfall. While a young maid adjusts her dress, the heroine's mask lies on the dressing table by the mirror, right between the two lovers, anticipating the evening's event as well as underlining her vanity and foolishness. Behind the mesmerized lover also lies his domino, the hooded cloak often worn at masquerades. The comfortably decorated dressing room operates as an extension of the heroine's adorned body, product of the sexual and economic exchange taking place with Laetitia as a kept mistress. Morland chose not the attendance at the masquerade itself, but its anticipation and preparations at the toilet as the most pregnant moment within the narrative, as the turning point that unleashes the heroine's demise. The following plates showed her abandonment and ruin, from which she is rescued in a moralizing ending by her parents' piety, thus appealing to the changing taste of the print market's consumers that searched for edifying and didactic stories that would furnish their walls.

The corpus of representations analyzed here sheds significant light into how the British print market drew from and re-elaborated preexisting cultural narratives when formulating the iconography of the woman at her dressing table or that of the female masquerader. The space of the dressing room as represented in this visual discourse came to signify women's propensity to falsity and artifice, a set of ideas that further shaped the female toilet in eighteenth-century British culture, especially when accompanied by a mask. Such an object in the context of the dressing room went beyond its associations with the event of the masquerade, bringing into the visual narrative of the toilet notions of women as face-painting deceivers. Nevertheless, this scornful imagery not only functioned as society's means to negotiate women's increasing agency in public entertainment but also attested to how cosmetic and sartorial preparations in the dressing room played a key role in the construction of Georgian women's identity and self-fashioning in the public space.

Notes

1 See Kimberly Chrisman-Campbell, "Dressing to Impress: The Morning Toilette and the Fabrication of Femininity," in *Paris: Life & Luxury in the Eighteenth Century*, ed. Charissa Bremer-David (Los Angeles: J. Paul Getty Museum, 2003), 53–73; Elise Goodman-Soellner, "Boucher's 'Madame de Pompadour at Her Toilette,'" *Simiolus: Netherlands Quarterly for the History of Art* 17, no. 1 (1987): 41–58; Elise Goodman-Soellner, "Poetic Interpretations of the 'Lady at Her Toilette' Theme in Sixteenth-Century Painting," *Sixteenth-Century Journal* 14 (2003): 426–42; Melissa Hyde, "The 'Makeup' of the Marquise: Boucher's Portrait of Pompadour at Her Toilette," *Art Bulletin* 82 (2000): 453–75; and Ulrich Leben, "The Toilette in the Eighteenth Century," *The Magazine Antiques* 162 (2000): 84–91.

2 Anonymous epigram, 1640. Quoted in Kimberly Poitevin, "Inventing Whiteness: Cosmetics, Race, and Women in Early Modern England," *Journal for Early Modern Cultural Studies* 11 (2011): 68.

3 Patricia Philippy, *Painting Women: Cosmetics, Canvases and Early Modern Culture* (Baltimore: Johns Hopkins University Press, 2006), 5–6.

4 Among the many authors outraged by these cosmetic practices some of the earliest key texts often quoted are Juan Luis Vives, *De institutione feminae Christinae* (1523), rapidly translated into English after its publication by the author's fellow humanist Richard Hyrde, or Thomas Tuke, *Discourse Against Painting and Tincturing of Women* (1616).

5 Philippy, *Painting Women*, 9–10.

6 Francis E. Dolan, "Taking the Pencil out of God's Hand: Art, Nature, and the Face-Painting Debate in Early Modern England," *PMLA* 108, no. 2 (1993): 229–30.

7 For a thorough exploration of the period's makeup practices, see Aileen Ribeiro, *Facing Beauty: Painted Women and Cosmetic Art* (New Haven: Yale University Press, 2011), 107–37.

8 Poitevin, "Inventing Whiteness," 80–1.

9 Will Pritchard, *Outward Appearances: The Female Exterior in Restoration London* (Lewisburg, PA: Bucknell University Press, 2008), 15.

10 Poitevin, "Inventing Whiteness," 68.

11 See Anonymous or Antoine Trouvain[?], *Woman Seated at her Dressing Table and Holding a Mask*, 1694, Paris, engraving and watercolor. London: Museum of London, 2002.139-359.

12 In the context of the cult of appearances that marked eighteenth-century French society, Melissa Hyde has argued that "identity, whether social identity or gender identity, is not simply a permanent *condition* fixed at birth but an *état* (a state), which was understood as the product of social performance—that is, as a way of being defined (or defining oneself) that was acted out through comportment, manners, speech, certainly, but also through dress, through the makeup of surface appearances." Hyde, "The 'Makeup' of the Marquise," 462–3.

13 Chrisman-Campbell, "Dressing to Impress," 54.

14 An essential part of such performance of grace and delicacy was the dexterity and smoothness of gestures in the manipulation of the dressing table's elements and the application of cosmetics. See Mimi Hellman, "Furniture, Sociability, and the Work of Leisure in Eighteenth-Century France," *Eighteenth-Century Studies* 32 (2011): 425–8.

15 Charles Saumarez Smith, *Eighteenth-Century Decorations: Design and the Domestic Interior in England* (New York: H. N. Abrams, 1993), 19.

16 *A Discourse of Auxiliary Beauty. Or Artificiall Handsomeness. In Point of Conscience between Two Ladies* (London: R. Royston, 1656), 167.

17 Tita Chico, *Designing Women: The Dressing Room in Eighteenth-Century English Literature and Culture* (Cranbury: Bucknell University Press, 2005), 31.

18 Diary of John Evelyn, 4 October 1683. Quoted in ibid., 33.

19 Jane Adlin, "Vanities: Art of the Dressing Table," *The Metropolitan Museum of Art Bulletin* 71, no. 2 (2013): 6–7.

20 Ribeiro, *Facing Beauty*, 117.

21 Adlin, "Vanities," 26 and Ribeiro, *Facing Beauty*, 117. See Robert Smythier, the Sizergh Toilet Service, 1690, silver. London: British Museum, Acquisition RF: 68/64.

22 Vincent Cochet, "Le Fard aud XVIIIe siècle: Image, maquillage, grimage," in *Annales du Centre Ledoux Vol. 2, Imaginaire et création artistique à Paris sous l'ancien régime (XVIIe–XVIIIe siècles)*, ed. Daniel Rabreau (Paris: Fayard, 1998), 104.

23 Goodman-Soellner, "Boucher's "Madame de Pompadour at Her Toilette,"" 48.

24 Ribeiro, *Facing Beauty*, 117–18.

25 A remarkable example, currently in a private collection, is Antoine Trouvain's *Madame la Duchesse de Valentinois en habit de bal* (1694). The iconography of the modish female masquerader at her toilet was also part of the allegorical language of the period and became popularized by decorative prints. See Henri II Bonnart, "Février," from the series *Twelve Months*, 1678–1700, etching and engraving. British Museum, 1922,0410.144

26 See Mimi Hellman, "Enchanted Night: Decoration, Sociability, and the Visuality after Dark," in *Paris: Life & Luxury in the Eighteenth*, ed. Charissa Bremer-David (Los Angeles: J. Paul Getty Museum, 2011), 91–113; and Denise Amy Baxter, "Fashions of Sociability in Jean François de Troy's Tableaux de Mode, 1725–1738," in *Performing the "Everyday:" The Culture of Genre in the Eighteenth Century*, ed. Alden Cavanaugh (Newark: University of Delaware Press, 2007), 28, 32–3.

27 *The Spectator*, March 12, 1711.

28 Chico, *Designing Women*, 48–50; Chrisman-Campbell, "Dressing to Impress," 71.

29 Chico, *Designing Women*, 22.

30 See Angela Rosenthal, "Visceral Culture: Blushing and the Legibility of Whiteness in Eighteenth-Century British Portraiture," *Art History* 27 (2004): 563–92.

31 See Peltro Williams Tomkins after Charles Ansell, *Dressing room à la Française*, 1789, stipple engraving. Farmington: Lewis Walpole Library, 789.04.07.02.

32 Lynn Festa, "Cosmetic Differences: The Changing Faces of England and France," *Studies in Eighteenth-Century Culture* 34 (2005): 31.

33 Oliver Goldsmith, *A Citizen of the World*, Letter 3. Quoted in Caroline Palmer, "Brazen Cheek: Face-Painters in Late Eighteenth-Century England," *Oxford Art Journal* 31 (2) (2008): 208.

34 For a complete analysis of the series and its intricate iconography, see Robert L. S. Cowley, *Marriage A-la-Mode: A Re-view of Hogarth's Narrative Art* (Manchester: Manchester University Press, 1983).

35 Saumarez Smith, *Eighteenth-Century Decorations*, 303.

36 Palmer, "Brazen Cheek," 205.

37 Chico, *Designing Women*, 47.

38 Saumarez Smith, *Eighteenth-Century Decorations*, 254.

39 Desmond Shawe-Taylor, *The Conversation Piece: Scenes of Fashionable Life* (London: Royal Collection Publications, 2009), 111–12.

40 See Anonymous, *The Lady's Maid, or Toilet head-dress*, 1776, hand-colored etching, British Museum, J,5.117, and Mattina Darly, *A Speedy and Effectual Preparation for the Next World*, 1777, hand-colored engraving, British Museum, J,5.109.

41 Epigram to Lady Sarah Archer, "She herself makes her own faces, / And each morning wears a new one." "Epigram on Lady A—-," in *An Asylum for Fugitive Pieces, in Prose and Verse*, 2nd edition, vol. 3 (London: Printed for J. Debrett, 1795), 106.

42 Mrs. Elizabeth Montagu, Letter to her sister, May 8, 1749, in Elizabeth Montagu, *Elizabeth Montagu, the Queen of the Blue-Stockings—her Correspondence*, ed. E. J. Climenson, vol. 1 (London, 1900), 264–5.

43 Chrisman-Campbell, "Dressing to Impress," 65.

44 For an acute social and historical study of the subscription masquerade as a key feature of Georgian society, see Meghan Kobza, "Dazzling or Fantastically Dull? Re-Examining the Eighteenth-Century London Masquerade," *Journal of Eighteenth-Century Studies* 43, no. 2 (2020): 161–81.

45 Silk mask, 1780–90, Museum of London, 70.59/2.

46 Thomas Rowlandson, *Six Stages of Mending a Face*, 1792, hand-colored etching, 28 × 38 cm, British Museum, 1876,1014.10. See Gillian Russell, "'Faro's Daughters': Female Gamesters, Politics and the Discourse of Finance in 1790s Britain," *Eighteenth-Century Studies* 33, no. 4 (2000): 486–91, and Ribeiro, *Facing Beauty*, 187–8.

47 Goodman-Soellner, "Boucher's *Madame de Pompadour at her toilette*," 55.

Bibliography

Adlin, Jane. "Vanities: Art of the Dressing Table." *The Metropolitan Museum of Art Bulletin* 71, no. 2 (2013): 1, 3–48.

Baxter, Denise Amy. "Fashions of Sociability in Jean François de Troy's *Tableaux de Mode, 1725–1738*." In *Performing the "Everyday": The Culture of Genre in the Eighteenth Century*, edited by Alden Cavanaugh, 27–46. Newark: University of Delaware Press, 2007.

Chico, Tita. *Designing Women: The Dressing Room in Eighteenth-Century English Literature and Culture*. Cranbury: Bucknell University Press, 2005.

Chrisman-Campbell, Kimberly. "Dressing to Impress: The Morning Toilette and the Fabrication of Femininity." In *Paris: Life & Luxury in the Eighteenth Century*, edited by Charissa Bremer-David, 53–73. Los Angeles: J. Paul Getty Museum, 2011.

Cochet, Vincent. "Le Fard aud XVIIIe siècle: Image, maquillage, grimage." In *Annales du Centre Ledoux Vol.2, Imaginaire et création artistique à Paris sous l'ancien régime (XVIIe–XVIIIe siècles)*, edited by Daniel Rabreau, 103–15. Paris: Fayard, 1998.

Dolan, Frances E. "Taking the Pencil out of God's Hand: Art, Nature, and the Face-Painting Debate in Early Modern England." *PMLA* 108, no. 2 (1993): 224–39.

Festa, Lynn. "Cosmetic Differences: The Changing Faces of England and France." *Studies in Eighteenth-Century Culture* 34 (2005): 25–54.

Gauden, John. *A Discourse of Auxiliary Beauty. Or Artificiall Handsomeness. In Point of Conscience between Two Ladies*. London: R. Royston, 1656.

Goodman-Soellner, Elise. "Poetic Interpretations of the 'Lady at Her Toilette' Theme in Sixteenth-Century Painting." *Sixteenth-Century Journal* 14 (1983): 426–42.

Goodman-Soellner, Elise. "Boucher's 'Madame de Pompadour at Her Toilette.'" *Simiolus: Netherlands Quarterly for the History of Art* 17, no. 1 (1987): 41–58.

Hellman, Mimi. "Furniture, Sociability, and the Work of Leisure in Eighteenth-Century France." *Eighteenth-Century Studies* 32 (1999): 415–45.

Hellman, Mimi. "Enchanted Night: Decoration, Sociability, and the Visuality after Dark." In *Paris: Life & Luxury in the Eighteenth*, edited by Charissa Bremer-David, 91–113. Los Angeles: J. Paul Getty Museum, 2011).

Hyde, Melissa. "The 'Makeup' of the Marquise: Boucher's Portrait of Pompadour at Her Toilette." *Art Bulletin* 82 (2000): 453–75.

Kobza, Meghan. "Dazzling or Fantastically Dull? Re-Examining the Eighteenth-Century London Masquerade." *Journal of Eighteenth-Century Studies* 43, no. 2 (2020): 161–81.

Leben, Ulrich. "The Toilette in the Eighteenth Century." *The Magazine Antiques* 162 (2002): 84–91.

Palmer, Caroline. "Brazen Cheek: Face-Painters in Late Eighteenth-Century England." *Oxford Art Journal* 31, no. 2 (2008): 197–213.

Philippy, Patricia. *Painting Women: Cosmetics, Canvases and Early Modern Culture.* Baltimore: Johns Hopkins University Press, 2006.

Poitevin, Kimberly. "Inventing Whiteness: Cosmetics, Race, and Women in Early Modern England." *Journal for Early Modern Cultural Studies* 11 (2011): 59–89.

Pritchard, Will. *Outward Appearances: The Female Exterior in Restoration London.* Lewisburg, PA: Bucknell University Press, 2008.

Ribeiro, Aileen. *Facing Beauty: Painted Women and Cosmetic Art.* New Haven: Yale University Press, 2011.

Rosenthal, Angela. "Visceral Culture: Blushing and the Legibility of Whiteness in Eighteenth-Century British Portraiture." *Art History* 27 (2004): 563–92.

Russell, Gillian. "'Faro's Daughters': Female Gamesters, Politics and the Discourse of Finance in 1790s Britain." *Eighteenth-Century Studies* 33, no. 4 (2000): 486–91.

Saumarez Smith, Charles. *Eighteenth-Century Decorations: Design and the Domestic Interior in England.* New York: H. N. Abrams, 1993.

Shawe-Taylor, Desmond. *The Conversation Piece: Scenes of Fashionable Life.* London: Royal Collection Publications, 2009.

Part Three

Hidden Lives and Interiority

Mythologies of the Boudoir: Jacques-Louis David's
The Loves of Paris and Helen

Dorothy Johnson

Boudoir: a small cabinet *where one can retire to when one wants to be alone.*
Dictionnaire de l'Académie française, 1740

The boudoir is understood as the abode of pleasure.
Nicolas Le Camus de Mézières, *Le Génie de l'architecture et*
l'analyse de cet art avec nos sensations, 1780

In 1788, Jacques-Louis David, famous for his moralizing history paintings based on antique themes of virtue, completed *The Loves of Paris and Helen* (Figure 8.1). He had hoped to exhibit it at the Salon of 1787 along with *The Death of Socrates*, a work he considered its pendant. Due to illness, he could not finish *Paris and Helen* in time and it appeared after the fall of the Bastille, at the Salon of 1789, alongside *The Lictors Returning to Brutus the Bodies of his Sons*.[1] It is difficult to imagine a more jarring juxtaposition. Owing to the social and political vicissitudes of the period, France had undergone a sea change from the time David had conceived of the representation of his mythological lovers in the early 1780s and negotiated its commission with the comte d'Artois. By the time the work was exhibited, Artois had fled, his name was effaced from the information about the painting and, although several critics praised the gracefulness achieved in this style all'antica, others expressed surprise and dismay that David had indulged in this type of amatory theme.[2] They had trouble fathoming the artist's unexpected emphasis on the depiction of erotic love. David, however, refused to renounce the work, instead praising it highly. In autobiographical notes of the 1790s, written in the third person, he gives us an encomiastic description of his artistic labors and their results:

> He had not before worked in this type of pleasing genre. He made something of this pleasing genre that had not been seen before and he made it in a Greek manner that was entirely antique. He astonished those who doubted he could succeed in this genre and the praise he received attests to the success of the work.[3]

He acclaimed the painting as introducing something new in this category of art, something never seen before. It is, indeed, one of his most remarkable and original paintings, and one that launched a new direction in the depiction of mythological themes in French art.[4]

The work is highly complex and David attended very carefully to the setting, which plays a prepotent role in the painting's meaning. Although officially commissioned in 1786 by Artois, a pleasure-loving patron of the arts, most likely for one of his boudoirs at Bagatelle (more on this later), David had begun to evolve his ideas for the composition years earlier, as seen in several drawings (Figures 8.9, 8.10). They reveal that he initially worked on the configuration of the couple and, once this was decided upon, he turned to the setting, which began as a simple partitioned room with a bed. It would evolve into something much more intricate. In the painting David depicts the ideally beautiful, sensual, and radiant youthful lovers before a rumpled and voluptuous daybed, enjoying a post-coital moment in the privacy of an intimate room that is screened off from a much larger space by a carved partition decorated with sculpted reliefs and covered in large part by sumptuous blue drapery. The nude, seated Paris, holding a golden lyre, looks up adoringly into the face of the demure, standing figure of Helen, who leans against him as he appears to draw her closer. The bed and all the objects and décor in the surrounding space have symbolic as well as narrative meaning.

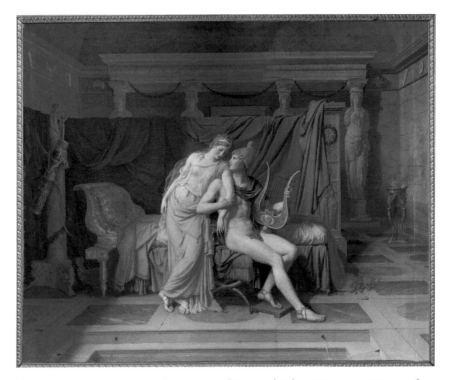

Figure 8.1 Jacques-Louis David, *The Loves of Paris and Helen,* 1788, 144 × 180 cm, oil on canvas, Musée du Louvre, Paris. © Erich Lessing/Art Resource, NY.

David has lavished attention not only on the brilliant depiction of the entwined lovers but on the room itself that supports the complex fabric of the interpretation.

In *The Loves of Paris and Helen*, I contend that David has created a boudoir *à la grecque*, in the antique style, a carefully crafted intimate space in which a beautiful woman from the Homeric past has an assignation with her lover. The creation of this neoclassical boudoir, with its eighteenth-century referents, presents a symbolic space in which the legendary lovers emerge from the ancient past into the modern world. David's painting has received a certain amount of exegetical energy, from myself and others.[5] I believe, however, that the neglected element that accounts for a great deal of the forceful impact and intellectual power of the painting is the conflation of classical antiquity with the appurtenances and configuration of the eighteenth-century boudoir and all of its attendant cultural associations. In order to understand this painting in its complexity and multiple meanings, and to understand in particular the prepotent role of the setting, it is essential to consider some of the major elements of the fascinating development and evolution of the boudoir in eighteenth-century France. During the course of the eighteenth century the boudoir became a storied, mythologized space, what Michel Delon describes in the following terms: "An object that is real and imaginary at the same time, this invention of the eighteenth century has its place in architecture, literature, and above all in symbolic representations ... It is a precinct of reverie, evasion, and dazzlement."[6]

The boudoir as an idea, a theory, an actual new space in domestic architecture, and as an important setting in eighteenth-century French libertine literature, has been the subject of considerable scholarly attention. The creation of the boudoir as a new space in architecture, an intimate room where women of the court or of means could withdraw for privacy and pleasure, inspired the idea of this space as a site of sexual freedom and intrigue, an idea that became pervasive after the mid-eighteenth century. The boudoir looms large in eighteenth-century French literature, especially as part of the subgenre of libertinage, from Claude Prosper Jolyot Crébillon's *The Sofa* of 1742 to Pierre Choderlos de Laclos's *Dangerous Liaisons* (1782) and the Marquis de Sade's *Philosophy in the Boudoir* (1795). Cultural historians such as Delon, cited above, whose *L'Invention du boudoir* (1999) serves as a foundational study, as does Edward Lilley's seminal article, "The Name of the Boudoir" (1994), examine broadly the predominance of the boudoir as a phenomenon in literature as well as architectural theory and practice.[7] These studies are complemented by more recent detailed investigations into the boudoir's importance in residential architecture and its impact more broadly on culture.[8] For the boudoir, of course, was intimately connected with the emergence of new notions of privacy and private life during the Enlightenment and, in particular, the private life and agency of women, whose role in French Enlightenment culture was preeminent.[9] The importance and prevalence of the boudoir in visual culture of the period, acknowledged and addressed as part of broader studies, has not been given its due, especially when considered as a new category or genre.[10] The boudoir played a signal role in the visual as well as the cultural imaginary of eighteenth-century France. Images of the boudoir abound in many categories of eighteenth-century French art, including genre imagery, portraiture, and mythological subjects. The boudoir constitutes a pervasive presence in visual culture of the period, especially before the

French Revolution, during which its associations with aristocratic and elite culture become understandably weaponized as part of revolutionary discourse and imagery, most notably in political prints and illustrations (the many lubricious images of Marie Antoinette in the boudoir are, perhaps, among the most well-known examples).[11] In this essay, I focus on salient, select examples from pre-revolutionary boudoir imagery with David's *The Loves of Paris and Helen* serving as a *terminus ante quem*. For I propose that this work addresses the philosophy, psychology, and poetry of love in the boudoir, and not only constitutes an acme of visual thinking about the eighteenth-century boudoir and its role in modern culture but also represents an innovative way of imagining the possibilities of the boudoir, beyond the prevailing notions of such intimate spaces as a private setting for sexual indulgence.

In 1740, the *Dictionnaire de l'Académie française* defined the boudoir as "a small *cabinet* where one can retire to when one wants to be alone."[12] During a period in which rooms in elite private residences were being defined and designated for specific uses (the salon, the dining area, the bedroom, the man's study, the *ruelle* or reception room in which ladies received morning guests, etc.), the boudoir emerged from the idea of the late seventeenth-century *cabinet* where women could retreat in order to pray or meditate.[13] Although the origins of the word remain somewhat obscure, scholars agree that it likely comes from "bouder," to sulk.[14] It is very interesting to consider the notion that women were believed to have a need to withdraw from social engagement to an intimate space where they could brood in private. During the eighteenth century the boudoir evolved into an almost sacrosanct interior space reserved for women's privacy and pleasures. It thus became a locus of fascination for male writers and artists who envisaged what women were like when they were in a private room of their own. These initiatives should be understood in the broader contemporaneous discourse on women, prominent in cultural and literary writings as well as the natural sciences, that interrogated their cultural, psychological, biological, and physiological nature, especially as it related to their sexuality.[15] In the context of this discourse, the boudoir served as a site of mystery and speculation about female nature. Male fantasies about the private space of the boudoir abound, primarily because it is a private space under female control. Women decided who could have access—a lover, a friend, or a confidante. As Lilley writes, the boudoir was "much more than a room: it generated discourse about sexual power relationships and was at the center of discussions about morality."[16]

In a plethora of examples from the visual arts, the boudoir is depicted as an intimate room devoted to privacy and pleasure in which women wielded their power of seduction over men who were sometimes active participants but who were also often attendant voyeurs. Sigismund Freudeberg, in *Suite d'estampes pour servir à l'histoire des moeurs et du costume des français dans le XVIIIe siècle* of 1775, claims: "The moderns have given the name of *boudoir* to an elegant cabinet, where beautiful women sacrifice a portion of their time to a retreat. The heart alone chooses the company of those who have a right to enter. This prerogative is that of the cherished lover or confidante."[17] In Freudeberg's engraving, *The Boudoir* (Figure 8.2), he depicted a beautiful young woman in elegant attire, who has undone her bodice, presumably to feel more comfortable in this private setting where she has been semi-reclining on a daybed while reading. Her

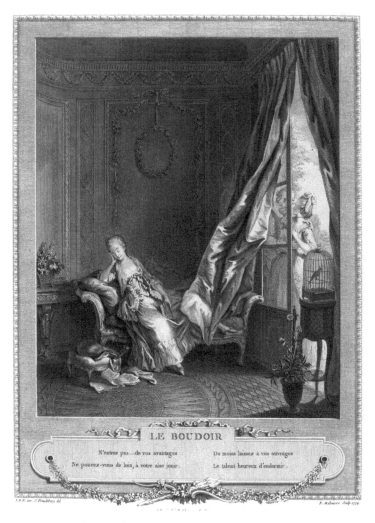

LE BOUDOIR

N'entrez pas...de vos avantages Du moins laissez à vos ouvrages
Ne pouvez-vous de loin, à votre aise jouir: Le talent heureux d'endormir .

Figure 8.2 Pierre Maleuvre after Sigismund Freudeberg (Sigmund Freudenberger), *Le Boudoir* (from *Suite d'estampes pour servir à l'histoire des moeurs et du costume des français dans le XVIIIe siècle*) (Paris: J. Barbou, 1774), etching and engraving. Rosenwald Collection, National Gallery of Art, Washington, D.C. Public Domain.

book has dropped into her lap and she is either napping or lost in reverie, likely due to the nature of the reading. She is the enticing, seductive object of interest for a young man who tries to catch a glimpse of her from the tall windows that give out onto the garden (many sources describe the boudoir with immediate access to a garden as an ideal situation). Although he has his arms around a beautiful young girl, he is more interested in the lady in the boudoir who is unaware of his presence. The boudoir's décor enriches the narrative of the young woman relaxing and daydreaming in her

private room. The objects have symbolic meanings as they do in David's *The Loves of Paris and Helen*. For example, the caged parrot adjacent to the potted flowers suggest that the lady's virtue is intact. She has been playing music and the scores lie next to a cushioned stool adjacent to her daybed. Flower garlands that symbolize delicacy and beauty adorn the walls, and a beautiful circular carpet further enhances the decorative luxury of the chamber. The appended verses advise the viewer to enjoy the sight of the lady in the boudoir as a voyeur, but not to intrude physically into her intimate space.[18]

The lady dozing and partially undressed, enticing a voyeur at the window, is a recurring motif in more licentious images of the boudoir such as Nicolas Lavreince's painting, *Frivolous Love*, of 1780, in which a young man reaches through the opened window and with his walking stick removes the scarf of a young woman to see better her exposed breasts. Lavreince's version, like Freudeberg's engraving, belongs to a popular category in visual culture, for a number of eighteenth-century artists specialized in boudoir imagery, such as Lavreince, Étienne Jeaurat, Nicolas Lancret, and Pierre-Antoine Baudouin, among others. Even prominent history painters such as François Boucher (we will recur to his imagery later in this essay) often produced genre paintings, including boudoir imagery. Did Boucher's most famous successor, Jean-Honoré Fragonard, represent the boudoir per se? Although he specialized in libidinous paintings of young women in bed for a private clientele, his focus was generally on activities in the bed rather than the chamber per se, as seen in *Girl Playing with her Dog* (1770), *Le feu au poudre* (1770s), and many others. One work at variance with this pattern is *The Lock* (1778–80). In this image, a young man, seen from the back and partially undressed, throws the bolt, while the young lady in his arms resists.[19] The huge bed, animated with voluptuous, oversized pillows and turbulent drapery, takes up the better part of the composition and plays a major narrative role. I would characterize this setting, however, as a bedroom rather than a boudoir, for the woman is not in control of the space and the overturned chair, as well as her resistance, implies that the agency in this room does not necessarily belong to her.

A salient fact to keep in mind is that the popular genre of boudoir imagery paralleled the historical development of the boudoir in architecture and that this space was distinct from the bedroom. In *The History of the Boudoir in the Eighteenth Century*, Diane Cheng traces its evolution from a small *cabinet* to a boudoir proper, a woman's private room.[20] The boudoir appears as a separate, named room in Jean Mariette's *L'architecture française* of 1727–8 (his plan for the boudoir was reprinted in Jacques-François Blondel's *Architecture française*, 1752).[21] In Charles-Étienne Briseux's *L'art de bâtir des maisons de campagne* of 1743, the boudoir is described with its furnishing of a *lit de repos* (a daybed).[22] The boudoir assumed an important place in the pleasure pavilions built for the king and court as well as for a wealthy clientele of financiers.[23] By 1758, the boudoir was becoming so well established as an architectural space that a *"pavilion à l'italienne"* with a boudoir was that year's subject for the Grand Prix d'Architecture.[24]

The elite fashion for the boudoir, and later its notoriety, was due not only to male patrons but to the influence of prominent women. One of the most famous examples is the Bagatelle of 1777, a *maison de plaisance* with a salon on the ground floor flanked by two boudoirs, built by the comte d'Artois, youngest brother of

Louis XVI (the patron, as mentioned earlier, of David's *The Loves of Paris and Helen*, who likely commissioned it for one of the Bagatelle boudoirs).[25] Bagatelle, designed by the architect, Joseph-François Bélanger, was built remarkably quickly in response to a bet by Marie Antoinette, who challenged her brother-in-law to have it built in record time. Although Artois won the bet, the construction was shoddy and the building began to deteriorate almost immediately. Marie Antoinette herself had several sumptuous boudoirs in various residences, decorated in different "exotic" styles.[26] But the queen was furthering a fashion for the boudoir that had already been established in the mid-eighteenth century by the great patroness of the arts, the marquise de Pompadour, official mistress to Louis XV. She had boudoirs in several of her residences, including the hôtel d'Evreux, the château de Bellevue, and, of course, at Versailles (we will return to Pompadour later).[27] Wealthy courtesans also competed with one another for creating the most lavish and celebrated boudoirs. Marie Anne Deschamps received her wealthy lovers in a boudoir in her private Parisian residence where she had famously covered the walls and ceilings with mirrors.[28] In 1760, when a downturn in her fortunes compelled her to auction off her belongings, the wealthy flocked to tour her boudoir. Boudoir tourism was popular among the elite during this period.

The boudoir as a highly specialized intimate interior was described in detail by the architect and theorist, Nicolas Le Camus de Mézières, in his remarkable *Le Génie de l'architecture et l'analyse de cet art avec nos sensations*, 1780, in which he relates architecture to sensory experience.[29] He delineates the role and function of each room of a residence—its furnishings, décor, colors, and the mood these elements should evoke along with the ways in which they contribute to awakening the senses appropriate to each room. His entry on the boudoir was inspired by Jean-François de Bastide's *La Petite Maison*, a popular novella of 1758 (revised 1763) that centered around the two boudoirs of a *maison de plaisance*, constructed by a young marquis who put all of his efforts into designing and furnishing the boudoirs in order to entice his would-be mistress.[30] His efforts were highly successful for the young woman in question was so captivated by the elegance and sensuality of the boudoirs that she acceded to the marquis. Bastide's popular novella demonstrates the crucial role that the boudoir played by mid-century in the French imaginary. If designed and furnished correctly, no woman could resist this private space dedicated to her pleasure. The remarkable phenomenon of the boudoir in architecture and literature led Sébastien Mercier, in *Tableau de Paris* of the 1780s, to denounce it in the following terms: "Architecture has foreseen and satisfied every inclination of debauchery and libertinage."[31] But at the same time Le Camus de Mézières heralded the boudoir as a space made for pleasure where women could enjoy whatever activities they desired in utmost privacy and comfort:

> The boudoir is seen as an abode of pleasure: this is where she appears to reflect on her projects or give herself over to her inclinations … It is essential that everything must be treated in a genre in which one sees that luxury, softness and taste reign … one must do everything possible, using the magic of painting and perspective to create illusions.[32]

Elements of the boudoir should engage the five senses, including enticing perfumes, the sounds of water in a fountain, and appeals to the sense of sight, thus paintings and mirrors were essential. Everything must contribute to the creation of a soothing, sensual atmosphere, including the colors, such as blue and white. And, of course, there needed to be a niche for a daybed or an ottoman.

Remaining cognizant of these structural and theoretical mandates for the boudoir, let us now return to our examination of the visual arts and look at the development of the boudoir in three categories—genre painting, portraiture, and mythological paintings (the last category included David's *The Loves of Paris and Helen*). As discussed earlier, Freudenberger's depiction of the boudoir from 1775 belonged to a popular genre of boudoir imagery that flourished from the 1740s onwards. His representation is reminiscent of Baudouin's *La Lecture* (*Reading*) of 1760 (Figure 8.3). Baudouin, who specialized in boudoir scenes and other types of erotic activities in intimate interiors, was known for the libertinage of his images (boudoir imagery of this type was targeted by Diderot in his Salon of 1767 in which he decried the immorality of the genre).[33] In *La Lecture*, Baudouin depicted an elegantly dressed young woman, alone in an intimate yet lavishly decorated boudoir. She reclines on a chaise longue and is propped up on pillows. She has been reading a book that has inspired her to pleasure herself (physiologists of the period warned that it was dangerous for women to read novels since they could easily get sexually aroused by them, although Dante in the episode of Paola and Francesca would not wait for scientific approbation to make the connection). The objects and the décor speak to her learning as well as her indulgence in sensuality. She has been playing a musical instrument and a small desk supports a globe, books, and a map, all in some disarray. Blue drapery partially occludes the ottoman or daybed. A screen behind her decorated with flowers, the luxurious carpet, the painting above her of playful putti, all indicate the comfort, sensuality, and activities in which the young woman can indulge in private. Perhaps she anticipates the arrival of her lover. A little dog sleeps on a small pillow or rug in a comfortable-looking kennel, a type of mini-boudoir. The young woman playing with her dog while frolicking semi-nude in bed was a popular theme with boudoir specialists like Nicolas Lavreince but also with painters like Fragonard, as we have seen. The voyeur here is the viewer, but the painter often included an interested young man in this role as in *The Morning* from his *Times of the Day* series (1753) in which the youth has entered a bedroom/boudoir to find the young woman asleep in a very seductive and revealing pose.

Use of a decorated screen to carve out an intimate space within a larger room is part of the many genre images of women at their toilette, getting dressed in a boudoir-type room. Boucher's *The Toilette* of 1742 is a case in point (Figure 8.4).[34] The young woman ties her garter, a feature of many period images. In Boucher's version a servant with her back to us has been helping her mistress dress. A folding screen decorated with birds and flowers, a popular motif of chinoiserie, encloses the intimate space. The dressing table and mirror at the right are staple elements in dressing imagery and the capacious fireplace with its requisite implements on the floor indicate the imminent arrival of a lover. Under the woman's uplifted petticoat lies a cat playing with a ball of yarn—the feline is also a familiar feature of this genre and is often seen with a female figure,

Figure 8.3 Pierre-Antoine Baudouin, *La Lecture, c.* 1760 29 × 22.5 cm, gouache on paper. Musée des Arts Décoratifs, Paris, Wikimedia Commons/Public Domain.

functioning as an emblem of her sexuality. Similar images include Étienne Jeaurat's 1769 painting *The Toilette* and Nicolas Lavreince's version of 1775.

Among the congeries of boudoir imagery produced during this period, the paintings of Boucher are among the most distinctive. For he represented the boudoir across categories—in genre scenes, portraiture, and mythological painting. His great patronness, the marquise de Pompadour, described by Joan DeJean as a "boudoir fanatic," commissioned what would become one of his most famous portraits of her as a commanding presence in her boudoir (Figure 8.5).[35] Pompadour, as mentioned earlier, was responsible for catapulting the boudoir into a most desirable and fashionable space that was indispensable for women of taste and means. In his resplendent 1756 portrait, Boucher depicts the royal mistress in her boudoir replete with requisite décor and furnishings that reveal her tastes and abilities as a woman

Figure 8.4 François Boucher, *La Toilette*, 1742. Museo nazionale Thyssen-Bornemisza, Madrid, 52.5 × 66.5 cm, oil on canvas. © Photo: Scala/Art Resource, NY.

who is desirable, seductive, and accomplished intellectually, all at the same time. She is the exquisitely beautiful woman presiding in her intimate interior. Recent scholarly studies have emphasized Pompadour's role in the portraits she commissioned and her involvement in these representations.[36] In Boucher's 1756 version the marquise presides regally in her boudoir. Dressed in formal attire, corseted, and wearing a green silk taffeta dress embroidered with roses, the viewer glimpses her at a private moment of reflection. She has interrupted her reading to reflect. There are no lubricious suggestions here as in genre images by Baudouin and so many others, including those by Boucher himself. The boudoir setting is sumptuous and sensual but also indicative of learning and intellectual pursuits. She semi-reclines on an ottoman and is propped up by beautiful, embroidered pillows. The night table with its letter, inkwell, books, and roses underneath (roses, the attribute of Venus, appear prominently throughout the painting), are all associated intimately with the figure of Pompadour, as is the gutted candle that likely indicates the end of her status as official mistress to Louis XV (in Boucher's genre image of *The Toilette*, discussed earlier, a candle is fiercely burning on the mantelpiece). The candle may also serve as a trope of the evanescence of time. In 1756, Pompadour was no longer the king's mistress, she nonetheless remained extremely powerful at court, assuming a new role as lady-in-waiting to the queen.

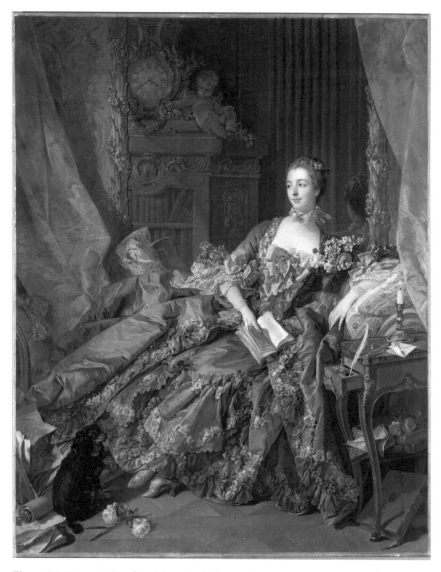

Figure 8.5 François Boucher, *Marquise de Pompadour*, 1756, 212 × 164 cm, oil on canvas, Alte Pinakothek, Munich. © Photo: Art Resource, NY.

Boucher represents her, however, as an enticing and seductive beauty in her boudoir, in reference to her earlier position.[37] The clock on the bookcase against the wall and the sleeping Cupid indicate the passage of time and that love is now asleep. The paired roses on the night table shelf and the floor may be signs of the passion that has turned to friendship with the king. Her faithful little spaniel is perhaps another indication of loyalty and fidelity to Louis XV that she anticipates will be mutual. In Boucher's

portrait the boudoir plays an important narrative and symbolic role that informs the viewer of Pompadour's new position at court. Her boudoir is a place to display her allure but is also a private space for reading, writing, and reflection. Thus, this portrait still adheres to the 1740 definition of the boudoir as "small *cabinet* where one goes when one wants to be alone."[38]

Five years prior to this portrait, Boucher had flattered the marquise de Pompadour in a mythological painting, *The Toilette of Venus* (Figure 8.6). It was commissioned by Pompadour to decorate a new suite of bathing pools at the château de Bellevue.[39] The features of the goddess of love predictably resemble those of Pompadour. The nude

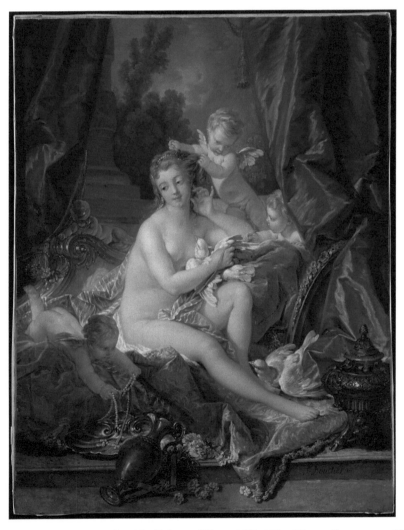

Figure 8.6 François Boucher, *The Toilette of Venus*, 1751, 108 × 85 cm, oil on canvas. The Metropolitan Museum of Art, New York © Photo: Art Resource, NY.

Venus is depicted in a boudoir setting at a moment of reflection, at her toilette, attended by putti who are putting on her jewelry. Lost in thought, the goddess of love seems oblivious to their presence. She sits on a sumptuous daybed with the curtains opened, revealing a dreamlike landscape beyond. The emphasis on lushness of materials, on sensuality (this includes the softness of the doves), on soothing colors, and the intimate interior opening up to nature or a garden, all meet the criterion for the boudoir as a site of "la volupté." In *The Loves of Paris and Helen* David will present a *sui generis* neoclassical version of sensuality and pleasure in the boudoir, replete with allusions to Venus.

Boucher had represented mythological figures in a much more modest boudoir in an earlier mythological painting—*Hercules and Omphale* from 1735 (Figure 8.7).[40] The mythological lovers are passionately kissing in a pre-coital moment on a prominent bed whose canopy serves as a means to separate the precinct of the bed from the rest

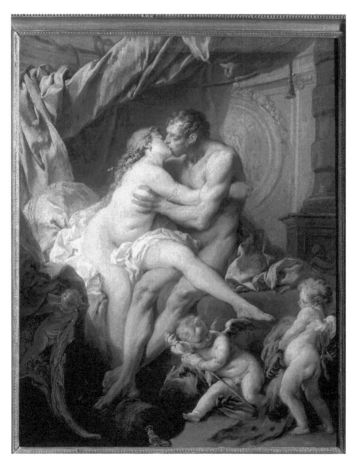

Figure 8.7 François Boucher, *Hercules and Omphale*, *c*. 1730. 90 × 74 cm, oil on canvas. Pushkin Museum of Fine Arts, Moscow. © Scala/Art Resource, NY.

of the room. The story of Hercules' enslavement by the queen of Lydia, as punishment for a murder he needed to expiate, was popular during the rococo era. Hercules was required to dress like a woman and to do women's work such as embroidery. Omphale falls in love and his new assignment is to make love to her. The narrative engages male/female identity and its cultural markers appealed to Enlightenment France with its interest in gender identity and cross-dressing. The putti in the foreground hold the masculine and feminine attributes of Hercules, his lion skin and distaff. Both are references to sexual identity and social roles, of ideas of male dominance but also to the sexual submission that Boucher dramatizes in this painting. Thus, as early as 1735, the artist revealed that the intimate interior in which lovemaking occurs may serve as a site of discourse about sexuality. In choosing a small and private interior space as a setting for their lovemaking Boucher diverges significantly from earlier, more static depictions of Hercules and Omphale that typically locate the couple in a landscape setting, including the 1724 painting by his teacher, François Lemoyne.

Because of their apparent psychological distancing from the contemporary world, mythological subjects provided an ideal means of making manifest modern ideas about sexuality and intimacy. A considerable number of amatory mythic scenes in eighteenth-century French art focus on settings in nature, considered the apposite milieu for the loves of the deities of Greco-Roman antiquity. A notable exception is the popular discovery scene from the myth of Cupid and Psyche. The event takes place in a castle bedroom in which the sleeping god of love is spied upon by the captive Psyche whom he has kidnapped. Psyche seeks by lamplight to discover her lover's true identity. This subject provided eighteenth-century artists with the opportunity to depict the lovers in a bedroom setting and the bed itself features prominently in these depictions.[41] In 1769 Louis-Jean François Lagrénée painted *Psyche Surprising the Sleeping Cupid* (Figure 8.8), a composition that reveals a voluptuous private interior in which a partially clad Psyche raises her lamp to gaze lovingly at a sensual, adolescent Cupid. The richly decorated bed on which he sleeps appears to be a daybed. A curtain hanging over a partition separates the space from the larger room. The interior could thus be described as a bedroom/boudoir space because the boudoir does seem to be a referent. David's teacher, Joseph-Marie Vien, in his 1761 version of the theme, included similar elements, although he emphasized the bed which dominates the space and depicts Cupid as a child.

In representations of other types of mythological themes, however, the boudoir setting may assume a significant role. And here is where we return to David's *The Loves of Paris and Helen*. As mentioned in the introduction, David's painting is a multi-layered narrative presentation of the mythological lovers in an *à la grecque* boudoir, but one that includes more modern furnishings and with many elements corresponding to the requisites for the boudoir as described in literary and theoretical sources such as Bastide and Le Camus de Mézières. The furnishings and the décor have a significant narrative function and relate different parts of the lovers' life stories whose destinies are conjoined in the boudoir.[42] David, who was exceptionally learned, would have been very familiar with the Homeric story. In the 1780s he was part of the well-known intellectual circle of the Trudaine brothers and likely frequented their classical library in Paris.[43] Since he was working on *The Death of Socrates* at the same time as *Paris and*

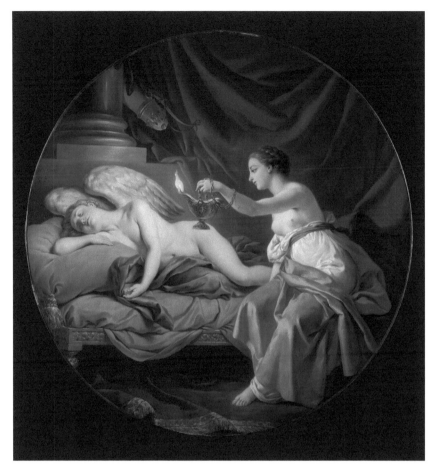

Figure 8.8 Louis-Jean François Lagrénée, *Psyche Surprising the Sleeping Amor*, 1768, Musée du Louvre, Paris, 121 cm diameter, oil on canvas. © RMN-Grand Palais/Art Resource, NY.

Helen, one can imagine the artist consulting Plato and Homer and perhaps discussing the subjects with classical enthusiasts in the Trudaine circle. He also likely consulted visual antecedents, none of which depict this episode. In fact, David, in keeping with his artistic innovations of the 1780s, invented a significant moment, one that does not appear in visual or textual sources.

Before receiving the commission, as noted earlier, David had conceived of his composition and made drawings of the mythological lovers. The early drawings, one a tracing of an engraving from d'Hancarville's publication of William Hamilton's collection, reveals that the painter was concerned primarily with the corporal configuration of the pair and worked out their positions relative to one another, finally deciding on a seated Paris and a standing Helen.[44] In another early drawing a prominent bed appears with Paris standing before it and a seated Helen appearing to supplicate

him (Figure 8.9). In later drawings the lovers are depicted in their final corporal configuration and details of the room begin to emerge. In a fine drawing of 1786 that is close to the final composition, the boudoir has appeared with an elaborate, elongated daybed that serves as the principal horizontal element, situated behind the figures and filling almost the entire space from left to right (Figure 8.10). Some objects in the room were not retained in the painted version. David modified the configuration of the alternating circles and rectangles of the floor and omitted Cupid stepping through his bow, likely rejecting this extraordinary conceit because of its allegorical nature. He does include Cupid and Psyche, but as a sculpted relief on the partition based on the famous antique sculpture in the Capitoline Museum.

The drawings reveal the elaboration of David's thinking about the final painting and especially the importance of a setting rich in multifarious meanings. The boudoir provides the ideal space for the fulfillment of mutual seduction that David represents. In the *Iliad*, Aphrodite has to compel a reluctant Helen to return to the palace where Paris awaits.[45] Helen even accuses Aphrodite of lusting for Paris herself but does not dare to defy the wishes of the goddess of love who has just saved Paris from slaughter by her husband Menelaus on the battlefield and dropped him off in the palace bedroom. The near-death experience has intensified Paris's desire for Helen and he seduces her

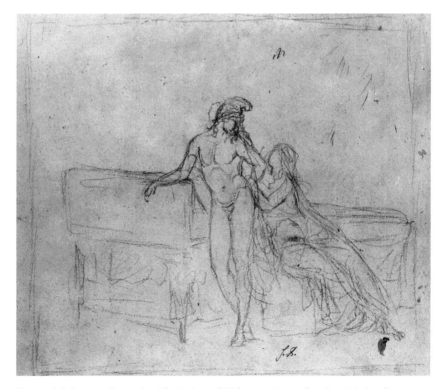

Figure 8.9 Jacques-Louis David, *Paris and Helen*, ca. 1786, drawing, Nationalmuseum, Stockholm/Public Domain.

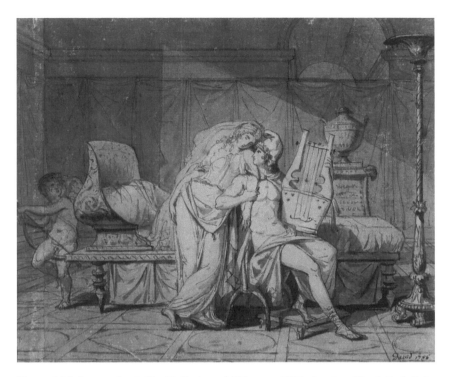

Figure 8.10 Jacques-Louis David, *Paris and Helen*, *ca.* 1786, drawing, The J. Paul Getty Museum, Los Angeles/Wikimedia Commons, Public Domain.

by describing his burning passion while reminding her of other instances in which they made love. Homer had thoroughly understood and signalized the primordial, intimate conjunction between love and death. Helen chides Paris initially but then willingly accedes. David depicts a bedroom turned into a boudoir by the youthful prince, in accord with modern architectural spaces built by aristocrats for this purpose, like the comte d'Artois's boudoirs at Bagatelle. I would suggest that since this painting was likely commissioned for the boudoir at Bagatelle, the setting itself serves to flatter the patron (amatory mythological paintings being *de rigueur* for the boudoir).

In placing the lovers in front of the rumpled bed, which suggests that lovemaking has already taken place, David changed the moment of the literary source. He also altered other features described in Homer. Aphrodite brings a chair for Helen to sit on. In David's painting, Paris sits on the chair and looks up adoringly at his mistress. It was his nature as a poet to choose beauty and love over war or wisdom. He clutches the arm of the downcast Helen, who leans on him as a type of muse, inspiring his Anacreontic love songs.[46] In Homer she accuses Paris of failure in battle and cowardice, which he deflects by saying that gods have ordained all that has happened and will happen. She had already expressed her regrets to Aphrodite about leaving her husband Menelaus and the ensuing Trojan War that her love affair with Paris launched.

David revealed in the setting of the composition that Aphrodite and the realm of Eros reign in the boudoir, which he depicted as a type of sanctuary of the goddess of love. This is her precinct and, by extension, that of her son. A statue of the goddess as *Venus Victorix* holding the apple Paris awarded her, is placed atop a column supported by three sphinxes.[47] She appears again in the relief sculpture of *The Judgement of Paris* on the golden lyre the Trojan prince holds and the tripod *Athénienne*, used as a *brule-parfum*, is held up by three delicately sculpted swans, birds sacred to the goddess, cygneous emblems of her beauty and grace. The pool that extends into the foreground space, with its small phallic-shaped waterspouts, recalls her birth from sea foam. Aphrodite presides over the lovers' destinies. Her son, Cupid, accomplishes what she has enjoined. The god of love appears in David's painting in the relief of Cupid and Psyche on the partition and is also referenced by the quiver of Paris slung over the statue of Aphrodite (conjoining one of the attributes of the god of love with that of Paris).

In the 1780 *Architecture, poem, in three cantos*, Maillier describes the boudoir as the sanctuary of the goddess of love and Cupid:

Here is the charming sanctuary of Venus,
The temple of the god adored at Cythera,
Everything thus in this amatory place must breathe
Luxury, pleasures, softness and love.
Love must preside over its architecture.
… the boudoir, destined for the mysterious lover
Must take his behavior from the bow of this god.[48]

Maillier also describes the amatory mythological paintings that should decorate the boudoir, all leading to the bed: "The voluptuous bed, amatory in its luxuriousness/ Decorated with gold striations and soft materials."

In accord with Maillier's description, David depicted an ornate version of a daybed for the lovers (likely designed by his cabinet-maker, Jacob), with gilded décor on the frame and gilded legs. The bed, covered with voluptuous, soft, and luxuriant materials, and by an ornate pillow, calls to mind the visual and literary descriptions of the boudoir bed by Bastide in *La Petite Maison*. The emphasis on softness and sensuality can be seen in Helen's drapery and Paris's cloak and Phrygian cap as well as in the sensuality of their bodies and the nuanced depiction of their skin. The couple's past histories that led them to the boudoir are represented throughout the room. On the bedframe in gilded low relief one sees the very moment of intercourse between Leda and the Swan when Helen was conceived. If we follow the diagonal from the statue of Aphrodite holding the apple down to the right, it leads directly to *The Judgement of Paris* depicted on the lyre. The prince's choice of Aphrodite over Hera and Athena seals his and Helen's fate and the ultimate fate of Troy. Thus, the life histories of Paris and Helen are interwoven throughout the fabric of the composition.

The Loves of Paris and Helen also presents elements described by writers such as Le Camus de Mézières as essential to creating the soft and sensual mood in the boudoir that depends on an appeal to the senses: the bed with its soft and luxuriant materials,

perfume from the tripod *Athénienne* supported by sculpted swans, the soothing sound of water from the foreground fountain, music, colors such as blue in Paris's cape and the drapery atop the partition, and the importance of décor throughout the room, including the statue of Aphrodite on a column, the sculpted relief of Cupid and Psyche kissing, the relief of Leda and the Swan on the bedframe, and the Judgment of Paris on the lyre. We also see the recurring motif of myrtles and roses throughout the room. The presence of the myrtles and roses, both symbols of love, is important because they were the flowers in the crown of Erato, the muse of erotic love poetry, which Paris has been singing. This introduces Apollo into the boudoir, the god who presided over the Muses, and who favored the beautiful poet/archer, Paris (at a later date, he guided the arrow that Paris shot at Achilles, wounding him fatally in his heel). A wreath of myrtles and roses is hanging from the partition above the head of Mercury, carved in relief above the embracing Cupid and Psyche. One recalls that Mercury brought the three goddesses to Paris for judgment, playing a crucial role in the story. Myrtle and rose garlands also festoon the caryatid porch, a structure based on Jean Goujon's famous 1550 work inspired by the Erectheion. In the 1780s it was located in the Louvre in a room in which classical sculpture was exhibited. Thus, David situated the amorous pair in a room that evokes the presence of the classical past and its sixteenth-century renascence in a French royal palace of the arts that housed the royal art collections as well as the monarch's artists who had their studios there. All of these resonances enrich the meaning of the work that merges the past and present, the ancient and the modern, on multiple levels.

The pool depicted in the composition's foreground is worthy of further consideration. It is a reference to the birth of Aphrodite from the sea foam but it also has direct links to the modern boudoir and perhaps to one in particular that was designed in the 1780s by the architect, Bélanger, for his lover, the famous courtesan, Anne Victoire Dervieux.[49] Bélanger had designed Bagatelle, including the two boudoirs, for the comte d'Artois, the patron of David's *Paris and Helen* (Artois, by the way, had also been Dervieux's lover). Dervieux, who was in competition with celebrated courtesans in Paris, turned to Bélanger when she decided to add two wings to her private pavilion. One of the wings was to house a bathing pool connected to a boudoir (Figure 8.11).[50] Dervieux's house and boudoir were described in ecstatic terms by several admirers. One was the baroness d'Oberkirch, who recounted in 1782 that Dervieux's boudoir was considered the most "coquette of all the retreats."[51] In 1788 Antoine Callet described it as a "sanctuary" where "two lovers in their voluptuous embraces, can consider themselves in every position" (the walls were covered in mirrors).[52] When Bélanger redesigned Dervieux's house and added the wing with the bathing pool and boudoir, he brought together the idea of the goddess of love in the bathing pool and the goddess of love in the boudoir, incarnated, of course, in Mlle. Dervieux. The bathing pool set into the floor differentiates it from eighteenth-century innovations in bathing rooms or bath rooms seen in domestic architecture. In Bélanger's design of the bathing room, the pool is depicted in the immediate foreground, extending into our space. Its position in the foreground is suggestive of the foreground marble pool in David's *Paris and Helen*. The chair facing the pool indicates the place where the lover sits and watches his beloved frolicking in the water. In the boudoir behind the chair we glimpse a daybed

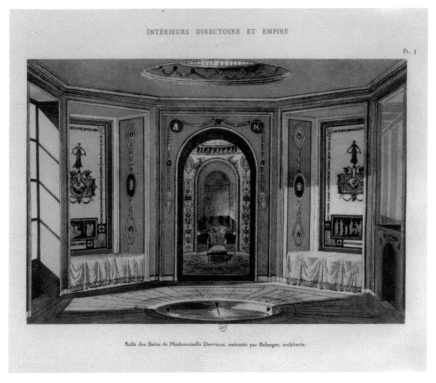

INTÉRIEURS DIRECTOIRE ET EMPIRE

Pl. 5

Salle des Bains de Mademoiselle Dervieux, exécutée par Bélanger, architecte.

Figure 8.11 François-Joseph Bélanger, *Bathing Room and Boudoir of the Petite Maison of Mademoiselle Dervieux*, colored plate by Détournelle, n.d. Bibliothèque Nationale de France, Paris.

in a niche. Nikolai Karazim, a Russian visitor to Dervieux's boudoir, described the pool in the following terms: "a marble pool has been made for bathing, and above there is a gallery for musicians so that the beauty can splash to the rhythm as she listens to their harmonious playing."[53] Karazim's description, uniting an almost Pythagorean harmony with its corporeal counterpart, indicates the extent to which bathing had become an essential sensual pleasure for the elite. For Dervieux, Bélanger had designed an innovative sunken, marble bathing pool all'antica accompanied by depictions of Venus and Cupid on the bathing room walls.

David's youthful connections to the architectural milieu through his uncles, the architects François Buron and Jacques-François Desmaisons, and Bélanger's association with the comte d'Artois who commissioned *Paris and Helen* likely for one of his boudoirs at Bagatelle that Bélanger designed,[54] suggest that David might well have known of the innovation of the bathing pool/boudoir designed for Dervieux. The artist was also acquainted with the milieu of wealthy Parisian courtesans. In 1773–4, the famous opera dancer/courtesan, Marie Madeleine Guimard, commissioned David to paint the ceiling of the Salon in her private hotel.[55] Guimard and Dervieux were intense rivals.[56] But David's painting does not lead the

viewer to contemplate joyful erotic frolicking in the boudoir. Instead, he presents the famous lovers, whose affair was predestined by the gods and would lead to tragedy, massive loss of life, and the destruction of Trojan civilization itself, in a quiet private moment after lovemaking. In fact, he presents the lovers in the boudoir enamored of one another. In his article in the *Encyclopédie* on "Love, Gallantry," the chevalier de Jaucourt, wrote the following:

> Gallantry is a vice since it is the libertinage of the mind, of the imagination, of the senses ... Love is the charm of loving and of being loved ... In love, the continuity of feeling enhances its sensuality ... Love delivers our heart without reserve to one person alone who fills it entirely, such that we are left indifferent to all the other beauties of the universe ... Love consists in tender, delicate, respectful feeling, a sentiment that must be elevated to the order of virtue.[57]

Do we not see this idea instantiated in David's depiction of Paris and Helen, a couple imbued with tender, delicate, respectful feelings for one another, who have experienced a continuity of their love, an illicit love but nonetheless heartfelt? And thus, this painting, in concert with David's earlier paintings of the 1780s, including its pendant, *The Death of Socrates*, poses complex and challenging questions that the artist presents to the viewer to contemplate.

David completed *The Loves of Paris and Helen* in 1788. He thought of it as offering something new in this genre, something "in the Greek manner that was entirely antique," something he had never worked on before, and that no one had ever seen previously. In presenting the Homeric lovers in the neoclassical boudoir he reimagined the classical past, making it a transparent window into modern, contemporaneous concerns of love and sexuality. He reimagined the capacity of the eighteenth-century boudoir to reveal love's mysteries and to serve as a meditation on the role of love and sexuality, for better or worse, as key elements in a civilized society. David understood that for the Greeks, Eros often brought catastrophe. Paris and Helen breached the bonds and codes of acceptable behavior that began with the Judgment of Paris, led to the kidnapping of the wife of Menelaus, and then ineluctably to the downfall of a city and civilization. The painting itself coincides with the end of an era, the end of the ancien régime, and with it, the seriousness of pleasure and the joyful mythologies of the boudoir.[58]

Notes

Translations are the author's unless otherwise noted.

1 Discussed in Antoine Schnapper and Arlette Sérullaz, *Jacques-Louis David, 1748–1825* (Paris: Réunion des Musées nationaux, 1989), 184–91; Régis Michel, *David e Roma* (Rome: De Luca Editore, 1981), 148–54; Colin Bailey, *The Loves of the Gods: Mythological Painting from Watteau to David* (New York: Rizzoli, 1992), 510–15.

2 Michel, *David e Roma*, 148–54, discusses the Salon criticism in some detail and concludes that they were largely negative.

3 David wrote the notes for Jean-Joseph Sue. Cited in Philippe Bordes, '*Le Serment du Jeu de Paume' de Jacques-Louis David: le peintre, son milieu et son temps, de 1789 à 1792* (Paris: Editions de la Réunion des Musées Nationaux, 1983), 174–5.

4 I have discussed this idea in *David to Delacroix: The Rise of Romantic Mythology* (Chapel Hill: University of North Carolina Press, 2011), 32 ff.

5 See, for example, E. Coche de la Ferté and J. Guey, "Analyse archéologique et psychoanalytique d'un tableau de David: *Les Amours de Paris et d'Hélène*," *Revue Archéologique* 40 (1952): 129–61; Michel, *David e Roma*, 148–54; Bailey, *The Loves of the Gods*, 510–15; Yvonne Korshak, "*Paris and Helen* by Jacques-Louis David: Choice and Judgement on the Eve of the French Revolution," *The Art Bulletin* 69, no. 1 (March 1987): 102–16; Johnson, *David to Delacroix*, 13 ff.

6 "Objet à la fois réel et imaginaire, cette invention du XVIIIe siècle a sa place dans l'architecture, de la littérature et surtout des représentations symbolique … c'est un enclos de rêverie, d'évasion et de vertige," Michel Delon, *L'Invention du boudoir* (Paris: Grains d'Orage, 1999), 20–1.

7 Edward Lilley, "The Name of the Boudoir," *Journal of the Society of Architectural Historians* 53 (June 1994), 193–8. Jill Casid investigates the uses of the term "boudoir" in late eighteenth-century Salon criticism and examines the phenomenon more broadly in the context of gender politics in France and its colonies. See "Commerce in the Boudoir," in *Women, Art and the Politics of Identity in Eighteenth-Century Europe*, ed. Melissa Hyde and Jennifer Milam (Burlington, VT: Ashgate, 2003), 91–114. See also Rémy Saisselin, "The Space of Seduction in the Eighteenth-Century French Novel and Architecture," *Studies on Voltaire and the Eighteenth Century* 319 (Oxford: Voltaire Foundation at the Taylor Institute, 1994), 417–31.

8 Two dissertations are dedicated to the architectural history and function of the boudoir in the eighteenth century: Diana Cheng, "The History of the Boudoir in the Eighteenth Century" Ph.D. diss., McGill University, 2011, and Joséphine Grimm, "Entre pièce intime et espace fantasmé: formes, décor et usages du boudoir de 1726 à 1802," Ph.D. diss., Ecole nationale des Chartes, 2019 (accessible only in abstracts of chapters).

9 The literature is vast but see especially Dena Goodman, "Women and Enlightenment," in *Becoming Visible: Women in European History*, 3rd edition, ed. R. Bridenthall, S. M. Stuard, and M. E. Wiesner (Boston: Houghton Mifflin, 1998), 233–62; Madelyn Gutwirth, *The Twilight of the Goddesses: Women and Representation in the French Revolutionary Era* (New Brunswick, NJ: Rutgers University Press, 1992). A primary source is Julien Joseph Virey, *De l'influence des femmes sur le goût dans la littérature et les beaux-arts, pendant le XVIIième et XVIIIième siècle* (Paris: Deterville, 1810).

10 See Melissa Hyde, *Making Up the Rococo: François Boucher and his Critics* (Los Angeles: Getty Publications, 2006), 45–81.

11 See Lynn Hunt, "The Many Bodies of Marie-Antoinette: Political Pornography and the Problem of the Feminine in the French Revolution," in *Marie Antoinette: Writings on the Body of a Queen*, ed. Thomas E. Kaiser and Dena Goodman (London: Routledge, 2003), 117–38.

12 "Boudoir," in *Dictionnaire de l'Académie française*, 3rd edition, 2 vols. (Paris: Coignard, 1740), 181.

13 Discussed in Delon, *L'Invention du boudoir*; Lilley, "The Name of the Boudoir"; Cheng, *The History of the Boudoir*.

14 The origins of the word were addressed by Delon, *L'Invention du boudoir*; Lilley, "The Name of the Boudoir"; Cheng, *The History of the Boudoir*.

15 The literature is vast. See, for example, D. T. de Bienville, *La Nymphomanie; ou Traité de la fureur utérine* (Amsterdam: Marc-Michel Rey, 1778) and Edme-Pierre Chavot de Beauchène, *De l'influence des affections de l'âme dans les maladies nerveuses des femmes* (Montpellier: Méquignon, 1781). Mary Sheriff discussed these issues in *Moved by Love: Inspired Artists and Deviant Women in Eighteenth-Century France* (Chicago and London: University of Chicago Press, 2004).

16 Lilley, "The Name of the Boudoir," 193.

17 "Les modernes ont donné le nom de Boudoir à un Cabinet élégant, où les Belles sacrifient quelques moments à la retraite ... Le coeur seul choisit la compagnie qui a le droit d'y pénétrer. Cette pérogative est celle de l'Amant chéri et de l'Amie de confiance," Sigismund Freudeberg, *Suite d'estampes pour servir à l'histoire des moeurs et du costume des français dans le XVIIIe siècle* (Paris: J. Barbou, 1774), cited in Cheng, *History of the Boudoir*, 245.

18 "N'entrez pas ... de vos avantages / Ne pouvez-vous de loin, à votre aise jouir / Du moins laissez à vos ouvrages / Le talent heureux d'endormir." Caption for "Boudoir," in Freudeberg, *Suite d'estampes pour server à l'histoire des moeurs*.

19 See Mary Sheriff, *Fragonard: Art and Eroticism* (Chicago and London: University of Chicago Press, 1990), 130–2.

20 Cheng, *The History of the Boudoir*, 24–81. See Jean-Charles Krafft and Pierre Nicholas Ransonette, *Les plus belles maisons de Paris* (Paris: Ransonette, 1801–3).

21 Cheng, *The History of the Boudoir*, 240 ff.

22 Ibid., 240–1.

23 Ibid., 245–54.

24 Ibid., 241.

25 See Taha Al-Douri, "The Constitution of Pleasure: François-Joseph Bélanger and the Château de Bagatelle," *RES: Anthropology and Aesthetics* 4 (Autumn 2005), 155–62.

26 In contrast to her sumptuous boudoirs at Fontainebleau and Versailles, in the Hameau de la Reine (Richard Mique, 1783–6), her boudoir was a discreet rustic cottage.

27 Joan DeJean, *The Age of Comfort* (New York: Bloomsbury, 2009), 178–9 and Cheng, *The History of the Boudoir*, 272–90.

28 DeJean, *The Age of Comfort*, 182–3.

29 Nicolas Le Camus de Mézières, *Le Génie de l'architecture: ou, l'analogie de cet art avec nos sensations* (Paris: Benoit Morin, 1780), 116–23 and idem., *The Genius of Architecture, or the Analogy of that Art with Our Sensations*, trans. David Britt (Santa Monica, CA: Getty Center for the History of the Arts and Humanities, 1992).

30 Jean-François de Bastide, *La Petite Maison* in *Contes de M. de Bastide* (Paris: Cellot, 1763). Discussed in Delon, *L'Invention du boudoir*, 27–9.

31 "L'architecture a prévu et satisfait toutes les intentions de la débauche et du libertinage," in Louis-Sébastien Mercier, *Tableau de Paris* (Amsterdam, 1782–8). Cited in Delon, *L'Invention du boudoir*, 63–5.

32 "Le boudoir est regardé comme le séjour de la volupté; c'est là qu'elle semble méditer ses projets, ou se livrer à ses penchans ... Il est essential que tout y soit traité dans un genre où on voit régner le luxe, la mollesse et le goût ... il faut tout mettre en oeuvre, employer la magie de la peinture et de la perspective pour créer des illusions"; Le Camus de Mézières, *Le Génie de l'architecture*, 116 and 123.

33 For Baudouin's *La Lecture*, see Sheriff, *Moved by Love*, 135–6. For Diderot's
 condemnation, see Denis Diderot, *Oeuvres complètes*, ed. Varloot et al., 25 vols.
 (Paris: Hermann, 1975), vol. 14, 163–4, and Hyde, *Making Up the Rococo*, 70–2.
34 Sheriff, *Moved by Love*, 133–4.
35 DeJean, *The Age of Comfort*, 179.
36 See Hyde, *Making Up the Rococo*, 109 and 112–14.
37 Hyde, *Making Up the Rococo*, 107 ff.
38 *Dictionnaire de l'Académie française*, 181.
39 The companion piece to this painting, Boucher's *Venus at her Bath*, is in the National
 Gallery of Washington.
40 Bailey, *The Loves of the Gods*, 372–9.
41 In addition to Lagrénée, many artists of the period painted this episode, including
 Vien.
42 Mimi Hellman likens the function of furniture in eighteenth-century French
 interiors to social actors who play a narrative role. See "Furniture, Sociability, and the
 Work of Leisure in Eighteenth-Century France," *Eighteenth-Century Studies* 32, no. 4
 (Summer 1999): 415–45.
43 See Antoine Schnapper and Arlette Sérullaz, *Jacques-Louis David, 1748–1825* (Paris:
 Réunion des Musées nationaux, 1989), 122.
44 The drawings are discussed in Schnapper and Sérullaz, *Jacques-Louis David,
 1748–1825*, 184–91, and Pierre Rosenberg and Louis-Antoine Prat, *Jacques-Louis
 David. 1748–1825. Catalogue raisonné des dessins*, 2 vols. (Milan: Mondadori Electa
 Spa, 2002), vol. 1, 101–3.
45 Homer, *The Iliad*, trans. A. T. Murray (Cambridge, MA: Harvard University Press,
 1971), vol. 1, Book II, lines 383–461 and 144–51. See also *L'Iliade d'Homère*, trans.
 into French by Mme. Anne Dacier (Geneva: DuVillard et Nouffer, 1779).
46 Mary Vidal discusses the affinities of gender dynamics of Paris and Helen and
 David's portrait of the Lavoisiers in which Mme. Marie Anne Lavoisier stands and
 leans against her seated husband, serving as a type of muse, in "Art, Science and the
 Lavoisiers," *Journal of the History of Ideas* 56 (October 1995), 595–623.
47 For antique sources for the furniture and décor, see E. Coche de la Ferté and J. Guey,
 "Analyse archéologique et psychoanalytique d'un tableau de David," 129–61.
48 "C'est ici de Vénus le charmant sanctuaire / C'est le temple du dieu qu'on adore
 à Cythère / Tout doit donc respirer dans ce galant séjour / Le luxe, les plaisirs, la
 mollesse et l'amour / L'amour doit présider à son architecture … / … le boudoir, destiné
 pour l'amoureux mystère / Doit de l'arc de ce dieu tirer son caractère … / Le lit
 voluptueux, galant dans sa richesse / Orné de réseaux d'or, tissus de la mollesse."
 Maillier, *L'architecture, poëme, en trois chants* (Paris: chez l'auteur, 1780). Cited in
 Delon, *L'Invention du boudoir*, 32–4.
49 Cheng, *The History of the Boudoir*, 321–58.
50 Ibid., 345.
51 Ibid., 334.
52 Ibid., 336.
53 Ibid., 349.
54 Antoine Schnapper states that *Paris and Helen* was commissioned for Bagatelle. See
 Schnapper and Sérullaz, *Jacques-Louis David, 1748–1825*, 185.
55 David lists paintings for the ceiling of the Salon of Mlle. Guimard in his personal
 manuscript lists of works. See Daniel and Georges Wildenstein, *Documents
 complémentaires au catalogue de l'oeuvre de Louis David* (Paris: Fondation

Wildenstein, 1973), nos. 1775, 1810, 1938. David never recorded the portrait of Guimard as Terpsichore, originally attributed to Fragonard but more recently attributed to him.

56 Cheng, *The History of the Boudoir*, 329.

57 Chevalier de Jaucourt, "Amour, Galanterie," in *Encyclopédie ou Dictionnaire raisonné des sciences, des arts and des métiers par une société des gens de lettres*, ed. Denis Diderot and Jean le Rond d'Alembert, 17 vols. (Paris: Briasson, 1765). See ARTFL *Encyclopédie* Project, University of Chicago, p. 17. Trans. Lyn Thompson Lemaire for *The Encyclopedia of Diderot and d'Alembert* translation project, University of Michigan.

58 Susanna Caviglia demonstrates the significance of the idea of pleasure in the court milieu in pre-revolutionary France in *History, Painting, and the Seriousness of Pleasure in the Age of Louis XV* (Liverpool: Liverpool University Press on behalf of the Voltaire Foundation, 2020). David revisited the setting of the bedroom/boudoir in two of his mythological paintings of the nineteenth century—*Sapho, Phaon, and Amor* of 1809 and *Amor and Psyche* of 1817, works with elements of parody that dramatically diverge in style and conceptualization from *The Loves of Paris and Helen*.

Bibliography

Al-Douri, Taha. "The Constitution of Pleasure: François-Joseph Bélanger and the Château de Bagatelle." *RES: Anthropology and Aesthetics* 4 (Autumn 2005): 155–62.

Bailey, Colin. *The Loves of the Gods: Mythological Painting from Watteau to David.* New York: Rizzoli, 1992.

Bastide, Jean-François de. *La Petite Maison in Contes de M. de Bastide.* Paris: Cellot, 1763.

Beauchêne, Edme-Pierre Chavot de. *De l'influence des affections de l'âme dans les maladies nerveuses des femmes.* Montpellier: Méquignon, 1781.

Bienville, D. T. de. *La Nymphomanie; ou Traité de la fureur utérine.* Amsterdam: Marc-Michel Rey, 1778.

Bordes, Philippe. *"Le Serment du Jeu de Paume" de Jacques-Louis David: le peintre, son milieu et son temps, de 1789 à 1792.* Paris: Editions de la Réunion des Musées Nationaux, 1983.

"Boudoir." In *Dictionnaire de l'Académie française.* 3rd edition. Paris: J.-B. Coignard, 1740, 181.

Casid, Jill. "Commerce in the Boudoir." In *Women, Art, and the Politics of Identity in Eighteenth-Century Europe*, edited by Melissa Hyde and Jennifer Milam, 91–114. Burlington, VT: Ashgate, 2003.

Caviglia, Susanna. *History, Painting, and the Seriousness of Pleasure in the Age of Louis XV.* Liverpool: Liverpool University Press on behalf of the Voltaire Foundation, 2020.

Cheng, Diana. "The History of the Boudoir in the Eighteenth Century." Ph.D. diss., McGill University, 2011.

DeJean, Joan. *The Age of Comfort.* New York: Bloomsbury, 2009.

Delon, Michel. *L'Invention du boudoir.* Paris: Grains d'Orage, 1999.

Diderot, Denis. *Oeuvres complètes.* Edited by Varloot et al., 25 vols. Paris: Hermann, 1975.

Ferté, E. Coche de la, and J. Guey. "Analyse archéologique et psychoanalytique d'un tableau de David: Les Amours de Paris et d'Hélène." *Revue Archéologique* 40 (1952): 129–61.

Freudeberg, Sigismund. *Suite d'estampes pour servir à l'histoire des moeurs et du costume des français dans le XVIIIe siècle.* Paris: J. Barbou, 1774.

Goodman, Dena. "Women and Enlightenment." In *Becoming Visible: Women in European History*, edited by R. Bridenthall, S. M. Stuard, and M. E. Wiesner, 233–62. Boston: Houghton Mifflin, 1998.

Grimm, Joséphine. "Entre pièce intime et espace fantasmé: formes, décor et usages du boudoir de 1726 à 1802." Ph.D. diss., Ecole nationale des Chartes, 2019.

Gutwirth, Madelyn. *The Twilight of the Goddesses: Women and Representation in the French Revolutionary Era.* New Brunswick, NJ: Rutgers University Press, 1992.

Hellman, Mimi. "Furniture, Sociability, and the Work of Leisure in Eighteenth-Century France." *Eighteenth-Century Studies* 32, no. 4 (Summer 1999): 415–45.

Homer. *L'Iliade d'Homère.* Translated by Anne Dacier. Geneva: DuVillard et Nouffer, 1779.

Homer. *The Iliad.* Translated by A. T. Murray. Cambridge, MA: Harvard University Press, 1971.

Hunt, Lynn. "The Many Bodies of Marie-Antoinette: Political Pornography and the Problem of the Feminine in the French Revolution." In *Marie Antoinette: Writings on the Body of a Queen*, edited by Thomas E. Kaiser and Dena Goodman, 117–38. London: Routledge, 2003.

Hyde, Melissa. *Making Up the Rococo: François Boucher and his Critics.* Los Angeles: Getty Publications, 2006.

Jaucourt, Chevalier de. "Amour, Galanterie." In *Encyclopédie ou Dictionnaire raisonné des sciences, des arts and des métiers par une société des gens de lettres*, edited by Denis Diderot and Jean le Rond d'Alembert, vol. 17, 754–5. Paris: Briasson, 1765. Trans. Lyn Thompson Lemaire for *The Encyclopedia of Diderot and d'Alembert* translation project, University of Michigan.

Johnson, Dorothy. *David to Delacroix: The Rise of Romantic Mythology.* 1st edition. Chapel Hill: University of North Carolina Press, 2011.

Korshak, Yvonne. "*Paris and Helen* by Jacques-Louis David: Choice and Judgement on the Eve of the French Revolution." *Art Bulletin* 69, no. 1 (March 1987): 102–16.

Krafft, Jean-Charles, and Pierre Nicholas Ransonette. *Les plus belles maisons de Paris.* Paris: Ransonette, 1801–3.

Lilley, Edward. "The Name of the Boudoir." *Journal of the Society of Architectural Historians* 53 (June 1994): 193–8.

Maillier, M. *L'architecture, poëme, en trois chants.* Paris: Maillier, 1780.

Mercier, Louis-Sébastien. *Tableau de Paris.* Amsterdam, 1782–8.

Mézières, Nicolas Le Camus de. *The Genius of Architecture, or the Analogy of that Art with Our Sensations.* Translated by David Britt. Santa Monica, CA: Getty Center for the History of the Arts and Humanities, 1992.

Michel, Régis. *David e Roma: dicembre 1981–febbraio 1982.* Rome: De Luca Editore, 1981.

Rosenberg, Pierre, and Louis-Antoine Prat. *Jacques-Louis David. 1748–1825. Catalogue raisonné des dessins*, 2 vols. Milan: Mondadori Electa Spa, 2002.

Saisselin, Rémy. "The Space of Seduction in the Eighteenth-Century French Novel and Architecture." *Studies on Voltaire and the Eighteenth Century* 319: 417–31.

Schnapper, Antoine, and Arlette Sérullaz. *Jacques-Louis David.* Paris: Réunion des Musées nationaux, 1989.

Sheriff, Mary. *Fragonard: Art and Eroticism.* Chicago and London: University of Chicago Press, 1990.

Sheriff, Mary. *Moved by Love: Inspired Artists and Deviant Women in Eighteenth-Century France*. Chicago and London: University of Chicago Press, 2004.

Vidal, Mary. "Art, Science and the Lavoisiers." *Journal of the History of Ideas* 56 (October 1995): 595–623.

Virey, Julien Joseph. *De l'influence des femmes sur le goût dans la littérature et les beaux-arts, pendant le XVIIième et XVIIIième siècle*. Paris: Deterville, 1810.

Wildenstein, Daniel, and Georges Wildenstein. *Documents complémentaires au catalogue de l'oeuvre de Louis David*. Paris: Fondation Wildenstein, 1973.

Political Interiority and Spatial Seclusion in West African Royal Sleeping Rooms

Katherine Calvin

I have unrolled my mat … only cowardice can roll it up again.
Translation of the *Fa* sign of King Adandozan (r. 1797–1818)[1]

Interiority was central to many aesthetic and political conceptions of kingship in West Africa throughout the long eighteenth century. In the kingdom of Dahomey in the modern republic of Benin, the physical body of the sovereign, as well as his movements through the royal palaces in the capital of Abomey, demarcated the polity's political and sacred center. Such affirmations of the absolute interior became increasingly necessary during the eighteenth century. Dahomey consolidated regional power and expanded territorially to become one of the most influential African agents in international trade and politics by the beginning of the nineteenth century. Like many other West African rulers, the singular distinction of Dahomean kings was marked through a variety of material, ritual, and architectural signifiers. Notable examples include the partial concealment of the body through elaborate regalia, face-covering crowns, and screens; restricted communication through intermediaries or close advisors; and enclosure within elaborate royal residences, a paradox that art historian Suzanne Preston Blier has likened to both a supernatural sanctioning and an incarceration.[2]

Engaging with previous scholarship on eighteenth-century West African kingship, this chapter focuses on the physical location, architecture, and ornamentation of Dahomean royal sleeping rooms, as well as their metaphorical political and religious significance. It is essential to consider West African interiors as part of a network of royal signifiers because, as art historian Labelle Prussin argued, political and economic hierarchies were communicated through the adornment and display of one's garb, which was then extended onto the built environment. Ritual behavior in space, as a means of visual communication, was in turn reinforced by the encompassing architecture, which operated as a material, fixed counterpart.[3] Dahomean royal sleeping rooms, as some of the most private spaces in the Abomey palace, informed and were informed by intersecting conceptualizations of interiority that included marking the royal body as sacred geographical center; reinscribing origin narratives and succession rituals; and, despite the expansive reach of Dahomean mercantile and diplomatic networks,

reaffirming spatial seclusion as a signifier of the political exceptionalism of the sovereigns residing therein.

In his 1789 travel narrative *Memoirs of the Reign of Bossa Ahádee, King of Dahomey*, British merchant Robert Norris (1724?–1791) describes the bedroom of Dahomean King Tegbesu (r. 1740–74) with whom he had an audience during his 1772 visit to Abomey. His account is significant in that it is one of the only known descriptions of a king's sleeping room from eighteenth-century Dahomey. As Norris himself notes, entrance to the innermost areas of the palace was typically forbidden for visitors (as well as for most palace residents). He writes:

> I never passed the limits of the courts before mentioned, except once at *Abomey*, when the old king *Ahadee* was sick, and would see me in his bed-chamber, which was a detached circular room, of about eighteen feet in diameter; it had a thatched, conical roof; the walls were of mud, and white-washing within; there was a small area before it, formed by a wall about three feet high, the top of which was stuck full of *human jaw bones*, and the path leading to the door was paved with *human skulls*.[4]

Norris's account delivers key information about the location, architecture, and ornamentation of Tegbesu's royal bedroom, and a subsequent passage further details the room's many imported European furnishings, which included a mattress, bedstead, small table, chest, two or three chairs, and a carpet previously sold to the king by Norris himself. Yet the text also records the space's visual effect on one foreign visitor. The paved path of skulls, according to Norris, were the heads "of neighbouring kings, and other persons of eminence and distinction, whom he [Tegbesu] had taken prisoners in the course of his wars; and had been placed there, that he might enjoy the savage gratification of trampling on the skulls of his enemies, when he pleased."[5] The merchant's emphasis on the Dahomean king's "savage gratification" in physically and symbolically trampling his enemies foreshadows the extent to which the West African kingdom became associated with unrestrained violence in the nineteenth-century European imagination.

Scholarship attentive to the influence of travel literature about early modern Africa on European conceptions of the continent has been a productive area of research.[6] However, it is essential to consider in greater depth how specific royal interiors were understood more locally by their royal occupants, other palace residents, new and established state subjects, and visitors from other West African polities. As a case study in this context, Dahomean royal sleeping rooms provide insight into how ideas of architectural and bodily interiority operated as necessary counterbalances to the external expansion of the state—and the concurrent incorporation of new subjects—by affirming the historical and geographic center associated with foundational narratives. By consolidating power in the early part of the century, the new kingdom increasingly centralized mercantile operations within its territory, which resulted in greater agency over the logistics and terms of the ever-expanding Atlantic trade.[7] Yet while it traded extensively with Europe, Dahomey also remained closely engaged with its neighbors

through diplomatic and military links. Ambassadors from the Asante kingdom's capital Kumasi, located about 300 miles west of Abomey, were frequent visitors at the Dahomey court and vice versa. This continued contact with other regional polities, as well as Europeans, generated a continual reshaping of so-called traditional stylistic boundaries of the royal arts of Africa in the eighteenth century.[8] Sleeping rooms were no exception. Comparisons between Dahomean royal bedrooms and Asante parallels reveal a number of resemblances, such as their position within labyrinthine palaces, orientation across from private courtyards, and assimilation of foreign furnishings. Dahomey's incorporation of appropriated materials and forms was part of a broader, regional process of marking eighteenth-century royal sleeping rooms as West African political centers.

None of the royal sleeping rooms considered in this chapter is extant, nor are any of the furnishings within definitively known to have survived. It is thus necessary to combine several sources and methods to gain insights into the appearance and functions of these interiors in the eighteenth century. The three most valuable sources are eighteenth-century European travel accounts; current archaeological and anthropological scholarship, much of which incorporates oral histories, focused on Abomey's royal architecture; and lastly, art historical studies of post-eighteenth-century Western African art and architecture. Each category has advantages and disadvantages. Although contemporaneous European accounts about Dahomey are relatively numerous and often include extensive detail about state rituals and material culture, nearly all are authored by merchants with vested interests in expanding the Atlantic trade, including in that of enslaved persons. Norris, for one, was an ardent anti-abolitionist who promoted his book as evidence of supposed African barbarity and as a justification for slavery as a way to "save" Africans from their own violent states.[9]

Recent archaeological work on Dahomean royal architecture has shed considerable light on the form of the palace and its symbolism within the capital's encompassing urban plan. Anthropologist J. Cameron Monroe, who oversees the Abomey Plateau Archaeological Project (est. 2000), has argued that the geospatial orientation of Dahomean palace complexes, their expansion by subsequent rulers, and the hierarchical organization of rooms therein represents an intentional strategy of manifesting political power. He has collaborated extensively with West African oral historians to complement his material analysis of Dahomean kingship and architecture.[10] However, his research is nonetheless limited by damage to the sites as well as the removal of most interior furnishings and ornamentations. Lastly, scholarship focused on West African arts since the nineteenth century, such as *djeho* roof finials from Dahomey, provide valuable comparative insights into extant royal works. Relying on such studies too heavily, however, risks collapsing change over time, a particularly relevant concern here as Dahomean kings frequently adopted (and abandoned) various signifiers of their office. Yet, when pieced together, these sources yield new insights into the organization and significance of royal sleeping rooms in relation to ideas of political interiority, spatial seclusion, historical memory, and state expansion throughout the eighteenth century.

From the Belly of Dan, Abomey's Royal Interior

Located just north of the West African region once known as the Slave Coast (see Norris's 1789 map; Figure 9.1), the expansionist kingdom of Dahomey began consolidating political power in the seventeenth century and reached its geographical apex in the nineteenth. The state was founded by migrants who claimed origins to the southwest of Abomey and settled at the center of what became known as the Abomey Plateau, approximately 100 kilometers north of the sea. Ethnically, Dahomey included a mix of peoples who came to be called Fon and spoke a dialect of the Gbe language known as Fongbe.[11] With the matrilineal Akan to their west and the patrilineal Yoruba-speaking peoples to the east, the populace of Dahomey lived midway between two of the most significant linguistic and cultural areas of West Africa and drew influence from both.[12] Historian Edna Bay has noted that, as the state expanded and incorporated new subjects, Dahomey willingly provided some talented and ambitious new arrivals with opportunities to amass wealth and political power.[13] This embracement of certain foreigners, as well as the appropriation of their arts and industries, undoubtedly facilitated the speedy development the Dahomean state.

Due to the so-called Slave Coast's more difficult coastal terrain, which included a heavy surf and a large sand bar parallel to the beach, communities that would later be incorporated into the Dahomean state remained isolated from the earliest Portuguese enterprises in West Africa. Many established trading relationships with Europeans only in the second half of the sixteenth century.[14] It was King Agaja (r. 1718–40) who, after nearly a century of Dahomean expansion across the Abomey Plateau, marched

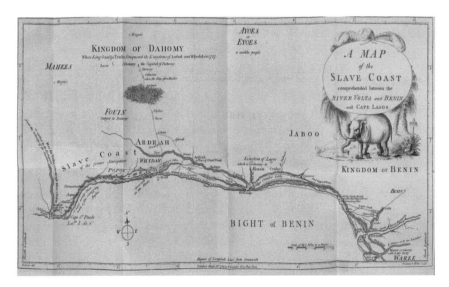

Figure 9.1 "A Map of the Slave Coast Comprehended between the River Volta and Benin with Cape Lagos." Robert Norris, *Memoirs of the Reign of Bossa Ahádee, King of Dahomey* (London: W. Lowndes, 1789), opposite page 1. Newberry Library (45-1392).

southward and conquered the kingdoms of Allada (1724) and Hueda (1727), providing the state with direct access to the coast and its ports.[15] Dahomey's eighteenth-century expansion also coincided with a near sixfold increase in both the volume and value of the commercial Atlantic trade in West Africa between the 1680s and the 1780s. This growth was generated primarily from expansions in the trade in enslaved peoples, which, for the first time, surpassed gold, ivory, and all other African commodity exports combined in value.[16] While participation in the Atlantic trade certainly contributed to Dahomey's economic strength, attention to this topic has overshadowed other factors essential to its development, including the way in which Dahomean rulers deployed architecture and history to define themselves as the center, geographically and ideologically, of their continually expanding kingdom.

Bodily and architectural interiority are foundational concepts to the origin narratives of the kingdom of Dahomey. Royal oral histories recount that Dahomey's ruling dynasty was born of a seventeenth-century succession dispute between two rival princes, Teagbanlin and Dogbari, both of the kingdom of Allada. While the former agreed to move south, the latter's son, Dakodonu, was granted permission to settle in the contested region by the Guedevi, a regional confederation of chiefs. Unsatisfied, however, Dakodonu requested more territory near present-day Abomey from a local leader named Dan, who responded sarcastically: "Have I given you so much land and yet you want more? Must I open my belly for you to build your house upon?" Dakodonu then promptly skewered Dan with a *kpatin* pole and built a royal palace over his adversary's exposed entrails.[17] The usurper-come-king then proclaimed that his kingdom would forever rest "in the belly of Dan," and the name Dahomey itself purportedly stems from this event, a combination of the Fongbe words *Dan* (victim), *xo* (stomach), and *me* (inside).[18] The centrality of conquest in defining the site and significance of royal architecture was shared by other West African polities. Asante histories, for example, emphasize the foreign origins of Kumasi's goldsmiths who originally came from the southern Denkiya and Akim communities that were defeated and incorporated into the expanding Asante state in the eighteenth century. The relocation, or perhaps usurpation, of these respected artists only deepened associations between the elaborate gold work adorning the royal palace and the kingdom's military power.[19]

The story of Dan's death and of the royal palace's construction over his entrails is but one example of the frequent metaphorical mingling of royal architecture and bodies in articulations of Dahomean kingship. Unlike many West African kingdoms, including the nearby Yoruba, the kingdom of Dahomey did not have a holistic creative myth, but rather defined itself through a narrative of political dominance replete with architectural signification, with the house as a vital, anthropomorphic symbol of state. For example, the *xo-ta* (roof) refers literally to the head of the house; the term for the main courtyard of a family compound, *agbonu*, translates as "mouth of the wall," while *xofome* (house floors) means "stomach of the house" and is generally considered the place where the fullness of the house, constituted by its inhabitants and wealth, is most protected.[20] Royal priest Mivede and local historian Nondichao, in an interview with Blier, also used architectural metaphors to characterize the state. Mivede explained, "Abomey is the house; Danhomè is the house. Thus no harm will come to the house.

Even if one puts fire to the house it will not burn. The enemies will not be able to take it away." Nondichao added, "the kingdom is like a room." Moreover, while one ordinarily greets people in Fongbe by asking *a fon gangia* (did you awaken well), to the king one instead says *n'kan hwegbio* (I have come to ask after the house), situating the king as the nation's ultimate house owner and housekeeper.[21] Such figurative language makes sense within the kingdom's broader worldview, as it was none other than the Dahomey god of war, Gu, who is said to have taught architecture to humanity.[22]

While the Abomey palace marked Dahomey's political center, other royal residences operated much like provincial architectural sentries. Monroe has argued that the construction of new regional palaces represented a conscious effort to mark new territories as Dahomean and thus craft a gerrymandered social identity using architecture vis-à-vis the emerging state.[23] Such strategic construction was necessary due to regional competition and the close association of a capital city's inhabitants not only with their state but with the physical body of the ruler. Eighteenth-century Kumasi, as a comparative example, was controlled, regulated, and given over to government business and ritual performance so completely that to be "a Kumase person" (*nkuraasefoɔ*) was to identify oneself and to be identified by others with the power and prestige of the state and the royal personage of the Asantehene, as the Asante king was known.[24]

Death and political continuity through succession were equally important leitmotifs in the interior location and architecture of Dahomean royal sleeping rooms of rulers past and present in the palace at Abomey. Encircled by a series of rooms with increasingly restricted access, they represented the most private space occupied by the king and were always already associated with funerary architecture and ritual. Using oral and period histories, art historian Lynne Anne Ellsworth Larsen classified the spaces in and around the Abomey palace into three categories—public, semi-private, and private—based on function and location.[25] Just outside the southeast palace gates was the largest and most accessible royal area, the *singbodji*, an open courtyard that hosted the *Xwetanu* (also known as *Hwetanu* or, in most European accounts, the Annual Customs). Inside the palace walls, rooms were subsequently divided into a semi-public zone of reception courtyards and a private residential zone that housed the king and his immediate dependants. Clustered along the outermost palace walls, the semi-public courtyards functioned as a buffer zone between palace residents and outsiders, as it was here where the king received visitors, held court, discussed matters of state, and performed sacrifices before ancestral shrines.[26] Such a hierarchical arrangement of interiors based on employment and/or social status also characterized the Asante palace at Kumasi. There, servants resided near the exterior while nearer to center were the more extensively decorated rooms of high-ranking officials, such as the influential *okyeame* who functioned as royal linguists, advisors, and intercessors for Asantehene.[27] In the Abomey palace, the courtyards, known as the *ajalala* (hall of many openings), were typically reserved for only the most important visitors and ceremonies. Beginning in the nineteenth century, the colorful bas-relief sculptures depicting royal histories and religious symbols that decorated these spaces became central to Dahomean royal arts.[28] The exclusivity of the *ajalala* nonetheless paled in comparison to the palace's private zone where the *honga*, or the residential courtyard with access to the detached royal sleeping room, was off-limits to visitors in nearly all circumstances.[29]

Each king constructed both a new semi-private *ajalala* and private *honga* in the Abomey palace to be used, respectively, for diplomatic and residential purposes exclusively during his reign. After the monarch died, both were transformed into sites of commemoration where rites on behalf of the deceased were performed. The plan of the Abomey palace (Figure 9.2) shows that kings' tombs were located in the order of their reigns along a curved axis running clockwise from northwest to southeast, reflecting the building of each successive palace section, with the reigning king in residence in the newest portion of the palace.[30] The palace should thus be conceptualized not only as a royal residence but also as a series of memorials, organized in a spiraling pattern, that materially trace the lineage of Dahomean kings. Based on court songs and local oral traditions, King Agaja initiated use of the spiral-form plan in both the palace and Abomey's broader urban plan as a signifier of growth and renewal.[31] Just as a massive mud wall as high as 30 feet and over 2 miles in length surrounded the palace, a dry moat and adjacent 20-foot-high wall, protected by cacti, encircled the capital city. The name of the capital, Abomey, from *me* (inside) and *agbo* (the moat),[32] similarly underscores this collective sense of Dahomean identity through enclosure. The concentration of

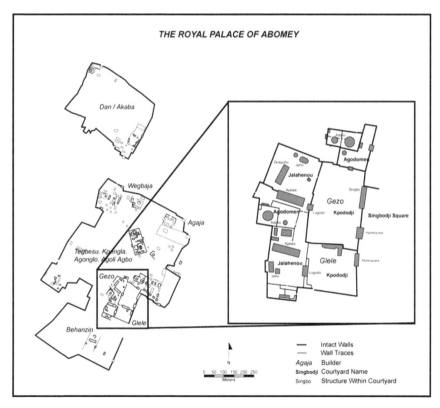

Figure 9.2 Ground plan of the royal palace at Abomey. J. Cameron Monroe/The Abomey Plateau Archaeological Project.

collective royal memory in the Abomey palace, doubled encircled by its own walls and those of the city, meant that gaining control over the site was an absolute prerequisite for aspiring rulers.[33]

Although the *ajalala* and *honga* would not be converted into commemorative sites until after a king's death, architectural similarities nonetheless linked the living king's sleeping room to royal funerary structures and practices. Unlike most palace structures, which were rectangular, the king's sleeping room was circular, as were the *adoxo*, or royal tomb, and the *djeho* (Figure 9.3) or the "soul house," which like the

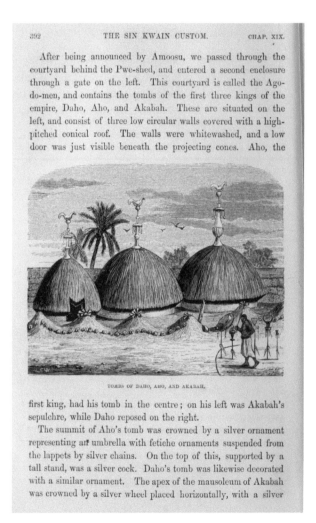

Figure 9.3 "Tombs of Daho, Aho, and Akabah." J. Alfred Skertchly, *Dahomey As It Is: Being A Narrative of Eight Months' Residence in that Country with a Full Account of the Notorious Annual Customs, and the Social and Religious Institutions of the Ffons* (London: Chapman and Hall, 1874), 392. UCLA Library (DT541.S62d).

sleeping room had a thatched conical roof. The *djeho* was constructed in the *ajalala* courtyard, the previous site of diplomatic meetings, so the king's spirit could participate in ceremonies held on his behalf.[34] The circular form of the sleeping room and *djeho* is also significant when considered as a juxtaposition, or alternatively as a complement, to the enclosing rectangular courtyards. Blier has suggested that the combination of circular and rectangular architectural forms symbolizes Dahomey's powerful position at the intersection of savanna and forest.[35] The sleeping chamber's geometric contrast to its surroundings may therefore indicate a particular concentrated site of geopolitical agency. Moreover, in at least one instance, a Dahomean ruler's *Fa* sign—a strong name and motto also known as a *du* taken upon installation—similarly underscored the political symbolism, vis-à-vis a metaphor of permanence, of the site where the king slept. The *Fa* sign of King Adandozan (r. 1797–1818), also this chapter's epigraph, can be translated as: "I have unrolled my mat ... only cowardice can roll it up again."[36] As a symbol of individual and national fortitude, then, the interior location and architecture of Dahomean royal sleeping rooms marked the state's private, political center and, as subsequent spaces of ancestral commemoration, visually attested to the longevity and durability of Dahomean rule.

An Iconography of Skulls and Sleeping Rooms

In addition to the geospatial and architectural significance of Dahomean royal sleeping rooms, their decoration and furnishings reaffirmed the centrality of the king's body—both living and deceased—to the state's martial and economic health. This importance was communicated through a corporeal iconography of heads, skulls, and bones. Norris, in his description of Tegbesu's sleeping room, underscores the abundance of ornamental human skull and jaw bones, and his account undoubtedly contributed to Dahomey's association with violently dismembered bodies in the European imaginary. Tales of the West African state's cruelty synecdochically confirmed the barbarity and greed believed endemic to the continent as a whole.[37] When William Wilberforce called in 1789 for the abolition of the slave trade before the British House of Commons, he was rebuked by anti-abolitionist member John Henniker who cited a 1726 letter from King Agaja to King George I of England. The missive boasted of Agaja's own military successes, execution of human sacrifices, and public display of slain enemy heads. Henniker then framed the continuation of the slave trade as a necessary reprieve—a Christian rescue!—from a brutal death in Africa.[38] By the time France conquered Dahomey in the late nineteenth century, the kingdom had become synonymous with an especially terrifying notion of the "primitive Other" based on travelers' tales and the entire mythology of human sacrifice and cannibalism they had conjured.[39] Even in the 1892 illustration (Figure 9.4) heralding the entry of French forces into Abomey, four severed heads loom above the palace's walls, where they are nearly (but not quite) obscured by the oversized *Tricolore* fluttering triumphantly at center.

Yet the European obsession with skulls as a symbol of Dahomey's supposed savagery has elided the complex ways in which heads, both physical and metaphorical, were

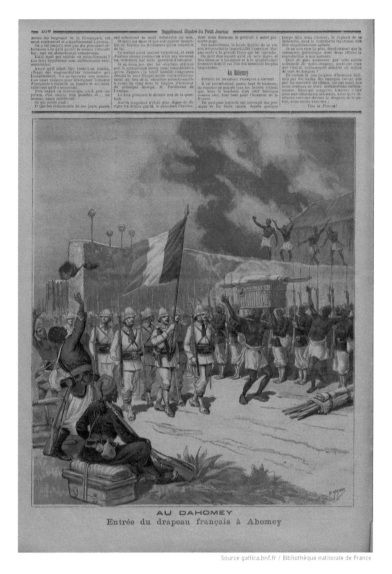

Source gallica.bnf.fr / Bibliothèque nationale de France

Figure 9.4 "Au Dahomey: Entrée du drapeau français à Abomey." Le Petit journal, supplément du dimanche 107 (Paris, December 10, 1892). BnF.

central to the articulation of political power during royal funerary and installation rites in the eighteenth-century kingdom itself. As Edna Bay remarked, Norris (had he asked) might have been told of the immense power concentrated in Tegbesu's sleeping room that nurtured and strengthened the occupant as he slept.[40] One such fortifying feature was the wall separating the sleeping room from the *honga* courtyard, which Norris characterizes as 3 feet in height and topped with jaw bones.[41] Fences,

both physically and linguistically, have been associated with secrecy and safeguarding in Benin for centuries. In Fongbe, two of the more common terms for "secret" are *kpanu* and *kpaho* (also spelled *kpaxo*), with *kpa* meaning fence, hedge, or screen. The first translates as "thing (*nu*) of the enclosure," and the latter as "speech (*ho, xo*) of the enclosure," or something found or said in a circumscribed, private area. Blier has argued that fences, as visual metaphors, simultaneously announce and obscure spaces identified in some way with mystery, secrecy, or power. The term *kpame*, meaning "in the enclosure," describes potent sites, such as religious convents and new tombs, as well as private places, such as the bath.[42]

The fence or wall separating the sleeping room from the *honga* is one material example of a broader set of forms and practices that distinguish the king's body through separation and/or enclosure. As had been the case for the nearby West African rulers of Oyo, Allada, and Whydah, both the movement and visibility of Dahomean kings was restricted. The French merchant and travel writer Antoine Edme Pruneau de Pommegorge (1720–1812) reported in his 1789 book that Tegbesu appeared in public only once a year, for four or five minutes, during a particular ceremony at *Xwetanu*. If he otherwise left the palace, it was in a closed hammock.[43] Neither Tegbesu nor any other Dahomean king before the nineteenth century was said to wear a beaded face-covering crown like those used by the neighboring Yoruba kings. Later, however, King Glele (r. 1858–89) briefly adopted such a beaded crown (Figure 9.5), which attests to the malleability of some forms of royal regalia. Bay has also suggested that eighteenth-century rulers may have been able to transfer some of the ritual restrictions typically placed on the king to others.[44] For example, Norris describes a woman at the Abomey court in 1772 as "too sacred to be seen; in fact, they secured her effectually from my sight with the umbrella, and certain long targets of leather, covered with red and blue taffeta, with which they encompassed her," which resemble beaded royal veils.[45] Such instances highlight how Dahomean political elites explored various ways of communicating status through enclosure, separation, and hiddenness.

Below the wall topped with jaw bones, Norris describes a path paved with skulls leading to the king's sleeping room door. He identifies the heads as "those of neighbouring kings, and other persons of eminence and distinction, whom he had taken prisoners in the course of his wars."[46] While Norris frames the skulls solely as a symbol of military conquest, it is also essential to contextualize them, and their particular location near the king's sleeping room, within Dahomean royal funerary and succession practices. Typically, after a king's death, several transitional processes took place over a period of one to two years before the successor's reign began. First, the deceased king was buried after a brief period of mourning. Contesting political coalitions then fought through differences until one candidate was able to retain control of the palace. Lastly, a long period of preparations culminated in *Xwetanu* or Annual Customs that included the final funeral of the previous king and the formal installation of the new monarch.[47]

The palace complex, especially the sleeping rooms of past and present kings, anchored many of these ritual practices during the state ceremonial cycle. Metaphors about sleep and night, such as *zan ku* (night has fallen), were common euphemisms for

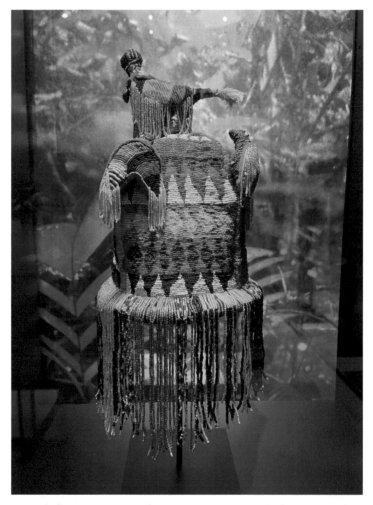

Figure 9.5 *Ade* funerary crown, Dahomey, 1860–1889, musée du Quai Branly. Author's photo.

the death of a king.[48] Such figurative language was made literal through the ritual use of royal sleeping rooms. In his 1874 account, British scientist J. Alfred Skertchly describes the *Sin Kwain* custom, or the Custom of Watering the King's Spirits, normally held in the days leading up to the major ceremonies of *Xwetanu*. He writes:

> In the Sin Kwain Custom, which was instituted by Agaja, the king visits each of the graves of his ancestors *seriatum*, usually sleeping four or five days in the palace of each of the seven predecessors of Gézu. The spirits of the deceased monarchs are invoked and solicited to lend their aid to the living representative, by the sacrifice of men and animals.[49]

Monroe has argued that such ceremonies reenacted dynastic succession, materializing royal history through architectural and ritual practice.[50] The *Sin Kwain* custom not only underscored the significance of interiors where the ruler slept but also, through his sequential movement, reinscribed the palace's spiral plan as the symbolic foundation of Dahomey's political continuity.

In addition to this spatial engagement with their predecessors, new rulers also exhumed and publicly displayed the previous king's skull as part of their installation. Brazilian Catholic priest Vicente Ferreira Pires, who traveled to Dahomey between 1796 and 1798, describes one such ceremony from the installation of Agonglo (r. 1789–97) that he was told about but did not personally witness.[51] The remains of the deceased ruler were exhumed and the incoming king appeared publicly holding the skull of his predecessor in his left hand and a ceremonial knife in his right to demonstrate that he had been ruling in the name of his father, as Agonglo's enstoolment did not take place until nearly two years after Kpengla's death. Then, dropping the skull and knife, Agonglo took up his own scepter, or *récade*, indicating that henceforth he would rule in his own name. Other accounts note that kings often pronounced their newly assumed praise name or strong name at the time of their installation.[52] The literal naming of a new king necessitated holding, and then dropping, the previous ruler's skull, which would be interred in the palace *djeho*, or soul house, dedicated to his ritual commemoration.

The circular form and internal, private location of a ruler's *djeho* resembled a living king's sleeping room, as previously noted. However, similar to the incorporation of skull and jaw bones around the sleeping room, the *djeho*'s materiality and ornamentation also foregrounded links to both military and ritual violence. After a king's death, the display of iconographic signifiers atop his *djeho* identified what had once been the deceased's *ajalala* and *honga* as his commemorative section of the Abomey palace. These were most commonly small metal *hotagantin*, or roof finials and other ornaments, and three examples can also be seen atop the *djeho* in Figure 9.2. Typically, their form was a visual representation of the king's praise name or accomplishments. The *hotagantin* of eighteenth-century King Agaja, for example, was a European-style ship (Figure 9.6) in reference to his conquest of the coast and subsequent expansion of international trade. This hammered silver example, although made after Agaja's reign in the later eighteenth or nineteenth century, likely resembled the earlier *hotagantin* that topped Agaja's *djeho* and served as a visual reminder of his military and economic accomplishments. In addition to the symbolism of the *hotagantin*, the very earth out of which the *djeho*'s walls were made was said to have been composed of a combination of sacrificial blood and imported alcohol. Blier has argued that the low ceilings and small entries to these buildings further enhance their deathly associations because one necessarily rubs against the blood and earthen walls on entering and exiting, as new rulers likely did during the *Sin Kwain* custom.[53] The visual emphasis on skulls and other signifiers of death, then, should be understood not merely as an external-facing warning of Dahomey's military might, as Norris and others singularly imagined, but rather as an essential part of the state's approach to political interiority manifested bodily through cycles of death, burial, exhumation, and permanent interment.

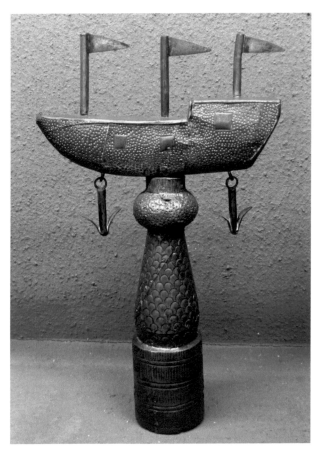

Figure 9.6 A staff or roof finial in the form of a ship, Dahomey, possibly late eighteenth century, silver on wood, approx. 8 × 5 in. (20.3 × 12.7 cm). Musée Africain, Lyon. Wikipedia (Ji-Elle).

Interiority, without Isolation

In addition to the location, architecture, and the external ornamentation of Dahomean royal sleeping rooms examined thus far, the furnishings within the space also provide insight into the room's symbolic significance, particularly in relation to the state's regional and international trade relations. Norris lists the furniture and decorations he observed in Tegbesu's sleeping room during his late eighteenth-century visit:

> The mattress and bedstead were of European manufacture, with check curtains; the furniture of the room consisted of a small table, a chest, and two or three chairs; and the clay floor was covered with a carpet, which I had sold to him some few months before.[54]

The description unfortunately provides little aesthetic or material details about the objects themselves. However, this lacuna is itself significant as Norris instead frames several furnishings only in relation to their country of origin and, consequently, their mobility as objects to be bought, sold, or gifted between West Africa and Europe. Negotiating the balance between stabilizing the kingdom's absolute interior in Abomey and expanding external mercantile and diplomatic relationship was certainly a key concern for eighteenth-century rulers. The transformation of once-foreign art, luxury objects, and ritual practices into local, Dahomean signifiers of political and economic power became a strategy by which kings flexed their agency while continuing to mark Abomey, and their sleeping room in particular, as the kingdom's unquestionable center.

Vast quantities of European goods entered West Africa from the era of exploration onward. Particularly noteworthy were the gifts to Dahomey's kings from the governments and commercial houses of France, England, Portugal, Spain, Germany, Denmark, and Holland, all given as efforts to win beneficial trade agreements and political influence.[55] Blier catalogs the diversity of objects in the Dahomey royal collection, which were paraded publicly during the *Xwetanu* and consequently appear in many European accounts:

> In addition to carriages, sedan chairs, and bath chairs, there were printed handkerchiefs with various scenes, mass books, German prints, sculptured figures of silver and bronze, decanters, chased work, silver and gilt waiters, crystal, Delft plates, Toby pots, chamber pots, basins, tubs, glass chandeliers, candelabrum, English and Dutch crowns, scepters, coats of mail, music boxes, bedsteads inlaid with gold, Louis XIV brass legged tables, Indian and Japanese cabinets, arm chairs, rocking chairs, folding screens, Turkish carpets, clocks, a spinning wheel, globe reflectors, arms, kites, umbrellas, bonnets, buckles, armlets, canes, pipes, peacocks, English dogs, Scottish sheep, and various "articles from Paris."[56]

Most items listed above would be kept in the palace's treasury for the majority of the year and overseen by the Keeper of the Stores; however, it appears that kings selected objects of particular interest for their sleeping rooms. Norris mentions a carpet that he recently sold the king. We do not know if Tegbesu asked for this carpet specifically, but archival records suggest that requests for specific objects from visiting diplomats and traders were not uncommon. In letters accompanying the 1805 and 1811 Dahomean embassies to Brazil and Portugal, King Adandozan articulated not just his political aspirations but also his desire for certain luxury objects. Such documents, as Ana Lucia Araujo has highlighted, provide valuable insights into Adandozan's own perception of his position and allow us to listen to his voice directly.[57] Yet we must remember that interest in a foreign form did not always indicate a desire to replicate its original function. Tegbesu, for one, made the unorthodox decision to be buried in a favorite European red sedan chair, which had been a gift from a merchant hoping to popularize an alternative to the rather uncomfortable hammocks typically used to carry important persons over long distances.[58] Although foreign visitors often complained of the long, required days of viewing the collection parade during the *Xwetanu*, the vast majority of observers were undoubtedly Dahomean subjects. This incorporation of European art

typologies, Blier has argued, served not only to underscore rulers' self-importance vis-à-vis foreign heads of state but also reinforced local class difference through the sheer quantity and quality of objects in the royal collection.[59]

Lastly, the appropriation and subsequent transformation of regional foreign forms into local royal symbols were a key way in which Dahomey and its West African neighbors positioned themselves in relation to each other as political rivals. Guezo, for example, named one of his princely palaces "Coomasi," after the Asante kingdom's capital, Kumasi, to the west. The adoption of this name followed a successful mock battle against this rival (and much more powerful) kingdom. In naming his palace "Coomasi," Guezo sought to make visible his superiority over this political competitor, despite the strong likelihood that neither he, nor his architects or troops, ever saw Kumasi. Guezo's son Glele followed the same foreign appropriation tradition by naming his palace entry, Wehonji, "the entrance of mirrors," a term apparently inspired by the palace of Louis XIV.[60] These examples should be contextualized in relation to other West African examples of appropriating and integrating once-foreign forms in royal sleeping rooms. While, to my knowledge, no illustration of a Dahomean royal sleeping room is extant from the long eighteenth century, the same is not true for the Asantehene's royal bedroom. One notable example appears in Thomas Bowdich's book, *Mission from Cape Coast Castle to the Ashantee*, alongside several other color illustrations of early nineteenth-century Kumasi's urban architecture. Bowdich spent five months in the capital in 1817 as part of a diplomatic mission sent by the new British governor, John Hope Smith (who was also Bowdich's uncle), of the African Company of Merchants, who hoped to establish a resident merchant in the capital.[61] His account far surpassed previous descriptions of the Asante capital in its attention to architecture and visual culture.[62]

In Bowdich's depiction (1819; Figure 9.7), the Asantehene's bedroom, like the Dahomean royal sleeping room, is located in front of an open *gyase*, or courtyard. It is a rectangular building with a thatched roof, a white front wall decorated in relief with geometric designs, and two oval-shaped entrances through which hanging checked fabrics are visible. The textiles function as door coverings for the two oval-shaped entrances, which contrast with the encompassing rectangular architecture. Hung from the inside of the doors, these fabrics provided privacy and protection from the elements, but also signal regional aesthetics connections. The checkerboard pattern recalls both Fulbe *khasa* and Dogon mourning cloths often hung at door openings.[63] This example is but one of many iconographic appropriations visible in the illustration, several of which are associated with Islamic practice. Another is the group of small, colorful hanging bags atop the left door to the sleeping room that likely contained what Bowdich called "Moorish charms." The presence of these bags, according to Prussin, suggests the concomitant use of secreted script with traditional ritual accoutrement and exposed Arabic script to effect similar preventive, protective results for the Asantehene.[64] And like the Dahomean ruler's sleeping room, the interior of the Asantehene's bedroom was furnished with imported luxury goods, including a European-style bed covered with pillows as well as gold and silver filigree wall ornamentations.[65] Royal West African sleeping rooms, then, should be understood as dynamic spaces in which a diversity of local, regional, and international objects provided protection and communicated status for the inhabiting ruler.

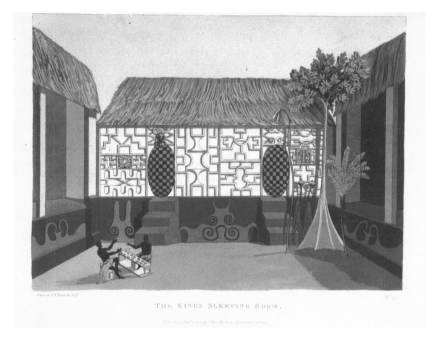

THE KINGS SLEEPING ROOM.

Figure 9.7 "The King's Sleeping Room." Thomas Edward Bowdich, *Mission from Cape Coast Castle to Ashantee; with a statistical account of that kingdom, and geographical notices of other parts of the interior of Africa. [With plates and maps.]* (London: John Murray, 1819), inset between 308–9. British Library.

Considering the strategic location of particular trees in royal palaces at both Abomey and Kumasi provides one last comparative example of how the sleeping spaces of West African rulers were symbolically marked as politically and religiously significant. In Bowdich's illustration, a large, leafy tree grows just outside the right entrance to the Asantehene's bedroom, and it is flanked by a smaller fern-like tree at right and a tall plant topped with a drooping red flower at left. Asante history maintains that the Asantehene selected Kumasi as his capital on the advice of his advisor, Okomfo Anokye, who reputedly planted kum trees in Kwaman, Kumawu and Kenyaase and selected as the capital the city where kum trees flourished. Kwaman was subsequently known as Kumasi, "under the Kum tree."[66] Although a kum tree is not represented here, visible instead are the equally significant stunted silk-cotton and manchineel trees, known as the *nyame dua* (literally "God's tree"), that functioned as altars and embodied the singular material symbol for the idea of "founding a hearth" among the Asante. Many *gyase* in important Asante domestic and religious interiors contained *nyame dua* altars either in the form of an entire tree or as a branch symbolically set in the ground; sacrificial offerings were deposited into the calabashes or brass containers wedged between branches.[67] While not the only Kumasi interior to incorporate *nyame dua*, the royal sleeping room's proximity to the sacred trees underscores the Asantehene's own proximity to sacrality. In Abomey, certain trees marked similarly significant royal sites by referencing, as in the story of Dan,

histories of Dahomean political triumph over regional rivals. Tegbesu, for example, established a tradition of planting red fruit-bearing *lise* trees in front of each ruler's palace *hounwa*, or entrance. As a youth, Tegbesu had been sent to the Yoruba court at Oyo as part of Dahomey's then-annual tribute; however, he reportedly protested his captivity by refusing to sleep indoors and instead rested under an outdoor *lise* tree. After gaining the palace in Abomey, he planted a *lise* tree in front of his specific *hounwa* to represent his gratitude for the protection it and his ancestors provided while he was a political captive of Oyo.[68]

As the example of Tegbesu above makes clear, Dahomean sleeping "rooms"— whether inside or out, in Abomey or further afield—informed a variety of royal iconographies and spatial politics during the long eighteenth century. The symbolism of these interiors contributed to and drew from local narratives about military conquest, often appropriating architectural forms, materials, and practices from West African rivals to reinscribe the king's body as the center of an often unwieldy, yet expanding state. Accounts of these spaces and the objects therein evince Dahomey's participation in the early modern global economy while also shedding light onto how imported goods took on new meanings in local contexts. Thus even in the absence of extant furnishings or representations of Dahomean royal sleeping rooms, a clear picture emerges of the importance not only of the small, circular room itself, deep in the heart of the Abomey palace, but also of the interior's metaphorical significance more broadly in relation to political interiority, history, death, and succession.

Notes

1 Ana Lucia Araujo, "Dahomey, Portugal and Bahia: King Adandozan and the Atlantic Slave Trade," *Slavery & Abolition* 33, no. 1 (2012): 5.
2 Suzanne Preston Blier, *Royal Arts of Africa: The Majesty of Form* (London: Laurence King Publishing, 1998), 27–8.
3 Labelle Prussin, "Traditional Asante Architecture," *African Arts* 13, no. 2 (1980): 60.
4 Robert Norris, *Memoirs of the Reign of Bossa Ahádee, King of Dahomey* (London: Printed for W. Lowndes, 1789), viii.
5 Norris, *Memoirs*, 128.
6 Examples include Mary Louise Pratt, *Imperial Eyes: Travel Writing and Transculturation* (New York and London: Routledge, 1992); Roxann Wheeler, *The Complexion of Race: Categories of Difference in Eighteenth-Century British Culture* (Philadelphia: University of Pennsylvania Press, 2000); and Elizabeth A. Sutton, *Early Modern Dutch Prints of Africa* (Burlington, VT: Ashgate, 2012).
7 David Northrup, *Africa's Discovery of Europe: 1450–1850*, 3rd edition (Oxford: Oxford University Press, 2014), 61.
8 Blier, *Royal Arts of Africa*, 39.
9 Robin Law, *The Slave Coast of West Africa, 1550–1760: The Impact of the Atlantic Slave Trade on an African Society* (Oxford: Clarendon and Oxford University Press, 1991), 1–2.
10 See J. Cameron Monroe, *The Precolonial State in West Africa: Building Power in Dahomey* (Cambridge: Cambridge University Press, 2014).

11 Different groups within this larger populace are sometimes called the Aja or Ewe and recently the term Gbe has been used (Edna Bay, *Wives of the Leopard: Gender, Politics, and Culture in the Kingdom of Dahomey* (Charlottesville: University of Virginia Press, 2012), 41–2).

12 Bay, *Wives of the Leopard*, 41–2.

13 Edna Bay, *Asen, Ancestors, and Vodun: Tracing Change in African Art* (Urbana-Champagne: University of Illinois Press, 2008), 2–3.

14 Law, *The Slave Coast of West Africa*, 188.

15 J. Cameron Monroe, "In the Belly of Dan: Space, History, and Power in Precolonial Dahomey," *Current Anthropology* 52, no. 6 (2011): 771.

16 Northrup, *Africa's Discovery of Europe*, 61.

17 *Kpatin* poles were significant in later Dahomean architecture as they were commonly used in the initial laying out of house compounds (Monroe, *The Precolonial State*, 146).

18 Monroe, "In the Belly of Dan," 769.

19 Blier, *Royal Arts of Africa*, 141.

20 Suzanne Preston Blier, "Razing the Roof: The Imperative of Building Destruction in Danhomè (Dahomey)," in *Structure and Meaning in Human Settlements*, ed. Tony Atkin and Joseph Rykwert (Philadelphia: University of Pennsylvania Museum of Archaeology and Anthropology, 2005), 170–1.

21 Blier, "Razing the Roof," 169–70.

22 Blier, "Razing the Roof," 165–7.

23 Monroe, "In the Belly of Dan," 769.

24 T. C. McCaskie, *Asante Identities: History and Modernity in an African Village 1850–1950* (Bloomington: Indiana University Press, 2000), 9–10.

25 See Lynne Anne Ellsworth Larsen, "The Royal Palace of Dahomey: Symbol of a Transforming Nation," Ph.D. diss., University of Iowa, 2014.

26 J. Cameron Monroe, "Continuity, Revolution or Evolution on the Slave Coast of West Africa? Royal Architecture and Political Order in Precolonial Dahomey," *The Journal of African History* 48, no. 3 (2007): 365.

27 Blier, *Royal Arts of Africa*, 128–9.

28 Citing traditional historian Bachalou Nondichau, Larsen explains that it was King Agaja who, after seeing the wall paintings of another Abomey family, commissioned similar works for his palace walls and those of his predecessors. They later became bas-relief sculptures set into the *hounwa*, or entrance building, and *ajalala* halls with scenes representing historical events tied to the space's associated king ("The Royal Palace," 37). In interviews with some other scholars, this historian's name is written as Nondichao Bachalou.

29 Larsen, "The Royal Palace of Dahomey," 53.

30 Bay, *Wives of the Leopard*, 9.

31 Blier, "Razing the Roof," 173–5.

32 Blier, *Royal Arts of Africa*, 104.

33 Bay, *Wives of the Leopard*, 9.

34 Blier, *Royal Arts*, 104; Larsen, "The Royal Palace of Dahomey," 13–14.

35 Blier, *Royal Arts*, 104.

36 Araujo, "Dahomey, Portugal and Bahia," 5.

37 Such accounts were not unique to Dahomey. James F. Searing has shown that while European documents repeatedly described the Senegambian coastal kingdom of Kajoor as a slave-raiding state whose king often enslaved his own people, archival

documents show the volume of slave exports from Lower Senegal to be relatively small. See James F. Searing, *West African Slavery and Atlantic Commerce: The Senegal River Valley, 1700–1860* (Cambridge: Cambridge University Press, 1993), 28–38.

38 Law, *The Slave Coast of West Africa*, 1.

39 Julia Kelly, "'Dahomey!, Dahomey!': The Reception of Dahomean Art in France in the Late 19th and Early 20th Centuries," *Journal of Art Historiography* 12 (2015): 6.

40 Bay, *Wives of the Leopard*, 153.

41 Norris, *Memoirs*, viii, 148.

42 Suzanne Preston Blier, "Art and Secret Agency: Concealment and Revelation in Artistic Expression," in *Secrecy: African Art that Conceals and Reveals*, ed. Mary H. Nooter (New York: The Museum for African Art, 1993), 185–6.

43 Bay, *Wives of the Leopard*, 112. One exception is King Agaja, who was described as relatively accessible and regularly moved about the kingdom to accompany his troops to war.

44 Bay, *Wives of the Leopard*, 112.

45 Norris, *Memoirs*, 110.

46 Norris, *Memoirs*, 128.

47 One year seems to have been the minimum time for the consolidation of the new monarchy and ceremonial preparations. Tegbesu, for example, died in May 1774 and the Grand Customs that confirmed Kpengla took place in June 1775; Kpengla died in April 1789 and Agonglo was enstooled in 1791 (Bay, *Wives of the Leopard*, 164, 153).

48 Bay, *Wives of the Leopard*, 154.

49 J. Alfred Skertchly, *Dahomey As It Is; Being a Narrative of Eight Months' Residence in that Country, with a Full Account of the Notorious Annual Customs, and the Social and Religious Institutions of the Ffons* (London: Chapman and Hall, 1874), 390–1.

50 Monroe, *The Precolonial State in West Africa*, 159.

51 For more on Brazilian diplomatic relations with Dahomey, see Júnia Ferreira Furtado, "Return as a Religious Mission: The Voyage to Dahomey Made by the Brazilian Mulatto Catholic Priests Cipriano Pires Sardinha and Vicente Ferreira Pires (1796–98)," in *Religious Transformations in the Early Modern Americas*, ed. Stephanie Kirk and Sarah Rivett (Philadelphia: University of Pennsylvania Press, 2014), 180–204.

52 Bay, *Wives of the Leopard*, 164.

53 Blier, "Razing the Roof," 178.

54 Norris, *Memoirs*, viii.

55 Suzanne Preston Blier, "Europia Mania: Contextualizing the European Other in Eighteenth- and Nineteenth-Century Dahomey Art," in *Europe Observed: Multiple Gaze in Early Modern Encounters*, ed. Kumkum Chatterjee and Clement Hawe (Lewisburg, PA: Bucknell University Press, 2008), 240.

56 Blier, "Europia Mania: Contextualizing the European Other," 247–8.

57 Araujo, "Dahomey, Portugal and Bahia," 1.

58 Bay, *Wives of the Leopard*, 25.

59 Blier, "Europia Mania: Contextualizing the European Other," 254.

60 Blier, "Europia Mania: Contextualizing the European Other," 265.

61 The treaty that resulted from this diplomatic trip, known as the "Bowdich" Treaty, is excerpted in *The Ghana Reader: History, Culture, Politics*, ed. Kwasi Konadu and Clifford C. Campbell (Durham: Duke University Press, 2016), 141–3.

62 Robert B. Edgerton, *The Fall of the Asante Empire: The Hundred-Year War for Africa's Gold Coast* (New York: Free Press, 1995), 15.

63 Prussin, "Traditional Asante Architecture," 64.
64 Prussin, "Traditional Asante Architecture," 63.
65 Blier, *Royal Arts of Africa*, 129.
66 Janet Berry Hess, "Imagining Architecture II: 'Treasure Storehouses' and Constructions of Asante Regional Hegemony," *Africa Today* 50, no. 1 (2003): 28.
67 Prussin, "Traditional Asante Architecture," 57; Blier, *Royal Arts*, 129.
68 Larsen, "The Royal Palace of Dahomey," 51–2.

Bibliography

Araujo, Ana Lucia. "Dahomey, Portugal and Bahia: King Adandozan and the Atlantic Slave Trade." *Slavery & Abolition* 33, no. 1 (2012): 1–19.

Bay, Edna. *Asen, Ancestors, and Vodun: Tracing Change in African Art*. Urbana-Champagne: University of Illinois Press, 2008.

Bay, Edna. *Wives of the Leopard: Gender, Politics, and Culture in the Kingdom of Dahomey*. Charlottesville: University of Virginia Press, 2012.

Blier, Suzanne Preston. "Art and Secret Agency: Concealment and Revelation in Artistic Expression." In *Secrecy: African Art that Conceals and Reveals*, edited by Mary H. Nooter, 181–96. New York: The Museum for African Art, 1993.

Blier, Suzanne Preston. *Royal Arts of Africa: The Majesty of Form*. London: Laurence King Publishing, 1998.

Blier, Suzanne Preston. "Razing the Roof: The Imperative of Building Destruction in Danhomè (Dahomey)." In *Structure and Meaning in Human Settlements*, edited by Tony Atkin and Joseph Rykwert, 165–84. Philadelphia: University of Pennsylvania Museum of Archaeology and Anthropology, 2005.

Blier, Suzanne Preston. "Europia Mania: Contextualizing the European Other in Eighteenth- and Nineteenth-Century Dahomey Art." In *Europe Observed: Multiple Gaze in Early Modern Encounters*, edited by Kumkum Chatterjee and Clement Hawe, 237–69. Lewisburg, PA: Bucknell University Press, 2008.

Bowdich, Thomas. *Mission from Cape Coast Castle to Ashantee; with a statistical account of that kingdom, and geographical notices of other parts of the interior of Africa. [With plates and maps.]* London: 1819.

Edgerton, Robert B. *The Fall of the Asante Empire: The Hundred-Year War for Africa's Gold Coast*. New York: Free Press, 1995.

Hess, Janet Berry. "Imagining Architecture II: 'Treasure Storehouses' and Constructions of Asante Regional Hegemony." *Africa Today* 50, no. 1 (2003): 27–48.

Kelly, Julia. "'Dahomey!, Dahomey!': The Reception of Dahomean Art in France in the Late 19th and Early 20th Centuries." *Journal of Art Historiography* 12 (2015): 1–20.

Konadu, Kwasi, and Clifford C. Campbell, eds. *The Ghana Reader: History, Culture, Politics*. Durham: Duke University Press, 2016.

Larsen, Lynne Anne Ellsworth. "The Royal Palace of Dahomey: Symbol of a Transforming Nation." Ph.D. diss., University of Iowa, 2014.

Law, Robin. *The Slave Coast of West Africa, 1550–1760: The Impact of the Atlantic Slave Trade on an African Society*. Oxford: Clarendon & Oxford University Press, 1991.

McCaskie, T. C. *Asante Identities: History and Modernity in an African Village 1850–1950*. Bloomington: Indiana University Press, 2000.

Monroe, J. Cameron. "Continuity, Revolution or Evolution on the Slave Coast of West Africa? Royal Architecture and Political Order in Precolonial Dahomey." *The Journal of African History* 48, no. 3 (2007): 349–73.

Monroe, J. Cameron. "In the Belly of Dan: Space, History, and Power in Precolonial Dahomey." *Current Anthropology* 52, no. 6 (2011): 769–98.

Monroe, J. Cameron. *The Precolonial State in West Africa: Building Power in Dahomey.* Cambridge: Cambridge University Press, 2014.

Norris, Robert. *Memoirs of the Reign of Bossa Ahádee, King of Dahomey.* London: Printed for W. Lowndes, 1789.

Northrup, David. *Africa's Discovery of Europe: 1450–1850.* 3rd edition. Oxford: Oxford University Press, 2014.

Prussin, Labelle. "Traditional Asante Architecture." *African Arts* 13, no. 2 (1980): 57–65, 78–82, 85–7.

Searing, James F. *West African Slavery and Atlantic Commerce: The Senegal River Valley, 1700–1860.* Cambridge: Cambridge University Press, 1993.

Skertchly, J. Alfred. *Dahomey as It Is; Being a Narrative of Eight Months' Residence in that Country, with a Full Account of the Notorious Annual Customs, and the Social and Religious Institutions of the Ffons* [sic]. London: Chapman and Hall, 1874.

On the Wings of Perfumed Reverie: Multisensory Construction of Elsewhere and Elite Female Autonomy in Marie Antoinette's *boudoir turc*

Hyejin Lee

Part travelogue and part autobiography, *Voyage autour de ma chambre* (1794) by Xavier de Maistre (1763–1852) is an account of the French author's forty-two-day journey around his room, conducted during his house arrest in Turin. Championing armchair voyage for its economy and ease ("Surely there is no being so miserable as to be without a retreat to which he can withdraw and hide himself from the world," he quips), de Maistre relates his sustained observations of every object and every nook and cranny of his room.[1] In the preface to the 1817 edition, de Maistre notes:

> The most illustrious journeys can be repeated: a fine line drawn across all maps shows us the route, and each is free to follow in the footsteps of these clever men who once made the journey themselves. The situation is different with the *Voyage autour de ma chambre*. It occurs only once and no mortal can boast being able to again repeat it, particularly since the world depicted within it no longer exists.[2]

While even the most ambitious circumnavigations of the globe could be replicated, de Maistre's travelogue was exceptional because it recounts an internal peregrination. According to him, the inimitable nature of his discoveries within the seemingly mundane setting of his room is the book's merit.

But seventeen years before de Maistre's eulogy for room journeys, a woman built a retreat to which she could withdraw from the world, a refuge specifically designed for her imaginary voyages to whatever destinations she fancied. Her sex, the appropriate occupations expected of it, and her status as the queen of France conferred profound sociopolitical implications on her architectural project. For the king's consort bound by the double expectation to live out her life publicly while confining her influence strictly to the private sphere, a space in which to be alone on her own terms manifested her desire for autonomy. Such a need was pressing in light of the mounting public disapproval she was facing. To facilitate her search for self-determination while circumventing social strictures, her private hideaway deployed a ruse, a multisensory illusion of an exotic locale.

This chapter addresses the *boudoir turc* in the château de Fontainebleau (Figure 10.1), commissioned in 1776 for Marie Antoinette (r. 1774–92), and its multifaceted evocation of an Oriental harem as conceived in the French cultural imagination. A space usually, but not exclusively, gendered as feminine, the boudoir was a room wherein privileged women in eighteenth-century France could revel in solitude. Incorporating decorative motifs associated with the Ottoman Empire, the *boudoir turc* coordinated an illusion of an Oriental harem in a miniature scale. Emulating exotic refuges built for other royal women, Marie Antoinette used the room as a make-believe realm in which to project an alternative identity, distinct from her politically precarious position at court. Ornamental references to the Orient allowed her to appropriate on an illusory level the supposedly greater freedom enjoyed by elite Ottoman women. However, unlike its precedent in Madame de Pompadour's *chambre à la turque* at the château de Bellevue, which represented the royal mistress as one of many enslaved consorts of the king, the Fontainebleau boudoir points to the queen as the sole authority within its confines, underscoring a fictive independence denied to her in reality.

Figure 10.1 A view of the western wall of the *boudoir turc*, including the chimneypiece and mirror. Decoration from 1777 by Jules-Hugues Rousseau and Jean-Siméon Rousseau de la Rottière, Château de Fontainebleau. © RMN-Grand Palais/Art Resource, NY/Adrien Didierjean.

Moreover, Marie Antoinette's retreat diverged from other forms of turquerie commissioned by women by setting in motion a distinctly multisensory and embodied evocation of the imagined Orient through its emphasis on perfume. Rich aromas had long served as olfactory markers of alterity, particularly the East, in the European imagination. In concert with this cultural association, perfume's cognitive function of indicating and constituting the presence of the Other worked to carry its inhaler's attention away from the present setting to an alternative one. The pleasant dislocation initiated by perfume participated in the boudoir's architecture of reverie, which privileged an inattentive mode of spectatorship with its disorienting sensuality. With all its ornaments composing an oneiric ambience conducive to daydreaming, the room posited the Orient as both a site and a state of mind for envisaging alternative modes of femininity, ones imbued with self-determination and liberty possible only in realms of the imagination. Through a close examination of the decorative program of the *boudoir turc* and a cultural analysis of perfume's associations with the Orient and reverie, this chapter illuminates the boudoir's spatial and ornamental configurations of elite female autonomy. Moreover, I propose that olfactory dimensions of intimate interiors in eighteenth-century Europe were crucial elements of their experiential dimensions and a key to understanding their sociopolitical significance for female patrons.[3]

Boudoir and the "Right to Remain with Oneself"

In August 1776, Marie Antoinette expressed to Charles-Claude Flahaut de la Billarderie, comte d'Angiviller (1730–1810), directeur général des Bâtiments du roi, her wish to redecorate her private rooms in the entresol of the château de Fontainebleau in turquerie, an artistic and architectural style fashionable in the late 1700s that was inspired by and conventionally associated with the Ottoman culture.[4] Situated directly above the private *cabinet de retraite* of Marie Leszczynska (r. 1725–68), the three small cabinets with northwest-facing windows overlooking the Jardin de la Reine served as a space for private religious devotion and toilette for the former queen.[5] Marie Antoinette found their existing decoration outdated, and Louis XVI (r. 1774–92) agreed to finance the cabinets' redecoration for her use during their annual autumnal visits to the ancient seat of the Bourbon monarchy.[6] In February 1777, the queen's architect, Richard Mique (1728–94) submitted his plan for the refurbishment to d'Angiviller (Figure 10.2), and the project quickly began to be completed in time for the court's return to Fontainebleau the following October.[7]

In 1776, having already commissioned a *cabinet turc* for herself at Versailles (inspired by that of her brother-in-law, the comte d'Artois), Marie Antoinette participated in the Fontainebleau boudoir's construction, communicating her preferences and overseeing design changes with the architects.[8] She focused on the decoration of the third cabinet, ensuring the installation of multiple mirrors in its interior to "multiply the *lit à la turc* [sic] and enlarge the room considerably."[9] This third cabinet, later known as the *boudoir turc*, was slightly expanded with a mirror-lined bed alcove.[10] The western wall features a mantel topped by another mirror, facing a two-way mirror draped with a double curtain on the opposite wall (Figure 10.2).

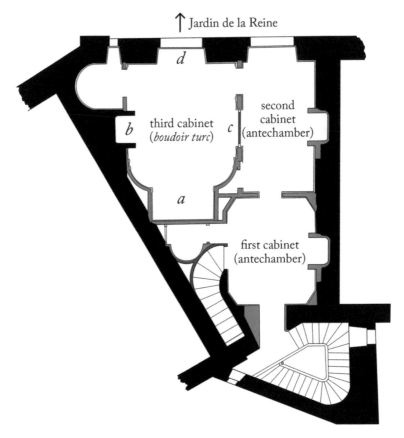

Figure 10.2 Author reproduction of Richard Mique's 1777 plan of the redecoration of the *cabinets d'entresol*. The *boudoir turc* features a mirror-lined bed alcove (a); a mirror-topped chimneypiece (b); a two-way mirror with mechanical drapes (c); and a window niche with a retractable mirror (d). © Hyejin Lee.

To realize Mique's turquerie design, Jules-Hugues Rousseau (1743–1806) and Jean-Siméon Rousseau de la Rottière (1747–1820) sculpted and painted the *boiserie* ornaments.[11] The Rousseau brothers' decorations present a full range of Turkish motifs, including stars, crescent moons, feathers, and pearls, arranged in the ornamental styles of arabesque and grotesque, highly fashionable in the 1770s. The interior walls display tripartite panels, interspersed with thin pilasters (Figure 10.1). The woodwork panels and ceiling were painted in a pearly pale gray in the *chipolin* technique, which imitated the "brilliance and freshness of porcelain" and gave the interior a subtle nacreous glow.[12] Each of the four large middle panels flanking the bed alcove and window niche (Figure 10.3) presents a stucco sculpture imitating a porphyry pedestal, atop which sit two winged putti, holding gilt bronze wall lights (now missing). Above them, a blue cassolette adorned with lion heads emits smoky perfume, painted on the background. The two cassolettes on the curved panels flanking the alcove (Figure 10.1)

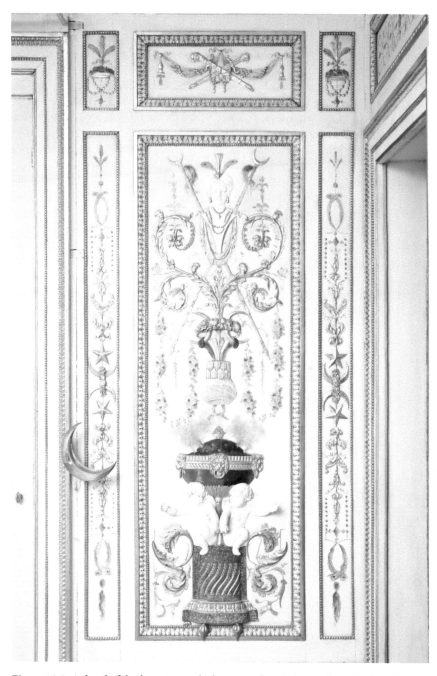

Figure 10.3 A detail of the *boiserie* panel adjacent to the window niche in the *boudoir turc*, Château de Fontainebleau. © RMN-Grand Palais/Art Resource, NY/Adrien Didierjean.

could serve as actual perfume containers, modeled in higher relief than the ones near the window niche and fitted with functional lids with holes and metal liners. Inside them, the queen could place potpourri (a fragrant mixture of fermented herbs, flowers, and plant materials) or pastilles (solid pellets made of aromatic materials) and relish the sensuous aroma. The recurrent motif of the cassolette, as the visual marker for amorphous perfume, contributes to the olfactory illusion of the Orient.

While the *boiserie* decorations have remained intact from Marie Antoinette's reign, only a few pieces of the original furnishings created for the boudoir are known to have survived the Revolution.[13] Based on surviving documents, Vincent Cochet proposes that the boudoir would have been furnished with a sofa with floor-length drapery in the alcove, as well as small console tables, *bergères*, *fauteuils*, and chairs.[14] The white marble chimneypiece, fitted with gilt bronze ornaments (Figure 10.4), continues the arabesque theme of the décor, while adding the turquerie elements, such as the crescent moon in the center of the architrave and turbans laden with pearls above the jambs.[15] A pair of gilt bronze firedogs in the form of sitting dromedaries added to the exotic ambience of the boudoir.[16] The redecoration also included a new custom carpet from the Savonnerie manufactory (Figure 10.5), featuring four cassolettes in the corners.[17]

Surrounded by scintillating ornaments simulating the imagined Orient in the small boudoir, Marie Antoinette would have enjoyed her privacy in a room specifically designed for that purpose, a privilege reserved only for the wealthiest and the most powerful women in Europe. A room built for one's "right to remain with oneself,"

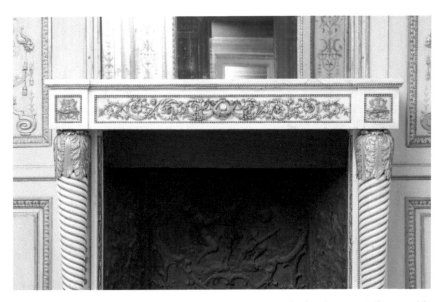

Figure 10.4 Architrave and jambs of the chimneypiece at the *boudoir turc*. White marble carved by Augustin Bocciardi, gilt bronze by Pierre Gouthière, after a design by Nicolas-Marie Potain, 1777, 103 × 123 × 28 cm. Château de Fontainebleau. © RMN-Grand Palais/Art Resource, NY/Adrien Didierjean.

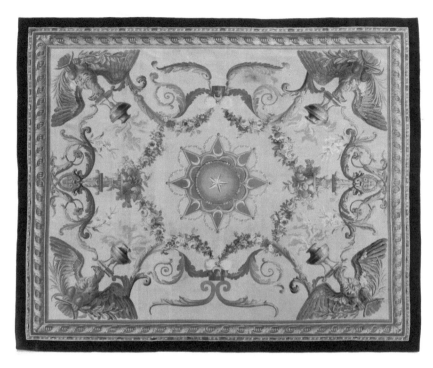

Figure 10.5 A later weaving of the carpet from the manufacture de la Savonnerie, designed by Michel-Bruno Bellengé, late eighteenth or early nineteenth century, wool, 4.04 × 4.5 m. Châteaux de Versailles et de Trianon, on deposit from Mobilier national, 2012. © RMN-Grand Palais/Art Resource, NY/Christophe Fouin.

the boudoir emerged in the most prestigious residences in France in the early 1700s, having evolved from the medieval *oratoire* and the late seventeenth-century *cabinet de retraite*, rooms designated for elite women's private religious devotions.[18] The boudoir, whose name derives from the French verb *bouder*, denoted a space where women could "sulk" alone.[19] Since its inception, it was associated with privileged women who could afford to be alone when no such luxury was available to their counterparts of lower social status, even as women's *état* defined by their familial and marital relations required them to devote themselves to their motherly and wifely duties. In their boudoirs, affluent women could disengage from society, relax with their companions, daydream, read, and write.[20]

The possibility of having rooms of their own contributed directly to women's ability to perceive themselves as individuals. The emergence of private cabinets designed specifically for women corresponded to the cultural concern with "interiorization," or the growing preoccupation with one's internal life as an individual subject in intimate spaces in which to cultivate this incipient sense of self.[21] Daniel Roche and Annik Pardailhé-Galabrun examined the relation between the increasingly nuanced conceptions of the private individual and the expanding variety of material lives among

the French across social ranks in the early modern period.[22] And as Dena Goodman explains, having a private cabinet allowed women to control access to this inner sanctum and to remove themselves from the company of others (and their spheres of power). As such, these rooms afforded women a sense of self-determination.[23]

Marie Antoinette's *boudoir turc* enacted several spatial and material strategies to ensure its intended occupant's seclusion and autonomy. The diminutive dimensions of the cabinet could have scarcely allowed more than one or two companions to share the queen's tranquil refuge. She could also enter and exit the room without being exposed to view. A private staircase from the *cour ovale* or from the queen's *cabinet de retraite* on the first floor (converted to another boudoir for Marie Antoinette in 1786) provided direct, discreet access to the *boudoir turc*, bypassing the ceremonial spaces of the king's and queen's *appartements*.[24]

Moreover, the presence of mirrors on all four walls maintained a closed circuit of gaze in the room (Figure 10.2). The queen could easily control how much of the boudoir's interior would be visible from the antechamber by manipulating the two rings installed inside the boudoir, which activated a hidden mechanism of curtains covering the two-way mirror.[25] The window niche featured a retractable mirror, which slid out of the wall along the metal rail on the floor at the push of a button, concealing the window.[26] With the retractable mirror masking the room's only aperture and mechanical drapes obscuring the two-way mirror, the queen could completely control her visibility from inside the room.

In addition to constructing an intimate environment for quiet introspection and privacy, the décor of the *boudoir turc* exuded luxurious sensuality, typical of boudoirs from the period. In his 1780 treatise on *maisons de plaisance* (pleasure pavilions erected for wealthy patrons in the outskirts of Paris), the architect Nicolas Le Camus de Mézières (1721–93) defines the boudoir as "the abode of delight," where one must "spare no efforts to make ... as pleasing as [one] can."[27] The primary objective of the room's spatial and ornamental arrangement was to orchestrate an illusion of an elsewhere. The architect recommended decorating the space with many mirrors (as in the Fontainebleau *boudoir turc*), mythological paintings of amorous themes, candles, and gilt furniture to simulate a private garden inside the room, as well as fragrant plants such as orange trees, honeysuckle, and jasmine.[28]

The boudoir's small dimensions and novelty allowed its well-heeled patrons to employ the latest trends and lavish materials for its ornamentation. Coupled with its function as a room built for wealthy women's privacy and pleasure, the room's close association with luxury turned it into an emblem of elite female vice—more specifically, their unruly taste for extravagance. Although women used their private retreats for such diverse purposes as religious devotion, needlework, and study, social commentators zeroed in on the boudoir's reputation as a space for female sexual transgression. In the majority of literary and artistic representations from the second half of the 1700s, the boudoir serves as a setting for and an accomplice in various scenarios of feminine corruption. In it, coquettes seduce and dupe unsuspecting men, who in turn become effeminate as a result of succumbing to women's insidious influence. In prints such as *Le roman dangereux* after Nicolas Lavreince (1781), the boudoir also provides a backdrop for female masturbation. The room's voluptuous

decoration and secrecy conspire with the lascivious contents of the "books one reads with one hand," encouraging women to satisfy their erotic desires alone. Such activities violated gender norms, constituting "a defiant and arguably political refusal, however momentary, of the demands of the spaces of heterosexual reproduction," according to Jill H. Casid. Neither completely public nor properly domestic, the boudoir constituted a "between-space" that blurred the boundaries between the sexes and the decorum belonging to each.[29] Cultural representations often portrayed women in their boudoirs as sexual-moral deviants whose inherently delicate nerves and impressionable morals were damaged by their penchant for decadence.[30] In their mirror-lined boudoirs, profligate women practiced the art of indolence, neglecting their duties as wives and mothers by electing to be alone.

An Oriental Harem in the Queen's Boudoir

Le Camus de Mézières's advice for decorating boudoirs and cultural critics' diatribes lay bare the common notion that such spaces could shape women's psychological state. More specifically, this idea underscores the boudoir's ability to carry its occupant's attention away from her immediate surroundings to an alternative order of existence.[31] The boudoir's decoration activated such imagined transports to elsewhere. In addition to the flowering arbor, the exotic ornamental styles and their multilayered evocation of distant places were popular settings for the boudoir's diversions.

In fact, in building private turquerie rooms, first at Versailles and later at Fontainebleau, Marie Antoinette was following examples set by other royal women and their "exotic" refuges.[32] Around two decades earlier, Jeanne Antoinette Poisson, marquise de Pompadour (1721–64), created her abode of exotic delight in the château de Bellevue.[33] For her bedroom directly below that of Louis XV (r. 1715–74), Pompadour commissioned Carle van Loo (1705–65) to paint three turquerie panels depicting a sultana, the highest-ranking and favorite consort of the sultan, in the domestic space strictly reserved for women and children in the seraglio—the harem.[34] Identifying as Pompadour the figure of the sultana painted in one of the overdoors by van Loo in the so-called *chambre à la turque*, Perrin Stein argues that the royal mistress visually aligned herself with the Ottoman sultana in order to solidify her position at court after her sexual relationship with the king ended in around 1750. By posing as the sultana, the king's former favorite wished to define her new role as a trusted advisor and friend to the monarch, and the most powerful woman in his seraglio.[35]

Much more than evidence of its patron's refined taste, the turquerie bedroom served political purposes for Pompadour. As a central figure occupying the position of "outsider" in Louis XV's court, she practiced what Nebahat Avcıoğlu calls the architectural strategy of self-representation, wherein an individual in a politically unstable position espouses an exotic building style to forge an alternative identity in cultural representations. Embracing "calculated 'otherness'" through architectural forms enabled powerful yet alienated notables to reformulate and publicize their subjecthood.[36] As a royal mistress of bourgeois origin, Pompadour adopted exotic decorations in her private space to envision a more secure footing in the court politics

of the mid-1700s. With her claim to power slowly eroding after 1750, she masqueraded as a sultana in her Turkish bedroom to underscore her lasting influence over the king and justify her preeminent position in his seraglio.

Marie Antoinette was also in an insecure position at Louis XVI's court when she built her *boudoir turc* at Fontainebleau in 1777. Her Habsburg origin permanently branded her as belonging to the ancient nemesis of the Bourbon dynasty. In light of the mounting Austrophobia in French political culture, members of the court scrutinized her every move, ever suspicious of her ties to the pro-Austrian faction. Further fueling her critics' hostility, she conspicuously "flaunted her Austrian origins" and interceded for her native land in matters of domestic and foreign policies.[37] In so doing, she transgressed the rules circumscribing the queen's involvement in public matters, raising the specter of powerful women overstepping their limits and invading the male/public sphere.[38] Her detractors constantly derided her as "l'autrichienne," casting in doubt her allegiance to her husband and to France. Moreover, the queen's spendthrift lifestyle and taste for gambling, thrown into stark relief against the backdrop of the bread riots of 1775, irreparably damaged her public reputation. Most importantly, the fact that she had not produced an heir seven years after marriage only added to the libelous gossip circulating in pamphlets, undermining her legitimacy.

Seen in light of her political precarity, Marie Antoinette's construction of the *boudoir turc* at Fontainebleau may be understood as an attempt at self-representation at a time of waning popularity and relevance. She could assume complete control over her internal, psychic domain within the confines of her boudoir at a time when her public image was hanging by a thread. Harnessing the boudoir's allure, the Turkish decorative mode offered its patron a "liberating cultural vocabulary" to craft an alternative identity.[39] Through this supposedly foreign ornamental language with its emancipatory potential, Marie Antoinette's boudoir posited her as the sole authority in her fantastical realm. Unlike Pompadour, whose power was rooted in her relation to Louis XV through the metaphor of the sultana, Marie Antoinette reigned supreme in her boudoir, with its decorations downplaying her connections to the other members of the court/seraglio. In Pompadour's *chambre à la turque*, the painted presence of odalisques under the sultana's supervision in van Loo's overdoors, as well as the room's placement directly below the king's bedchamber, points to the absent presence of Louis XV as the source of her power in the harem. In contrast, the odalisques populating the *boudoir turc*'s harem (Figure 10.6) are relegated to the status of grotesque ornaments, figuring as voluptuous apparitions with their lower bodies emerging from delicate flowers. This effectively defused their potential threat to the queen's power. In reality, Marie Antoinette's queenly authority remained unchallenged because Louis XVI never took any mistress—another point of contention with her enemies as they perceived it as a dangerous concentration of power in one woman.[40] Moreover, eunuchs, famously portrayed in Montesquieu's widely read *Lettres persanes* (1721) as ruthless wardens tasked with reminding the sultan's wives of "their own absolute dependence" to their ruler, adorn the bottom panels of the doors (Figure 10.6) and the top of woodwork panels as busts (Figure 10.3), their faces frozen in petrified, powerless gazes.[41] Lastly, the sultan, whose presence is the very principle that orders the seraglio, is all but absent, hinted only through his metonymic substitution by the

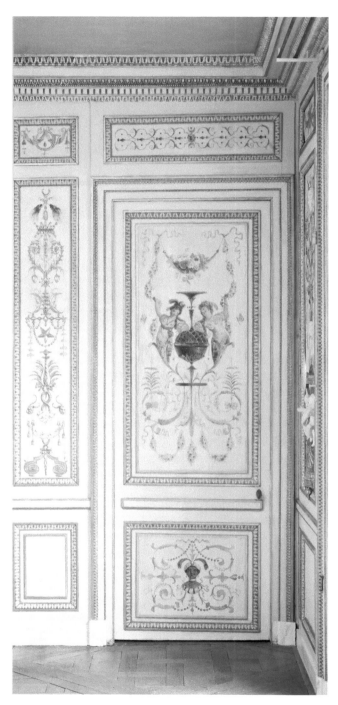

Figure 10.6 Painted decorations on the door panels on the western wall of the *boudoir turc*, Château de Fontainebleau. © RMN-Grand Palais/Art Resource, NY/Adrien Didierjean.

turban in the carved *boiserie* decoration (Figure 10.3) and the ends of the architrave of the chimneypiece (Figure 10.4).

With all threats to her power reduced to ornaments, the queen availed herself to a mirage of near-complete autonomy, its references to foreignness underlining its strictly illusory nature. Indeed, in this architectural iteration of "cultural cross-dressing," the make-believe Oriental harem must reveal itself as an illusion in order to fulfill its patron's desire to occupy this otherworldly site.[42] Iconographical motifs in the conventional European repertory of turquerie designate this space as "Oriental," while alerting its occupants that it is but an imaginary construction of that remote empire.

Unlike the other harems that enthralled the eighteenth-century European imagination, which were often products of Oriental novels written by male authors, the *boudoir turc* was not oriented toward the all-powerful sultan, whose pleasure was the raison d'être of all in the seraglio. Overturning the fictions of the harem produced for male enjoyment, the Fontainebleau boudoir configured a fantastic domain of female self-rule. Although the theme of the harem implies a male master, that sultan's presence lingers only as a single metonym of a turban. The suggestion of heterosexual *volupté* centered around the sultan, which characterized the seraglio in early modern European cultural representations, is conspicuously absent in the queen's boudoir. The door panels painted in 1781 by the Rousseau brothers for the *cabinet turc* at Versailles for the comte d'Artois (1757–1836), in contrast, feature central cameo medallions showing the sultan in various amorous pursuits with multiple women, as well as fish-tailed odalisques, completely nude and displaying their assets at multiple angles.[43] Although an explicit celebration of erotic indulgence would have been unsuitable, the lack of reference to the king/sultan or to the queen as an object of *his* pleasure augmented the boudoir's emancipatory potential, positing Marie Antoinette as a self-governing individual whose *own* pleasure was the ultimate logic organizing the space.

In fact, in the late 1700s, the use of an exotic guise to explore and communicate self-determination was a strategy employed by elite women around Europe. In particular, costume *à la turque* signified transgressive femininity to the educated milieu, granting women greater freedom in their private fantasy realms. Several female sitters in portraits by Angelica Kauffman (1741–1807) from the late 1760s and 1770s—for instance, Mary Lennox, duchess of Richmond, or Theresa Robinson Parker—sport lavish Turkish-style outfits, including long, baggy trousers gathered at the ankles, waistcoats, and embroidered robes cinched at the waist, as well as flat silk slippers.[44] The loose-fitting silhouettes allowed for greater mobility, in contrast to the highly restricting stays of traditional European dress. The low-cut necklines and relatively lightweight fabric enhanced the Oriental costumes' informal sensuality.[45]

Angela Rosenthal names this imaginary geography of female autonomy invoked in Kauffman's turquerie portraits the "inner Orient." In dressing and posing as harem women, Kauffman's female patrician subjects imagined a cultural space in which to explore moral liberty beyond male control, rather than appealing to the fiction of Oriental sexual excess created by male European writers.[46] This "inner Orient" was akin to the vision of ideal homosocial spaces for Ottoman women in the harem and the bath described in *Turkish Embassy Letters* (first published in England in 1763) by Lady Mary Wortley Montagu (1689–1762), based on her sojourn in the Ottoman Empire accompanying her husband, the British ambassador to the Sublime Porte. In

fifty-two letters elaborating her first-hand observations of Ottoman society, Lady Mary noted the greater independence enjoyed by elite Turkish women. According to her, Ottoman women are "the only free people in the Empire" and "Queens of their slaves," treated with great respect even by the most powerful men.[47] Translated into French in 1763 and popular among educated readers in France, Lady Mary's letters advanced a perception of the Ottoman Empire as a place where women could govern their own bodies and destinies to a greater extent than their counterparts in Europe.[48] Through their patronage of turquerie, privileged European women, such as Marie Antoinette, sought to claim as their own the supposed feminine autonomy of Ottoman culture, albeit on an imaginary register.

Magic, Perfume, Dream …

While the liberating power of turquerie portraits for European women operated primarily through the visual, Marie Antoinette's *boudoir turc* enacted a multisensory process of evoking the imagined Orient. In addition to the visual stimulation of glittering and shape-shifting ornaments, the touch of luxurious textiles decorating the room provided haptic pleasures. The preponderance of textile furnishings in the space also heightened the occupants' auditory awareness by dampening ambient sound. The boudoir would have offered an aural oasis of welcome silence, where soft voices in a tête-à-tête or the rustle of fabric would have had a much more acute sensory impact.

But it was the olfactory sense that reigned in the *boudoir turc* as the primary vehicle for the room's Oriental ambience. Perfume pervaded the space through both illusionistic and material means. In addition to the blue sculpted cassolettes on the *boiserie* panels (Figure 10.3), spherical perfume burners adorn the doors, issuing scented smoke from their apertures (Figure 10.6). The perfume containers atop tripods are also woven into the Savonnerie carpets commissioned for the boudoir (Figure 10.5). Moreover, it is not difficult to imagine ceramic or hardstone potpourri vessels with gilt bronze mounts or metal cassolettes embellishing the mantel, as they were popular decorative objects for sumptuous interiors in the period.[49]

Perfume and its container, most notably the cassolette (a small brazier used to burn liquid or solid perfume), served as shorthand for the exotic Orient. Since the medieval period, Middle Eastern merchants held a monopoly over the commerce on aromatic ingredients, and several eighteenth-century encyclopedic entries point to the Orient as the origin for the best perfumes.[50] Perfume and the Orient were so inextricably linked that the cassolette appears as an attribute of Asia, along with coffee, pepper, and a camel in front of a mosque, in *Iconologie par figures* (1791), based on Cesare Ripa's influential emblem book.[51]

Although portrayed as an accessory for both sexes, perfume was strongly linked to Ottoman femininity in cultural representations, partly as a projection of the European cultural practice of gendering perfume as feminine. One of the engravings after paintings by Jean-Baptiste Vanmour (1671–1737) of Turkish life made during his stay in Constantinople, published in *Recueil de cent estampes représentant différentes Nations du Levant* (1714–15), depicts Sultana Asseki in the harem, standing next to a fuming cassolette on a table (Figure 10.7). The perfume container exhibits the bulbous

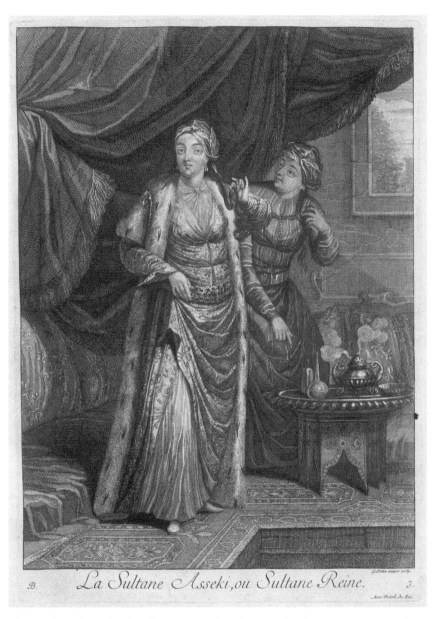

Figure 10.7 Gérard Scotin, after Jean-Baptiste Vanmour, *La Sultane Asseki, ou Sultane Reine*, from Charles de Ferriol, *Recueil de cent estampes représentant différentes nations du Levant* (Paris: L. Cars, 1714), engraving on paper, 34 × 24.5 cm. The Miriam and Ira D. Wallach Division of Art, New York Public Library.

shape typical of its European form with the openwork lid and scrolling handles and feet. The Franco-Flemish artist's invention, this scene included in the hugely influential *Recueil* (which informed subsequent depictions of the Ottomans) buttressed perfume's connection to Ottoman femininity in the European cultural imagination. Later European depictions of sultanas routinely include cassolettes in their interiors, indicating their feminine allure and exotic locale.[52]

Literary representations also portray the Ottoman Empire as a realm of superlative fragrance and beauty. For example, a cosmetic-medical manual from 1748 presents itself as a translation of a Turkish manuscript found in the rubble after an earthquake in Constantinople.[53] Along with the central narrative of a romance between the most beautiful woman in the sultan's harem and the harem doctor, the book contains instructions on how to make and use various perfumed products, including potpourri and pastilles, framed as beauty secrets passed down from the male protagonist to his paramour.[54] Indeed, to increase their appeal, late eighteenth-century French beauty products co-opted the Orient's exotic allure with names such as "eau de Chypre," "pommade de la sultane," and "eau du sérail."[55] In consuming perfumed goods redolent of the East, French women aspired to the fragrant charm of Ottoman sultanas.

Such cultural associations with the Orient facilitated perfume's construction of an otherworldly sensory environment. In the 1700s, domestic fragrance such as potpourri and pastilles in ornate vessels adorned lavish urban interiors and fashioned an olfactory ambience of salubrity, distinct from the noxious effluvia pervading outside. Urbanites perfumed their homes to ward off foul-smelling and stagnant air, believed to cause and spread diseases.[56] Moreover, French consumers increasingly relied on perfume to cultivate a heightened sensitivity toward their domestic smellscape, effecting a "perceptual revolution" in which bad odors became intolerable and pleasant smells desirable to an unprecedented degree.[57] Perfume was absolutely necessary to indicate that one's home (and, by extension, oneself) was free from the deadly mephitis of the cities, with their crowded housing and high concentrations of hospitals, abattoirs, and stables.

In addition to its role in aerial hygiene, perfume denoted alterity on the cognitive level, conditioned by cultural representations. The *Encyclopédie* entry on perfume mentions its role in classical antiquity as not only a tribute to the gods but the very sign of their presence, which always announced itself by an ambrosial scent.[58] In Christianity (as with other religions), the exquisite "odor of sanctity" distinguished the sacred and the virtuous from the foul-smelling wicked.[59] And as a widely recognized attribute of the Orient, pleasant scent triggered imaginary transports to far-flung locales for those who consumed it. A fundamental principle underlying perfume's intimate ties to otherness is olfaction's ability to activate cognitive drift to elsewhere. On this note, the anthropologist David Howes argues that smells not only mark category-change but motivate it in a deeply experiential manner. Smell's power to transport one's attention to a place distinct from one's immediate whereabouts operates "across all of the boundaries we draw between different realms and categories of experience."[60] Furthermore, odors initiate this transition in an embodied process, wherein they physically enter and become part of those who inhale them. Literally incorporating a scent evocative of the Orient, one is carried to and absorbed into this imagined realm on both physical and symbolic levels.

Alfred Gell likewise proposes that perfume is both the model and agent for effecting the exchange between one world and another.[61] Because smell is an evaporated essence and a dematerialized version of an object, it acquires meaning by "association with a context within which it is *typical*," rather than by contrast with other smells (as do linguistic signs). In other words, a scent is not a communicative, linguistic sign (as in, smell X equals idea/thing Y). Rather, it vaguely invokes the contexts or situations associated with it. This "incompleteness" enables perfume to express "an ideal, an archetypal wholeness," thus launching the "transcendence" to a world different from real life for those who smell it.[62]

Indeed, the indistinct nature of perfume's aroma is key to its transcendental role. Most perfumes result from heterogeneous mixtures of multiple ingredients. For instance, recipes from 1771 for different pastilles call for anywhere from four to twenty-two different aromatic substances.[63] The same is true for potpourri, which got its name (a compound of the French words *pot* and *pourri*, directly translating to "rotten pot") because its aroma comes from fermenting a macerated concoction of dozens of materials in a pot. By inhaling a whiff of a burning pastille or fermenting potpourri, one typically cannot register all its individual constituents. According to Gell, what the perfume sparks in the inhaler's mind instead is a situation, an "ideal" that is attached to that particular aroma through conventional practice or individual experience.

In short, perfume's fundamentally indistinct quality lends itself to semantic openness. Consequently, scent serves as "an odor-sign giving vicarious access to a kind of experience not really matched by anything in real life," transporting its inhaler to otherworldliness.[64] With its association with the East and the decorative ensemble reminiscent of a sultana's intimate abode serving as its signifying context, perfume in all its multisensory references in the *boudoir turc* was for the queen the scent of the Orient and beyond, the mysterious enchantment of places and entities both real and imagined. And internal peregrinations to elsewhere, the process by which one could gain "vicarious access" to an alternative mode of existence, turned on a particular mode of inattention, called reverie.

The Architecture of Reverie and the Orient State of Mind

A cognitive state of daydreaming in which one's thoughts wander, reverie as conceived in the 1700s was predicated on the ability and desire to excise oneself from the world and to escape from the constraints of reality. Described as a transitory and pleasant moment of escape into interiority, it blurs one's relation with the exterior and renders fluid the borders demarcating the self.[65] To revel in these flights of thought, writes Madeleine de Scudéry (1607–1701),

> one needs to be capable of inducing a certain dormancy of the senses, which makes one believe oneself to be almost dreaming of things that one is thinking of … it is necessary that the eyes themselves do not see distinctly the diversity of objects.[66]

A person in the state of reverie throws an inattentive gaze to her surroundings, letting the sensations wash over her while not fixating on any single object. Women, whose supposedly "tender" organs render them more susceptible to distraction than men, were portrayed in cultural representations as prone to reverie, especially when given access to the luxury of their own private rooms.[67] Indeed, the boudoir heady with the aroma of honeysuckle and jasmine, according to Le Camus de Mézières, is a space in which to allow "a sweet slumber to overcome our senses, and airy dreams [to] set our souls adrift."[68] A perfumed boudoir is, therefore, a "rêvoir," a privileged site for women to chase the intangible objects of their dreams.[69]

Perfume, as a vehicle for "vicarious access" to otherworldliness, served as an agent of this "détente heureux" by providing a temporary distraction from reality and signaling the presence of the Other.[70] *The Sweet Melancholy* by Joseph-Marie Vien (1716–1809; Figure 10.8) visualizes the moment of mental digression triggered by perfume.

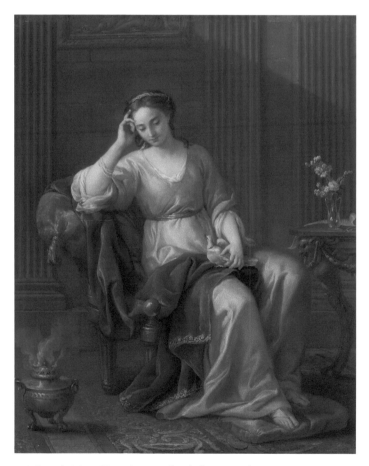

Figure 10.8 Joseph-Marie Vien, *Sweet Melancholy*, 1756, oil on canvas, 68 × 55 cm. Mr. and Mrs. William H. Marlatt Fund, Cleveland Museum of Art.

Set in a luxurious neoclassical *mise-en-scène*, a maiden sits on a plush chair in her private retreat, holding a dove and resting her forehead on her hand. She is lost in her thoughts, whose meandering passage is launched by the scrolling letter on the table and sustained by the smoke pouring from the gleaming metal cassolette on the floor. Like the aimlessly floating vapors, her somber ruminations drift from one object to another. Vien's appropriation of the gesture of melancholy, part of the malady's iconography since the Renaissance, points to a "delirium" that renders her inattentive to the bird in her hand or to her surroundings.[71] Although the title's reference to melancholy evokes the pathologization of overactive female imagination in eighteenth-century cultural discourse, the central subject of this painting is a young woman's dreamy introspection, made possible by the cloud of perfume inside her intimate interior.[72] It is through perfumed reverie's involuntary rupture from the immediate and transport to the world of her own that she can explore her internal life.[73]

Similarly, the decorative program of the *boudoir turc* constituted the architecture of reverie by activating an unfocused mode of embodied, multisensory introspection. To aid this altered mental state, the preponderance of mirrors reflecting the flickering light of the wall sconces and chandelier created an almost spectral illumination in the room. In a perfume-filled, nocturnal ambience evocative of the setting of *Thousand and One Nights* (whose translation by Antoine Galland captivated French readers throughout the 1700s), the queen was both the sultan Schahriar and the sultana Scheherazade, luxuriating in the winding tales that she herself spun in her head. The dazzling visuality of the space with the pearlescent wall paint and the gleaming facets of the gilt furnishings, as well as the *mise en abyme* generated by the presence of mirrors on all four sides, disabled a focused viewing inside the boudoir. Trapping the queen and her companions in the infinitely multiplying reflections of themselves, the room sent them on to imaginary voyages traversing dreamy terrains and their internal domains. The arabesque ornaments filling the interstices of mirrored surfaces set into motion delightful flights of fancy, with whimsical motifs cheerfully transmogrifying from one form to another.

In addition to providing the olfactory catalyst and backdrop to reverie, perfume vessels contributed to conjuring up the oneiric ambience in the boudoir with their own marvelous visuality. Potpourri vases and cassolettes from the period incorporate mythical, exotic, and grotesque motifs into hybrid creations offering heterogeneity and artifice for viewers' delectation. A pair of two potpourri vases (Figure 10.9) combining turquoise shell-shaped Chinese porcelain lidded pots with French gilt bronze mounts illustrates perfume's reference to fictive realms. Each vase features a swan menacingly spreading its wings on one side and the head of a river god on the other. An openwork frieze allows the potpourri's scent to escape, while four lion paws on an oval base support the pot.[74] Despite its common aquatic theme, the resulting assemblage is a bewildering amalgamation that renders irrelevant certain ontological distinctions— between hard and soft, organic and inorganic, East and West, to name a few. This exuberant disregard for verisimilitude in the vases' form, in turn, temporarily dissolves the boundaries between the self and the Other.

In the moments of pleasant displacement instantiated by such exotic ornaments, the boudoir's female occupant could fashion her own subjectivity, the imaginary voyage to

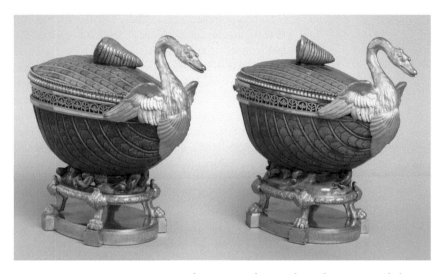

Figure 10.9 Two potpourri vases, Chinese porcelain, eighteenth century; gilt bronze mounts by Pierre Gouthière, *c.* 1770–5, 28 × 32 × 19 cm. Musée du Louvre, transfer from the Mobilier National. © RMN-Grand Palais/Art Resource, NY/Thierry Ollivier.

a place outside her own ironically allowing her an internal space in which to develop her sense of self. Also incongruous are the metaphor of the harem, a place portrayed in French literature as a prison for the sultan's enslaved wives, and the psychic liberation that it granted to its queenly protagonist. Within the confines of the small boudoir, Marie Antoinette could conceive of her individual autonomy in a perfume-filled reverie.[75]

The architecture of reverie assembled in the *boudoir turc* conceptualized the Orient not just as an exotic destination for imaginary transports or the inspiration for a fashionable ornamental lexicon. Standing in for all places and entities encountered in dreamy passages, the Orient was a state of mind that enabled for elite women visions of alternative modes of living. This latter function of the Orient as a mood that concretized the affinity between reverie and female autonomy is a salient theme in images of solitary women in harems, such as *Sultana on an Ottoman* by Jean-Honoré Fragonard (1732–1806; Figure 10.10). With her elbow resting on the ottoman (an eighteenth-century invention also associated with the Orient) and holding a text, the sultana gazes into the distance.[76] To where her mind has set sail is anyone's guess. But the empty space framing her head implies the boundless possibilities for her oneiric journey, the hazy infinitude defining the shape of her psychic emancipation.

Similarly, the *boudoir turc*'s multisensory evocation of the Orient provided the queen with an atmosphere and a point of departure for her reverie. The transgressive potential of this small room seems to have been immediately recognized by those in her inner circle. Florimond Claude, comte de Mercy-Argenteau (1727–94), the Austrian diplomat who kept a close watch on Marie Antoinette, reported to Empress Maria Theresa (r. 1743–80) in November 1777 on the "charming" boudoir and hoped

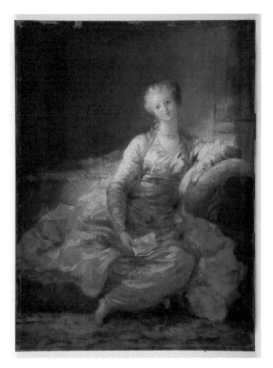

Figure 10.10 Jean-Honoré Fragonard, *Sultana on an Ottoman, c.* 1772–6. oil on paper mounted on panel, 33.5 × 25.08 cm. David Owsley Museum of Art; E. Arthur Ball Collection, gift of the Ball Brothers Foundation, 1995.035.127.

that in withdrawing from the noise and dissipations, the queen would use the space for "useful occupations and reflections"—that is, contemplating her paramount duty to bear the dauphin.[77] Mercy-Argenteau's attempt to circumscribe the queen's activities in the boudoir betrays his anxiety toward the futility of such an endeavor. In the Turkish boudoir, Marie Antoinette was free to build worlds that existed only in her imagination, worlds where she could embrace the Other and shape her own alterity on her own terms. And what she could have done, to where she could have traveled in her fragrant daydreams was her prerogative, and hers alone.

Notes

The author wishes to thank Franny Brock, Axel Moulinier, Cabelle Ahn, and Allison Harbin for their assistance.

1 Xavier de Maistre, *Voyage autour de ma chambre, suivi du Lépreux de la cité d'Aoste* (Paris: Delaunay, 1817), 15–16.
2 Ibid., 2. Translation from Bernd Stiegler, *Traveling in Place: A History of Armchair Travel*, trans. Peter Filkins (Chicago: University of Chicago Press, 2013), 9.

3 On olfaction's central place in the phenomenology of architecture, see Jim Drobnick, "Volatile Effects: Olfactory Dimensions of Art and Architecture," in *Empire of the Senses: The Sensual Cultural Reader*, ed. David Howes (Oxford: Berg, 2005), 265–80.

4 Muriel de Raïssac, *Richard Mique: Architecte du roi de Pologne Stanislas I^er, de Mesdames et de Marie-Antoinette* (Paris: Honoré Champion, 2011), 205.

5 See Manuel Lalanne, "L'appartement de Marie Leszczyńska (1725–1768)," *Bulletin du Centre de recherche du château de Versailles* 1, no. 2 (2012): 35–6; Vincent Cochet, "Vie de cour et vie privée au temps de Marie-Antoinette," in *Refuge d'Orient: Le boudoir turc du château de Fontainebleau de Marie-Antoinette à Joséphine*, by Vincent Cochet and Alexia Lebeurre (Château de Saint-Rémy-en-Eau: Éditions Monelle Hayot, 2015), 32.

6 Cochet, "Vie de cour et vie privée," 32–3.

7 Raïssac, *Richard Mique*, 206.

8 Nothing is known about the location and décor of Marie Antoinette's *cabinet turc* at Versailles. Christian Baulez, "Le goût turc: François Rémond et le goût turc dans la famille royale au temps de Louis XVI," *L'Objet d'art* no. 2 (December 1987), 37. For a discussion of the comte d'Artois's *cabinet turc* in Paris and Versailles, see Ashley Bruckbauer's essay in this volume.

9 Archives Nationales, O¹ 1435, 319.

10 Ibid., 198.

11 The Rousseau brothers previously worked on the decoration of the comte d'Artois's and the queen's *cabinets turcs* at Versailles. Archives Nationales, O¹ 1435, 302.

12 Jean-Félix Watin, *L'Art du peintre, doreur, vernisseur* (Paris: Grangé, 1773), 77.

13 Vincent Cochet, "Introduction," in *Refuge d'Orient*, 22. During the First Empire, the *boudoir turc* was refurbished with different furniture and textiles for Joséphine. See Vincent Cochet, "Une chambre turque pour Joséphine," in *Refuge d'Orient*, 115–63.

14 Cochet, "Vie de cour et vie privée," 65–6.

15 See Charlotte Vignon and Christian Baulez, eds., *Pierre Gouthière: Virtuoso Gilder at the French Court* (New York: The Frick Collection, 2016), 258–63.

16 See Vignon and Baulez, *Pierre Gouthière*, 234–7; and Jannic Durand, Michèle Bimbenet-Privat, and Frédéric Dassas, eds., *Décors, mobilier et objets d'art du musée du Louvre: de Louis XIV à Marie-Antoinette* (Paris: Somogy, 2015), 466.

17 Never actually installed in its intended location and known only through its later weavings from the First Empire with slight variations, the Savonnerie carpet's design suggests the overall coherence of the Turkish theme and opulence of the original décor for the queen's boudoir. Cochet, "Vie de cour et vie privée," 64–5.

18 Louis-Antoine de Caraccioli, *Dictionnaire critique, pittoresque, et sentencieux* (Lyon: B. Duplain, 1768), 1: 27. For the evolution of the boudoir in this period, see Diana Cheng, "The History of the Boudoir in the Eighteenth Century," Ph.D. diss., McGill University, 2011.

19 Ed Lilley, "The Name of the Boudoir," *Journal of the Society of Architectural Historians* 53, no. 2 (June 1994): 193. The exact reason for the verb's association with the space remains a matter of speculation.

20 In the 1700s, boudoir was also called *la méridienne* (referring to the function of the chamber as a space for taking midday naps) and *cabinet de retraite*.

21 Pierre Saint-Amand, "Disclosures of the Boudoir: The Novel in the Eighteenth Century," in *A History of Modern French Literature: From the Sixteenth Century to the Twentieth Century*, ed. Christopher Prendergast (Princeton: Princeton University Press, 2017), 312–13.

22 See Daniel Roche, *A History of Everyday Things: The Birth of Consumption in France, 1600–1800*, trans. Brian Pearce (Cambridge: Cambridge University Press, 2000); and Annik Pardailhé-Galabrun, *The Birth of Intimacy: Privacy and Domestic Life in Early Modern Paris*, trans. Jocelyn Phelps (Cambridge: Polity Press, 1991).

23 Dena Goodman, *Becoming a Woman in the Age of Letters* (Ithaca: Cornell University Press, 2009), 253. See also Monique Eleb-Vidal and Anne Debarre-Blanchard, *Architectures de la vie privée: maisons et mentalités, XVIIᵉ–XIXᵉ siècles* (Brussels: Archives d'Architecture Moderne, 1989), 236.

24 Cochet, "Vie de cour et vie privée," 35–6. The private staircases were installed to allow for privacy and better circulation inside the château during Marie Leszczynska's reign. See Lalanne, "L'appartement de Marie Leszczyńska," 32–3.

25 Archives Nationales, O¹ 1435, 263.

26 Pulling the button sent the mirror back to its position behind the wall to the right of the window. Archives Nationales, O¹ 1435, 263.

27 Nicolas Le Camus de Mézière, *The Genius of Architecture: or, the Analogy with That Art with Our Sensations*, trans. David Britt (Santa Monica: Getty Center for the History of Art and the Humanities, 1992), 115.

28 Ibid., 115–18.

29 Jill H. Casid, "Commerce in the Boudoir," in *Women, Art and the Politics of Identity in Eighteenth-Century Europe*, ed. Melissa Hyde and Jennifer Milam (Aldershot: Ashgate, 2003), 95–7.

30 For a historical survey of the luxury discourse of the eighteenth century, see Maxine Berg and Elizabeth Eger, "The Rise and Fall of the Luxury Debates," in *Luxury in the Eighteenth Century: Debates, Desires and Delectable Goods*, ed. Maxine Berg and Elizabeth Eger (New York: Palgrave Macmillan, 2003), 7–27.

31 The idea that boudoirs' décors could move the hearts and minds of their occupants forms the premise of several fictional narratives of architectural seduction, most notably Jean-François de Bastide's *La Petite Maison* (1763) and Louis Carrogis de Carmontelle's "Le boudoir" (1768–69) in *Proverbes dramatiques*.

32 Marie Leszczynska also refurbished a private cabinet for herself at Versailles in 1761 in the chinoiserie style. For the decoration of the so-called *cabinet des chinois*, see Jennifer G. Germann, "Figuring Marie Leszczinska (1703–1768): Representing Queenship in Eighteenth-Century France," Ph.D. diss., University of North Carolina at Chapel Hill, 2002, 109–51; and Xavier Salmon, *Parler à l'âme et au coeur: La peinture selon Marie Leszczyńska* (Dijon: Éditions Faton, 2011), 88–103.

33 Perrin Stein, "Madame de Pompadour and the Harem Imagery at Bellevue," *Gazette des Beaux-Arts* 123 (January 1994): 29.

34 Pompadour also decorated her bedroom with furnishings evocative of the Orient—a sofa *à la turque*, Oriental carpets, and firedogs in the form of a Turkish couple. Ibid., 30–1.

35 After his sexual relations with Pompadour ended, Louis XV kept his young, low-born mistresses in the Parc-aux-Cerfs in Versailles as his version of a harem. Ibid., 39.

36 Nebahat Avcıoğlu, *Turquerie and the Politics of Representation, 1728–1876* (Burlington, VT: Ashgate, 2011), 14.

37 Thomas E. Kaiser, "From the Austrian Committee to the Foreign Plot: Marie-Antoinette, Austrophobia, and the Terror," *French Historical Studies* 26, no. 4 (2003): 586.

38 Lynn Hunt, *The Family Romance of the French Revolution* (Berkeley: University of California Press, 1992), 112.

39 Alexander Bevilacqua and Helen Pfeifer, "Turquerie: Culture in Motion, 1650–1750," *Past and Present* 221 (2013): 101.

40 Mary D. Sheriff, *The Exceptional Woman: Elisabeth Vigée-Lebrun and the Cultural Politics of Art* (Chicago: University of Chicago Press, 1996), 157.

41 Charles de Secondat, baron de Montesquieu, *Persian Letters*, ed. and trans. C. J. Betts (London: Penguin Books, 1973), 42.

42 For the notion of cultural cross-dressing, see Inge E. Boer, *Disorienting Vision: Rereading Stereotypes in French Orientalist Texts and Images* (Amsterdam: Rodopi, 2004), chap. 4.

43 See Durand, Bimbenet-Privat, and Dassas, *Décors, mobilier et objets d'art du musée du Louvre*, 372–3; Daniëlle O. Kisluk-Grosheide, "French Royal Furniture in the Metropolitan Museum," *The Metropolitan Museum of Art Bulletin* 63, no. 3 (2006): 19–20.

44 See Bettina Baumgärtel, ed., *Angelica Kauffman* (Chicago: University of Chicago Press, 2020), 121; and Angela Rosenthal, *Angelica Kauffman: Art and Sensibility* (New Haven: Yale University Press, 2006), 130–2.

45 Kimberly Chrisman-Campbell, *Fashion Victims: Dress at the Court of Louis XVI and Marie-Antoinette* (New Haven: Yale University Press, 2015), 242.

46 Rosenthal, *Angelica Kauffman: Art and Sensibility*, 141–2.

47 Mary Wortley Montagu, *Letters of the Right Honourable Lady M—y W—y M—e: Written, during her Travels in Europe, Asia, and Africa …* (London: T. Becket and P. A. De Hondt, 1763), 2: 34–6. Moreover, Lady Mary dismissed the myth of multiple wives for a single man in a household, stating that although the law permits polygamy, she had not seen it in practice.

48 For the *Turkish Embassy Letters*' translation and reception in France, see Rachele Raus, "Lady Mary Wortley Montagu's *Letters* in France," in *Travel Narratives in Translation, 1750–1830: Nationalism, Ideology, Gender*, ed. Alison E. Martin and Susan Pickford (New York: Routledge, 2012), 157–80.

49 For the social function of perfume vases in elite interiors, see Hyejin Lee, "Materializing Air in Eighteenth-Century French Decorative Art," Ph.D. diss., University of North Carolina at Chapel Hill, 2018, chap. 3; and Vincent Cochet, "Odeurs intérieures, atmosphères parfumées aux XVIIᵉ et XVIIIᵉ siècles," *Histoire de l'art* 48 (2001), 39–52.

50 See Louis de Jaucourt, "PARFUM, (Composition de parfums)," in *Encyclopédie, ou Dictionnaire raisonné des sciences, des arts et des métiers, etc.*, ed. Denis Diderot and Jean le Rond d'Alembert (Paris: Briasson, David, Le Breton, and Durand, 1751–65), 11: 940. Aromatic ingredients imported from the Orient included incense, myrrh, benzoin, storax balsam, labdanum, and ambrette. These were frequently used in perfumed commodities. See D. J. Fargeon, *L'art du parfumeur, ou traité complet de la préparation des parfums …* (Paris: Delalain fils, 1801), 4.

51 Hubert-François Gravelot and Charles-Nicholas Cochin, *Iconologie par figures, ou Traité complet des allégories, emblêmes, &c.* (Paris: Le Pan, 1791), 1: 37–8. *Iconologia* by Cesare Ripa (*c.* 1560–*c.* 1622) was first published in 1593.

52 One instance of almost direct quotation of the side table with a cassolette and perfume vessels occurs in Claude Duflos's engraving after François Boucher, titled *La Sultane*, published in Jean-Antoine Guer's *Moeurs et usage des Turcs …* (1746).

53 Antoine Le Camus, *Abdeker, ou l'art de conserver la beauté* (Paris: Cuchet, 1754), 1: viii–ix.

54 Ibid., 1: 236–9.

55 For the Oriental references in the marketing of cosmetic products in France, see
 Morag Martin, "French Harems: Images of the Orient in Cosmetic Advertisements,
 1750–1815," *Journal of the Western Society for French History* 31 (2003): 125–37.
56 While in the first half of the century air was thought to provoke disease in concert
 with other elements internal and external to the body, after about 1750, air alone,
 particularly malodorous air, was believed to spread illness. See James C. Riley, *The
 Eighteenth-Century Campaign to Avoid Disease* (New York: St. Martin's Press, 1987),
 15–16; and Laurence Brockliss and Colin Jones, *The Medical World of Early Modern
 France* (Oxford: Clarendon Press, 1997), 462–3.
57 Alain Corbin, *The Foul and the Fragrant: Odor and the French Social Imagination*,
 trans. Miriam L. Kochan (New York: Berg, 1986).
58 Louis de Jaucourt, "Parfum, (Littérature)," in *Encyclopédie*, 11: 940.
59 Annick Le Guérer, *Scent: The Mysterious and Essential Powers of Smell* (New York:
 Turtle Bay Books, 1992), 120–3.
60 David Howes, "Olfaction and Transition: An Essay on the Ritual Uses of Smell,"
 Canadian Review of Sociology and Anthropology 24, no. 3 (1987): 401.
61 Alfred Gell, "Magic, Perfume, Dream …," in *The Smell Culture Reader*, ed. Jim
 Drobnick (New York: Berg, 2006), 403–4.
62 Ibid., 405.
63 Pierre-Joseph Buc'hoz, *Toilette de Flore ou essai sur les plantes et les fleurs qui peuvent
 servir d'ornement aux dames* (Paris: Valade, 1771), 160–2.
64 Gell, "Magic, Perfume, Dream …," 405.
65 Robert Morrissey, "Vers un topos littéraire: la préhistoire de la rêverie," *Modern
 Philology* 77, no. 3 (Feb 1980): 288; Arnaud Tripet, *Rêverie littéraire: Essai sur
 Rousseau* (Geneva: Librairie Droz, 1979), 23.
66 Madeleine de Scudéry, *Clélie, Histoire Romaine* (Paris: Augustin Courbé, 1662),
 2: 891.
67 The emergence of the modern notion of reverie was linked to the rise of privacy
 that made it possible. See Florence Orwat, *L'Invention de la rêverie: une conquête
 pacifique du Grand Siècle* (Paris: Honoré Champion, 2006), 429–69. On the gendered
 conception of distraction in early modern European culture, see Natalie M. Phillips,
 Distraction: Problems of Attention in Eighteenth-Century Literature (Baltimore: Johns
 Hopkins University Press, 2016), chap. 2.
68 Le Camus de Mézières, *The Genius of Architecture*, 116.
69 Michel Delon, *L'Invention du boudoir* (Cadeilhan: Zulma, 1999), 131.
70 Tripet, *Rêverie littéraire*, 23.
71 Tripet explains that in the Renaissance reverie was associated with delirium of a
 pathological type. It later evolved to signify a mode of introspection and shed its
 negative connection to melancholy by the end of the 1700s. Ibid., 10–23.
72 For the connections between women's "soft" viscera and their sensibility in
 Enlightenment medical discourse, see Anne C. Vila, *Enlightenment and Pathology:
 Sensibility in the Literature and Medicine of Eighteenth-Century France* (Baltimore:
 Johns Hopkins University Press, 1998), chap. 7.
73 Morrissey, "Vers un topos littéraire," 262, 276.
74 See Vignon and Baulez, *Pierre Gouthière*, 178–81.
75 Calling this irony "the paradox of womanhood," Dena Goodman makes a similar
 observation about young women and their relationships to their private cabinets.
 Goodman, *Becoming a Woman in the Age of Letters*, 272. For the literary trope
 of the "happy prison" in *mémoires* by women authors, see Luba Markovskaia, *La*

conquête du for privé: récit de soi et prison heureuse au siècle des Lumières (Paris: Classiques Garnier, 2019).

76 An *ottomane* is a type of *lit de repos* featuring curved armrests at either ends, first mentioned in 1729 in the *Inventaire général des meubles de la couronne*. See Henry Havard, "Ottomane," in *Dictionnaire de l'ameublement et de la décoration: depuis le XIIIᵉ siècle jusqu'à nos jours* (Paris: Quantin, 1894), 3: 1335; and Nicole de Reyniès, *Le mobilier domestique: Vocabulaire typologique* (Paris: Imprimerie Nationale, 1987), 1: 152–3.

77 Alfred von Arneth and Mathieu-Auguste Geffroy, eds., *Correspondance secrète entre Marie-Thérèse et le comte de Mercy-Argenteau: avec les lettres de Marie-Thérèse et de Marie-Antoinette* (Paris: Firmin Didot Frères, 1874), 3: 130 (letter from November 19, 1777), quoted in Cochet, "Vie de cour et vie privée," 70.

Bibliography

Archives Nationales, O¹ 1435.

Arneth, Alfred von, and Mathieu-Auguste Geffroy. *Correspondance secrète entre Marie-Thérèse et le comte de Mercy-Argenteau: avec les lettres de Marie-Thérèse et de Marie-Antoinette*. Paris: Firmin Didot Frères, 1874.

Avcıoğlu, Nebahat. *Turquerie and the Politics of Representation, 1728–1876*. Burlington, VT: Ashgate, 2011.

Bevilacqua, Alexander, and Helen Pfeifer. "Turquerie: Culture in Motion, 1650–1750." *Past & Present* 221 (2013): 75–118.

Buc'hoz, Pierre-Joseph. *Toilette de Flore ou essai sur les plantes et les fleurs qui peuvent servir d'ornement aux dames*. Paris: Valade, 1771.

Caraccioli, Louis-Antoine de. *Dictionnaire critique, pittoresque, et sentencieux*. Lyon: B. Duplain, 1768.

Casid, Jill H. "Commerce in the Boudoir." In *Women, Art and the Politics of Identity in Eighteenth-Century Europe*, edited by Melissa Hyde and Jennifer Milam, 91–114. Aldershot: Ashgate, 2003.

Chrisman-Campbell, Kimberly. *Fashion Victims: Dress at the Court of Louis XVI and Marie-Antoinette*. New Haven: Yale University Press, 2015.

Cochet, Vincent. "Introduction." In *Refuge d'Orient: Le boudoir turc du château de Fontainebleau de Marie-Antoinette à Joséphine*, by Vincent Cochet and Alexia Lebeurre, 21–3. Château de Saint-Rémy-en-Eau: Éditions Monelle Hayot, 2015.

Cochet, Vincent. "Vie de cour et vie privée au temps de Marie-Antoinette." In *Refuge d'Orient: Le boudoir turc du château de Fontainebleau de Marie-Antoinette à Joséphine*, by Vincent Cochet and Alexia Lebeurre, 25–85. Château de Saint-Rémy-en-Eau: Éditions Monelle Hayot, 2015.

Corbin, Alain. *The Foul and the Fragrant: Odor and the French Social Imagination*, translated by Miriam L. Kochan. New York: Berg, 1986.

Delon, Michel. *L'Invention du boudoir*. Cadeilhan: Zulma, 1999.

Gell, Alfred. "Magic, Perfume, Dream …" In *The Smell Culture Reader*, edited by Jim Drobnick, 400–10. New York: Berg, 2006.

Goodman, Dena. *Becoming a Woman in the Age of Letters*. Ithaca: Cornell University Press, 2009.

Howes, David. "Olfaction and Transition: An Essay on the Ritual Uses of Smell." *Canadian Review of Sociology and Anthropology* 24, no. 3 (1987): 398–416.

Hunt, Lynn. *The Family Romance of the French Revolution*. Berkeley: University of California Press, 1992.

Kaiser, Thomas E. "From the Austrian Committee to the Foreign Plot: Marie-Antoinette, Austrophobia, and the Terror." *French Historical Studies* 26, no. 4 (2003): 579–617.

Le Camus, Antoine. *Abdeker, ou l'art de conserver la beauté*. Paris: Cuchet, 1754.

Le Camus de Mézière, Nicolas. *The Genius of Architecture: or, the Analogy with That Art with Our Sensations*, translated by David Britt. Santa Monica: Getty Center for the History of Art and the Humanities, 1992.

Le Guérer, Annick. *Scent: The Mysterious and Essential Powers of Smell*. New York: Turtle Bay Books, 1992.

Lilley, Ed. "The Name of the Boudoir." *Journal of the Society of Architectural Historians* 53, no. 2 (1994): 193–8.

Maistre, Xavier de. *Voyage autour de ma chambre, suivi du Lépreux de la cité d'Aoste*. Paris: Delaunay, 1817.

Montagu, Mary Wortley. *Letters of the Right Honourable Lady M—y W—y M—e: Written, during her Travels in Europe, Asia, and Africa* …. London: T. Becket and P. A. De Hondt, 1763.

Montesquieu, Charles de Secondat, baron de. *Persian Letters*, edited and translated by C. J. Betts. London: Penguin Books, 1973.

Morrissey, Robert. "Vers un topos littéraire: la préhistoire de la rêverie." *Modern Philology* 77, no. 3 (February 1980): 261–90.

Raïssac, Muriel de. *Richard Mique: Architecte du roi de Pologne Stanislas Ier, de Mesdames et de Marie-Antoinette*. Paris: Honoré Champion, 2011.

Rosenthal, Angela. *Angelica Kauffman: Art and Sensibility*. New Haven: Yale University Press, 2006.

Saint-Amand, Pierre. "Disclosures of the Boudoir: The Novel in the Eighteenth Century." In *A History of Modern French Literature: From the Sixteenth Century to the Twentieth Century*, edited by Christopher Prendergast, 312–29. Princeton: Princeton University Press, 2017.

Scudéry, Madeleine de. *Clélie, Histoire Romaine*. Paris: Augustin Courbé, 1662.

Sheriff, Mary D. *The Exceptional Woman: Elisabeth Vigée-Lebrun and the Cultural Politics of Art*. Chicago: University of Chicago Press, 1996.

Stein, Perrin. "Madame de Pompadour and the Harem Imagery at Bellevue." *Gazette des Beaux-Arts* 123 (1994): 29–44.

Stiegler, Bernd. *Traveling in Place: A History of Armchair Travel*, translated by Peter Filkins. Chicago: University of Chicago Press, 2013.

Tripet, Arnaud. *Rêverie littéraire: Essai sur Rousseau*. Geneva: Librairie Droz, 1979.

Watin, Jean-Félix. *L'Art du peintre, doreur, vernisseur*. Paris: Grangé, 1773.

"Virginian Luxuries" at Thomas Jefferson's Monticello

Maurie McInnis

In the young United States, most houses were seen as private spaces, that is, other than the White House and a few official residences for governors, they rarely served as the site of official functions. Yet the houses of famous men became "public" in that Americans saw their homes as stand-ins of the men themselves. They even served as surrogates of nationhood where nationhood was rhetorically and metaphorically explained through architectural metaphors including Architects of Democracy, Founding Fathers, and Framers of the Constitution. In 1858, President Abraham Lincoln understood the power of the house as a metaphor for nation when he famously said, "A House divided against itself cannot stand."

In the United States, no home and individual were as intimately intertwined as Monticello and Thomas Jefferson (Figure 11.1). Anticipating the public role that he would be expected to play even after retirement from the presidency, Jefferson designed the architecture of Monticello to visualize a powerful separation between public, private, and enslaved (Figure 11.2). In a triad of public rooms (entrance hall, parlor, and dining room) Jefferson's purchases in France created a didactic display of art and maps to which he added native American artifacts, geological and natural history specimens, and other curiosities that were intended to instruct his visitors on America's national character and its role in the westward march of civilization. These rooms functioned as Jefferson's public face creating a vision of Jefferson as a man of Old World learning and New World exploration.[1]

But there was also a private Monticello, to serve the very private life of the former president. Jefferson was well versed in the creation of a public persona for political purposes; one that often stood in considerable contrast to the private version.[2] On one end of the house was Jefferson's "sanctum sanctorum": his private quarters (library, office, bedroom, and conservatory) where few were permitted to enter. Additionally, there were bed chambers for family members that were discretely positioned on upper stories. Unlike most homes of the period, there was no central staircase leading to the upper floors, and from the outside the fenestration suggested that Monticello was only a one-story home. By masking the multiple family chambers on the second and third stories, the architecture created an outward impression that the house was

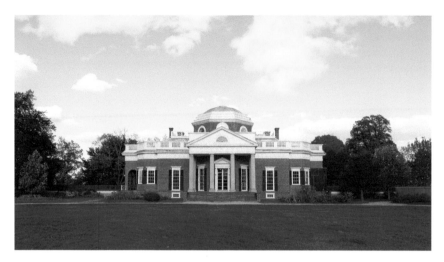

Figure 11.1 Monticello, Thomas Jefferson, completed 1809. © Thomas Jefferson Foundation at Monticello.

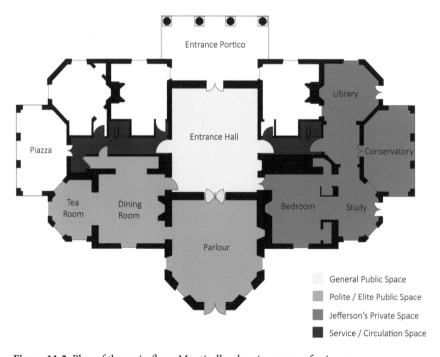

Figure 11.2 Plan of the main floor, Monticello, showing zones of privacy.

about the lone patriarch, diminishing the presence of everyone else who resided there, including his children and grandchildren.

Finally, there was a third Monticello, an enslaved Monticello. Tucked away and carefully hidden were narrow stairs and transverse hallways where the enslaved moved about performing their work. These spaces and thus these individuals were largely screened from the sight of visitors. Small staircases leading down to the service spaces or up to the family chambers and narrow hallways on the north and south side of the entrance hall hid the work of the enslaved as they moved through the house to light fires, clean rooms, or deliver food and drink. Jefferson owned hundreds of people in his lifetime. Those few who were trusted to labor in the house lived on the mountain (most of them members of the Hemings family), many of them along Mulberry Row, but most of the people Jefferson owned lived far from the mansion at Monticello, in quarters down the mountainside and in the surrounding farms.[3]

Jefferson had begun construction on Monticello long before he was minister plenipotentiary to France or president of the United States, but it changed and evolved over the decades and did not take its final form until he was retiring from the presidency in 1809. In this evolution, it acquired many features rarely encountered in other grand houses in the United States. By the time it reached its final iteration, he knew that Monticello would have an unavoidable public function because Jefferson was a man the people would wish to visit, making often long journeys to see at least the house, if not the man. He was right. Monticello was often filled with guests besides Jefferson's family and friends. During his retirement years, hundreds, if not thousands, made the trip up the mountain to see the famous home of the third president, hoping to get an audience with the celebrated statesman. He was open and generous to visitors, often feeding them and their horses even though that taxed his already precarious financial resources. Rather than viewing hospitality as a nuisance, Jefferson considered the attention as a token of esteem.[4]

Unusually for the era, Jefferson sited his home at the top of a mountain on land he had inherited from his father. Guests would have to follow a winding path as they rode their horses up the mountain, arriving at the summit from the east. When they made their presence known, they would likely have been ushered into the entrance hall, Jefferson's "Indian hall" as he sometimes called it, where they would have been greeted by Jefferson's enslaved butler Burwell Colbert.[5]

The architecture of the building clearly directed a visitor's movements. The east–west axis was marked by panes of glass, creating a transparent axis that drew a visitor in and through. After entering the entrance hall from the east through glass doors flanked by tall triple-sashed windows that stretched down to the floor, one faced double doors with panes of glass that visually invited the visitor into the next room, the parlor (Figure 11.3). That space, with its bowed western front, was also pierced with glass-paned doors and triple-sash windows, thus beckoning visitors to the ornamental west lawn beyond. The dining room was located to the north, just off the parlor. Each of these three rooms were clearly marked by the architecture as "public" spaces. They each had double-height ceilings and were ornamented and decorated with Jefferson's pedagogic program of classical architecture. In addition to the architectural didacticism, the three rooms held a display of art acquired in Europe, maps, native American artifacts,

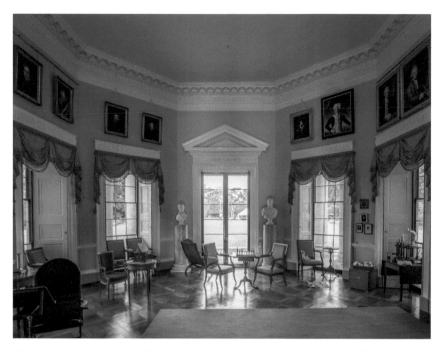

Figure 11.3 Parlor, Monticello. © Thomas Jefferson Foundation at Monticello.

geological and natural history specimens, and other natural and cultural curiosities. It functioned much as a museum would with a layout intended to instruct his visitors on the continuity between Europe and the United States, linking Old World learning with the westward march of civilization in the New World. This trio of rooms—the entrance hall, the parlor, and the dining room—served as the public face of Jefferson.

These proscribed public routes were very different from those Colbert would have taken. In the course of his day, the trusted enslaved butler would have moved freely throughout all the parts of the house and property: public, private, and enslaved. While he might have accompanied visitors as they moved from entrance hall to parlor to dining room, Colbert would also have taken routes that visitors would never see. On the north and south side of the entrance hall, there were wooden doors that were usually kept closed, in contrast to the transparent doors and windows marking the east–west axis. These wooden portals masked narrow, dark transverse hallways with low ceilings that led to the house's private rooms and to the service spaces below. After leaving guests waiting in either the entrance hall or parlor, Colbert might have passed through the wooden door to the south, where he would have knocked on another door and, if permitted, would have entered Jefferson's private suite of rooms, or at least orally informed Jefferson of the arrival of guests. After receiving direction, if these were guests who were to be staying a while and perhaps offered a meal, then Colbert would likely have gone down one of the narrow staircases in the transverse hall that connected the main floor to the "dependencies" below (Figure 11.4). A passageway ran

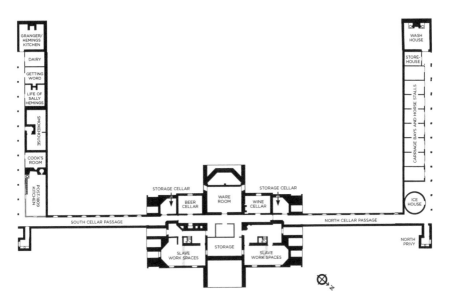

Figure 11.4 Plan of the ground floor, Monticello, showing the many service spaces under the main house and the north and south terraces. © Thomas Jefferson Foundation at Monticello.

beneath the house. It connected storage rooms and numerous service spaces located underneath the house and the north and south terraces. Colbert might have visited the stables, ice house, beer and wine cellars, and, of course the kitchen in order to give instructions to other enslaved workers who would have had duties related to the newly arrived guests.

Such service spaces were a central feature of every southern plantation house, but they were usually located in separate buildings close to but physically separated from the residence. In his earliest architectural musings about Monticello, Jefferson envisioned having entirely separate outbuildings, as would have been common in mansion homes throughout Virginia. But by the mid-1770s he began to experiment with the idea of having the dependencies below the grade of the mountain and underneath the house.[6] A comparison of Monticello with Mount Airy in Virginia is instructive (Figure 11.5). Built in the 1760s after a design from James Gibbs's *Book of Architecture*, Mount Airy was fronted by two symmetrical flankers. While visually identical, these housed entirely distinct functions as the one on the left was for the use of family and guests and the one on the right housed the cook and wash kitchen. Surrounding it were other outbuildings that supported the functioning of the main house.[7] As these structures were close to the main house and near the dining room, the sounds and smells generated by the activities that took place there would have been experienced by all. Guests approaching the house would have seen or at least heard the enslaved at work. The constant smoke from burning fires, food cooking, and the sounds of the enslaved workers as they conducted their duties would have made the

Figure 11.5 Mount Airy before the 1840s fire, date and artist unknown. Library of Congress, Prints & Photographs Division, HABS, Reproduction number VA, 80-WAR.V, 4–42.

existence of slavery a very present reality for the family and their guests. Perhaps even more visible, the enslaved moved throughout the house while working, occupying the same spaces and following many of the same routes that were used by the white family and their guests.

Jefferson's first-floor plan for Monticello, the one that was largely designed by 1769 and in place until 1796, consisted of a largely cruciform design, much smaller than the ultimate design. Importantly, it would have functioned as an almost entirely public house, in that there were no hallways and moving around the house required passing through one room to get to another. That is, to access either bedroom, one would have to pass through either the drawing room or the dining room.[8] As there were no hallways or passageways, the enslaved household laborers would have been omnipresent, moving through the same spaces as the white family and guests, just as they would have been at the Virginia homes Jefferson had known in his youth.

The final floor plan for Monticello was the result of Jefferson's many decades of architectural experiments in a slave society. When he took office as the governor of Virginia in 1779, Jefferson began a series of sketches for the remodeling of the Governor's Palace. His unbuilt designs included the insertion of a service passage that would have allowed for the movement of enslaved domestics into and through the governor's residence without having to use the main entrances or passing through the public entertaining rooms.[9]

When Jefferson, now a widower, redesigned Monticello after his return from Paris, he more than doubled the size of the house. After retiring from the presidency, his only surviving daughter from his marriage to Martha Wayles Jefferson (also named Martha) moved to Monticello with her family (including eight children; she gave birth to three others in her father's house). Describing his new plans, Jefferson claimed to a friend, "I make some alterations in it with a greater eye to convenience than I had when I was younger."[10] The most significant alterations were aesthetic and reveal the many architectural inspirations he encountered in his years living in Paris. But in addition to these stylistic elements, there were other changes that ultimately distinguished his floorplan from those of other Virginia homes. Perhaps the most significant was his private suite of rooms, but also of note was the addition of transverse hallways and hidden staircases that connected to underground service spaces allowing for the largely hidden movement of enslaved workers. Perhaps these changes are among the "conveniences" he mentioned to his friend.

In the underground service spaces beneath the terraces on the northern and southern side of the mansion house, many enslaved people labored for the leisure of Jefferson's family and guests. Colbert's daily labors would certainly have taken him there frequently. In the kitchen the butler would have likely spoken with enslaved cook Edith Fossett, who was trained in French cookery. Her meals were described as "half Virginian, half French style, in good taste and abundance."[11] Here he might have needed to gather supplies from the ware room or get wine ready for the evening meal.

Down the hill from the south terrace was Mulberry Row, the extensive street of buildings where enslaved workers lived and labored. Along Mulberry Row there were multiple cabins and a row of work buildings including a dairy, blacksmith shop, nailery, and a joinery, among others.[12] But none of that would have been visible along the road that approached the house nor from the leisure space of the west lawn that Jefferson created for the enjoyment of his family and guests. Jefferson's decision to put the service spaces underground meant that the west lawn, the space onto which the parlor opened, became a contained space of white leisure. With a winding pathway and ornamental plantings, it was frequented by Jefferson's family and his many visitors. Guests often recounted how Jefferson's family and friends used this space to stroll or for the grandchildren to run races, returning to the embrace of their grandfather on the portico. An 1825 image of the west lawn at Monticello demonstrates how the north and south terraces and trees limited one's sightlines (Figure 11.6). The presence of slavery was masked. Vision was contained and controlled: the house to the east, the terraces to the north and south, and Mount Alto to the west, metaphorically gesturing towards the purchased lands of the Louisiana Purchase engineered by the third president in 1804.

For Monticello's guests who were invited to stay, dinner was the main social event. Numerous visitors recounted a similar rhythm to the day. Breakfast (around 8 or 9 in the morning), was usually followed by Jefferson retiring to his rooms, to read or attend to his voluminous correspondence. For visitors and for his white family, the only significant time they might share with the former president was at dinner which was commonly served around 4 p.m., often lasting for hours. The virtual invisibility of

Figure 11.6 Jane Braddick Peticolas, view of the west lawn of Monticello, 1825. © Thomas Jefferson Foundation at Monticello.

slavery that Jefferson wished to create was nowhere more evident than in the dining room. Throughout the eighteenth century, non-Southern visitors were dismayed by the omnipresence of enslaved waiters. One described it as a "cohort of black guards."[13] They were omnipresent, but simultaneously invisible, in that Southerners spoke freely in front of the enslaved attendants. By the nineteenth century, however, that began to change. No longer did Southerners think of the enslaved who surrounded them as invisible. As slavery became increasingly a topic of political disagreement, Southerners were aware that it was at the dinner table where enslaved attendants were able to pick up both local and national political intelligence that they could take back to their quarters. As one former enslaved man recounted: "the arrangement had been made with Jake that as soon as possible after dinner, he was to run down and tell them any news he might gather during the meal."[14]

At Monticello, Jefferson not only adapted the floor plan to minimize the presence of enslaved servants, but his material objects enabled him to all but eliminate their presence in the dining room. Perhaps the most conspicuous addition is the revolving door at the back of the room. This allowed enslaved waiters to bring dishes from the kitchen, up the narrow set of stairs to the transverse hallway, and then place those dishes on the revolving door. Then either the guests themselves or one trusted person such as Colbert could deliver dishes to the table. Jefferson also had a wine elevator, buried inside the mantle that led directly to the wine cellar below (Figure 11.7). He also had a number of "dumbwaiters," as he called them, furniture with open shelves that allowed for the stacking of plates and dishes, and thus obviating the need for enslaved waiters. Margaret Bayard Smith, who visited in 1809, understood exactly why Jefferson employed these devices:

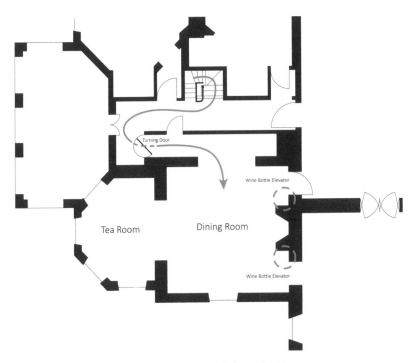

Figure 11.7 Plan of dining room, Monticello, highlighting fixed service devices.

> When he had any persons dining with him, with whom he wished to enjoy a free and unrestricted flow of conversation … by each individual was placed a dumb-waiter, containing everything necessary for the progress of the dinner from beginning to end, so as to make the attendance of servants entirely unnecessary, believing as he did, that much of the domestic and even public discord was produced by the mutilated and misconstructed repetition of free conversation at dinner tables, by these mute but not inattentive listeners.[15]

Smith clearly grasped the significance of Jefferson's changes. Conversations at Jefferson's dinner table were often political in nature, and by diminishing the number of enslaved people in the dining room, it meant that fewer were able to overhear the news of the day.

Other architectural choices made by Jefferson would have been quite notable to visitors. His powerful separation between public and private is perhaps most obvious in the lack of a main staircase. It was common for homes in Europe and America to have a staircase present in the entrance hall. But at Monticello there is not a single staircase visible from the public spaces. The only stairs were small, narrow ones located in the transverse hallways behind closed wooden doors off the entrance hall. Even more significant, however, is the set of rooms that he set aside for his private use—a library, study, bedroom, and conservatory. Margaret Bayard Smith noted in 1809, "Mr. J. went to his apartments, the door of which is never opened but by himself and his retirement

seems so sacred that I told him it was his sanctum sanctorum." Even though these rooms connected with the public rooms, they did so only reluctantly and with multiple layers of shut doors that would have disappeared from the visitors' perceptions. These were spaces where very few white visitors were ever invited. As Smith commented, these were areas "where any other feet than his own seldom intrude."[16] Other guests noted, "he keeps it constantly locked," and "he did not like of course to be disturbed by visitors."[17]

For Jefferson, while physically shielded from the house, his suite of rooms, opened up through transparent walls onto the conservatory and the south terrace, where, if he wanted, he could stroll and overlook the work going on in the south yard or along Mulberry Row. Ultimately, this open visibility to the exterior had a drawback. Visitors to the mountain sometimes wandered around the house and peered into his private quarters. This led him to add Venetian porches, or "porticles" as he called them, to either side of the conservatory. The louvered shades proved useful in preventing prying eyes.

Such architectural features provided Jefferson with considerable privacy at Monticello, even from his own family, yet he desired an even more private retreat from the public world. In 1806 he began the construction of another home, Poplar Forest, a working plantation he inherited about 90 miles south of Charlottesville. The location's remoteness, combined with the fact that many did not even know of its existence, meant that Jefferson could simply disappear from the throngs of visitors. The house he designed there, an octagon with a series of interconnected octagon-shaped rooms surrounding a central space, greatly pleased him, describing it as "the best dwelling house in the state, except that at Monticello." Perhaps what he liked best about it was that it was well suited for the "faculties of a private citizen," and was certainly better for that than Monticello.[18]

These very private spaces at Monticello and at Poplar Forest, however, were not completely private. Jefferson's needs would have been daily attended to by the most intimate of his enslaved attendants, above all Colbert and Sally Hemings. Of all the people Jefferson owned in his retirement years, he placed enormous trust in Colbert. Forty years the junior of Jefferson, Colbert served as the former president's man servant and butler, executing his owner's commands. He occupied a special status at Monticello. Even when Colbert was young, Jefferson made sure to let everyone know that Colbert was *never* to be whipped. He later directed the overseer to give Colbert spending money whenever he asked for it. As Annette Gordon-Reed explicates, these early actions on the part of Jefferson were part of signaling that Colbert was special. By saving him from the worst aspects of slavery, Jefferson worked to cultivate loyalty, creating a bond between the two men that meant that Jefferson could rely on Colbert for everything, including keeping his private life private.[19]

Colbert was a member of the Hemings family, all of whom had special status at Monticello. The Hemings family made up about a third of the enslaved people at Monticello; they were all descended from Elizabeth (Betty) Hemings. She was the daughter of an English sea captain and an enslaved African woman. She had twelve children, six of whom were likely fathered by one of her owners, John Wayles, Jefferson's father-in-law, meaning that the six were all half-siblings of Jefferson's wife,

Martha. When Wayles died, Hemings and her children came to live at Monticello. Most of the Hemings family worked either in the mansion or in the industries along Mulberry Row.

Jefferson's most intimate rooms also helped to shield his long-term relationship with Sarah ("Sally") Hemings. She was the daughter of Betty Hemings and John Wayles, and was thus the half-sister of Jefferson's wife, who died in 1782. During his lifetime it was rumored that he had a long-standing sexual liaison with Hemings. Family histories among different branches of the Hemings family had long said that they were descended from Jefferson and Sally Hemings. For decades, however, Jefferson's white family and most historians labored to create an alternative explanation. Now it is broadly accepted that Jefferson fathered all of Sally's children.[20] However close Jefferson and Colbert were, Jefferson's relationship with Sally Hemings existed on a different plane of intimacy; it was physical, sexual, and lasted for decades. It is believed that Hemings first became pregnant by Jefferson in Paris in 1789, although that child did not survive infancy. Over the next nearly twenty years she gave birth to five more children, four of whom survived to adulthood: Beverly (born 1798), Harriet (born 1801), Madison (born 1805), and Eston (born 1808). Madison recounted in his memoirs, "It was her duty, all her life which I can remember, up to the time of father's death, to take care of his chamber and wardrobe, look after us children and do such light work as sewing."[21] She lived near Jefferson, in one of the rooms under the south terrace (Figure 11.8).

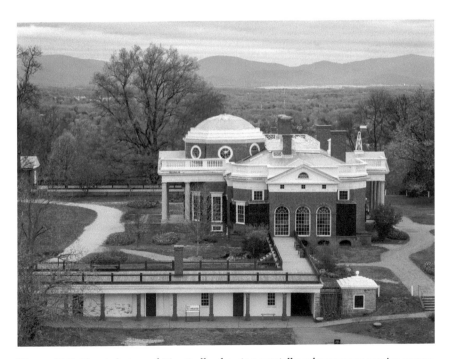

Figure 11.8 Elevated view of Monticello showing partially subterranean service spaces. © Thomas Jefferson Foundation at Monticello.

She could have easily entered his rooms either from the conservatory or triple-sashed windows that opened onto the south terrace, or by coming up the narrow stair into the hallway off the entrance hall. These paths would not have been observable by the white family or guests. While one can only speculate on the emotional nature of their relationship and of that with his children, Jefferson's will might provide some clue. Significantly, he manumitted only five people in his will, including all four of Sally's living children (and Burwell Colbert). According to Madison, this was the deal that Sally made with Jefferson in Paris. He recounted,

> He desired to bring my mother back to Virginia with him but she demurred ... in France she was free, while if she returned to Virginia she would be re-enslaved. So she refused to return with him. To induce her to do so he promised her extraordinary privileges, and made a solemn pledge that her children should be freed at the age of twenty-one years.[22]

While little is known about the nature of Jefferson's relationship with Sally and their children, many have speculated that the very private nature of his suite of rooms, with their exterior entrances, may have been a way that they could have visited with Jefferson without being observed by either visitors or Jefferson's white family. This distinct physical separation mirrored the distinctly separate lives he led.[23] Jefferson clearly prized his privacy behind those doors. One visitor recounted that his grandson tried to bring important news (the defeat of the British at the Battle of New Orleans in 1815 by General Andrew Jackson), "but the old philosopher refused to open his door, saying he could wait till the morning."[24] Even tidings of such national import could not pierce the fortress of privacy that Jefferson had constructed for himself.

Madison Hemings noted that he and his siblings

> were permitted to stay about the "great house," and only required to do such light work as going on errands. We were free from the dread of having to be slaves all our lives long, and were measurably happy. We were always permitted to be with our mother.

Sally and Jefferson's children were treated differently from other enslaved people at Monticello. Yet, it is not at all clear whether Jefferson outwardly acknowledged his relationship with his illegitimate children. Madison recounted, "He was not in the habit of showing partiality or fatherly affection to us children." And this stood in marked contrast to how he was with his white grandchildren. As Madison noted, "He was affectionate toward his white grandchildren."[25]

The story of Jefferson's illicit liaison with Sally Hemings began circulating publicly while he was president and thus years before he finalized his architectural modifications to Monticello. In 1802, a Jeffersonian rival, James Callender, published an article in the *Richmond Recorder*. Angered by then President Jefferson's refusal to appoint him post-master of Richmond, he made very public the accusation that Jefferson "keeps, and for many years has kept, as his concubine, one of his own slaves. Her name is Sally." Callender referred to her as the "African Venus" and said that she officiated as

the housekeeper at Monticello and that Jefferson had fathered several children by her, describing one as bearing

> a striking though sable resemblance to those of the president himself … By this wench Sally, our president has had several children. There is not an individual in the neighborhood of Charlottesville who does not believe the story, and not a few who know it.[26]

A young political satirist named James Akin published "A Philosophic Cock" that directly responds to Callender's accusation and the corresponding Federalist attention to the topic by showing Jefferson as the cock (a slang term for penis since the seventeenth century) wooing the hen Sally Hemings (Figure 11.9). While such

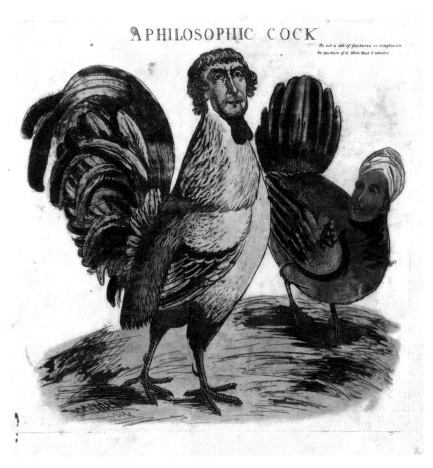

Figure 11.9 James Akin, *A Philosophic Cock*, 1804, hand-colored engraving with aquatint, 42 × 33.5 cm. American Antiquarian Society.

interracial coupling happened frequently in the American South, it was almost never represented visually. Such interracial sexual desire was frightening to most whites and would have been shocking, if unsurprising. Such an explicit reference to an American president had no precedent.

One of the president's strategies for diminishing the impact of these rumors was to present himself in Washington, D.C. as a family man. He invited his daughters Martha and Maria to visit for several months shortly after the appearance of Callender's article. They did so again in 1805, staying for the entire session of the Ninth Congress, often attending political dinners and more broadly presenting an outward image of a dedicated family man to counter the persistent rumors. Martha was well aware of the "cruel slanders" of her father's critics and she served a vital role in creating a domestic tableau that blunted such rumors, both in D.C. and later at Monticello. The purpose of these visits while he was president was understood by Margaret Bayard Smith who noted that they served as "the best refutation of all the calumnies that have been heaped upon him."[27]

The controversy, however, did not disappear. The rumored alliance between Jefferson and his "concubine" continued to circulate. When a man named Elijah Fletcher, an educator from Vermont, visited in 1811, he wrote:

> The story of Black Sal is no farce—That he cohabits with her and has a number of children by her is a sacred truth—and the worst of it is, he keeps the same children as slaves—an unnatural crime which is very common in these parts. This conduct may receive a little palliation when we consider such proceedings are so common here that they cease here to be disgraceful.[28]

And his local contemporaries were also well informed about the liaison with Hemings. Commenting on sexual relationships between white men and black women, Jefferson's own close friend, John Hartwell Cocke, made the following comment in his diary: these relationships were "not few, and not far between … Were they enumerated … they would be found by hundreds. Nor is it to be wondered at, when Mr. Jeffersons [sic] notorious example is considered."[29]

After Jefferson's death, his white family refuted the claim that he was the father of Sally Heming's children. But they could not deny that Sally's offspring were nearly white and bore a striking resemblance to the Jefferson family. They thus claimed that Jefferson's nephew Peter Carr (or perhaps Samuel Carr) was the father. They had to have known the truth. In his will, Jefferson freed all of Sally's children. Sally was not freed but, while most of the people he owned were sold to help cover his debts, Sally was not sold. Instead, she was "given her time," and went to live with two of her freed children, Madison and Eston, in Charlottesville.[30] Her children Beverly and Harriet, with Jefferson's assistance, had earlier left Monticello when they turned twenty-one, and later married and passed into white society. The denial put forth by Martha and her children provided an influential counternarrative. It was, however, similar to those promulgated by many other white families in the American South. As noted by South Carolinian Mary Boykin Chesnut, "the mulattoes one sees in every family exactly resemble the white children—and every lady tells you who is the father of all the mulatto children in everybody's household, but those in her own she seems

to think drop from the clouds."[31] While Martha had to have been acutely aware of the nearly white children being raised at Monticello, and while she had to have been knowledgeable about the relationship between Sally and her father, in many ways Jefferson's private rooms with their hidden and private access meant that she may have rarely seen them together. This architectural separation of private, public, and enslaved gave cover to the fiction she publicly promulgated that someone else must have been the father of Sally's children.[32]

When Jefferson was a younger man he published *Notes on the State of Virginia*, written while he was residing in Paris. In it, he decried the corrupting influence of slavery on the morals of Southerners. He noted that there must be an "unhappy influence on the manners of our people ... The whole commerce between master and slave is a perpetual exercise of the most boisterous passions, the most unremitting despotism on the one part, and degrading submissions on the other." He worried about how children learn this attitude from a young age, and that "thus nursed, educated, and daily exercised in tyranny, cannot help but be stamped by it with odious peculiarities."[33]

An unknown painter in the early nineteenth century captured poignantly the violent passion, despotism, and submission of living in a slave society (Figure 11.10). On the back of a portrait of an unknown individual, the artist created a dual image with the words "Virginian Luxuries" at the bottom, capturing the depravity that Jefferson had

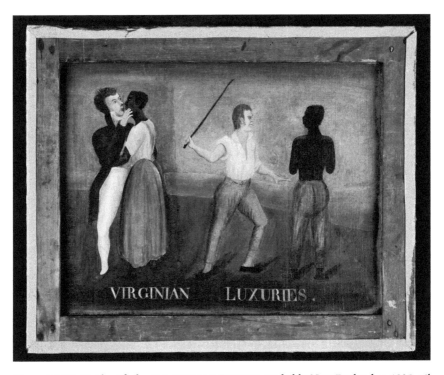

Figure 11.10 Unidentified artist, *Virginian Luxuries*, probably New England, *c.* 1825, oil on canvas, 20 7/8 × 16 in. (53 × 40.6 cm). The Colonial Williamsburg Foundation, Museum Purchase.

warned about decades earlier in his *Notes on the State of Virginia*. His comments were written before it is believed that he first began his sexual relationship with Hemings. Nevertheless, the "boisterous passions" of his statement deserve special scrutiny. The meaning of passion here is so important because it had multiple and somewhat contradictory definitions in the late eighteenth century signifying both intense anger and rage, and intense affection and love. Especially when used in the plural, it usually meant amorous impulses, desires, or even lewd behavior. Its modifier "boisterous" is also significant here because even though we may now tend to think of it more as a synonym for strong, nearly all of its period definitions are linked to violence. More than anything, it seems quite appropriate to think of this image as one that illustrates the combination of violence and sexual desire to which Jefferson was referring and to which he succumbed. In his own description of slavery, with the hindsight we now possess, we can read a very personal reflection on the cost of slavery, the violence, and the sexual desire, and understand more fully the "Virginian Luxuries" enabled by the architectural plan for Jefferson's Monticello.

Notes

1 The literature on Monticello is extensive. For more on the interior collections at Monticello, see Susan R. Stein, *The Worlds of Thomas Jefferson at Monticello* (New York: Harry N. Abrams, 1993); Joyce Henri Robinson, "An American Cabinet of Curiosities: Thomas Jefferson's 'Indian Hall at Monticello,'" *Winterthur Portfolio* 30, no. 1 (Spring 1995): 41–58; Roger B. Stein, "Mr. Jefferson as Museum Maker," in *Shaping the Body Politic: Art and Political Formation in Early America*, ed. Maurie D. McInnis and Louis P. Nelson (Charlottesville: University of Virginia Press, 2010), 194–230.

2 John Meacham, *Thomas Jefferson: The Art of Power* (New York: Random House, 2012), especially 363–4, 394–8.

3 The scholarship on those enslaved at Monticello is extensive. See especially Annette Gordon-Reed, *The Hemingses of Monticello: An American Family* (New York: W. W. Norton & Co., 2009), and Lucia Stanton, *Those Who Labor for my Happiness: Slavery at Thomas Jefferson's Monticello* (Charlottesville: University of Virginia Press, 2012).

4 Gordon-Reed, *The Hemingses of Monticello*, 606.

5 Robinson, "An American Cabinet of Curiosities," 43 and 54; Gordon-Reed, *The Hemingses of Monticello*, 624.

6 Gene Waddell, "The First Monticello," *Journal of the Society of Architectural Historians* 46, no. 1 (March 1987): 5–29.

7 Dell Upton, "White and Black Landscapes in Eighteenth-Century Virginia," *Places* 2, no. 2 (November 1984): 59–72.

8 Waddell, "The First Monticello," 14.

9 Mark Wenger, "Jefferson's Designs for Remodeling the Governor's Palace," *Winterthur Portfolio* 32, no. 4 (Winter 1997): 223–42.

10 Thomas Jefferson to Mann Page, [1796] quoted in William L. Beiswanger, "Thomas Jefferson's Essay in Architecture," *Thomas Jefferson's Monticello* (Charlottesville: Thomas Jefferson Foundation, 2002), 10.

11 Daniel Webster, *The Private Correspondence of Daniel Webster*, ed. Fletcher Webster (Boston: Little, Brown and Company, 1857), 365.

12 Monticello has done extensive archeology and has recently recreated a number of the buildings that once stood along Mulberry Row. For more see, William M. Kelso, "Mulberry Row: Slave Life at Thomas Jefferson's Monticello," *Archaeology* 39, no. 5 (September/October 1986): 28–35, and Gardiner Hallock, "Mulberry Row: Telling the Story of Slavery at Monticello," *SiteLINES: A Journal of Place* 14, no. 2 (Spring 2019): 3–8.

13 "Diary of Timothy Ford," *South Carolina Historical and Geneaological Magazine* 13, no. 3 (July 1912): 143.

14 Sam Aleckson, *Before the War, and after the Union: An Autobiography* (Boston: Gold Mine Publishing Co., 1929), 78.

15 Margaret Bayard Smith, *The First Forty Years of Washington Society*, ed. Gaillard Hunt (New York: Charles Scribner's Sons, 1906), 387–8.

16 Ibid., 70.

17 Anna Thornton, diary, September 20, 1802, quoted in *Visitors to Monticello*, ed. Merrill D. Peterson (Charlottesville: University Press of Virginia, 1989), 34; Augustus John Foster, *Jeffersonian America: Notes on the United States of America collected in the years 1805–6–7 and 11–12 by Sir Augustus Foster, Bart., ed.*, quoted in Peterson, *Visitors to Monticello*, 39.

18 Thomas Jefferson to John Wayles Eppes, September 18, 1812, Huntington Library, quoted in Gordon-Reed, *The Hemingses of Monticello*, 615.

19 Gordon-Reed, *The Hemingses of Monticello*, 305–6.

20 In 1998 DNA analysis confirmed a match between a descendant of Eston Hemings and a male of the Jefferson family. In 2000, a consensus emerged among historians that Jefferson likely fathered all of Sally's children; that conclusion was also confirmed by the Thomas Jefferson Foundation that owns and operates Monticello. The literature on this is extensive, but see especially Annette Gordon-Reed, *Thomas Jefferson and Sally Hemings: An American Controversy* (Charlottesville: University of Virginia Press, 1997) and Jan Ellen Taylor and Peter S. Onuf, eds., *Sally Hemings and Thomas Jefferson: History, Memory, and Civic Culture* (Charlottesville: University of Virginia Press, 1999).

21 Madison Hemings, "Life among the Lowly, No. 1," *Pike County (Ohio) Republican*, March 13, 1873.

22 Ibid.

23 Gordon-Reed, *The Hemingses of Monticello*, 613.

24 George Ticknor, *Life, Letters, and Journals of George Ticknor* (Boston: Houghton Mifflin, 1909), quoted in Peterson, *Visitors to Monticello*, 65.

25 Hemings, "Life Among the Lowly."

26 J[ames] T. Callender, *Richmond Recorder*, September 1, 1802.

27 Margaret Bayard Smith, quoted in Cynthia A. Kierner, *Martha Jefferson Randolph, Daughter of Monticello: Her Life and Times* (Chapel Hill: University of North Carolina Press, 2012), 130. Kierner recounts an episode of Martha bringing a poem to her father that recounted the allegations and he is said to have laughed at its contents.

28 "Elijah Fletcher's Account of a Visit to Monticello," May 8, 1811, *The Papers of Thomas Jefferson: Retirement Series*, ed. J. Jefferson Looney et al., vol. 3 (Princeton: Princeton University Press, 2006), 610 quoted in Gordon-Reed, *The Hemingses of Monticello*, 617.

29 Journal of John Hartwell Cocke, January 26, 1853, in John Hartwell Cocke Papers,
 box 188, Alderman Library, University of Virginia, in Joshua Rothman, *Notorious
 in the Neighborhood: Sex and Families across the Color Line in Virginia, 1787–1861*
 (Chapel Hill: University of North Carolina Press, 2003), 13.
30 Kierner, *Martha Jefferson Randolph*, 203, 262.
31 Mary Boykin Chesnut, *Mary Chesnut's Civil War*, ed. C. Vann Woodward (New
 Haven: Yale University Press, 1981), 29.
32 In fact, when she was near death herself, she explicitly told her sons that Jefferson
 was not the father of Sally's children, and instructed them to "remember this fact,
 and always to defend the character of their grandfather." Kierner, *Martha Jefferson
 Randolph*, 263.
33 Thomas Jefferson, *Notes on the State of Virginia* (London: Printed for John Stockdale,
 1787), 270–1. Access to Jefferson's personal copy is available at http://static.lib.
 virginia.edu/rmds/tj/notes/index.html (accessed October 2, 2022).

Bibliography

Aleckson, Sam. *Before the War, and after the Union: An Autobiography*. Boston: Gold Mine
 Publishing Co., 1929.
Beiswanger, William L. "Thomas Jefferson's Essay in Architecture." In *Thomas Jefferson's
 Monticello*, 1–39. Charlottesville: Thomas Jefferson Foundation, 2002.
Callender, J[ames] T. *Richmond Recorder*. September 1, 1802.
Chesnut, Mary Boykin. *Mary Chesnut's Civil War*, edited by C. Vann Woodward.
 New Haven: Yale University Press, 1981.
"Diary of Timothy Ford," with notes by Joseph W. Barnwell, *South Carolina Historical and
 Geneaological Magazine* 13, no. 3 (July 1912): 143.
"Elijah Fletcher's Account of a Visit to Monticello." May 8, 1811, in *The Papers of Thomas
 Jefferson: Retirement Series*, edited by J. Jefferson Looney et al., vol. 3, 610–11.
 Princeton: Princeton University Press, 2006.
Gordon-Reed, Annette. *Thomas Jefferson and Sally Hemings: An American Controversy*.
 Charlottesville: University of Virginia Press, 1997.
Gordon-Reed, Annette. *The Hemingses of Monticello: An American Family*. New York:
 W. W. Norton & Co., 2009.
Hallock, Gardiner. "Mulberry Row: Telling the Story of Slavery at Monticello." *SiteLINES:
 A Journal of Place* 14, no. 2 (Spring 2019): 3–8.
Hemings, Madison. "Life among the Lowly, No. 1." *Pike County (Ohio) Republican*,
 March 13, 1873.
Jefferson, Thomas. *Notes on the State of Virginia*. London: Printed for John Stockdale,
 1787.
Kelso, William M. "Mulberry Row: Slave Life at Thomas Jefferson's Monticello."
 Archaeology 39, no. 5 (September/October 1986): 28–35.
Kierner, Cynthia A. *Martha Jefferson Randolph, Daughter of Monticello: Her Life and
 Times*. Chapel Hill: University of North Carolina Press, 2012.
Meacham, John. *Thomas Jefferson: The Art of Power*. New York: Random House, 2012.
Peterson, Merrill D., ed. *Visitors to Monticello*. Charlottesville: University Press of Virginia,
 1989.
Robinson, Joyce Henri. "An American Cabinet of Curiosities: Thomas Jefferson's 'Indian
 Hall at Monticello.'" *Winterthur Portfolio* 30, no. 1 (Spring 1995): 41–58.

Rothman, Joshua. *Notorious in the Neighborhood: Sex and Families across the Color Line in Virginia, 1787–1861*. Chapel Hill: University of North Carolina Press, 2003.

Smith, Margaret Bayard. *The First Forty Years of Washington Society*, edited by Gaillard Hunt. New York: Charles Scribner's Sons, 1906.

Stanton, Lucia. *Those Who Labor for my Happiness: Slavery at Thomas Jefferson's Monticello*. Charlottesville: University of Virginia Press, 2012.

Stein, Roger B. "Mr. Jefferson as Museum Maker." In *Shaping the Body Politic: Art and Political Formation in Early America*, edited by Maurie D. McInnis and Louis P. Nelson, 194–230. Charlottesville: University of Virginia Press, 2010.

Stein, Susan R. *The Worlds of Thomas Jefferson at Monticello*. New York: Harry N. Abrams, 1993.

Taylor, Jan Ellen, and Peter S. Onuf, eds. *Sally Hemings and Thomas Jefferson: History, Memory, and Civic Culture*. Charlottesville: University of Virginia Press, 1999.

Ticknor, George. *Life, Letters, and Journals of George Ticknor*. Boston: Houghton Mifflin, 1909.

Upton, Dell. "White and Black Landscapes in Eighteenth-Century Virginia." *Places* 2, no. 2 (November 1984): 59–72.

Waddell, Gene. "The First Monticello." *Journal of the Society of Architectural Historians* 46, no. 1 (March 1987): 5–29.

Webster, Daniel. *The Private Correspondence of Daniel Webster*, edited by Fletcher Webster. Boston: Little, Brown and Company, 1857.

Wenger, Mark. "Jefferson's Designs for Remodeling the Governor's Palace." *Winterthur Portfolio* 32, no. 4 (Winter 1997): 223–42.

Index

dressing rooms
 female identity and cosmetic practices
 and 143-4
 in Georgian culture 149-56, *150*, *151*,
 152, *153*, *155*
 see also boudoirs

East Asian porcelain
 Augustus II of Saxony-Poland 35-6
 displays of 35, *36*
Emanuel, Max 65
The Empty Quiver (Delauney) 21-2, *22*, 25
enslaved people, hidden spaces for in
 Monticello house 247, 248-53, *250*,
 252, *253*
estrado (dais) of Doña Rosa Juliana
 Sánchez de Tagle
 antechamber 112-16, *113*, *114*, *115*,
 116
 apartment, marchioness's 104-5
 background of the marchioness 101
 bedroom attached to 109-12, *110*, *111*,
 112
 decline of indicated in inventory 117
 decoration and furniture *106*, 106-18,
 107, *108*, *110*, *111*, *112*, *113*, *114*,
 115, *116*
 defined 105
 foreign-made objects, significance of
 118
 gendered nature of *estrados* 100-1
 inventory 100
 material culture shown through 117
 new freedoms for women 101
 number and types of *estrados* 105
 origin and development of *estrado*
 concept 99-100, *100*
 paintings 107-8, *108*, 109-10, *110*, *112*
 *Portrait of Doña Rosa Juliana Sánchez
 de Tagle* (Aguilar) *102*
 religious art, importance of 117
 social protocol 105
 social spaces, bedrooms as 111-12
 Tagle family, rise of 101-3
 Tagle mansion 103-4, *104*
 use of *estrados* in Spanish America 105
Evelyn, John 146
exoticism, European, critical
 reassessments of 13

female self-fashioning, concerns over
 masks and make-up use 143
female sexuality as threat 25
Ferdinand IV 45-6
Festa, Lynn 152
Fletcher, Elijah 258
Fragonard, Jean-Honoré 174, 237, *238*
France *see cabinet turc* of comte d'Artois at
 Versailles
Freudenberg, Sigismund 172-4, *173*, 176
Freund, Amy 58
Frézier, Amédée François. 99, *100*
Frivolous Love (Lavreince) 174
functionality of rooms, tailoring to 2

Gell, Alfred 234
gender
 estrado (dais) of Doña Rosa Juliana
 Sánchez de Tagle 100-1
 female sexuality as threat 25
 identity, *Hercules and Omphale*
 (Boucher) and 182
Gies, David 4
global turn in art history, scholarship on
 3-4
Goldsmith, Oliver 152-3
Goodman, Dena 226
Goodman-Soellner, Elise 161
Gordon-Reed, Annette 254
Gricci, Giuseppe 45, *48*, *49*, *50*, *51*, *52*

Hague, Stephen G. 3
Hamilton, John Potter 105
handkerchief, symbol of 23
Hann, Andrew 4
Harry, Prince, Duke of Sussex 1
Hasse, Johann Adolf 39
Hay, Jonathan 91
The Heavenly and Earthly Trinities
 (unknown artist) 109-10, *111*
Hellman, Mimi 4
Henniker, John 205
Hercules and Omphale (Boucher) *181*,
 181-2
Hogarth, William *153*, 153-4, 155
Horemans, Peter Jakob 58
Hundezimmer, Amalienburg Palace,
 Munich
 alcoves for dogs 65